한국타이포그라피학회
글짜씨 18

KB084256

글짜씨 18

ISBN 978-89-7059-557-3(04600)

2020년 10월 12일 인쇄
2020년 10월 19일 발행

기획: 한국타이포그라피학회 편집부
지은이: 김경선, 김영나, 김현미, 노은유,
　　　　민병걸, 민본, 윤충근, 이건하, 이노을,
　　　　이지혜, 조영호, 최성민, 함민주
옮긴이: 김노을, 김요한, 박경식,
　　　　제현정, 최성민, 홍기하
편집: 한국타이포그라피학회 편집부,
　　　안그라픽스 편집부
디자인: 유현선

펴낸곳: (주)안그라픽스
　　　　10881 경기도 파주시 회동길 125-15
　　　　tel. 031-955-7766
　　　　fax. 031-955-7744
펴낸이: 안미르
주간: 문지숙
진행: 안마노
영업관리: 이정숙
커뮤니케이터: 김나영

인쇄·제책: 엔투디프린텍
종이: 두성 인버코트 크레아토 260 g/㎡,
　　　두성 문켄프린트화이트15 80g/㎡
글자체: 산돌 그레타산스 베타, 아르바나,
　　　　윤슬바탕체, Charter, IBM Plex Sans

© 2020 한국타이포그라피학회

이 책의 국립중앙도서관 출판예정도서목록(CIP)은
서지정보유통지원시스템(seoji.nl.go.kr)과
국가자료공동목록시스템(www.nl.go.kr/kolisnet)에서
이용하실 수 있습니다.

CIP제어번호: CIP2020042386

한국타이포그라피학회
글짜씨 18

안그라픽스, 2020

『글짜씨』의 이름을 짓던 때가 생각납니다. 초대 회장님과 몇 분의 임원들이 함께
인사동 한식집 바닥에 둘러앉아 "시각 문화, 글자, 씨앗, 글자의 씨, 글자 말고 글짜,
발음 그대로 짜, 짜기, 짜임새, 짜장면, 글을 짜, 누구씨? 글, 짜, 씨." 하고 뜻을 모았습니다.
그 학술지가 많은 분들의 노력과 희생으로 18번째 발행을 이어가고 있습니다.
작고 쉬운 내용을 지향하며 출발한 『글짜씨』는 점점 몸집이 불어가더니, 국제적 언어와
감각으로 단단함과 화려함을 뽐내던 시기를 지나 사춘기 청춘답게 잠시 방황도 하였습니다.
하지만 다시 채비하고 선보이는 18호의 인상은 여전히 푸르고 의욕에 차 있습니다.

조영호, 이건하의 논고는 작지만 단단하게 논지를 펼치고, 작업으로 소개된 이노을, 민본,
노은유, 함민주의 글꼴 디자인에 대한 각기 다른 이야기는 국내외 중요한 지점에서 주목받은
글자와 미래 글꼴 디자인의 방향을 제시하고 있으며, 윤충근이 소개한 《2019 타이포잔치》의
온라인 일간지 프로젝트는 새로운 가능성을 보여주는 좋은 사례입니다. 《물체주머니》라는
전시를 준비한 김영나 작가와의 대화는 비대면 시대의 전시를 맞이하는 생소함 때문인지 더욱
가치 있게 느껴졌으며, 「한국타이포그라피학회 10년의 기록」은 『글짜씨』가 자신이 태어난
가문의 이모저모를 돌아보고 스스로 관찰한 기억을 정리한 것입니다. 「뜻깊은 손글씨」는
학술지에 여유를 더하기 위해 기획되었고, 김현미의 스탠리 모리슨 저서 비평은 약 100년 전
세워진 타이포그래피 원칙을 논함과 동시에 이 시대 디자이너에 대한 기대를 이야기합니다.
이번에 처음으로 만든 인물 꼭지에선 학회 5대 부회장을 지낸 고(故) 조현 디자이너의
조형 세계를 다루며 먼저 떠난 그를 기립니다.

창립 모임을 할 당시 약 50여 명이었던 학회원은 이제 300명이 넘습니다. 학회는 지면에서
시작한 타이포그래피 논의를 확장하여 디지털 시대에 걸맞는 제안과 생각을 나눌 계획을
가지고 있고, 다양한 활동과 프로젝트를 궁리하며 규모에 맞게 웹사이트도 개편하고,
2년간 학회를 응원해주실 파트너도 모시고 있습니다. 이 노력이 학회원 한 분 한 분에게
잘 전달될 수 있도록 학회 메신저 역할을 하는 『글짜씨』를 더욱 열심히 만들도록
애쓰겠습니다. 유현선 출판국장과 함께 『글짜씨』18호에 참여해주신 모든 분께 깊이
감사드립니다.

　　　김경선

일러두기

본문의 외래어와 고유명사, 전문용어는 국립국어원
외래어 표기법과 『타이포그래피 사전』을 참고했다.

책, 정기간행물, 학위 논문은 겹낫표(『　』)로,
글, 학술지 논문, 기사, 글자체는 홑낫표(「　」)로,
전시, 앨범은 겹화살괄호(《　》)로,
작품, 방송, 노래, 영화는 화살괄호(〈　〉)를 사용했다.

'논고'는 한국타이포그라피학회 학술지인 『글짜씨』가 운영하는 가장 기본적인 이유이고 학술지와 잡지를 구분하는 지점이다. 자신의 분야에서 꾸준히 연구를 하고 있는 작업자들의 다양한 연구를 투고 받고 심사를 거쳐 책에 게재한다. 『글짜씨』 18에는 2개의 논고가 실렸다. 하나는 조영돈의 「고유의 디지털폰체 구현을 위한 타이포그래픽 알고리듬」이고 다른 하나는 이건하의 「김기림의 시의 시각화 실험: 구체시와 북 디자인 기법을 활용하여」다.

고유의 디지털필체 구현을 위한 타이포그래픽 알고리듬

조영호
05studio, 서울

주제어: 디지털필체, 인터랙티브 타이포그래피,
알고리듬, 데이터시각화, 인터랙티브디자인

투고: 2020년 5월 30일
심사: 2020년 6월 1일 – 6월 10일
게재 확정: 2020년 6월 12일

초록

손으로 쓴 글씨와 달리 디지털 텍스트에는 작성자 개인이 잘 드러나지 않는다. 반면, 디지털 대화상에는 의사 표현을 보다 개인화하기 위해 사용하는 다양한 폰트나 이모티콘, 신조어 등과 같은 보조물이 넘쳐난다. 이는 보다 개인적인 의사와 개인 그 자체를 드러내고자 하는 작성자의 욕구가 디지털 텍스트의 익명성과 충돌하는 것으로, 지금의 디지털 텍스트 입출력력이 가진 해결과제로 볼 수 있다.

따라서 본 연구는 손글씨를 통한 소통이 디지털 텍스트를 통한 대화 환경으로 변모하는 과정 속에서 누락된 요소와 그 누락의 원인을 고찰하고, 현재의 디지털 텍스트 환경 안에서 프로토타이핑과 소프트웨어 개발을 통한 필체의 구현을 시도한다. 이는 그간 디지털 환경상에서의 내용 전달이라는 우선순위에 밀려 충분히 표현되지 못했던 개인성을 회복하기 위한 작은 시도다. 비록 연구자의 경험과 기술적 한계 때문에 깊이 있고 충분한 구현이 이루어지지는 못했지만 이 연구가 앞으로 관련 연구에 조그마한 단초라도 제공할 수 있게 되기를 바란다.

1. 서론

1.1. 연구의 배경과 목표

손글씨를 통한 소통과 달리 디지털 텍스트를 활용한 대화에서는 작성자의 고유성이 잘
표출되지 않는다. 하지만 이모티콘이나 스티커, 신조어 등이 끊임없는 양산되고 소비되는
지금의 상황은 사람들이 의사소통에서 내용 외에도 자신에 대해서 추가로 표현하거나
전달하고 싶은 정보가 분명히 남아 있음을 시사한다.

내용 전달을 주목적으로 하는 글쓰기, 가령 보고서나 도표, 정보성 기사 등과 같은
텍스트에는 객관성과 빠른 전달을 위한 높은 수준의 균질함과 규칙성 등이 요구되며,
이와 같은 요구는 과거 어느 때보다 오늘날의 디지털 텍스트 출력이 잘 구현해내고 있다.
하지만 채팅이나 문자 메시지와 같은 개인적인 텍스트에서는 내용의 정확하고 빠른 전달
못지않게 텍스트가 가진 시각적 측면도 중요할 수 있다. 메시지가 가진 형태나 양식 또한
글을 쓴 대상에 대한 식별이나 의미에 대한 해석 측면에서 큰 비중을 차지하기 때문이다.

활자 시대로부터 시작된 글자조합 기술이 디지털 환경을 통해 한결 편리하고
정교해진 사용성과 결과물을 우리에게 제공하고 있는 것은 분명해 보인다. 하지만 그런
편리함과 정교함이 한편으로는 우리의 인간다움과 다양성을 조금씩 앗아가고 있는 것은
아닐까? 기능적인 문서작성에서 필요한 편리성이 정말 인류가 사용하는 모든 디지털
텍스트 입출력 환경에 그대로 적용되어도 괜찮은 걸까? 세상은 변했고 도구도 변했다.
과거 펜이나 연필을 활용해야 했던 필기도 이제는 디지털 기기를 통해 가능해졌다.
그렇다면 기존의 아날로그 도구로 입력된 글씨뿐 아니라 디지털 입력으로 만들어진 글씨도
필체로 바라볼 수 있지 않을까.

본 연구는 손글씨가 지금의 디지털 대화 환경으로 변모해가는 과정에 대한 고찰을
통해, 지금의 디지털 텍스트가 가진 고유성 부재의 원인, 즉 누락된 '필체적 요소'를
정의하고 이를 바탕으로 디지털 환경에서 입력된 텍스트를 개인만의 고유한 디지털필체로
구현하는 타이포그래픽 알고리듬을 제안한다.

마지막으로 프로토타이핑에 사용한 키보드오토마타의 개발과 설계한 알고리듬을
웹상에서 구현하는 데는 전문 프로그래머인 권재영(TFX)의 도움을 받았음을 밝힌다.

1.2. 용어 정의

본문에서 해석의 차이나 이해의 어려움이 예상되는 용어를 다음과 같이 정의하였다.

텍스트 Text

본 연구에서 텍스트는 글의 외형이 아닌 내용 Content 만을 지칭한다.
작성환경에 관계없이 텍스트는 인간에게 전달되기 위해 글자라는
약속된 기호로 시각화, 즉 글씨화된다.

필체 Handwriting

사전적으로는 글씨를 써놓은 모양[1]을 의미하나, 본 연구에서는 작성자의
고유성이 반영된 텍스트의 형상을 지칭하는 용도로 보다 폭넓게 활용되었다.
필체는 크게 아날로그필체와 디지털필체, 두 가지로 나뉜다.

아날로그필체 Analog Handwriting

붓이나 펜 등 실재하는 쓰기 도구를 사용하여 실재하는 대상 위에 쓴 아날로그

텍스트의 형상을 지칭한다. 개념적으로는 타자기와 같은 아날로그
기계로 만들어진 글씨도 인간에 의해 발생된 물리값을 결과물에
반영하게 되므로 아날로그필체의 일종이라고 볼 수 있다.

1. 네이버 국어사전, 검색어 '필체'.

2. 네이버 국어사전, 검색어 '알고리듬'.

디지털필체 Digital Handwriting
본 연구가 지향하는 결과물로, 키보드나 마이크, 카메라 등과 같은 디지털 도구를
활용한 입력이 작성자의 고유성을 반영해 출력된 디지털 텍스트의 형상을 지칭한다.

알고리듬 Algorithm
입력된 자료를 토대로 하여 원하는 출력을 유도하여 내는 규칙의 집합[2]을 뜻하는
용어다. 본 연구에서는 키보드 입력 간 검출 된 물리값을 바탕으로 디지털 텍스트를
시각화할 때 사용하는 규칙을 '디지털 타이포그래픽 알고리듬'으로 정의했다.

키보드오토마타 Keyboard Automata
키보드 타이핑한 한글 자소들을 자동으로 조립해주는 프로그램이다. 대부분의
OS가 내장하고 있는 기본 키보드오토마타도 문자를 조립해주기는 하지만
본 연구에서 필요한 값인 문자의 조립과정을 전달해주는 이벤트가 생략되어 있다.
따라서 본 연구에서는 조립과정의 시각화 및 로그의 재생이 가능한 2벌식 한글의
조합형 문자 조립기, 즉 키보드오토마타를 개발하여 사용했다.

키프레스이벤트 Keypress Event
키보드 자판을 누르는 행위를 통해 발생되는 이벤트를 모두 키프레스이벤트로
통칭한다. 키를 손으로 누를 때 발생되는 키다운이벤트 Key-down Event와
누른 키에서 손이 떨어질 때 발생되는 키업이벤트 Key-up Event로 나뉜다.

키홀드시간 Key-hold Duration
손으로 키를 누르고 있는 시간, 즉 키다운이벤트와 키업이벤트 사이의 시간을 뜻한다.

키프레스인터벌 Keypress Interval
이전 키 입력의 키업이벤트와 다음 키 입력의 키다운이벤트 사이의 시간 간격이다.

2. 디지털필체에 대한 고찰
2.1. 아날로그필체 vs. 디지털 텍스트
손글씨를 보면 글쓴이가 정성을 들여 썼는지, 상황이 급박했는지, 혹은 이 글씨를 쓴 사람이
누구인지 등에 대한 복합적인 평가가 가능하다. 글에 담긴 내용 외에도 종이의 종류나
글씨의 균질함, 조형성 등과 같은 여러 정보가 함께 전달되기 때문이다. 또한 손글씨는
누가 쓴 글씨인지 파악할 수 있는 고유한 패턴을 띠면서도, 한편으로는 동일인이 동일한
도구를 사용하여 같은 내용을 유사한 상황에서 다시 작성해도 매번 그 결과물의 모습이
다소 달라지는 특성이 있다.
　　이는 글씨의 형상이 보는 사람으로 하여금 그 글이 작성된 상황이나 도구뿐
아니라 작성자의 인격이나 교육 수준, 마음가짐 등을 판단하게 하는 기준이 될 수 있기
때문이며, 이로 인해 손글씨는 필연적으로 연마가 필요한 기교의 대상이 된다. 예술의 창작

및 재현에서 그 목적을 효과적으로 달성할 수 있도록 소재를 처리하고 문제점을 해결하여 작품을 형성하는 신체적·정신적 활동능력[3]를 뜻하는 기교는 더 훌륭하면서도 자신만의 독창적인 표현을 해내기 위해 인간이라면 누구나 연마할 수 있는 대상이다. 이는 디지털 창작, 즉 컴퓨터를 활용한 디자인 분야에서도 아날로그의 그것과 동일하게 유효하다.

비단 손글씨뿐 아니라 어떠한 유형의 표현에 접근하든 우리는 이 기교를 숙련하는 과정을 거치게 되며, 그 과정에서 환경적·경험적 이유에 의한 개인차가 필연적으로 발생하게 된다.

하지만 디지털 환경에서는 어떤 식으로 자판을 눌러도 최종 확정되는 텍스트만 같다면 동일한 형상으로 출력되기 때문에 글씨 그 자체만 놓고 보았을 때 더 훌륭한 입력이라는 개념이 존재하지 않으며, 따라서 숙련의 과정도 큰 의미를 가지기 어렵다. 가령, 글을 쓰는 사람 입장에서는 입력Enter 키를 누르기 전에 자신이 실수를 얼마나 많이 했는지도, 입력에 시간이 얼마나 오래 걸렸는지도 상대방에게 전혀 드러나지 않기 때문에 더 훌륭하게 만들기 위해 신경 쓸 동기가 없다. 디지털 대화 환경에서 인간이 연마해야 하는 기교란 그저 자판을 더 빨리 누르는 정도일 것이다. 심지어 이제는 필기나 음성인식 등의 신기술 덕분에 과거와 같이 글씨를 쓰기 위해 연습할 필요가 더더욱 사라지고 있다.

물론 이런 상황을 보다 편리하고 내용에 집중 가능한 환경 등 긍정적으로 바라보는 관점도 있을 것이다. 하지만 한편으로는, 디지털 대화 환경에서 대부분의 인간은 텍스트가 가진 내용 외의 부가 정보를 전달함으로써 고유성을 표출할 수 있는 기회와 권리를 반강제로 포기해야 하는 입장에 놓인 것으로도 볼 수 있지 않을까. 설사 지금의 디지털 텍스트 입출력 환경이 편리를 위한 필요라고 전제하더라도, 사용자가 의도하지 않은 획일화를 피할 수 있는 방법이, 최소한 선택적으로는 주어지는 것이 옳지 않을까.

[1]은 아날로그 텍스트와 디지털 텍스트의 전달체계를 구조화한 것이다. 이 전달체계 모형은 클로드 섀넌Claude E. Shannon의 일반적인 소통체계의 구조적 모형Schematic Diagram of a General Communication System(1948)[4]을 참고해서 만들어졌다. 참고한 본래 모형은 정보자료Information Source가 송신기Transmitter를 거치며 신호의 형태로 부호화Encoding 되고, 이를 수신기Receiver가 받아 다시 정보로 해독Decoding하는 과정과 송수신 과정에서 발생하는 노이즈Noise를 기술적으로 잘 구조화한 것이다. 연구자는 이 섀넌의 소통체계 모형 확립이 한편으로는 지금의 디지털 텍스트 출력이 고유성을 상실하게 된 주요한 계기가 되었을 수도 있다고 보았는데, 이 모형에서 메시지를 송수신하는 과정을 위해 다룬 부호Code라는 개념이 관념상 글자로 이루어진 문장에서는 텍스트만을 지칭하는 경향이 있다고 보았기

텍스트 전달체계

아날로그 A의 생각 — 텍스트 및 물리값이 반영된 글씨 작성 — A의 글씨 — 오프라인 → A의 글씨 — A의 텍스트 및 글씨 해석 — B의 이해

디지털 A의 생각 — 텍스트만 데이터화 — 텍스트 데이터 — 온라인 → 텍스트 데이터 — 텍스트만 해석 — B의 해석

[1] 아날로그 텍스트와 디지털 텍스트의 전달체계 비교.

고유의 디지털펄체 구현을 위한 타이포그래픽 알고리듬

때문이다. 하지만 이는 섀넌의 모형 자체가 가진 결함이 결코 아니며,
오히려 해당 모형은 오늘날의 디지털 정보 전달체계에서도 여전히 유효할
정도로 시대를 초월하고 있다고 생각했다. 따라서, 본 연구자는 해당 모형을
토대로 디지털과 아날로그 환경에서 텍스트 전달체계 기본적인 흐름을
본 연구의 목적에 맞게 노이즈의 개념을 뺀 뒤 재구성하고, 추가로 여기에
수신자 B에게 작성자 A의 고유성이 얼마나 잘 전달될 수 있는지를 덩어리의
형태로 표시하여 비교함으로써 디지털 텍스트 전달체계의 어느 지점에서
정보의 누락이 발생하며, 개선점이 무엇인지 살펴보고자 하였다.

3. 두산백과, 검색어 'technic'.

4. Shannon, Claude. E.
「A Mathematical Theory
of Communication」.
『The Bell System Technical
Journal』 Vol. 27(1948년 7월):
pp379-423.

먼저 아날로그 텍스트 전달체계에는 디지털 텍스트와 같이 전달하고자 하는 정보
중 일부만 부호화되고, 이를 다시 해독하는 과정이 없다. 따라서 작성자 A의 글씨는 원본
그대로 수신자 B에게 전달된다. A는 내용 외적으로도 자신의 의도를 표현할 기회를 가지게
되며, B는 완전히 정확하지는 않더라도 A가 전달하고자 하는 바를 내용 외적인, 즉 글씨의
형태나 상황적인 측면에서도 해석할 수 있는 기회를 가지게 된다.

반면, 디지털 텍스트에서는 오로지 텍스트만 데이터화되어 B에게 전송된다.
여기에도 글씨화된 형태는 존재하지만 이는 컴퓨터의 글씨, 즉 OS나 프로그램에서
미리 설정된 폰트이다. 따라서 이 전달체계상에서 'A의 필체'라는 개념은 입력과 동시에
사라진다. 텍스트의 생산 주체인 A는 B가 받게 되는 텍스트의 외형에 사실상 거의 관여할
수 없으며, B는 오로지 A로부터 받은 텍스트에만 기대어 A의 메시지를 해석해야 한다.
메시지의 내용에 따라 이는 심각한 오해를 낳을 소지도 있는데, 만약 B가 A에 대해 가지고
있는 사전 정보가 부족할 경우에는 더욱 그러하다. 뿐만 아니라 B는 해당 텍스트를 정말
A가 입력한 것인지, 아니면 누가 A를 흉내 내고 있는 것인지조차 판단하기 어려울 수 있다.

이 상황을 초래한 원인은 아마도 인류가 오랫동안 글씨를 주로 내용 전달의
관점에서만 다뤄온 탓에, 문서를 효율적으로 대량생산하기 위한 목적으로 사용되던
활자 기술과 방식을 특별한 개량 없이 거의 그대로 지금의 디지털 대화 환경에 적용한 탓일
것이다. 또 다른 가정으로는, 현재에 비해 상대적으로 많이 느렸던 과거의 정보처리 기술
수준도 원인으로 들 수 있다. 당시의 단위 데이터 전송량 증가는 곧 비용의 막대한 증가를
의미했으므로 어떤 종류의 데이터든 작게 만드는 것이 중요했고, 이 과정에서 상대적으로
덜 중요하다고 여겨진 나머지 정보들이 무시된 것이다.

2.2. 디지털 음악 vs. 디지털 텍스트

다음 쪽의 [2]는 기존의 아날로그 표현을 디지털로 보다 수준 높게 재현해 내고 있는
음악 분야의 상황을 한번 살펴보기 위해 아날로그 음악과 디지털 음악의 전달체계를 [1]을
기준으로 정리한 것이다. 악기 연주나 노래를 녹음하여 전달하는 방식은 본 연구의 취지와
근본적으로 맞지 않음으로 고려하지 않았다.

그림에서 보듯이, 본 연구는 아날로그 음악이 전달될 때보다 디지털 음악이
A의 의도를 오히려 더 정확하게 반영할 수도 있다고 보았다. 이를 이해하기 위해서는
아날로그 음악이 디지털 음악으로 이식될 때 일어나는 상황을 간단히 살펴볼 필요가 있다.

초창기의 컴퓨터 음악은 음의 높낮이와 길이, 소리의 크기 정도만 재현할 수 있을
정도로 표현의 폭이 좁았기 때문에 자연스러운 연주를 통해 느낄 수 있는 악기 자체의
소리 특성이나 연주 방법에 의해 발생할 수 있는 변화나 정밀한 소리의 파형을 전달하는
것이 불가능했다. 하지만 최근의 수준 높은 디지털 음악을 통해 음악이 디지털로 이식되는
과정은 틀림없이 텍스트의 시각화와는 차원이 달랐음을 쉽게 짐작할 수 있는데,

이는 음악이 가진 독특한 기록 방식, 즉 악보가 있었기에 가능했다.

소리의 높낮이로만 구성된 단순 정보인 음들로 내용과 의미를 만들어 내기 위해서는 음들 간의 상호연계나 다양한 길이 구성과 조합, 세기의 변화 등이 필요하다. 이와 같은 조합의 특징은 마치 최소 단위로는 거의 의미를 가지지 않는 알파벳이나 한글 등의 표음문자의 그것과도 유사해 보인다. 하지만, 표음문자가 독음이 정해진 자음과 모음만으로 비교적 단순하게 조합이 완성되는 것과 달리 음악은 옥타브, 길이, 화음구성, 연음, 세기변화, 다양한 주법 등과 같은 복잡한 기교와 조합을 거쳐야 비로소 전달하고자 하는 바가 구현된다. 뿐만 아니라 문자의 경우 동일하게 조합할 경우 대체로 동일한 의미를 가진 단어나 문장으로 발전되는 것에 반해, 음악은 완전히 같은 음의 조합이라도 그 음들을 몇 개씩 마디로 묶는지, 어떤 속도로 연주하는지, 또는 각 음의 소리를 어떻게 만들어 내는지 등에 따라서 완전히 다른 의미와 느낌으로 발전하는 복잡성을 띤다.

이러한 복잡성 때문에 음악은 오래전부터 이를 기록하고 전달하기 위해 복잡하고 상세한 기호를 활용한 악보의 기록법, 즉 기보법Notation을 발전시켰다. 음악의 연주나 발표, 보존, 학습 등을 목적으로 일정한 약속이나 규칙에 따라 기호를 써서 악곡을 기록하는 방법[5]인 기보법을 통해 수신자는 음의 높낮이를 비롯하여 음악에 대한 보다 정교한 해석과 재현이 가능해진다. 이는 일종의 변환부호화Tanscoding 프로세스로, 인간의 의도가 부호화되었다가 다시 해독되는 이와 같은 과정은 기본적으로 문자언어와 음악의 소통 과정에 동일하게 적용이 가능하다. 하지만 음악은 문자에 비해 기본 단위는 단순한 반면 조합 측면에서 복잡성을 띠는 특징으로 아날로그 단계에서도 많은 정보를 고도로 부호화시켜 오랜 시간 동안 그 사용규칙을 확립해왔고, 결과적으로 디지털화되는 초기 단계에서도 문자와는 차원이 다른 수준의 데이터화가 가능할 수 있었다.

3. 디지털필체 알고리듬
3.1. 구현세부목표 및 방법 설정

앞서 고찰하며 다룬 전달체계를 좀 더 자세히 살펴보면 디지털 텍스트의 전달체계가 나머지 세 가지 전달체계와 근본적인 차이를 보이는 지점은 작성자가 입력한 생각이 작성자의 디지털 환경에서 출력될 때라는 것을 알 수 있다. 즉 작성자가 입력함과 동시에 텍스트를 제외한 나머지 모든 데이터가 유실되고 있는 것이다. 따라서 현재의 보편적인 디지털 텍스트 입력 환경 기준으로 보았을 때, 작성자가 자판을 입력할 때 발생하는 물리값이

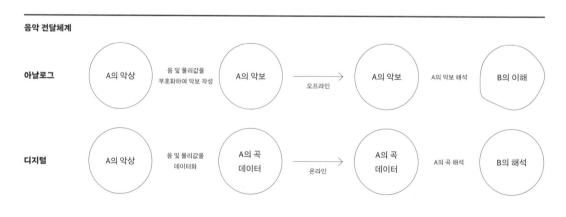

[2] 아날로그 음악과 디지털 음악의 전달체계 비교.

고유의 디지털필체 구현을 위한 타이포그래픽 알고리듬

바로 작성자가 반영된 텍스트, 즉 디지털필체를 만드는 데 필요한 핵심 누락
요소라고 할 수 있다.

5. 네이버 국어사전, 검색어
'기보법'.

본 연구가 지향하는 디지털필체는 디지털이라는 새로운 도구에
적합한 새로운 형식의 필체를 구현하는 것으로, 아날로그 필체를 흉내 내는 것과는 거리가
있다. 이를 바탕으로 본 연구의 디지털필체 구현방향과 연구 접근은 네 가지로 요약된다.

첫째, 디지털상에서 고유성을 가진, 즉 인간이 물리적으로 개입된 글씨를 생산할 것
본 연구는 자판 입력 간 발생되는 키다운 및 키업이벤트의 시간값을 검출하여,
이를 키홀드 및 인터벌값으로 치환해 해당 값을 글씨를 시각화하는 데 적용했다.

둘째, 디지털 환경의 장점을 적극 수용할 것
디지털이 가진 여러 장점을 최대한 활용하겠다는 뜻이다. 본 연구에서는 입력 시
발생된 물리값을 바탕으로 쓰기과정이 재현Replay되는 알고리듬을 구상했다.

셋째, 보편적인 디지털 환경상에서 구현할 것
새로운 입력장치의 개발 없이 알고리듬 설계와 프로그래밍만으로 최종 시각화를
구현하겠다는 뜻이다. 디지털필체는 사용하는 도구의 수준과 관계없이 구현
가능하다고 생각했기 때문에, 새로운 도구의 개발보다 인간의 동작을 반영하는
텍스트 입출력 환경, 즉 알고리듬의 구현이 선행되어야 한다고 판단했다.

넷째, 디지털필체의 분석과 훈련이 가능한 환경을 구축할 것
디지털필체 또한 펜글씨나 서예처럼 훈련을 통해 다듬어져야 할 대상이다.
따라서 결과물을 웹페이지상에서 출력해주는 것을 넘어 자신의 입력을 복기하고
입력 간 발생한 값들의 로그를 분석할 수 있도록 이를 웹사이트상에 축적Archive하여
필요시 대조하거나 자신의 디지털필체를 개발하는 등의 목적에도 활용할 수 있게
하고자 하였다.

3.2. 1차 시각화 프로토타이핑
본 연구는 크게 2차에 걸친 프로토타이핑 과정을 거쳤다. 그중 1차 프로토타이핑은
고유성의 중요한 전제조건 중 하나인 식별이 가능할 정도로 기존 디지털 텍스트 출력과는
확연히 다른 디지털필체의 시각화가 가능한지 검토하기 위해 비교적 가볍게 수행되었다.
간단히 그 과정을 소개하자면, 평소 사용하는 애플사 맥 OS 표준 키보드로 '안녕하세요'라는
텍스트를 입력하고, 텍스트가 출력되는 화면을 30fps의 영상으로 녹화하여 플레이어에서
글자가 만들어질 때 소요된 프레임수를 수동으로 검출한 뒤, 그 값을 시각화에 적용해보는
식이다. 먼저 글자별로 검출된 프레임수는 다음과 같다.

안29 (19) 녕22 (12) 하7 (9) 세10 (8) 요13

글자 옆의 수치는 해당 글자를 완성하는 데 소요된 프레임수이며, 각 괄호 안의 수치는
글자와 글자 사이 공백 동안 소요된 프레임수다. 다음으로는 이 수치들의 평균을 내어
시각화의 기준이 될 값을 설정했다.

한 글자 완성에 소요된 프레임수의 평균 ≒ 16
글자와 글자 사이 프레임수의 평균 ≒ 12

다음 [4]는 검출된 프레임수를 포지션Position과 투명도Opacity 등에 각 글자별로 적용해 본
시안이다. 간단하게 진행한 작업이었지만 입력과정에서 발생할 수 있는 단 두 가지 물리값의
적용만으로도 한 사람의 입력이 다양한 텍스트의 형상으로 확장될 수 있다는 점을 알 수
있다. 뿐만 아니라 확장된 글자들의 형상은 기본적으로 시스템에서 제공되는 디지털 텍스트
출력과 확연히 달라 보이는데, 이는 입력에 따른 고유한 시각적 패턴, 즉 디지털필체가
충분히 가능할 수 있음을 시사한다고 판단했다.

3.3. 테스트용 커스텀 키보드의 활용

디지털필체가 실제로 일정한 패턴, 즉 고유성을 띨 수 있는지 검토하고자 반복적인 입력 시
발생하는 시간값을 자동검출해주는 테스트용 커스텀 키보드를 개발하여 실험을 이어나갔다.
테스트용 커스텀 키보드는 시간 관계상 모든 OS가 아닌 애플 iOS상에서 영문 자판의
입출력만 가능한 수준으로 만들어졌다. 프로그램 개발에는 애플 스위프트 3이 활용되었다.
　　[5]는 개발된 테스트용 커스텀 키보드를 실제 사용하고 있는 화면이다. 테스트는
평소 한글 자판을 입력하듯이 '안녕하세요'를 영문 자판으로 10회에 걸쳐 입력하고,
각 키의 로그를 검출하는 방식으로 진행되었다. 테스트 시간값의 검출에는 시분초가 0으로
리셋되지 않는 유닉스타임스탬프Unix Timestamp를 활용했으며, 편의상 키보드 좌하단의
'123' 키에는 검출된 모든 로그를 일괄 클립보드에 복사해주는 기능을 심었다.
테스트 샘플의 생산에는 스마트폰의 영문 자판만으로 한글 입력이 자연스럽게 가능한
사람을 찾기가 어려워 연구자 본인만 참여하였는데, 이는 분명 데이터의 객관성을
떨어뜨리는 접근임을 인정한다. 하지만 본 테스트는 한 사람이 여러 번 입력한 텍스트가

	아날로그필체	디지털 텍스트	디지털 텍스트 보조표현도구	디지털필체
개념 정의	손글씨나 서예처럼 실재하는 대상, 또는 캔버스에 쓰여진 글씨	디지털상에서 퓨어 텍스트값만 가지고 구축되는 텍스트 결과물	폰트나 이모티콘, 스티커 등 불완전한 커뮤니케이션을 보완하는 도구	필체화 알고리듬을 적용한 디지털 텍스트 결과물
원본의 고유성이 있는가?	있음	없음	없음	있음
생산 주체의 물리적특성을 반영하는가?	반영함	반영하지 않음	반영하지 않음	반영함
모방하기 쉬운가?	어려움	쉬움	쉬움	다소 어려움
복제/대량생산이 가능한가?	불가능	가능	가능	가능
글 쓴 주체를 식별할 수 있는가?	있음	없음	다소 있음	있음
쓰는 과정을 그대로 재현할 수 있는가?	없음	다소 있음	다소 있음	있음

[3] 비교를 통한 디지털필체의 특징 정의.

고유의 디지털필체 구현을 위한 타이포그래픽 알고리듬

일정한, 즉 고유한 패턴을 보일 가능성이 있는지와 여러 입력 간 발견되는 특이점이 있을 수 있는지를 검토하는 것이 주목적이었으므로 정확성이나 객관성이 다소 부족하더라도 일단 진행하는 것이 옳다고 판단했다.

다음 [6]은 검출된 샘플 데이터 중 10개를 스프레드시트로 정리하고 해당 데이터를 바탕으로 그래프 시각화를 수행한 결과다. 입력 중 오탈자도 몇 차례 발생했는데, 분석 정확도를 높이기 위해 해당 값은 배제했다. 그래프를 보면 여러 입력값들이 대체로 일정한 패턴을 띄고 있음을 확인할 수 있는데, 이는 자판 입력과 같은 비교적 단순한 입력방식을 통해서도 충분히 개인의 필체가 만들어질 수 있는 가능성이 있음을 시사한다.

이어서 좀 더 긴 문장으로 다른 특이점이 없는지 한 번 더 검토를 진행했다. 이번에는 조금 더 나아가, 영문 입력 시 발생되는 값을 한글 낱글자 단위로 구간별 합산수식을 만들어 정리한 뒤 이를 [7]의 그래프와 같이 시각화했다. 테스트에 사용한 문장은 아래와 같다.

dkssudgktpdy whdudgh dlqslek (안녕하세요 조영호입니다)

보다 긴 입력에서도 패턴은 대체로 일정하게 나타났다. 하지만 예상치 못한 특이점도 발견되었는데, 첫 번째는 스페이스바의 입력값이다. (그래프상에 세로 막대로 표시한 부분) 이 값은 대체로는 일정했지만 일부는 판이하게 다른데, 스페이스바를 입력하는 시점에서 잠시 머뭇거리거나 쉬었기 때문이다. 이는 누가 입력해도 동일한 양상이 나타날 소지가 있는 부분으로 어떻게 처리하는 것이 적절한지에 대한 추가 검토가 필요했다. 또 다른 특이점은 키홀드시간값들에 비해 입력간격Interval값들이 일정하지 않게 나타난 점과 키홀드시간 합산(가운데 맨 위 그래프)에 비해 키홀드시간 평균(오른쪽 맨 위 그래프)이 일정하지 않게 나타난 점이다. 이는 한글 텍스트의 디지털필체화에는 입력간격보다 키홀드값이, 키홀드값의 평균보다는 합산을 활용하는 것이 보다 적합할 수 있음을 뜻한다.

[4] 1차 시각화 프로토타이핑 결과물.

마지막으로 동일한 텍스트가 서로 다른 문장에서 사용될 경우와 신규 입력이 기존 입력과 연관성이 있는지를 한 번 더 검토했다. 이를 위해서는 2017년 8월 23일에 입력한 'dkssudgktpdy(안녕하세요)'와 약 한 달 이후 입력한 'rmaksgktpdy(그만하세요)'에서 'gktpdy(하세요)'라는 텍스트만 분리해 결과값을 서로 대조해 보는 방식을 사용했다.

이 마지막 검토를 통해 동일인이 동일한 텍스트를 입력할 경우 비교적 일관된 패턴, 즉 일정한 필체 데이터를 이룰 가능성이 크다는 점을 다시 한번 확인할 수 있었다. 한 가지 더 발견된 흥미로운 점은, 테스트를 진행하는 동안 입력을 반복하는 과정에서 연구자가 테스트용 커스텀 키보드에 익숙해진 탓에 9월에 실시한 테스트에서는 보다 안정적인 'gktpdy(하세요)' 입력 패턴, 즉 디지털필체를 이루었다는 점이다.

[5] 테스트용 커스텀 키보드(영문).
개발환경: 맥 OS 10.12. 애플 스위프트 3
테스트환경: 아이폰 7, iOS 10.13

3.4. 2차 시각화 프로토타이핑

2차 시각화 프로토타이핑에서는 앞서 커스텀 키보드를 활용한 테스트 과정에서 얻게 된 결과값과 인사이트를 바탕으로 다양한 시각화 방향을 구상하는 데 집중했다. 연구자는 디지털 환경이 아날로그에 비해 시각화 측면에서 가장 탁월한 지점 중 하나가 데이터화를 통한 재현성이라고 보았다. 디지털 환경은 텍스트 입력 과정을 데이터화할 수 있으며, 나아가 해당 데이터를 기반으로 입력과정을 시간순으로 다시 재현Re-play할 수 있다. 따라서 본 연구는 시각화 적용 단계에서 어도비 애프터 이펙트를 활용하여 디지털필체가 만들어지는 과정을 애니메이션으로 재현하고, 최종적으로는 이와 같은 재현이 웹상에서도 가능하도록 구현하여 디지털필체가 정지된 결과물을 통해 입력 과정을 유추해야 하는 아날로그 필체와 분명한 차이를 띄도록 의도했다.

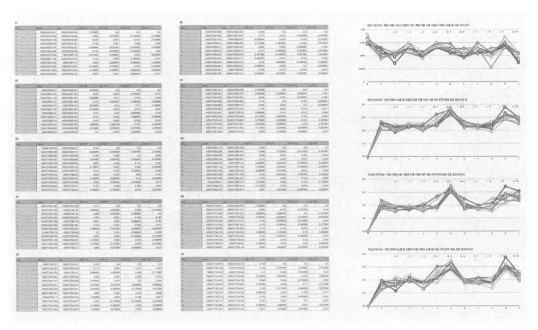

[6] 'dkssudgktpdy(안녕하세요)'의 그래프. 2017년 8월 23일 테스트 수행 결과물.

고유의 디지털필체 구현을 위한 타이포그래픽 알고리듬

이 작업을 위해 우선 커스텀 키보드 입력을 통해 얻게 된 샘플값 중 하나를 선택하여, 해당 샘플의 다운 및 업 타임스탬프를 0부터 시작하는 소수점 2자리(반올림) 형식으로 정리하고, 이를 [9]와 같이 50fps 영상용 프레임값으로 치환하여 영문 및 한글 낱글자 당 키홀드시간과 키입력간격의 프레임수에 적용하는 과정을 거쳤다.

초당 50프레임 영상으로 만들기 위해 0.02초가 1프레임으로 환산되었다. 예를 들어 초 단위 업 타임스탬프의 1행 값이 0.15인데, 이는 프레임으로 그대로 환산하면 7.5프레임이 된다. 영상의 프레임은 소수점 이하가 있을 수 없으므로 이를 반올림하여 정수화하면 결과는 8프레임이 되는 방식이다. 표에서는 이를 0s08로 표기하였다. 그 밖에도 한글의 경우, 영문과 달리 조합되어 완성되는 특성이 있어 아래와 같은 세 가지 값의 추가 설정이 필요했다.

1. 낱글자당 키홀드시간 합산 Total Key-hold Duration
키입력간격이 키홀드시간에 비해 상대적으로 일정하지 않은 점을 고려해 만들어진 참조치로 일부 시각화 접근에 적용되었다. 이 값을 활용할 경우 키입력간격이 일정하지 않아도, 즉 연속으로 입력하지 않아도 키홀드시간만 일정하면 항상 유사한 느낌의 디지털필체가 출력된다.

2. 낱글자와 낱글자의 입력간격 Interval between Letters
한글 낱글자의 마지막 자소와 다음 낱글자의 첫 번째 자소 사이 입력간격이다. 이 값은 각 입력이 낱글자를 만들어내는 영문에서는 고려할 필요가 없는 부분이지만 한글에서는 상황이 다르다. 한글에서 각 자소간의 입력간격값을 조합된 글자 속에 반영한다는 것은 곧 새로운 반응형 폰트 체계의 개발을 의미하기 때문이다. 이는 기존 폰트 개발을 넘어서는 작업으로 본 연구 안에서 다룰만한 사안이 아니라고 판단했다.

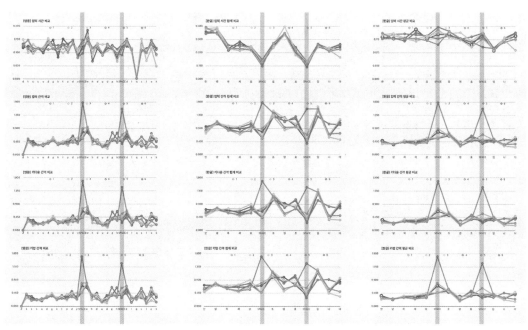

[7] '안녕하세요 조영호 입니다'의 그래프. 왼쪽부터 차례대로 영문 입력, 한글 글자 단위 입력 합계, 한글 글자 단위 입력 평균.

논고

따라서 본 연구에서는 현재의 기술적 상황 안에서 바로 영문과 한글에 공통적으로 적용 가능한 낱글자당 간격만 참조치로 만들어 사용했다.

3. 낱글자당 소요된 총시간 Whole Duration per One Letter

위의 두 번째 참조치를 영문과 한글에 동일한 기준으로 적용하기 위해 만든 참조치다. 앞서 설명한 대로 한글은 자소가 조합된 낱글자 단위로 조합되기 때문에 글자 하나를 만드는 데 걸린 총시간이라는 영문과 한글에 일관되게 적용 가능한 개념을 만들었다. 이 값은 두 번째 참조치가 사용될 때에만 함께 쓰였다.

즉 입출력 방식의 차이로 영문 시각화는 2개의 값으로 충분하지만, 한글 시각화에는 총 5개의 값이 고려될 필요가 있는 셈이다. 실제 이 연구의 마지막 단계에서 한글 디지털필체용 키보드오토마타를 개발할 때도 키 입력에 따른 물리값을 조합된 글자에 맞게 재산정하도록 만드는 데 보다 많은 고민과 시간이 소요되었다. 이는 한편으로는 복잡도가 높은 한글을 위한 디지털필체 알고리듬만 잘 만들면 영문 디지털필체는 어느 정도

[8] 'gktpdy(하세요)' 입력값 그래프 비교. 2017년 8월 23일 결과(좌측 2열), 2017년 9월 24일 결과(좌측 2열).

영어	한글	다운 타임스탬프 (초)	업 타임스탬프 (초)	다운 타임스탬프 (프레임)	업 타임스탬프 (프레임)	영문 낱글자당 프레임수		한글 낱글자당 프레임수		
						키홀드시간	키프레스인터벌	낱글자당 키홀드시간 합산	낱글자와 낱글자 사이의 입력간격	낱글자 당 소요된 총시간
d	ㅇ	0.00	0.15	0s00	0s08	8	0	17	0	26
k	ㅏ	0.21	0.29	0s11	0s15	4	4			
s	ㄴ	0.41	0.51	0s21	0s26	5	6			
s	ㄴ	0.61	0.71	0s31	0s36	5	5	15	5	26
u	ㅓ	0.78	0.88	0s39	0s44	5	3			
d	ㅇ	1.03	1.14	1s02	1s07	5	8			
g	ㅎ	1.38	1.49	1s19	1s25	6	12	11	12	16
k	ㅏ	1.60	1.69	1s30	1s35	5	5			
t	ㅅ	1.78	1.89	1s39	1s45	6	4	11	4	17
p	ㅔ	2.02	2.11	2s01	2s06	5	6			
d	ㅇ	2.31	2.43	2s16	2s22	6	10	11	10	29
y	ㅛ	2.59	2.69	2s30	2s35	5	8			

[9] 2차 시각화 프로토타이핑용 프레임수 계산 테이블.

고유의 디지털필체 구현을 위한 타이포그래픽 알고리듬

자동 해결될 수도 있음을 뜻한다. 따라서 본 시각화 프로토타이핑에서는 영문 텍스트는 따로 다루지 않았다. [10]은 위 값을 바탕으로 만든 애니메이션 시각화 프로토타입 결과물의 목록이다. 각 목록에는 애니메이션을 확인할 수 있는 링크가 함께 정리되어 있다.

목록 중 '0. 노멀 텍스트 타이핑 샘플'은 가이드로 활용하기 위해 정리한 프레임수를 바탕으로 시각화 작업의 기준이 될 애니메이션 샘플을 만든 것으로, 메모장 등에서 텍스트를 입력했을 때 보여지는 과정을 재현한 것과 거의 동일하다. 본래 논문에서는 모든 프로토타입을 상세히 다루었는데 여기서는 실제 웹에서 구현한 5번, 7번, 8번, 총 세 가지 프로토타입만 좀 더 상세히 소개하겠다.

먼저 프로토타입 5번[11]은 한 폰트 패밀리 안에서 키홀드시간을 구간별로 나누어 굵기마다 할당하여 적용한 것이다. 사용된 「애플 산돌고딕 네오 Apple SD Gothic Neo」는 총 아홉 단계의 굵기를 가지고 있어, 키홀드시간을 0.05s 단위로 나눈 뒤 각 폰트 굵기별로 구간을 할당하여 0.41s 혹은 그 이상일 때 최대 굵기인 헤비Heavy가 출력되도록 설정했다. 이 프로토타입은 각 자소를 입력할 때마다 폰트의 굵기가 점차 증가하며 시각적 즐거움을 준다. 하지만 여기에는 근본적인 문제가 있는데, 조합 없이 단 하나의 자소만으로 표현되는 영문은 대체로 얇은 굵기로 출력되어 두 언어의 병기 시 균형 문제가 발생한다는 점이다.

다음 프로토타입 7번[12]은 글자 자체에 시각적 효과를 직접 적용하지 않고 추가적인 그래픽 요소를 만든 결과다. 색이 채워진 면과 하부의 빈 공간은 각각 낱글자 생성에 소요된 시간과 글자와 글자 사이 입력간격의 흐름을 나타낸다. 면과 공간의 생성은 각 글자의 중심 하단으로부터 낱글자 생성 시간 혹은 글자와 글자 사이 입력간격에 따라 꼭지점Peak·Vertex이 시각적으로 상승하며 만들어진다. 이 프로토타입은 글자만으로 디지털필체를 구현하지는 않지만 어떻게 타이핑되었는지 해석이 가능한 시각화이므로 충분히 디지털필체의 한 접근으로 볼 수 있다고 판단했다. 이와 같은 시각화 방식은 현재의 디지털 텍스트가 가진 가독성을 거의 저해하지 않고도 디지털필체의 표현이 가능하다는 장점이 있다.

마지막으로 소개할 프로토타입 8번[13]은 각 자소별 키홀드시간과 자소간 입력간격, 낱글자당 입력시간 등 지금의 보편적인 자판을 통한 텍스트 입력 환경에서 발생할 수 있는 거의 모든 값을 한 번에 시각화한다. 글자와 글자 사이 입력간격만 제외되었다. 한글의 경우 특히 글자가 조합되는 과정이 레이어 형태로 누적되어 글자 입력과정을 자소 단위로 볼 수 있다는 점이 특징이다. 키를 누르면 각 키에 해당하는 자소가 대각선 우측하단 방향으로 자라나며, 각 자소와 자소 사이의 입력간격은 해당 시간만큼

순번	시각화 방식	Animation URL
0	노멀 텍스트 타이핑 샘플	vimeo.com/248626477
1	키홀드시간을 Y포지션에 적용	vimeo.com/248626660
2	키홀드시간을 스케일에 적용 1	vimeo.com/248626682
3	키홀드시간을 스케일에 적용 2	vimeo.com/248626695
4	키홀드시간을 투명도에 적용	vimeo.com/248626837
5	키홀드시간을 폰트 두께에 적용	vimeo.com/248626859
6	자소별 키홀드시간을 점선으로 시각화	vimeo.com/248626884
7	글자별 총소요시간과 입력간격을 면으로 표현	vimeo.com/248626897
8	자소별 키홀드시간과 입력간격을 볼륨으로 시각화	vimeo.com/248626909

[10] 2차 시각화 프로토타이핑 결과물 목록.

대각선 하단 아래 방향으로 벌어진다. 이 작업은 개인적으로는 모든 프로토타입 중에서 시각적으로 가장 흥미롭다고 생각하지만 아쉽게도 글줄의 가독성이 다른 시각화에 비해 분명히 떨어진다. 실제 프로그램 구현 때에는 컬러체계를 보완하는 방식으로 이 문제를 약간이나마 보완했다.

3.5. 디지털필체 알고리듬의 구현

본 연구의 최종 목적지는 고안한 디지털필체 알고리듬을 일회성 출력물이 아닌 향후 자신 또는 타 연구자의 유사연구에 밑거름이 될 수 있도록 모두가 접속 가능한 웹상에서 구현하는 것이다. 따라서 웹사이트 구축 시 비영리 도메인(org)을 사용하였으며, 이름은 'AS-YOU-ARE(당신의 있는 그대로)'로 명명했다.

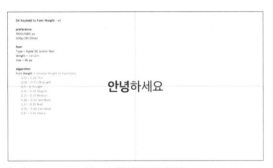

[11] Prototype 05. 키홀드시간을 폰트 굵기에 적용.
Animation URL: vimeo.com/248626859

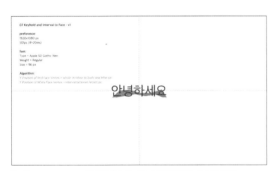

[12] Prototype 07. 글자별 총소요시간과 입력간격을 면으로 표현.
Animation URL: vimeo.com/248626897

[13] Prototype 08. 자소별 키홀드시간과 입력간격을 볼륨으로 시각화.
Animation URL: vimeo.com/248626909

http://AS-YOU-ARE.org

웹사이트는 1920×1080px 비율의 스크린에서 브라우저를 전체화면으로 했을 경우를 기준으로 기본형을 디자인했다. 프로토타이핑에는 「애플 산돌고딕 네오」가 사용되었으나, 실제 웹사이트에는 다양한 OS 및 브라우저 환경에서 동일한 폰트로 출력될 수 있도록 「본고딕」 폰트 패밀리를 적용했다. 프로젝트 초기단계에서 결과물 구현 시 사용자가 원하는 다양한 폰트의 선택지를 주는 것이 고려되었으나, 연구가 진행되어감에 따라 디지털필체의 핵심이 폰트가 아닐 수 있으며, 또 연구자 개인이 특정 폰트를 선정하는 것이 지나치게 주관적일 수 있다고 판단하여 배제했다. 웹사이트는 크게 디지털필체를 출력해주고 상세한 로그를 확인할 수 있는 'MAIN' 페이지와 웹사이트를 방문한 사용자들의 이해를 돕고 사이트를 만드는 데 크고 작은 도움을 주신 분들께 감사를 표하기 위한 목적의 'ABOUT' 페이지, 저장한 로그를 볼 수 있는 'ARCHIVE' 페이지로 구성되어 있다. 'MAIN' 페이지의 주 기능은 본 연구의 핵심인 디지털필체를 텍스트 입력을 통해 생산하는 것이다. 따라서 가장 눈이 쉽게 가고 넓은 중앙 영역을 시각화 영역으로 지정하였다. 왼쪽 아래에 키보드 자판으로 입력할 수 있는 텍스트 입력창Text Field을, 반대편에는 시각화 알고리듬을 선택할 수 있는 타입 셀렉트 버튼들을 위치시켰다. 입력창에 텍스트를 입력하면 이를 키보드오토마타가 조합함과 동시에 결정된 타임스탬프를 바탕으로 필요한 값 계산이 자동으로 이루어지게 되고, 시각화 영역에서 선택된 각 알고리듬 타입에 맞게 실시간 시각화가

이루어진다. 시각화 알고리듬에 따라서 차이는 있지만 키보드오토마타에서 조합이
완료되어야 마지막 글자의 시각화 역시 완료되므로 현재 버전에서는 편의상 입력 키를
눌러야 마지막 글자조합이 완료되도록 설정했다. 시각화 타입은 개발 진행간 테스트를
위해 만들어진 알파 버전과 2차 시각화 프로토타입
결과물 중 최종 선별된 세 가지, 이렇게 총 네 가지로
구성되어 있으며, 입력한 후에 다른 타입을 선택해도
해당 알고리듬에 맞는 시각화가 입력값을 바탕으로
재현되도록 구현했다. 입력창 하부에는 좌측부터
순서대로 'Re-play' 버튼과 'Reset' 버튼, 그리고
입력 간 발생한 키 로그와 시각화 결과물을 종합해서
확인할 수 있는 'View Log' 버튼이 배치되었다.
'View Log' 버튼을 누르면 다음 [15]와 같이
'TYPING LOG' 창이 플로팅^{Floating} 된다.

[14] 'MAIN' 페이지 화면.

　　'TYPING LOG' 창의 좌측 영역은
로그를 활용한 시각화 및 입력환경 정보와 저장에
필요한 기능들로 구성되어 있다. 사용자가 만약
자신의 로그를 검토하고 이를 저장하고 싶을 때는
필수입력 사항을 모두 기재하고 'Save Your Log'
버튼을 클릭하면 사이트의 'ARCHIVE' 페이지에
등록된다. 우측은 정보 영역으로 타이핑 회수나 오류,
소요시간 등을 보여주는 'Summary', 키다운 및 업
타임스탬프를 테이블로 출력해주는 'Timestamps',
키홀드시간과 키입력간격의 흐름을 그래프로
시각화하여 보여주는 'Graph' 등 총 세 가지
세부 영역으로 나뉜다.

[15] 'TYPING LOG' 창이 플로팅된 모습.

　　[16]과 [17]은 각각 사용자들이 저장한
로그를 둘러볼 수 있는 'ARCHIVE'의 목록과 상세보기
페이지 시안이다. 목록을 클릭하면 상세보기 화면으로
이어지도록 설계했다. 상세보기 화면은 앞서 설명한
'TYPING LOG'와 거의 동일한 구성이지만, 저장과
관련된 기능 대신 이전, 또는 이후 게시물로 이동할 수
있는 버튼과 비밀번호를 입력하여 해당 로그를 삭제할
수 있는 'Delete' 버튼이 배치된 점만 다르다.

[16] 'ARCHIVE' 목록 화면 디자인.

　　'AS-YOU-ARE.org'는 아직 일부 기능이
구현되지 않은 알파오픈^{Alpha-Open} 상태로,
현재는 알고리듬의 시연만 가능하다.

4. 결론 및 한계
본 디지털필체 구현 연구는 고유성이 없는 디지털
텍스트의 외형에 인간이라는 특성을 반영하여
궁극적으로는 고유한 대상으로 시각화하고,
이와 같은 인식을 보다 널리 보편화하고자 하는

[17] 'ARCHIVE' 상세보기 화면 디자인.

시도의 일환으로 진행되었다.

본 연구가 가진 한계 중 첫 번째는 알고리듬을 설계하기 전 디지털필체의 과정을 직접 개발한 키보드오토마타를 통해 확인하는 과정에서 기술적, 상황적 한계 때문에 연구자 1인만 실험에 참여함으로써 떨어진 객관성이다. 향후 보다 많은 사용자를 통해 각자의 키보드 입력이 서로 명확히 구별되는 다른 패턴을 띨 수 있는지에 대한 추가 검토가 필요한 부분이다.

두 번째는 일부 시각화 알고리듬이 컴퓨터의 성능고하에 따라서 일종의 지연현상Latency이 발생하고 있다는 점이다. 이는 컴퓨터 성능 부족의 문제라기보다는 알고리듬의 최적화와 관련된 문제로, 관련해서 차후 리플레이 방식 및 구현 시 과부하를 방지하기 위한 프로그램상의 개선이 필요한 부분이다.

세 번째는 서로 다른 언어 간 동일한 알고리듬을 적용할 때 발생하는 일관성의 문제다. 이는 본문에서도 다룬 내용으로, 가령 키홀드시간을 굵기에 적용 시 한글은 여러 자소가 조합되며 값이 누적되어 대체로 두꺼워지는 반면 영문은 자소가 바로 글자를 이루는 관계로 입력값이 상대적으로 작아 필연적으로 얇게 출력되는 불균형이 야기된다. 이 문제를 보완하기 위해 새로운 참조치인 낱 글자내 각 자소의 키홀드시간 평균을 적용한 시각화 알고리듬 타입의 추가개발을 검토 중이다.

네 번째는 백스페이스의 처리 문제이다. 지금의 알고리듬은 백스페이스를 누를 경우 로그는 남기되 시각적으로는 텍스트를 삭제하는 방식으로 구현되고 있어 아쉽다. 다만 이 부분은 디지털 환경의 이점을 십분 활용하여 리플레이를 통해서는 백스페이스를 누르는 행위가 확인되도록 구현되었는데, 관점에 따라서 손글씨가 지우개 자국이나 덧칠 자국을 남기는 것처럼, 오류 혹은 오류가 아닌 것을 삭제하는 것도 분명히 텍스트를 입력하는 과정상에서 인간의 특징을 반영하는 행태라고 볼 수 있으므로 현재의 결정에 약간은 아쉬움이 남는다.

그리고 무엇보다도 가장 큰 한계는 시각화 측면에서 유희와 기술적 확장이 충분하지 못한 점이다. 연구가 지나치게 고찰과 데이터화에 편중됨으로써 서예와 같은 아날로그 쓰기의 깊이와 풍부함은 말할 것도 없고, 이미 수없이 시도된 인터랙티브 타이포그래피 작품들에도 한참 못 미치는 시각적 결과에 그치고 말았다. 여기에는 연구자의 프로그래밍에 대한 이해의 폭은 물론이고, 폰트에 대한 기술적 이해나 경험의 부족도 크게 작용하였음을 인정하는 바이다.

그밖에도 영어나 한글 외 기타 다양한 언어의 지원이나 압력 및 기울기, 조도와 같은 현재 기술로 검출 가능한 추가적인 물리값의 반영, 음성 및 사진 인식 등에 대한 해석과 같은 여러 해결과제가 산재해 있다.

여러모로 부족한 연구였음에도 본 연구를 통해 '필체'란 아날로그나 디지털이라는 환경적 요인과 관계없이 인간이 글을 쓰는 과정에서 발생되는 여러 고유한 값들의 온전한 반영을 의미한다는 점을 깨달은 게 뜻깊었다고 생각한다. 그렇기에 본 연구의 가장 긍정적인 측면도 최종 산출물인 알고리듬을 공개적인 웹사이트의 형태로 구축한 점이라고 생각한다. 이는 앞으로도 관련 연구를 계속해 나갈 연구자들이 기존의 연구를 직접 활용해볼 수 있을 뿐만 아니라, 한계점이나 개선점을 파악하기에도 용이한 환경이기 때문이다. 아무쪼록 이 작은 시도가 디지털 환경을 인간의 여러 도구 중 하나로서 보다 풍부하고 정교하게 만드는 데 조금이나마 도움이 되기를 소망한다.

참고문헌

로버트 브링허스트.『타이포그래피의 원리(The Elements of Typographic Style)』.
　　　박재홍 외 옮김. 서울: 미진사, 2016.
박연주 외.『터치 타입(Touch Type)』. 서울: 한국공예·디자인문화진흥원, 2016.
알레시오 레오나르디 외.『한 줄의 활자(A Line of Type)』. 윤선일 옮김.
　　　파주: 안그라픽스, 2010.
에밀 루더.『타이포그래피(Typography)』. 안상수 옮김. 파주: 안그라픽스, 2001.
제임스 글릭.『인포메이션(Information)』. 박래선 외 옮김. 서울: 동아시아, 2017.
조영호.『AS-YOU-ARE.org: 식별 가능한 디지털 필체의 구현을 위한
　　　타이포그래픽 알고리듬 디자인』. 석사 학위 논문, 서울: 홍익대학교, 2018.
한국타이포그라피학회.『타이포그래피 사전』. 파주: 안그라픽스, 2012.
Claude. E. Shannon.「A Mathematical Theory of Communication」.
　　　『The Bell System Technical Journal』 Vol. 27(1948년).
Jiwon Lee.『User Aspect Type Design』. California: California Institute of Arts, 2006.

웹사이트

김수정.〈소리반응 폰트(Sound Reactive Font)〉. 2020년 6월 30일 접속.
　　　http://www.suzung.com/
네이버 국어사전. 2020년 6월 30일 접속. https://ko.dict.naver.com/
두산백과. 2020년 6월 30일 접속. http://www.doopedia.co.kr/
AS-YOU-ARE 웹사이트. 2020년 6월 30일 접속. http://as-you-are.org/
John Maeda.〈Reactive Books〉,《MAEDASTUDIO》. 2020년 6월 30일 접속.
　　　https://maedastudio.com/
Michael Flückiger.「LAIKA」. 2020년 6월 30일 접속. https://www.laikafont.ch/
Nicolas Nohornyj.〈Lazy Pen〉. 2020년 6월 30일 접속.
　　　https://www.nahornyj.com/
Yuzo Azu.〈INSTAMP〉,《Lexus Design Award》. 2020년 6월 30일 접속.
　　　https://discoverlexus.com/experiences/lexus-design-award-2020

김기림 시의 시각화 실험: 구체시와 북 디자인 기법을 활용하여

이건하
그래픽하, 파주

주제어: 김기림, 시, 구체시, 북 디자인

투고: 2020년 5월 25일
심사: 2020년 6월 1일 – 21일
게재 확정: 2020년 6월 25일

초록

이 연구는 구체시와 북 디자인 기법을 활용하여 시의 심상 표현 시각화와 감각 결합을 통한 시 감상법 발견을 목적으로 한다. 구체시란 글의 문맥이나 의미, 논리를 무시하고 문자를 그림 그리듯 배열해 회화적 요소를 중점으로 한 시 형식을 의미한다. 이처럼 시의 구성 요소 중 한 가지 요소만을 전달하는 것에 집중한 구체시 형식은 글자를 그림의 수단으로 활용한 방식이며, 언어의 의미보다 시에서 전달하고자 하는 심상 표현에 중점을 두고 있다.

연구의 시작은 구체시와 더불어 기존에 시도가 흔치 않았던 기법과 수단을 접목했을 때, 시 속 이미지 표현과 심상 전달의 새로운 가능성에 대한 의문이었다. 먼저 시의 해석을 기반으로 글 의미를 파악하고 글에서 느껴지는 감정, 무게, 색상, 질감, 은유적 표현 등을 각기 다른 형태로 표현할 수 있는 기법을 모색해 보았다. 연구 최종 결과물은 지면에 글자를 인쇄하여 책으로 엮는 것을 전제로 하기 때문에 북 디자인 기법을 필요로 했다. 이 두 가지 수단을 이용해 물리적으로 책을 변형하여 구체시 형식을 강화하고, 심상 표현을 위한 시각과 촉각의 결합을 시도했다.

위 실험은 국내 시 문학계에서 새로운 시도와 표현으로 접근했던 시인 김기림의 시집『바다와 나비』를 선정해 진행되었다. 김기림은 1930년대 구인회에서 활동하던 시인이다. 국내 문학계에 모더니즘 이론을 본격적으로 도입하여 작품 활동을 펼쳤던 비평가이자 시인으로, 그를 선정한 이유는 다음과 같다. 첫째, 김기림은 과거 서정시와 달리 회화성을 중시하는 모더니즘 이론을 전파하며, 창작을 통해 이미지 표현을 분명히 한 점이다. 둘째, 김기림의 대표작 「바다와 나비」는 1930년대 기존 시에 비해 시각적 표현과 이미지가 선명하게 드러난 작품으로 평가받았다. 셋째, 김기림은 영국 모더니즘 시인, 평론가로 알려진 엘리엇의 영향을 받아 이미지와 이미지를 결합한 감각적 표현에 주력했다는 점이다. 이는 앞서 언급한 구체시 형식 강화와 시의 심상 표현 전달에 중점을 둔 시각화 실험에 부합하는 요소이다. 국내에서 구체시에 관한 연구와 실험은 많은 편이 아니지만, 다양한 시도가 조금씩 보이고 있다. 그러나 시를 시각화하는 것에 대해 기준이 명확하게 주어진 작품은 찾기 쉽지 않다. 이 연구는 문학의 시각화와 감상법을 다양한 형태로 제안하는 것에서 그 의미를 찾을 수 있다.

1. 시각화를 위한 짧은 글

오늘날 한국 근대시 모더니즘의 전개는 1930년대 활동했던 시인 김기림의 시론에서
발단되었다. 김유중에 따르면 김기림의 등장은 계급주의 문학으로 일컬어지는 카프KAPF
계열 문인들의 활동이 한풀 꺾이기 시작한 지점이다. 김기림은 카프 문인들의 이념 편향적인
태도, 편내용주의적인 활동 방식에 한계를 느끼고 근대 문학의 추구를 실천에 옮기고자
모더니즘 시론을 도입하기 시작했다.[1] 이 연구는 김기림이 주장했던 모더니즘 운동 중
시 표현에 대한 문제를 중점으로 두고 있다. 이미지즘과 주지주의를 바탕으로 감정과
정서를 배제하고 시의 회화성, 즉 심상을 중시한 지점이다. 이는 1920년대 감정에 호소했던
낭만주의 시와 명백하게 대조되는 모더니즘 시의 특징이다. 그는 모더니즘 운동을 통해
기존 문학의 전통과 권위를 부정하며, 서구의 주지주의와 이미지즘에서 시의 근대성을
찾으려 했다. 이러한 시의 이미지즘 표현은 현대에 들어서며 디자인 분야에서 두각을
드러내기도 했다. 국내에서는 본격적으로 『타이포그라피적 관점에서 본 李箱 시에 대한
연구』로 박사 학위를 받은 안상수를 중심으로 이루어지기 시작한다. 안상수는 1930년대
김기림과 활동했던 시인 이상에 관심을 가졌고, 시를 그래픽 요소를 활용한 이상의
'시각시視覺詩·Visible Poetry'를 타이포그래피 실험으로 보았다. 한국에서는 2010년
타이포그라피학회의 주최로 시인 이상의 탄생 100주년을 맞이해 시각시 전시회
《시:시》가 열렸으며, 디자인 분야에서 활동하는 여러 그래픽 디자이너가 참여해 이상의
작품을 시각적으로 풀어냈다. 그러나 이미지즘을 기반으로 시의 심상 표현에 중점을 두었던
김기림은 디자인 분야에서 논의된 바가 거의 없는 편이다. 시인, 문학평론가로 알려진
장석주는 김기림이 이상의 멘토라고 보았고, 김기림은 구인회[2] 내부에서도 이상의 문학을
가장 잘 이해하고 있었다고 말한다. 이에 연구자는 모더니즘의 이념 도입을 시도한 후
작품으로 풀어낸 김기림의 시론과 작품을 시각과 촉각, 감각 간 결합을 통한 시각화 실험을
진행하고자 한다. 연구에서 진행되는 시각화는 이미지즘 기반 시론과 작품 해석을 거쳐
심상 표현 강화와 새로운 시 감상법 발견을 목적으로 한다.

2. 접근 방법과 태도

김기림의 작품 해석과 시론을 시각화하기 위한 방법을 주지적인 태도로 바라본다.
이는 시의 감상과 해석에서 감정이나 정서적인 면을 배제하는 관점으로 인간의 감정보다
이성과 지성을 우선시하는 태도이다. 1920년대 감성적이고 낭만적인 시를 비판했던
김기림 모더니즘 문학의 중심이 되는 이 견해는 시각화를 위한 연구자의 태도와 입장을
명확히 굳혀주었다. 김기림의 시를 읽는 독자의 입장에서 절대주의적 관점을 통해
시 속의 이미지를 떠올리며 심상 표현의 감각을 구현하는 것이다.

먼저 종이에 글자가 새겨진 물리적인 형태, 즉 책의 형태를 결과물로 예상한다면
북 디자인 기법이 반드시 필요했다. 특히 제책과 더불어 현대에서 활용되고 있는 인쇄 기반
후가공은 책이 담고 있는 내용의 전달을 함축적으로 표현하거나 강조하기 위한 방법으로
쓰인다. 그뿐만 아니라 책을 읽는 독자들의 편의를 위해 활용되는 공정이기도 하다.
이 실험에서 제책 방식과 후가공은 구체시 심상 표현 강화를 위한 수단으로 활용되었다.
타공과 박, 코팅, 따내기 외에 기존 인쇄에서 사용되는 후가공이 아닌 수작업으로
책을 가공하는 방식을 택했다. 후가공의 적절한 활용은 제작자의 의도에 맞게 역할을
수행함으로써 책의 완성도를 더욱 높이는 것이다.

마지막으로 김기림의 대표작 「바다와 나비」에서 선정된 시의 심상 표현을 위해
구체시 기법을 사용하여, 시에서 표현하고자 하는 심상 표현의 강화를 돕도록 했다.

정리하자면 북 디자인 기법과 구체시의 활용으로 책을 물리적으로 시각화·촉각화할 수 있는 방법을 모색하여 한 편의 시가 한 권의 책이 되는 구조로 제작했다. 이는 시에서 전달하는 심상 표현이 온전히 한 권의 책에서 드러날 수 있도록 하며, 표현을 위한 실험 기법을 극대화하기 위함이다. 북 디자인 기법을 기반으로 한 책의 물리적 형태 변화 시도가 두드러진 실험이므로 한 권에 여러 작품이 수록되는 것을 의도적으로 배제했다.

3. 근대 문학의 모더니즘 전개

1930년대 근대 문학 모더니즘은 김기림을 비롯한 구인회 소속 문학인을 중심으로 전개되기 시작한다. 문학에서 모더니즘이란 기성 문학의 관습에서 벗어나 실험적인 경향의 문학을 의미하며 20세기 초반 등장한 여러 유파가 이 범주에서 논의되는 편이다. 국내의 경우 1930년대 카프파의 해체 이후 급격하게 펼쳐지는데 당시 모더니즘 문학은 주지주의와 이미지즘에 기반을 두고 감정과 정서보다 지성과 이성을 중요시하는 태도를 강조했다. 국내 문학계 최초로 모더니즘 이론을 전파했던 인물로 최재서가 있었으나, 이 연구에서는 모더니즘 이론을 시와 접목해 선보였던 김기림에 주목한다. 회화적 이미지 활용과 감각 표현에 주력한 작품은 당시 문학계에 신선한 충격이었다. 이처럼 기존 낭만적이고 서정적인 시를 비판하고 감정보다 지성을 앞세운 시의 선명한 이미지 표현은 당시 그가 주장했던 모더니즘 시의 특징이었다.

4. 김기림의 모더니즘 운동: 이미지즘과 주지적 태도를 기반으로

김기림은 당시 시대 상황과 문학을 날카롭게 통찰하여 모더니즘 운동의 근간을 이루었다. 그는 신문학의 전개를 서양문명의 영향을 받아 출발할 수밖에 없다는 것을 인정하고 이 주장에 대해 아래와 같이 언급한다.

> "19세기의 중엽 이래 서양문명은 더욱 급격하게 동양제국을 그 영향 아래
> 몰아넣었다. 일본, 중국과 인도 등 제국에서 일어난 신문학은 맨 처음에는
> 서양 문학의 모방에서 시작되었다. 그것은 그 문학의 모체인 문명의 침입에
> 따라오는 불가피한 일이다."[3]

이처럼 기존 시인들이 받아들였던 감성과 정서를 바탕으로 한 로맨티시즘을 강하게 비판하며, 신문학 수용으로 인한 근대 문학의 발전을 급진적으로 이끌어 내었다. 김기림의 등장 이전 1920년대 서구문학 이론이 맹목적인 태도에 머물러 있던 것에 비해 1930년대 최재서와 김기림의 활동으로 영미문학이 본격적으로 도입되며 체계를 잡아가기 시작한 것이다.

5. 문자로 시를 그리다: 구체시의 활용

시각시는 문자를 단지 의미를 전달하는 수단이 아니라 시각적인 형태를 연구하는 20세기 초의 모든 전위이념으로부터 퍼져 나와 시와 회화의 결합 가능성 추구에서 탐구되었다. 시어에 이미지, 회화 개념을 도입하여 문자의 형태를 시각화시킨 것을 시각시라 한다. 인쇄에서 활자의 배치나 활자의 선택 여부가 중요한 작용을 한다. 즉 활자가 더욱 더 적극적인 창작의 수단이 된다.[4] 이 연구는 그러한 수단 중에서 문자의 시각적 배열을 통해

1. 김유중. 『김기림 평론선집』. 서울: 지식을만드는지식, 2015. p268.

2. 구인회: 1933년 8월 일제 강점기 조선에서 결성된 문학 단체로 이종명, 김유영이 발기인을 맡았고, 이효석, 이무영, 유치진, 조용만, 이태준, 김기림, 정지용 등 9명이 함께 결성하였다. 이후 이종명과 김유영, 이효석이 탈퇴하고 박태원, 이상, 박팔양이 가입하였으며, 유치진과 조용만 탈퇴 후 김유정, 김환태가 가입함으로써 구인회가 구성되었다. 1930년대 이후 문학의 흐름을 이끌어 나가는 데 이바지했다.

3. 정순진. 『새미작가론총서 10: 김기림』. 서울: 새미, 1999. p43.

4. 한주연. 「한국 현대 시각시에 나타난 타이포그라피의 역할 연구」. 석사 학위 논문, 서울: 홍익대학교, 1997. p4.

논고

[1] 오이겐 곰링어. 「침묵(Schweigen)」.

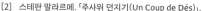

[2] 스테판 말라르메. 「주사위 던지기(Un Coup de Dés)」.

[3] 기욤 아폴리네르. 「비가 오도다(Il Pleut)」.

'읽기'에서 벗어나, 이미지로 전달되어 '보는' 시의 형식을 활용한다. 이는 시각시에서
발전되어 1945년 이후 독일, 프랑스, 중남미 등지에서 전개되었던 구체시의 형식이다.
구체시의 경우 대칭, 대비, 기능성, 회화성 등 복합적 양상을 띠었던 신타이포그래피로
발전되었다.[5]

시각시는 시의 본문을 활용하여 시각화한 형식이지만 문학에 바탕을 두고 있는
구체시와는 타이포그래피에서 해석한 개념이라는 차이가 있다. 구체시에서 구체의 개념은
문자나 부호 등의 시각적 물질성을 의미하며 시를 구성하는 문자의 크기, 배열, 순서가
불규칙적으로 해체되어 사용된다.[6] 이러한 근거들로 미루어 볼 때 명확한 구분은 없으나
구체시는 시각시의 범주 내에서 하위 개념으로도 볼 수 있을 것이다. 그러나 구체시의
장르는 일반 명사화되어 시각나 음향시 등을 포함한 기존 형태를 벗어난 실험시를
통칭하여 사용하는 경향이 있다. 작가별, 시기별로 그 유형이 너무나 다양하고 변화되므로
어떠한 범위내에 둔다는 것은 무리가 있는 것이다.[7] 구체예술을 기반으로 시 문학에 도입한
것으로 구상시라고도 불리며, 독일의 오이겐 곰링어Eugen Gomringer가 구체시의 대표적인
작가로 알려져 있다. 구체시라는 개념은 1955년까지 거슬러 올라간다. 그 해에 오이겐
곰링어가 구체예술이라는 개념으로 알려진 미술사조를 (몬드리안, 칸딘스키) 원용하여
구체시를 "단어와 문자들의 수열을 통해 그리고 새로운 구조적 방법을 통해 만들어지는
하나의 질서 단위체"라고 정의했다. 이 정의는 앞으로 구체시가 발전하게 될 방향과
가능성을 한데 모아 보여주는 것이다.

전통 시에서는 단어가 이미지나 상징, 은유 등으로 쓰이며 전달하고자 하는 내용을
의미상으로 나타낸다. 이에 반해 구체시는 단어를 반복, 배열하거나 문자를 일정한 법칙에

따라 늘어놓는 방법을 사용함으로써 시어에 새로운 기능을 부여한다.
또한 단어나 문자를 시에서 떠오르는 모양으로 나열하거나, 시의 외양을
구조적으로 변형하는 등 전통적인 시 형식을 파괴하고 있다.[8] [1]은
오이겐 곰링어의 구체시로 침묵의 배열을 통해 침묵 속의 침묵을 보여주고
있다. 기존 시 형식 문법을 해체하고 문자의 시각성을 강조하는 것이다.
이는 시에서 전달하는 언어의 의미가 파괴될 수 있으나 이미지의 형상을
시각적으로 그려내며, 시각뿐 아니라 음성의 청각성을 표현하기도 한다.
한편 곰링어는 구체시와 관한 여러 선언문을 발표했다. 1956년 작성된
한 선언문에서는 구체시가 갖추어야 할 세 가지 가치를 제시하고 있다.

첫째, 시각적 측면Visual Aspect에 있어서 기존의 선형적인 형태를
따르지 말 것.

둘째, 정보와 커뮤니케이션Information and Communication에 있어
시어는 그 의미로서 소통하는 것이 아니라, 그것 자체가
기호로 사용되어야 한다.

셋째, 국제성과 초국가성International and Supernational을 가지고 있을 것.

곰링어가 제시한 이러한 사항 중 시각적인 측면은 구체시가 기존의
시의 형식과 구별되는 가장 큰 특징으로 주목된다.[9] 특히 19세기
프랑스 상징파의 대표적인 시인으로 손꼽히는 스테판 말라르메Stephane
Mallarmé의 시를 살펴보면 실험적인 시각 요소를 살펴볼 수 있다.[2]
이는 구체시의 특성을 고스란히 드러내고 있는 작품으로 다양한 활자
크기와 배열로 시각 이동을 이루어 운동성을 지닌다. 프랑스의 시인이자 소설가였던
기욤 아폴리네르Guillaume Apollinaire 역시 문장을 도형이나 그림의 형태로 변환시켜
시에서 떠오르는 심상을 그려낸다. 아폴리네르의 시 「비가 오도다」에서 비가 내리며 빗물이
퍼져나가는 모양으로 배열되어 있다.[3] 읽고 '보는' 시로 시각뿐 아니라 비가 주룩주룩
내리는 형태의 리듬을 잘 나타내고 있다.
 시의 인상을 이미지로 각인시키는 구체시의 표현은 형식에 얽매이지 않고 창작자의
감각과 의도를 통해 새로운 창작이 가능하다. 구체시는 통일된 양식을 보여주지 못할
정도로 매우 다양하지만 공통되는 특징은 축소된 언어를 통해 과감하게 변형하여 특수한
방식으로 입력·인쇄한다는 점이다. 그리고 한 편의 시가 시각적인 통일체로 감지되는
대상물로서 독자의 주의를 끌 수 있도록 하고 있다는 공통점을 가진다. 이러한 이유로
여러 구체시들이 관습적인 감상법으로는 읽을 수 없는 것이 많다. 왜냐하면 이 시들은
구성 문자들의 순서와 위치가 조직적으로 뒤바뀐 단어나 구로 구성되었거나, 분절된 단어
또는 무의미한 음절, 문자, 숫자, 구두점의 단편들로 이루어져 있기 때문이다.
이렇게 이루어진 형태 속에서 구체시의 시인들은 여러 가지 활자 형태와 크기 및 색깔을
다양하게 이용하며, 때때로 사진을 본문에 첨가하는 등의 실험을 한다.[10]
 국내에서는 시인 고원에 의해 시집 『미음ㅁ속의 사랑』『나는 ㄷㅜㄹ이다』[4, 5]
『미음ㅁ속의ㅇ이응』[6, 7]『한글나라』 등에서 처음 소개되기 시작했다. 이 책들에서 소개된
구체시는 한글의 특성을 담은 시를 본격적으로 도입한 것으로 보인다. 특히 한글 구체시는

5. 안상수. 『타이포그라피적
관점에서 본 李箱 시에 대한
연구』. 박사 학위 논문. 서울:
한양대학교, 1995. p74.

6. 한국타이포그라피학회.
『타이포그래피 사전』. 파주:
안그라픽스, 2012. p297.

7. 김지연. 『타이포그라피의
예술적 관점에서 본 구체시의
정신성과 조형성』. 석사 학위 논문,
서울: 홍익대학교, 2006. p69.

8. 연세대학교 인문학연구원.
〈"문자의 사회문화적 연구"
문자를 시의 대상으로 만들다—
독일의 구체시〉.
http://munja.yonsei.ac.kr/
archives/archives_02_1_
concrete_poem.php

9. 김지연. 『타이포그라피의
예술적 관점에서 본 구체시의
정신성과 조형성』. 석사 학위
논문, 서울: 홍익대학교, 2006.
pp81–82.

10. 한국문화평론가협회.
『문학비평용어사전(상)』. 서울:
국학자료원, 2006. p268.

[4] 『나는 ㄷㅜㄹ이다』.「나는 둘이다 또는 아니다 그리고 이곳은 안이다」.

[5] 『나는 ㄷㅜㄹ이다』.「나는 둘이다」.

[6] 『미음ㅁ속의ㅇ이응』.「세로」.

[7] 『미음ㅁ속의ㅇ이응』.「도시의 풍경」.

김기림의 시의 시각화 실험: 구체시와 북 디자인 기법을 활용하여

한글 고유의 조형성을 두드러지게 보여주는 작품이다. 구체시는 일반 시와는 다르게 문장, 문단 단위의 포괄적인 의미전달보다 자음과 모음 혹은 음절과 단어 사이에서 전달하고자 하는 의미를 전개·이동·발전시킨다.[11]

 고원의 구체시를 살펴보면 단순하지만, 시의 제목과 연결되는 문자의 이미지와 연결 지점을 찾을 수 있다.『미음ㅁ속의ㅇㅇ이응』에서 디자인 비평가 김민수 교수(서울대학교)는 고원의 시를 이렇게 평가한다. "그의 시가 지나치리만큼 단순하다는 것. 그러나 절대 단순하지 않다는 것. 시각적이면서도 음성적이고 유동적이라는 것. 이상하게 접합되는 파편적 의식의 흐름이 엿보인다는 것."이라고 언급했다. 또한, 곰링어의 「침묵」은 고원이 초기 한글시가 전개될 기본 틀이자 이후 구체시로부터 벗어나는 점에서 의미가 크다고 보고 있다. 즉 곰링어의 구체시가 고원의 첫 구체시 시집『한글나라』에 실렸던 시를 창작하게 된 계기이자 원동력이 되었다고 하는 것이다.[12] 시집『미음ㅁ속의ㅇㅇ이응』에서도 곰링어의 구체시 영향을 받은 듯한 표현을 살펴볼 수 있다.

 한글 구체시의 기법을 활용한 디자이너로는 안상수가 있었다. 그는 시의 창작이라기보다 구체시의 기법을 그래픽 디자인에 활용한 인물이다. 특히 한글의 조형적 요소와 특징을 중점으로 글자로 이미지를 그려내는 작품을 선보였다. 조각가 금누리와 창간한 잡지「보고서\보고서」에서 실험적인 문자의 이미지 표현이 급진적으로 이루어졌다. 현대 이전 1930년대 시인들의 작품에서도 구체시를 찾을 수 있다. 시문학에서 구체시로 가장 먼저 언급되는 인물은 시인 이상이다. 1934년 조선중앙일보에 연재했던 이상의 「오감도」[8]는 문자를 사용한 실험적인 형식으로 당시 난해하다는 독자의 비난으로 연재가 중단되었다. 그러나 새로운 시의 감상법과 시각을 발견할 수 있다는 점에서 국내 시문학의 발전 가능성을 끌어냈다고 본다.「오감도」는 주제의 중첩과 병렬이라는 특이한 구조를 드러내고 있는 연작시의 형식을 유지하고 있다. 새로운 작품이 추가되는 순간마다 새로운 정신과 기법과 분위기가 전체 시적 정황을 조절한다. 물론「오감도」의 작품들이 소제목처럼 달고 있는 순번은 작품의 연재 방식이나 연작으로서의 결합에서 필연적으로 요구하는 순서 개념을 말해주는 것은 아니다. 이 연속적인 순번은 각 작품의 제목을 대신하면서 시적 주제의 병렬과 반복과 중첩을 말해 준다. 그러므로 오감도의 연작 형식은 이질적인 정서적 충동을 직접으로 드러낼 수 있도록 고안된 '병렬'의 수사와 그 미학을 추구하는 것이라고 할 수 있다.[13]

 연구자는 이와 같은 구체시의 형식이 시의 심상 표현을 강화하기 위한 실험적인 시도에 적합하다고 보았다. 창작자의 의도에 따라 다양한 감각 전달과 표현을 할 수 있다는 점과 더불어 북 디자인과 인쇄 매체의 후가공이 더해졌을 때 기존과 다른 시 감상법을 찾을 수 있다. 또한 디자이너의 관점에서 볼 때 이것은 구체시의 기법과 효과를 강화하는 새로운 수단으로 발전시킬 수 있다.

6. 종이와 책, 그리고 북 디자인 기법

현대에 이르러 책은 과거의 종이에 인쇄되었던 형태에 국한되지 않고 다양한 미디어를 통해 접할 수 있고, 정보 전달뿐 아니라 여러 분야와 용도에 맞추어 제작되고 있다. 그러나 연구자는 종이와 잉크 인쇄를 통한 책의 원형은 다른 매체로 활용되는 책과는 다른 감상법을 독자에게 전달할 수 있다고 보는 것이다. 제책방식과 종이 두께, 종이의 재질, 색상 등에 따라 독자들의 감각을 활발하게 자극할 수 있다. 또한 인쇄에서 활용되는 후가공 기법들을 통해 책에서 전달하고자 하는 감정과 심상을 독자가 더욱 적극적으로 수용할 수

11. 고원.「독일어 구체시와 한글구체시―작품비교를 통한 수용한계의 극복가능성」.『독일어문화권연구』15권 0호 (2006년 1월). p116.

12. 고원.『미음ㅁ속의ㅇㅇ이응』. 서울: 태학사, 2002. pp162-168.

13. 권영민.『이상문학대사전』. 서울: 문학사상, 2017. p41.

[8]　권영민. 「오감도」 시제1호. 『이상문학대사전』. 서울: 문학사상, 2017. p50.

있다. 현대에는 여러 매체를 통해 책을 감상할 수 있으나, 이 연구는 인쇄를 기반으로 제작된 책이 독자에게 책을 가장 가까운 거리에서 감상할 수 있게 해준다고 판단했다.

　　　먼저 인쇄된 책의 구조를 파악해 보았다. 여기서 알아보는 책 구조 범위는 책 표지 및 본문과 차례, 판권, 표제, 제목, 부제, 주석, 후기 등 파라텍스트 개념을 제외한 물리적 구조만을 기준으로 했다. 이는 하나의 시를 한 권의 책으로 만드는 이 실험에서 불필요한 요소를 걷어내기 위함을 미리 밝힌다. 이 연구에서 실험하는 책의 정의는 사전적 의미와는 조금 다르다. 반드시 제책되어 묶인 책이 아니라, 종이 위에 인쇄되거나 가공하여 어떠한 형태로든 독자들이 읽거나 볼 수 있는 물리적 형체로 정의하려 한다. 즉 책의 외형을 온전하게 갖추지 않아도 책이 지니고 있는 내용을 전달할 수만 있다면 어떠한 형태라도 그 지면 자체가 책이 되는 것이다. 그러나 이 실험에서 제책과 인쇄를 완전히 배제한 것은 아니다. 제책에 따라 책이 물리적으로 가질 수 있는 특성을 활용하여 시의 심상 표현에 걸맞은 제책을 적용했다.

　　　북 디자인 기법 중 현대에 활용되고 있는 인쇄 기반의 후가공은 책이 담고 있는 내용의 전달을 함축적으로 표현하거나 강조하기 위한 방법으로 쓰인다. 뿐만 아니라 책을 읽는 독자들의 편의를 위해 활용되는 공정이기도 하다. 이 연구의 실험에서 후가공은 구체시의 심상 표현을 더욱 강화하기 위한 방법으로 쓰였다. 타공과 박, 코팅, 따내기 외에 기존 인쇄에서 사용되는 후가공이 아닌 수작업으로 책을 가공하는 방식을 택했다. 후가공의 적절한 활용은 제작자의 의도에 맞게 역할을 수행함으로써 책의 완성도를 더욱 높일 수 있다.

7. 시의 심상표현 강화: 구체시+북 디자인 기법을 통한 시각화 실험

지금까지 살펴본 내용을 정리하자면 구체시는 시어를 조형적 요소로 활용하여 시 속의 이미지를 표현·전달하는 시 형식으로 요약할 수 있다. 시에서 연상되는 이미지를 감각적으로 전달하고 형상화하는 기능을 지닌 것이다. 이 점은 시각화 실험에서 시도하고자

[9] 「바다와 나비」 본문 샘플. 원본의 약 1/5 크기.

하는 연구자의 의도와 일치하는 면이 있다. 더불어 시각화를 위해 선정한 김기림의
시가 이미지즘, 주지주의를 기반으로 심상 표현에 중점을 두고 있다는 점도 그러하다.
이는 연구자가 김기림의 시를 해석했을 때, 절대주의적 관점을 시 감상의 기준으로 둔
이유이기도 하다. 즉 시 어조와 운율, 전개, 심상 등의 요소에 집중한 것이다. 그러나
구체시의 변형은 문학적으로 정의된 바가 있으므로 그 범주를 벗어난 변형에는 한계가
있었다. 그러다 문득 시와 시 구성 변형에 한계가 있다면 물리적으로 변형을 시도하는 것은
어떨지 의문이 생겼다. 이 연구의 결과물은 인쇄를 기반으로 한 책을 제작하고자 했기에
북 디자인 기법을 도입해 본 것이다. 책의 물리적 구조를 구체시에 적합한 요소로 활용하여
시각과 촉각을 자극할 수 있다고 판단했다. 제책의 방식이라든지 용지의 종류와 색상 등의
변형 그리고 인쇄 후가공을 이용해 심상표현 강화를 실험한 것이다.
　　　앞서 언급했듯 하나의 시가 한 권의 책으로 구성되며, 온전히 하나의 시에서
심상 표현을 극대화할 수 있는 방법에 집중하고 있다. 이 장에서는 김기림 대표 시집
『바다와 나비』에서 선정한 세 편의 구체시 작품을 제작한 과정과 실험 의도를 설명하고자
한다. 시의 해석은 연구자가 바라본 김기림의 시적 태도와 시대성을 기반으로 하며,
『김기림 평전』에서 서술한 자료를 바탕으로 구성했다.

7.1. 첫 번째 시: 바다와 나비
아무도 그에게 수심(水深)을 일러준 일이 없기에
흰나비는 도무지 바다가 무섭지 않다.

청(靑)무우 밭인가 해서 내려갔다가는
어린 날개가 물결에 절어서
공주(公主)처럼 지쳐서 돌아온다.

[10] 「바다와 나비」 시각화 실험 작품.

삼월(三月)달 바다가 꽃이 피지 않아서
서글픈 나비 허리에 새파란 초생달이 시리다

「바다와 나비」 전문

시집 『바다와 나비』에 수록된 시 중 대표작으로 꼽히는 시이다. 1930년대 실체를 잘 알지
못하고 새로운 근대 문명을 선망하는 지식인들이 좌절과 절망을 겪고 상처를 받아 돌아오는
이야기를 다루고 있다. 깊은 바다를 청무 밭으로 착각하고 뛰어들었던 나비의 상처를
나약한 공주에 빗대어 표현했다. 막상 접해본 근대 문명은 그들이 동경했던 세상이 아니라
험난한 심연의 바다인 것이다. 이 책에서는 깊고 어두운 심연으로 빠져드는 심상 표현을
구현했다. 거친 바다에 빠져드는 효과를 표현하기 위해 책의 사각 형태 따내기(톰슨)와 함께
양끝 정렬된 구체시를 만들었다. 책 전면부에 깊이 빠져들수록 글자의 굵기가 가늘어지는데,
이는 조금씩 깊어지는 심연의 효과를 더욱 강조하기 위함이다. 제책과 표지의 형태는 책을
넘기는 개념이 아닌 '열다'라는 개념으로, 책을 펼쳤을 때 보이는 심상의 표현을 극대화했다.
바다의 넓고 큰 형태를 물리적으로 구현하기 위해 검정 색상의 216g/㎡ 용지로 1,280쪽
분량의 본문을 제작했다. 사각 형태 따내기와 제본은 모두 수작업으로 진행되었으며,
별색 인쇄 후 낱장제책으로 제작하여 하드커버로 마무리했다.

구성 심상표현: 깊은 어둠, 거대함, 빠져드는
 판형: 215×285mm
 쪽수: 1,280쪽
 인쇄: 화이트 별색

김기림의 시의 시각화 실험: 구체시와 북 디자인 기법을 활용하여

제책: 낱장제책, 하드커버
가공: 따내기(수작업)
폰트: 산돌고딕 네오
종이: 스튜디오 컬렉션 뉴블랙 216g/㎡

7.2. 두 번째 시: 우리들의 8월로 돌아가자

들과 거리 바다와 기업도
모도다 바치어 새나라 세워가리라 —
한낱 벌거숭이로 돌아가 이나라 지추돌 고이는
다만 쪼악돌이고저 원하던
오 — 우리들의 팔월로 돌아가자.

명예도 지위도 호사스런 살림 다 버리고
구름같이 휘날리는 조국의 깃발 아래
다만 헐벗고 정성스런 종이고저 맹세하던
오 — 우리들의 팔월로 돌아가자.

어찌 닭 울기 전 세 번 뿐이랴
다섯 번 일곱 번 그를 모른다 하던 욕된 그날이 아퍼
땅에 쓰러져 얼골 부비며 끓는 눈물
눈뿌리 태우던 우리들의 팔월

먼 나라와 옥중과 총칼 사이를
뚫고 헤치며 피 흘린 열렬한 이들마저
한갓 겸손한 심부름꾼이고저 빌던
오 — 우리들의 팔월로 돌아가자.
끝없는 노염 통분 속에서 빚어진
우리들의 꿈 이빨로 물어뜯어 아로새긴 조각
아모도 따를 이 없는 아름다운 땅 맨들리라
하늘 우러러 외우치던 우리들의 팔월
부리는 이 부리우는 이 하나 없이
지혜와 의리와 착한 마 꽃처럼 피어
천사들 모다 부러워 귀순하는나라
내 팔월의 꿈은 영롱한 보석바구니.

오 — 팔월로 돌아가자
나의 창세기 에워싸던 향기론 계절로 —
썩은 연기 벽돌데미 몬지 속에서
연꽃처럼 혼란히 피어나던 팔월
오 — 우리들의 팔월로 돌아가자.

「우리들의 8월로 돌아가자」 전문

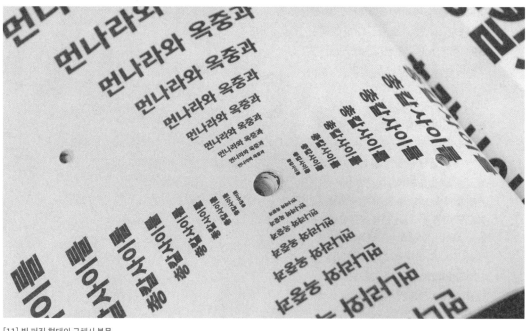

[11] 빛 퍼짐 형태의 구체시 본문.

희망과 새로운 시대를 맞이했던 찬란한 시절, 광복했던 그 시절로 돌아가고자 하는 염원이
담긴 시이다. 해방 이후 시간이 지남에 따라 서로 분열되어 반목질시하는 시대 상황으로
바뀌어 가고 있음을 몹시 안타까워하며 '우리들의 팔월'로 돌아가고 외치고 있다.[14]
새 나라를 이루기 위한 시대의 움직임이 원하는 것은 희망차게 빛나던 시절로 돌아가는
것이다. 연구자는 이 시에서 간절히 바라는 '찬란함'의 심상을 표현의 중점으로 삼았다.
이를 위해 인쇄 매체에 사용되는 후가공 중 타공과 금박을 사용했다. 본문에 불규칙적으로

타공이 되어 있고, 그 타공을 중심으로 시의 전문이 퍼져나가는 구체시 형태가
그려진다. 시에서 전달하는 메시지를 빛의 퍼짐을 통해 시각화하고 본문
타공 위치를 그대로 표지에 옮겨 금박으로 처리했다. 표지에서는 빛이 나는 듯한
효과를 느끼며, 본문에서 빛 퍼짐 형태의 구체시로 심상 표현을 전달한다.

14. 김학동. 『김기림 평전』.
서울: 새문사, 2001. p157.

구성 심상표현: 찬란함, 빛 퍼짐
 판형: 198×257mm
 쪽수: 164쪽
 인쇄: 디지털
 제책: 무선제책, 하드커버
 가공: 타공, 금박
 폰트: 본고딕
 종이: 스노우지 150g/㎡, 백상지 120g/㎡

7.3. 세 번째 시: 어린 공화국이여
식은 화산 밑바닥에서
희미하게 나부끼던 작은 불길
말발굽 구루는 땅 아래서
수은처럼 떨리던 샘물
인제는 목단같이 피어나라 어린 공화국이여

그늘에 감춰온 마음의 재산
우리들의 오래인 꿈 어린 공화국이여
음산한 '근대'의 장렬에서 빼앗은 기적
역사의 귀동자 어린 공화국이여
오 ― 명예도 지위도 부귀도 다 싫소
오직 그대 가는 길 멍에 밑 즐거운 노역에 얽매어 주오
빛나는 공화국이여 그러고 안심하소서
젊은이 어깨에 그대 얹히셨으니 ―

어린 공화국
오 ― 우리들의 가슴에 차 오는 꽃봉오리여
저 대담한 새벽처럼 서슴지 말고
밤새워 기다리는 거리로 어서 다가오소서

「어린 공화국이여」 전문

「어린 공화국이여」는 새로 세워질 나라, 즉 '어린 공화국'을 찬양한다. 짓밟히고 암담했던
고난과 역경의 시대를 극복하고 새로 세워질 '어린 공화국'이 '모란'처럼 피어나기를
원하는 것이다. 이러한 시의 해석을 바탕으로 모란을 매개체로 사용하여 기다림과
만개의 보람, 환희를 표현함으로써 모란이 피어나는 과정을 표현하고자 했다. 검정 씨가
고난과 역경을 극복하고 만개했을 때 새로운 시대를 맞이하며 가슴에 꽃봉오리를 피울 수

[12] 심상표현의 매개체 '모란'의 만개를 상징하는 시각화 실험.

있음을 보여주고 있다. 본문의 시는 양 끝에서 시작해 책 중앙에서 끝을 맺고 펼쳐진 책은
꽃을 피운 형태를 상징한다.

구성 심상표현: 피어남, 기다림
　　　　판형: 150×100mm
　　　　쪽수: 100쪽
　　　　인쇄: 디지털, 리소
　　　　제책: 무선제책
　　　　가공: 표지 유광 코팅
　　　　폰트: 본고딕
　　　　종이: 아트지 250g/㎡, 120g/㎡

8. 연구를 마치며

구체시의 기법에 대해 시를 감상하는 모든 독자에게 긍정적인 반응을 기대할 수는 없을 것이다. 문자의 배열이나 형태를 활용한 시각적 요소는 대부분 '읽기'보다는 '보기'에 비중을 두고 있기 때문이다. 이는 감성적인 표현보다 이성적이고 합리적인 구조를 기반으로 한다. 그러나 연구자는 이 실험에서 주정적 요소가 완전히 배척되었다고 생각하지 않는다. 오히려 구체시와 북 디자인 기법을 활용한 심상 표현을 통해 주지적인 태도를 견지한 것이 시의 새로운 감상법을 발견하게 했다고 본다. 시를 '읽고' 그다음 '보는' 구체시의 구성에서 대부분 글이 그렇듯 독자가 받아들이는 지점은 제각기 다를 것이라 믿고 있기 때문이다. 물론 이러한 주장의 근거는 이 연구의 범위 내에서 내세운 것이다.

이 주장을 내세우기 전 구체시와 북 디자인의 결합으로 어떤 효과를 낼 수 있을지가 가장 큰 문제로 자리 잡았다. 연구자가 결정한 방식은 구체시의 기법을 조금 더 단순화하여 읽을 수 있도록 하고, 독자에게 주정적 요소인 감성을 자극할 수 있도록 한다. (「바다와 나비」는 이성이나 감성을 통해 주지주의 문학의 시적 전환을 시도한 바 있다.) 더불어 주지적 태도를 곁들임으로써 부족한 회화성을 북 디자인 기법으로 대신하며 구체시의 심상 표현을 메꾼 것이다. 이는 결코 시문학에 국한되지 않고, 디자이너의 관점에서 문학을 연구할 때 위와 같은 방식이 문학 감상 방법의 새로운 가능성을 찾아 나갈 수 있을 것이라 믿는다. 한 가지 오류가 있다면 이 논문의 구체시 시각화 실험에서 기법의 결합에 치우친 나머지 절대주의적 관점을 지나치게 강조한 점은 반드시 해결해야 할 부분이다.

연구자는 이 실험에서 구체시 그리고 책이 가지고 있는 특성을 통해 근대 문학 시인들의 작품을 새롭게 재탄생 시킬 수 있다는 점을 확신했다. 그 시대 시인들은 구체시의 기법을 정확히 알지 못하고 창작했을 것이다. 원작을 훼손하지 않는 범위에서 현시대와 연결되는 지점을 찾고 개발하는 것은 문학 분야 그리고 디자이너로서 미약하나마 연구의 가치를 발견할 수 있다.

참고문헌

고원.『나는 ㄷㅜㄹ 이다』. 서울: 이응과리을, 2004.
고원.「독일어 구체시와 한글 구체시─작품비교를 통한 수용한계의 극복가능성」.
　　『독일어문화권연구』15권 0호(2006년 1월).
고원.『미음ㅁ속의ㅇ이응』. 서울: 태학사, 2002.
권영민.『이상문학대사전』. 서울: 문학사상, 2017.
김예리.『이미지의 정치학과 모더니즘 김기림의 예술론』. 서울: 소명출판, 2013.
김유중.『김기림 평론선집』. 서울: 지식을만드는지식, 2015.
김유중.『한국 모더니즘 문학과 그 주변』. 서울: 푸른사상, 2006.
김윤정.『김기림과 그의 세계』. 서울: 푸른사상, 2005.
김지연.『타이포그라피의 예술적 관점에서 본 구체시의 정신성과 조형성』.
　　석사 학위 논문, 서울: 홍익대학교, 2006.
김학동.『김기림 평전』. 서울: 새문사, 2001.
나민애.『1930년대 '조선적 이미지즘'의 시대』. 서울: 푸른사상, 2016.
나민애.『1930년대 한국 이미지즘 시의 세계 인식과 은유화 연구: 정지용과
　　김기림을 중심으로』. 석사 학위 논문, 서울: 서울대학교, 2013.
서준섭.『한국모더니즘 문학 연구』. 서울: 일지사, 1988.
안상수.『타이포그라피적 관점에서 본 李箱 시에 대한 연구』. 박사 학위 논문,

서울: 한양대학교, 1995.

앤드류 해슬램.『북디자인 교과서』. 송성재 옮김. 파주: 안그라픽스, 2008.

엄성원.『한국 모더니즘 시의 근대성과 비유 연구: 김기림·이상·김수영·조향의
시를 중심으로』. 박사 학위 논문, 서울: 서강대학교, 2001.

윤여탁.『김기림 문학비평』. 서울: 푸른사상사, 2002.

윤태성.『1930년대 김기림 시에 나타난 근대성 연구』.
석사 학위 논문, 서울: 명지대학교, 1997.

이광주.『아름다운 책 이야기』. 파주: 한길사, 2014.

이유진.『시각언어로 표현한 현대시의 시각은유 분석』. 석사 학위 논문,
서울: 서울산업대학교, 2009.

이재은.『김기림 시론 연구』. 석사 학위 논문, 서울: 성균관대학교, 2013.

이창배.『시 이야기』. 서울: 태학사, 2005.

정경해.『김기림 시에 나타난 이미지 연구』. 석사 학위 논문, 서울: 중앙대학교, 2003.

정병필.『김기림 시의 이미지 연구: G. 바슐라르의 현상학을 중심으로』.
석사 학위 논문, 광주: 전남대학교, 2013.

정순진.『새미작가론총서 10 김기림』. 서울: 새미, 1999.

정희모.『한국근대비평의 담론』. 서울: 새미, 2001.

조혜진.『1930년대 모더니즘 시의 타자성 연구: 김기림, 이상, 백석 시를 중심으로』.
박사 학위 논문, 서울: 성신여자대학교, 2007.

한국문화평론가협회.『문학비평용어사전(상·하)』. 서울: 국학자료원, 2006.

한기호.『디지털과 종이의 행복한 만남』. 서울: 창해, 2000.

한주연,『한국 현대 시각시에 나타난 타이포그라피의 역할 연구』.
석사 학위 논문, 서울: 홍익대학교, 1997.

홍동원.『책 만드는 11가지 이야기』. 서울: 글씨미디어, 2014.

황윤석.『Helmut Heißenbüttel의 구체시 Konkrete Poesie 연구:「Textbücher 1 – 6」을
중심으로』. 석사 학위 논문, 서울: 서강대학교, 1989.

웹사이트

권규호 국어 연구실.〈권규호의 당신이 몰랐던 문학 김기림 바다와 나비〉. 2020년 6월
16일 접속. https://www.youtube.com/watch?v=JtL0Ie80KtI

문자인.「문자를 시의 대상으로 만들다―독일의 구체시」. 2020년 6월 16일 접속.
http://munja.yonsei.ac.kr/archives/archives_02_1_concrete_poem.php

아트앤스터디.〈구인회 멤버, 이상과 김기림의 관계―장석주(시인, 문학평론가)〉.
2020년 6월 16일 접속. https://www.youtube.com/watch?v=MM9htH-_lrU

이상금.「문자로 이미지를 만들어 의미를 창조하다, 독일의 구체시」.『부대신문』(2015년
5월 18일). 2020년 6월 16일 접속. http://weekly.pusan.ac.kr/news/
articleView.html?idxno=4490

한국민족문화대백과사전. 2020년 6월 16일 접속. http://encykorea.aks.ac.kr/

한국현대문학 위키.「김기림」. 2020년 6월 16일 접속. http://ko.kliterature.wikidok.
net/wp-d/588080335fb7f1a936080de0/View

'작업'은 편집위원회에서 선정한 타이포그래피 프로젝트를 소개한다. '작업'은 편집위원회에서 선정한 타이포그래피 프로젝트를 소개한다. 내용과 형식에는 특별한 제약이 없다. 주제와 관련된 의미 있는 타이포그래피 작품이나 과정의 모음이고, '작업' 항목은 해당 글자체가 전문이 되는 방식이다. 『글짜씨』 18부터는 매호마다 하나의 글자체를 소개하고 '작업' 항목은 해당 글자체가 전문이 되는 방식이다. 글자체와 작업자를 매호마다 하나의 글자체를 소개하는 것은 『글짜씨』의 목적에 부합하며 그 자체가 전문이 되는 방식이다. 『글짜씨』 18에서는 이노을의 「아르바나」와 민본의 「생프란시스코 개발기」, 노은유, 함민주의 「매리어블 폰트와 한글」, 윤충근의 「이것저것 이모저모: 《2019 타이포잔치》의 구성과 내용을 중심으로」를 소개한다.

아르바나

이노을
글자 디자이너·lo-ol foundry,
제네바

「아르바나」는 제6회 방일영재단 글꼴창작지원공모에 선정된 작업으로 납작펜과 스카펠 나이프Scapel Knife의 특성이 담긴, 날카로우면서도 부드러운 인상을 지닌 휴머니스트 스타일의 바이스크립트 글꼴Bi-scriptual Typeface이다. 「아르바나」는 한글 부리 글꼴 디자인을 붓이 아닌 서양의 쓰기 도구들로 써본 형태를 상상하면서 시작되었다. 필획의 섬세함을 유지하는 선에서 날카로운 형태를 부드럽게 나타내고자 했고, 디자이너의 손글씨 느낌을 일부 자소에 반영한 것이 주요 특징이다. 한글은 이노을, 라틴 알파벳은 로리스 올리비에Loris Olivier가 제작하였다.

제작 배경

한글과 로마자가 병기된 서적들이 많이 발행되면서 디자이너 사이에서는 한글과 로마자 섞어짜기에 대한 여러 가지 노하우가 생겨나기 시작했다. 그러나 로마자에는 다양한 종류의 본문형 글꼴이 있는 반면, 한글은 최근까지도 기본 명조(해서)를 기반으로 약간의 변화만을 준 유사 형태의 글꼴들이 대부분이었다. 일부 흘림체의 형태를 바탕으로 만들어진 글꼴들도 있었지만 대체로 전통적 서예의 틀에서 벗어나지 않은 형태였다.

글꼴 디자이너로서, 또 현대의 한국에서 한글을 읽고 말하고 쓰는 사람으로서 「아르바나」의 제작은 크게 두 가지 관점에서 출발하였다. 먼저 앞서 언급한 다양한 한글 글꼴이 부족한 상황에서 본문용으로 사용할 수 있는 명조 계열의 글자체를 제작하되, 전통적인 붓이 아닌 다른 도구를 뼈대로 한 새로운 느낌의 명조체를 만들어 보고 싶었다. 방법을 연구하던 중 서양 캘리그라피 도구 가운데 하나인 브로드닙 펜Broad Nib Pen의 조형적 특징에 주목하게 되었는데, 브로드닙 펜이 가진 특유의 직선과 곡선이 공존하는 독특한 미감을 붓글씨를 바탕으로 한 명조체의 구조에 잘 적용한다면 분명 현대적인 느낌의 글꼴이 나올 것이라고 판단하였다.

「아르바나」는 타 문화권에서 쓰이는 도구에 대한 관심에서 출발했기에 브로드닙 펜을 사용해 라틴 캘리그래피에서 펜이 지니는 특징을 파악했다.

[1] 납작하고 평평한 선.

1. 납작하고 평평한 선Parallel Line[1]
브로드닙의 주된 특징은 우선 촉의 가장자리 부분이 다른 펜촉에 비해 넓고 평평하다는 점에 있다. 이러한 선의 형태는 궁서체나 명조체가 가지고 있는 붓글씨의 느낌과는 다른, 오히려 서양의 캘리그래피와 좀 더 유사한 느낌을 표현할 수 있다.

2. 각도에 따라 달라지는 선의 형태
Varying Strokes as an Angle[2]
브로드닙 펜은 보통 일정한 각도로 수평을 유지해서 사용하며 스크립트의 종류에 따라 각기 다른 펜촉의 각도가 필요하다.

[2] 각도에 따라 달라지는 선의 형태.

획의 각도와 방향을 변경하여 두껍고 얇은 획을 만들어 낼 수 있다. 각도에 따라 달라지는 획의 형태는 브로드닙 펜이 지니는 매력 중 하나라고 볼 수 있다.

쓰기 도구에 대한 관심 외에도 섞어짜기가 일반화된 한글 디자인 환경에서 로마자 글꼴과 잘 어울리는 한글이 있다면 어떤 모습일지 궁금했던 적이 많았다. 이런 다국어 환경에 적용 가능한 글꼴 제작에 대한 호기심 역시 「아르바나」 제작에 큰 영향을 미쳤다. 초기 기획 단계에서 모티프가 된 로마자는 평소 눈여겨보았던 그릴리타입Grilli Type에서 2014년에 출시한 「GT 섹트라GT Sectra」[3]다. 또한 네덜란드 글꼴 디자이너인 헤릿 노르트제이Gerrit Noordzij의 『획: 글자쓰기에 대해The Stroke: Theory of Writing』와 그가 만든 글꼴 「부르군디카Burgundica」[4]에 크게 영감을 받았다. 「GT 섹트라」는 브로드닙 펜과 스카펠 나이프로 깎은 듯한 느낌을 동시에 아우르는 세리프 글꼴이다. 하지만 고전적 쓰기 도구를 통해 나오는 글자 형태를 그대로 반영한 것이 아닌, 다른 쓰기 도구를 조합해 만든 새로운 디지털 글꼴이라는 점이 흥미로웠고 이를 한글 디자인 과정에도 적용해 브로드닙 펜이 가진 직선과 곡선의 대비 그리고 스카펠 나이프의 날카로운 느낌, 이 두 특징을 한글에 적용해 보고 싶었다. 한마디로 「아르바나」는 한글 명조체 디자인을 붓이 아닌 다른 쓰기 도구들로 써본 형태를 상상해 본, 날카로우면서도 부드러운 인상을 지닌 휴머니스트 스타일의 바이스크립트 글꼴이라 할 수 있다.

[3] 그릴리타입. 「GT 섹트라」. 2014.

[4] 헤릿 노르트제이. 「부르군디카」. 1983.

[5] 아이디어 스케치 1.

[6] 아이디어 스케치 2.

제작 과정

디자인을 발전시켜 나가는 과정에서는 필획의
섬세함을 유지하는 선에서 날카로운 형태를
조금 더 부드럽게 변형하고, 디자이너의 손글씨
느낌을 일부 자소에 반영하였다. 예를 들어
받침 니은과 리을에 있는 약간의 굴곡은 캘리그라피
흘림의 형태를 차용함과 동시에 작업자의
이름에 들어간 자음을 강조하여 본문에 개성을
부여하면서도 디자이너의 정체성을 무겁지 않게
녹여내었다. 로마자는 한글 작업을 어느 정도
진전했을 때 작업을 시작했다. 로마자는 모티브가
된 글꼴의 콘셉트만을 남기고, 형태를 만들어 나갈
때는 한글과 어울리게끔 부드러운 휴머니스트
글꼴로 만들었다.[5, 6]

[7] 부리 형태.

본문형 굵기
기존 부리 글꼴들의 레귤러 굵기에서
크게 차이 나지 않을 정도로 아주 조금
더 굵게 기준을 잡았다. 아르바나는
납작 펜의 형태를 도드라지게 하기 위해
가로획과 세로획의 굵기 차이를 줄였다는
점에서 다른 부리 글꼴과 차이가 있다.

[8] 맺음 형태.

가변 너비
「아르바나」는 가변 너비로 제작되었다.
홀자에 따라 너비 차이를 주었다.

부리 형태[7]
쓰기 방향에 따라 가로획에서 시작되는
지점의 휘어지는 부분, 세로획에서의
부리 등에 납작 펜의 느낌이 도드라지는
형태로 잡아보았다.

[9] 자소 형태 ㅁ, ㅂ.

맺음 형태[8]
맺음의 모양새를 직선적이고 날카로운
느낌으로 처리함으로써 펜의 느낌을
강조했다. 그러나 본문에서 보았을 때 눈에
거부감이 크게 느껴지지 않도록
선의 각도를 조금 덜 가파르게 조절했다.
맺음의 각도는 모임과 받침에 따라
조금씩 다르게 적용했다.

[10] 자소 형태 ㅇ, ㅎ.

작업

[11] 자소 형태 ㅍ.

[12] 받침 ㄴ, ㄷ, ㄹ, ㅌ.

트럼프식 영어는 '단순무식'? 그래서 더 먹히나

트럼프의 글에서 문맥에 맞지 않는 문장이나 철자가 틀린 것은 부지기수다. 전임자인 버락 오바마의 유려한 글이나 연설과는 비교할 필요도 없다. 지난 4일 트럼프는 오바마가 대선 때 자신의 전화를 도청했다(tapp)고 썼다. 말하랴면 p 를 하나면 써야 하는데 두 번 썼다. 지난해 12월에는 "전례없는 행위(unpresidented act)'라고 썼다가 맞는 단어 (unprecedented)로 고쳤다. '그들의(their)'를 '거기(there)' 로, '낭비(waste)'를 '허리(waist)'로 적기도 했다. 단수를 복수로 잘못 쓰기나 억지로 하이픈(-)을 넣곤 한다. 러시아 스캔들을 "터무니없다(non-sense)"고 썼고, 매우 매럴 스트리브는 "과대평가됐다(over-rated)"고 썼다. 트럼프의 글에는 독특한 형식이 있다. 간단한 성별과 감정 표현 뒤 느낌으로 마무리짓는 구조다. 문장 끝에 "나쁘다(Bad!)" "위대하다(Great!)" "매우 슬프다(So Sad!)" 등을 즐겨 쓴다. 긍정적인 표현보다는 부정적인 표현이 많다.

트럼프의 트윗들을 분석하는 '트럼프 트위터 아카이브' 사이트를 보면 그가 가장 많이 언급한 단어는 패배자(loser, 234건), 명청한(dumb, 222건), 공격인(terrible, 204건).

기본(default) 유선형 받침

트럼프식 영어는 '단순무식'? 그래서 더 먹히나

트럼프의 글에서 문맥에 맞지 않는 문장이나 철자가 틀린 것은 부지기수다. 전임자인 버락 오바마의 유려한 글이나 연설과는 비교할 필요도 없다. 지난 4일 트럼프는 오바마가 대선 때 자신의 전화를 도청했다(tapp)고 썼다. 말하랴면 p 를 하나면 써야 하는데 두 번 썼다. 지난해 12월에는 "전례없는 행위(unpresidented act)'라고 썼다가 맞는 단어 (unprecedented)로 고쳤다. '그들의(their)'를 '거기(there)' 로, '낭비(waste)'를 '허리(waist)'로 적기도 했다. 단수를 복수로 잘못 쓰기나 억지로 하이픈(-)을 넣곤 한다. 러시아 스캔들을 "터무니없다(non-sense)"고 썼고, 매우 매럴 스트리브는 "과대평가됐다(over-rated)"고 썼다. 트럼프의 글에는 독특한 형식이 있다. 간단한 성별과 감정 표현 뒤 느낌으로 마무리짓는 구조다. 문장 끝에 "나쁘다(Bad!)" "위대하다(Great!)" "매우 슬프다(So Sad!)" 등을 즐겨 쓴다. 긍정적인 표현보다는 부정적인 표현이 많다.

트럼프의 트윗들을 분석하는 '트럼프 트위터 아카이브' 사이트를 보면 그가 가장 많이 언급한 단어는 패배자(loser, 234건), 명청한(dumb, 222건), 공격인(terrible, 204건).

평행선 스타일 (Parallel line)

[13] 오픈타입 피처 사용 예시: 문단에 적용.

자소 형태 ㅁ, ㅂ [9]

ㅁ, ㅂ의 획의 순서와 맺음 처리에 차이를 주었다. ㅁ의 경우, 4획으로 처리되는 기존의 한글 쓰기법과 달리 3획으로 처리했다. 「아르바나」의 ㅁ과 ㅂ의 아래 받침의 획은 세로획의 삐침이 없고, 가로획의 삐침이 강조되면서 맺어지는 점이 특징이다.

자소 형태 ㅇ, ㅎ [10]

ㅇ획의 시작 부분인 왼쪽 상단 부분에 납작 펜에서 보이는 획 사이의 끊김을 디자인 요소로 적용했다. 이는 펜이 종이에 닿아 넓은 면적을 가지고 시작되는 부분과 다시 넓은 면적으로 돌아오는 연결 지점을 하나의 특징요소로 잡아본 것이다. ㅎ은 ㅇ의 꼭지를 생략한 대신 ㅎ의 상단의 가로 줄기와의 연결을 위해 펜 흘림의 느낌을 차용했다. 이 부분은 바로 뒤에 언급할 ㅍ과도 같은 맥락으로 적용한 것이다.

자소 형태 ㅍ [11]

ㅍ의 양쪽 세로획 사이에 펜 흘림을 디자인 요소로 적용하였다. 받침으로 오는 피읖은 피드백을 통해 흘림의 느낌을 지우고 좀 더 단순화시켰다.

받침 ㄴ, ㄷ, ㄹ, ㅌ [12]

받침 니은, 디귿, 리을, 티읕 등에 있는 약간의 굴곡은 동서양의 캘리그래픽 흘림의 형태를 차용해 역동적이고 생동감 있게 표현하였다. 이 부분은 「아르바나」의 가장 큰 특징 중 하나로 볼 수 있다. 또한 도구를 가지고 빨리 쓰고 싶은 마음을 글자의 형태에 그대로 실은 형태이기도 하다. 받침 하단의 유연한 선 흐름과 고유한 리듬이 글자 구조와 세부에 영향을 미쳐서 마치 흘림체 같은 독특한 인상을 보여준다. 디폴트로 설정된 곡선형 받침과 더불어 직선형의 느낌도 같이 선보이고 싶었다. 이에 사용자 편의성을 확장하는 차원에서 오픈타입 피처 기능Opentype Features을 이용해 '평행선 스타일 옵션Parallel Line'을 추가로 더했다. 사용자가 프로그램에서 이 옵션을 선택하면 아르바나의 곡선형 받침인 ㄴ, ㄷ, ㄹ, ㅌ이 직선화되어 나타난다. [13]

「아르바나」를 제작하게 된 계기는 본문용 글꼴과 제목용 글꼴 사이의 느낌을 찾아보는 것에서 출발했으나, 본문보다 작은 글자 크기(캡션이나 신문용 글자 등)에서도 개성과 가독성을 모두 유지할 수 있도록 개발해 나갈 예정이다. 현재 「아르바나」 레귤러의 첫 버전은 한글 KS 코드 규격에 추가자를 더한 2,400자, 유럽권 언어 지원을 위한

확장 로마자와 숫자 278자, 또한 필수 문장부호들을 포함하며 2019년 10월 9일에 해외 글꼴 판매 플랫폼인 퓨처폰트(futurefonts.xyz)에서 버전 0.1을 출시했으며, 2020년 1월 버전 0.2로 업데이트를 진행해 한글 추가자 및 다양한 기호 활자들을 포함했다. (버전 0.2를 기준으로 「아르바나」는 한글 2,780자, 라틴 알파벳 245자, 숫자 44자, 문장부호 및 약물 135자 등을 포함하고 있다.)[14] 2020년 7월에는 레귤러 업데이트를 비롯해 「아르바나」 블랙을 출시했다. 차후 「아르바나」는 헤어라인, 미디움, 볼드 등의 추가 자족들을 개발할 예정이다. 글자체 「아르바나」의 최종 완성이 언제쯤일지는 아직 확답하기 어렵지만 계속해서 더 나은 방향으로 업데이트를 진행할 수 있다는 점에 만족하고 있다.

「아르바나」 in Use

「아르바나」가 첫선을 보인 10월 초부터 조금씩 글자체 사용예시를 아카이브하고 있다. 제작자의 의도에 딱 맞게 사용된 예시도 볼 수 있었고, 생각 외로 참신한 사용예시들도 볼 수 있었다. 대표적인 예시를 꼽자면 페미니스트 디자이너 소셜 클럽(FDSC)에서 발행한 『디자인FM』(디자인: 신인아, 장윤정)[15], 연구보고서 『청년연구자, 도시 '서울'의 문제를 정의하다』(디자인: O·O·H), 유어마인드에서 발행한 단행본 『실로 놀라운 일: 자수 배우는 만화』, 사진잡지 『보스토크』 18호, 과천 국립현대미술관 《판화, 판화, 판화》(디자인: 크리스 로)의 전시 디자인 등에서 사용되었다.

「아르바나」 전시

「아르바나」는 방일영재단 글꼴창작지원사업의 후원을 받아 마포구에 위치한 전시공간 whatreallymatters(wrm)에서 2019년 11월 26일부터 12월 2일까지 일주일 동안 기념 전시를 열었다.[17] 전시는 이현송 그래픽 디자이너와의 협업으로 구성하였다. 여러 스케일에서 글자를 보여주기 위해 크고 작은 글자들을 큐브 벽면에 붙였고, 영상 및 설치물을 공간 안에 적절하게 배치해 다채로운 분위기를 연출하고자 했다. 예상 외로 디자이너가 아닌 방문객도 여럿 있었다. 처음에는 흰 공간 안에서 진행하는 글자체 작업과 관련된 전시에 대해 그리 호의적이진 않았지만, 글자의 스케일을 키워 전시 공간과 사물에 입혔을 때 느껴지는 감각은 또 다른 경험을 불러일으킨다는 점에서 서체 디자인 전시는 그 가치가 있다는 생각이 들었다.

아쉬운 점, 그리고 그다음은?

「아르바나」는 본문용과 제목용 그 사이의 어떤 가능성을 탐색 후 나온 결과물이다. 그래서일까, 본문용, 제목용 등으로 다양하게 쓰인 예시를 볼 때마다 사용자가 제작자의 어떤 마음을 알아주는

[14] 서체견본집 이미지 중 일부. futurefonts.xyz/noheul-lee/arvana에서 pdf 파일로 확인 및 내려받기 할 수 있다.

[15] FDSC. 『디자인 FM』. 2019. / 사진: 이노을 / 2019년 발행된
서적 『디자인 FM』의 본문에 쓰였다. 「아르바나」가 처음 출시되자마자
상업용으로 처음 사용된 기념적인 사용 예시. 본문 안에서 세세한
조판체계가 빛을 발한다.

[16] 서울특별시 청년허브, 재단법인 카카오임팩트. 『청년연구자, 도시
'서울'의 문제를 정의하다』. 2020. / 사진: O-O-H / 연구 보고서의
제목, 본문, 표 등에 사용되었다. 책 제목부터 표까지 여러 방면에서
크고 작은 크기로 사용된 걸 볼 수 있어 그래픽 디자이너가
글자체 디자이너의 제작 의도를 확실하게 이해한 것을 눈여겨볼 수
있었던 작업 예시이다.

[17] 전시장 모습. 전시디자인은 이현송 그래픽 디자이너와 협업으로 제작했다. / 사진: 이노을

것 같은 감동을 느낀다. 그러나 한편으로는 첫 공식 발매된 글자체인 만큼 중간중간 고민이 많았고, 생각보다 작업 기간이 너무 길어 그 점이 고통으로 다가오기도 했다. 또한 개성을 불어넣고 싶은 욕심이 조금 과하게 들어간 점도 없지 않다. 오픈타입 피처 기능의 경우, 아직은 여러 사용자에게 다소 생소할 수 있다는 점을 크게 생각하지 않았던 것 같다. 하지만 이 부분은 시간이 지나면 조금씩 해결되는 지점이기 때문에 크게 후회진지 않는다.

「아르바나」는 라틴 알파벳도 소홀히 하고 싶지 않다는 욕심에 네이티브 전문 디자이너와 함께 작업을 진행했다. 협업은 너무 잘 될 때도 뜻대로 되지 않을 때도 많았다. 특히나 디렉팅하는 입장에서는 본인 스스로가 전체 디자인 방향을 확실히 전달해야 하지만 생각대로 쉽게 잘 풀리지 않아 협업자를 힘들게 하기도 했다.

「아르바나」는 어떤 때는 느리게, 또 어떤 때는 빠르게 순차적으로 업데이트가 진행될 예정이다. 그 동안 어떤 사용예시를 볼 수 있을지 기대할 수 있다는 점은 글자체 디자이너에게 가장 행복한 지점이 아닐까. 이번 경험은 다음 작업을 구상할 때 큰 자양분이 될 것이다.

샌프란시스코 개발기

민본
홍익대학교, 서울

서론

「샌프란시스코San Francisco(이하 SF)」는 미국 애플사에서 애플워치라는 새로운 기기를 개발하던 당시, 그 OSOperating System와 UIUser Interface를 위해 처음 제작되었던 디지털 폰트이다.

이 폰트는 2014년 애플워치 발매와 함께 공개된 이후 자족 확대, 지원 언어 확장, 타이포그래픽적 요소의 보강, 디테일의 세련 등 다양한 변화를 겪으며 아이폰과 매킨토시 제품군의 OS와 UI에 차례로 적용되었다. 이후에는 마케팅 폰트로도 선택되어 제품 로고와 패키지, 광고, 웹사이트, 매장 디스플레이 등에 폭넓게 활용되고 있다. 이후 제작된 세리프 폰트 「뉴욕New York」, 심볼과 아이콘 등으로 이루어진 폰트 「SF 심볼즈SF Symbols」 등의 디자인적 기준이 되었으며, 지금도 꾸준하게 진화와 개선이 이루어지고 있는 애플의 대표 기업 폰트라고 할 수 있다.

근래 기업 폰트가 마케팅의 일환으로서 기업 정체성과 글자 형태의 유착을 시도하는 모습을 많이 보게 된다. 이에 비해 「SF」는 제품의 UXUser Experience영역에 먼저 투입되어 그 사용성을 검증받으며 사용자의 무의식에 충분한 친숙도를 쌓은 후에야 애플의 마케팅과 브랜딩으로 활용 범위가 넓혀진 사례로, 그 방향성에 특이점이 있다고 하겠다. 따라서 타입 디자인 과정에서 '정체성'과 같은 추상적 관념을 표현하기 위한 '양식'보다는, UI 속 타이포그래피의 '기능성'에 초점을 맞추어 보다 빠르게 의사결정을 할 수 있었다. 또한 소수 서체 디자이너의 글자에 대한 관점, 또는 여러 타이포그래피 분야의 관습만을 고수하기보다 여러 영역의 디자이너와 엔지니어의 실용적인 의견을 충분히 반영할 수 있었다.

이 폰트는 기업의 소유물로 관련 정보 공개에 한계가 있다. 또한 다년간 광범위한 자족의 확장과 세부 양식의 개편이 끊임없이 진행되어 왔기 때문에 그 역사를 모두 살피는 것은 상당한 분량의 지면이 허락되어야 가능한 일일 것이다. 따라서 이 지면에서는 폰트 개발 초기 단계에서 글자체 디자이너가 어떤 글자들을 상상하였고, 그것이 실제로 어떻게 형상화되었는지에 대해 압축하여 소개해 보기로 한다.

본론1. 타입페이스 구상 초기 추구하려던 바를 정리하면 다음과 같다

첫째, 인쇄 매체 타이포그래피를 상회하는 수준의 중립성과 가독성을 추구하고자 하였다. 국제적으로 널리 소비되는 제품군 안에서 이 타입페이스가 표시하는 정보들이 수십 가지 언어 및 문자로 번역되는 상황을 고려할 때, 소수 유럽국가의 타이포그래피 전통만을 염두에 둔 디자인으로는 충분한 중립성이 담보될 수 없다고 생각했기 때문이다. 또한 다양한 크기의 스크린 안에서 글자들은 더 이상 인쇄 지면에 우아하게 자리잡고 의미 전달을 투명하게 매개하는 존재가 아니다. 손가락과 도구들로 두드려지고 만져지고, 작아지고 커지며, 매체와 함께 움직이고 흔들리는 존재가 되었다. 따라서 한층 더 안정적인 가독성을 보장할 방안이 필요했다.

둘째, 서로 다른 디자인 영역 간에 미묘하게 차이가 나는 조형 언어들을 호환시키는 방안을 (주로 타입 디자인 관점에서) 고민하게 되었다. 당시 제품 디자인을 중심으로 '애플'이라는 강력한 브랜딩이 이미 이루어진 상태였고, 새로운 제품 개발을 통해 새로운 방향성을 모색하고 있었다. UI 디자인은 '스큐어모픽Skeuomorphic'에서 '플랫Flat'으로 큰 변혁을 만들어 내고 있었다. 즉 사실적이고자 하는 그래픽 효과를 걷어내고 미니멀한 형태와 색상을 지닌 평면 도형들만으로 UI를 구성하면서, 물리적 제품과의 차별점과 접점들을 구분하는 작업이 이루어지고 있었다. 그리고 이러한 GUIGraphic User Interface가 놓치게 되는 정보전달의 상당 부분을 타이포그래피를 통해 보완하려는 의도가 느껴졌다.

이를 지원하기 위해 타입페이스 디자인은 어떤 기능들을 포함해야 하고, 어떠한 글자 생김새가 유리할 것인지에 대한 고민과 논의가 활발하게 일어났다.

셋째, 인쇄 매체보다 더 선명한 해상도를 구현하게 된 스크린상의 글자 형태에 대한 고민이 필요했다. 인쇄 공정에서 종이의 거친 표면이나 잉크의 번짐, 초기 저해상도 모니터 스크린에서 육안으로 확인되는 픽셀 모양은 타입페이스를 제작하는 입장에서 글자 판독을 방해하는 요소로 인식되어 그 해결책을 찾으려는 노력이 오랜 시간 이어져 왔다. 소위 시각적 보정기술이 그 극복안의 대표적 예들인데, 사실 이 인쇄용 활자와 스크린용 활자의 보정기술들이 적절히 뒤섞여서 오늘날 타입 디자인 교육 내용의 한축을 이루고 있기도 하다. 이에 반해, 웬만한 인쇄 품질을 뛰어넘는 해상도가 이미 확보된 스크린(레티나 디스플레이Retina Display) 위의 타이포그래피에서는 이 모든 보정행위의 목적과 방법 대한 재정의가 필요해 보였다. 즉 매체의 기술적 한계 극복을 위해 행해지는 시각보정과, 순수하게 글자가 활용되는 시각적 크기(옵티컬 사이즈)에 따라 요구되는 형태적 차별을 구분 짓고, 의도적으로 전자보다 후자에 더 집중하고자 하였다.[1]

[1] 원쪽부터, 12pt로 종이 위에 인쇄된 'a', 현수막에 글자폭 약 40cm 크기로 인쇄된 'a', 애플닷컴 웹페이지의 한 'a'. 모두 「SF」다.

본론2. 실제 디자인이 구현된 과정은 대략 다음과 같았다

모서리 곡률

당시 애플 제품의 모서리가 가지는 특유의 곡률은 사람들 사이에 '연속적 곡률Continuous Curvature' '스퀘클Squarcle' 등으로 불리며 일종의 디자인 정체성을 형성하고 있었다. 일견 모서리의 곡률이 기기마다 유지되는 것으로 보이지만, 잘 살펴보니 한 기기 안에서도 적용 부위가 다양하고, 서로 비율이 변화하기도 하고, 모서리의 곡률이 입체적으로 적용되어 부풀거나 납작해지기도 하는 등 한눈에 파악하기 힘들 만큼 다양한 변주가 일어나고 있었다.

한편 스크린 안에서는 앱 아이콘과 그래픽적 요소들에서 입체감이 사라지면서, 제품 외관과 확실하게 구분되는 효과가 발생했는데, 이때 제품 모서리에 적용되었던 곡률이 새롭게 설계된 앱 아이콘의 모서리에도 동일하게 적용되면서 제품디자인과 UI 디자인이 서로 최소한의 연계를 유지하는 장치 역할을 하고 있었다. 따라서 타입 디자인의 영역에서도 독자적인 방식으로 모서리 곡률을 재해석하여 도입하고자 하였다.

글자는 본래 그림과 같은 범주에서 비롯되었음에도 일종의 언어적 기호로서 그 기능이 더 섬세하게 발달되어 왔기 때문에, 글자 안에서 구체적 사물을 그린 흔적이 직접 등장하면 예전 상태로 회귀하는 꼴이 되어 어색해 보이는 경우가 많다. 하지만 이 경우 제품의 형상 자체가 이미 이론상에서나 존재할만한 정교한 곡선들로

이루어져 있어서, 모서리 곡률을 조금 다듬기만 한다면 글자의 요소로 삼을 만하다는
생각이 들었다.[2]

그리드 시스템과 그로테스크

절제된 미학을 추구하는 제품 디자인의 방향성과 극단적으로 단순화된 새로운 UI,
이 둘과 조화를 이룰 수 있는 타입 디자인의 방향성은 수학, 기하학, 그리드 등
보편적 그래픽 요소를 적극 도입하는 데에 있다고 생각했다. 특히 그리드가 글자의 형태에
엄격하게 영향을 줄수록, 특히 곡선 부분의 형태들이 수학적으로 정의되면서 제품 및
아이콘 모서리의 곡률과 접점을 만들어 내는 기회가 많아지는 장점이 있었다.
　　　　글자의 기본 골격은 그로테스크 계열의 산세리프체가 적합하다고 생각했다.
아메리칸 고딕, 휴머니스트 산스 등이 고려 대상이 되기도 하였으나, 향후 글자의 높이와
너비의 변화 용이성, 다른 언어로 적용이 용이한 점 등으로 설득력을 얻은 그로테스크를
그리드상에서 녹여낸 아이디어가 최종 채택되었다.[3]

[2]　초기 스케치 1.

[3]　초기 스케치 2.

[4] 「노이에 하스 그로테스크」(왼쪽)와 「SF」(오른쪽)의 대문자 너비 비례 비교.

[5] 「SF」(위)와 「노이에 하스 그로테스크」(아래)의 대문자 P 너비 비교.

글자 비례

그리드를 기본으로 한 그로테스크라는 말은 얼핏 대문자의 글자 폭이 고정된 모습을 연상시킨다. 디스플레이용 그로테스크 타입페이스들이 관습적으로 대문자를 늘리거나 줄여서 일정 폭의 블록에 끼워 넣는 일이 잦은 데다가, 이 경우 블록보다 더 엄격한 통일성을 강요하는 그리드까지 적용되어 있기 때문이다. 하지만 이 타입페이스는 처음부터 작은 화면을 위한 것이었으므로, 가변 폭을 가진 전통적인 대문자 비례를 최대한 적용하기 위해 애썼다. 전통적 대문자 비례는 대문자만으로 구성된 텍스트에서 문자 간 구분을 돕는 역할을 하고, 소문자와도 균형 잡힌 자간 구성에 유리하기 때문이다. 그리고 획의 굵기 비례 또한 도형의 반전을 이용하는 그로테스크의 관습에, 닙 펜의 원리에 입각한 비례를 미세하게 대입하였다. 굵기 변화가 작기 때문에 쉽게 눈에 띄지 않지만 자세히 살펴보면 여타 그로테스크 타입페이스에 비해 자연스러운 획의 흐름을 발견할 수 있다.[4, 5]

텍스트와 디스플레이의 구분

전통적 인쇄 매체에서 활자 크기의 변화는 비연속적이므로, 디스플레이용, 텍스트용 활자는 형태상의 차이가 상당한 경우가 많다. 하지만 디지털 기기에서 글자의 크기는 유기적으로 확대·축소되는 경우가 대부분이다. 따라서 디스플레이와 텍스트 컷의 형태를 최대한 같게 유지하여 연속성을 지키면서 최소한의 변화만을 주었다. 예를 들어 글자 간격, 잉크 트랩의 크기, 개구Aperture의 닫힌 정도, 자족 구성에서 최대 굵기와 최대 가늘기 등. 그리고 이들이 시스템 안에서 미리 설정된 사이즈 차트에 따라 자동으로 변환되도록 하였다.

대체자

OS에서 전방위로 활용되어야 하는 폰트는 특정한 독자를 위한 특별한 독서 방식을 세밀하게 지정하고 디자인할 수 없는 어려움이 있다. 이럴 때 잘 활용되는 것이 대체자Alternate Characters이다. 몇 개의 특수한 글자만 다른 형태로 대체함으로써 전체 글의 목소리Typographic Voice를 변주할 수 있게 된다. [6]은 그 몇 가지 예시들이다.

123456789 123456789

1mIlli0n 1mIlli0n

Formal lowercase 'a' Informal lowercase 'a'

1119 1119
9991 9991

[6] 위에서부터 아래로, 작은 글자 사이즈에서도 가독성을 보장하는 열린 구조의 숫자들(4, 6, 9). 대문자 'I'와 소문자 'l', 대문자 'O'와 숫자 '0'을 구분하기 위한 대체자들. 자연스러운 느낌을 주는 단층구조 소문자 'a', 일반 가변 폭을 가지는 숫자와 고정 폭을 가지는 도표용 숫자.

본론3. 확장사례

「SF」의 적용사례는 사내에서 매우 성공적이어서 기기 내외부, 마케팅, 홍보물, 웹사이트에 빠르게 적용사례가 퍼져나갔다. 동시에 단 하나의 폰트가 이 모든 용도를 떠맡다 보니 그 피로도가 눈에 띄게 빠르게 쌓여가게 되었다. 자족 확장을 서두르고, 더불어 동일한 디자인 유전자를 지닌 다른 스타일의 폰트들을 제작하게 되었다. 다음은 「SF」가 각종 UI와 홍보에 확장 적용된 대표적 예시들이다.

SF 프로 SF Pro

기존 애플워치용 폰트의 타입페이스들이 작은 화면의 타이포그래피를 위해 특별히 제작된 바, 이를 보다 보편적 모습으로 정돈하여 iOS, 맥 OS를 위한 시스템 폰트로 자족을 확장하였다. 이때, 글자를 가두던 그리드 시스템은 완화되었고, 컴팩트하게 좁혀졌던 글자너비가 자연스런 비례로 돌아갔다. 이에 따라 기존 애플워치용 타입페이스는 「SF 컴팩트 SF Compact」로 보다 일반화된 타입페이스를 「SF 프로」로 재정비하게 되었다.

워치페이스를 위한 커스텀 폰트

애플워치의 워치페이스 개발을 위해 고안된 디스플레이 전용 서체들이다. 시스템폰트와의 연계성을 유지하기 위해 「SF」 폰트의 특정 굵기를 선택하여 그 골격을 유지하면서 그래픽적으로 흥미로운 양식들을 고안해냈다. 처음에는 시간 표시를 위해 숫자만 개발되었으나, 나중에 대문자까지 포함되었다. 이는 애플뮤직, 매장 디스플레이 등에서 활용되고 있다.[7]

SF 모노 SF Mono

「SF 컴팩트」가 이미 그리드 시스템을 기반으로 작은 본문용 글자에 최적화된 디자인을 지니고 있던 바, 이를 고정 폭으로 정리하여 모노스페이스 폰트를 추출할 수 있었다.[8]

[7] 워치OS에 포함된 워치페이스들. https://www.apple.com/watch/

애플페이를 위한 커스텀 폰트

애플페이Apple Pay에서 지불 금액을 표시하기 위해 디자인한 숫자 폰트. 돈의 액수를
표현하기 위해 다소 무겁고, 다른 숫자들에 비해 중요해 보이는 시각적 효과가 필요했다.
워치페이스용 폰트 중 「치셀드Chiseled」에서 아이디어를 따왔다.[9]

SF 심볼즈SF Symbols

맥 OS의 상단 메뉴에서 「SF」 폰트의 알파벳과 기존 시스템의 심볼이 시각적으로 충돌하는
것이 불편하게 느껴져 심볼을 「SF」에 맞게 새로 그려보던 것이 이 프로젝트의 시작이다.
이에 대한 불만은 iOS와 맥 OS의 UI에서 전반적인 폰트와 심볼, 아이콘, 도형의 부조화에
대한 불만으로 이어졌다. OS 및 각종 앱의 UI 내에 존재하는 모든 심볼을 조사하고
이를 「SF」와 조화롭게 리디자인하여 폰트로 제작하는 작업이 수년에 걸쳐 이루어졌다.[10]

결론

이상으로 애플이라는 다국적 기업에서 경험한 타입 디자인에 대한 간단한 회고를 마친다.
요즘 타입 디자인은 오랜 시간 쌓여온 문자 문화의 전통을 계승하면서도 우리의
시대상을 반영하는 새로운 형태를 제시하고, 해당 문자 사용자들의 동의를 얻거나 반론에
대처하는 재미있는 조형 게임인 것 같다. 따라서 한 사회의 전통과 현재에 대한 상식을

```
Last login: Wed Jul 29 02:31:04 on console

The default interactive shell is now zsh.
To update your account to use zsh, please run `chsh -s /bin/zsh`.
For more details, please visit https://support.apple.com/kb/HT208050.
Bons-Silver-MacBook-Pro:~ bonmin$ 
```

[8] 맥 OS의 터미널.

[9] iOS의 메시지앱을 통해 돈을 보내는 장면 예시.
https://www.apple.com/apple-pay/

[10] 「SF 심볼즈」와 「SF」 폰트의 조화.
https://developer.apple.com/videos/play/wwdc2020/10207/

갖추고 적절한 논리와 철학을 바탕으로 예술성을 추구한다면 누구든지 어느 나라의
어떤 문자인지 구애받지 않고 즐겁게 플레이(디자인)할 수 있다고 생각한다.

대다수 한국인에게 한글 외 여타 문자 문화를 체득할 기회가 상대적으로 적다는
이유로 한글 이외의 문자는 잘 다루지 못할 것이란 선입견이 존재하는 듯하다. 필자도
유럽에서 처음으로 이 분야를 접했을 당시, 유럽 친구들이 이미 저절로 알고 있는 라틴
알파벳 조형에 대한 감각 중 어떤 것은 실제로 전혀 이해할 수 없어서 당황했다. 하지만
어린아이처럼 그들의 문자를 처음부터 다시 익혀보면서 곧 깨달은 한 가지는, 그들 안에서도
국적과 출신에 따라 지향하는 바가 각기 달라서 이상적인 라틴 알파벳의 형태 또한 다양하게
존재한다는 사실이었다.

라틴 알파벳은 어느 민족과 국가의 소유물이 아니며, 창제 때부터 오늘날까지
여러 문명이 뒤섞이며 형성된 결과물이기 때문에 게임의 요건, 즉 사회적 동의를 얻는
데에만 성공한다면 앞으로도 얼마든지 새로운 문화의 영향으로 변신할 수 있다.
「SF」의 디자인은 그러한 측면이 드러난 예시들 중 하나라고 생각한다. 미국 서부라는
문화적 사막에 여러 나라 문화권 출신의 사람들이 모여 앉아서 글꼴에 대해 의견을
나누다 보면 자연스레 더 많은 수의 세계인이 동의할 만한 아이디어가 나오게 마련이다.
이를 바탕으로 제작된 폰트는 다국적 기업의 국제 마케팅 전략에 따라 전 세계로
퍼져나가는 일이 일어나기도 하는 것이다.

이 게임을 함께 플레이할 사람이 더 많아지길 기대해 본다.

배리어블 폰트와 한글

<u>노은유</u>
노타입, 서울

<u>함민주</u>
글자 디자이너, 서울·베를린

1. 배리어블 폰트란

1. 국제타이포그래피협회 (Association Typographique Internationale)에서 주최한 행사.

배리어블Variable은 영어로 '변화하는, 변수, 다양한'이라는 뜻을 가진 형용사로서 '배리어블 폰트'는 하나의 데이터에 여러 개의 스타일을 포함하고 있는 폰트를 말하며 가변 폰트 혹은 변수 폰트라고도 불린다. 기존에는 한 파일에 하나의 스타일이 저장되어 있었다면, 배리어블 폰트는 단일 폰트 파일에 다양한 축Axis으로 구성된 여러 개의 스타일을 동시에 넣을 수 있다.

〈헤릿 노르트제이 큐브Gerrit Noordzij's Cube〉[1]를 보면 알파벳 e가 5×5×5의 상자 안에서 다양한 형태로 확장된 모습을 볼 수 있다. 이러한 영역을 '디자인 스페이스Design Space'라고 한다. 배리어블 폰트를 활용하면 글꼴 디자이너는 이러한 복합적 디자인 스페이스를 하나의 파일로 저장할 수 있고, 사용자는 배리어블 제어 장치를 조절하여 원하는 스타일을 선택할 수 있다.[2] 배리어블 제어 장치는 소프트웨어나 웹상의 '슬라이더'의 형태가 될 수도 있고, 동적 데이터, 카메라 또는 감지 장치가 될 수도 있다.

[1] 헤릿 노르트제이 큐브.

[2] 배리어블 폰트의 구조.

배리어블 폰트는 누가 만들었나

배리어블 폰트는 어도비, 애플, 구글, 마이크로소프트 관계자들이 협동 연구하여 'ATypI 바르샤바 2016'에서 처음 발표했다.[1] 같은 해 CJ 둔CJ Dunn은 굵기, 엑스하이트, 시각적 크기를 조절할 수 있는 배리어블 폰트 「둔바르Dunbar」를 출시했으며, 움직이는 딩뱃 폰트인 데이비드 벌로우David Berlow의 「자이콘Zycon」, 굵기와 너비를 극단적으로 변화시킬 수 있는 데이비드 조너선 로스David Jonathan Ross의 「핏Fit」[3] 등과 같은 배리어블 폰트 기술을 활용한 재미있는 실험들이 이어지고 있다. 타이포그래퍼 닉 셔먼Nick Sherman은 직접 제작한 아카이브 웹사이트에서 배리어블 폰트 목록과 함께 지원하는 OS, 브라우저와 애플리케이션 현황 등을 업데이트하고 있다.[4]

배리어블 폰트의 장점

배리어블 폰트의 장점은 첫째로 파일 크기가 경제적인 것이다. 미국의 폰트회사 모노타입에서 실험한 결과에 따르면, 48가지 스타일의 글자가족을 하나의 배리어블 폰트로 저장했을 때, 파일 크기의 88% 정도를 줄일 수 있었다고 한다. 이러한 폰트 파일의 경량화는 웹처럼 빠르게 반응해야 하는 매체에서 이점이 크다. 또한 반응형 웹 디자인에서도 다양한 화면 크기에 맞추어 빠르고 유연한 형태의 폰트 설정이 가능하기 때문에 더욱 편리하다.

둘째, 배리어블 폰트는 폰트 하나에 다양한 스타일을 담고 있어 다채롭고 역동적인 타이포그래피를 할 수 있다. 예를 들어서 배리어블 축을 움직이면 연속적인 형태를 얻을 수 있기 때문에 이를 활용하여 애니메이션을 구현할 수 있으며, 이는 웹 영상이나 플래시Flash 파일보다 훨씬 더 가볍다. 아서 라인더스 폴머Arthur Reinders Folmer는 자신의 웹사이트 〈Typearture〉에서 배리어블 컬러폰트를 활용한 흥미로운 애니메이션 작업을 소개하고 있다.[5]

배리어블 폰트는 어떻게 사용하나

배리어블 폰트는 스케치 59, 코렐드로우 2020, 어도비 크리에이티브 클라우드의 인디자인 CC 2020, 포토샵 CC 2018, 일러스트레이터 CC 2018 등의 버전부터 사용할 수 있다.

어도비 인디자인의 문자 패널을 살펴보자. 선택한 폰트에서 배리어블 기능을 지원한다면, 폰트 이름 옆 배리어블 폰트 버튼이 활성화된다. 버튼을 클릭하면 아래 배리어블 축 슬라이더가 나타난다.

또한 인터넷 익스플로러를 제외한 모든 웹 브라우저에서 배리어블 폰트를 지원한다. 배리어블 폰트를 웹 환경에서 미리보기 해보고 싶다면 디나모Dinamo가 만든 〈다크룸Darkroom〉[6], 로렌스 페니Laurence Penny가 만든 〈액시스프락시스AxisPraxis〉[7]와 〈삼사Samsa〉[8]를 활용하면 된다. 웹 브라우저에 배리어블 폰트 파일을 끌어서 놓기(드래그 앤 드롭)하면, 배리어블 축을 조정해볼수 있다. 특히 〈삼사〉에서는 사용자가 배리어블 축을 움직이면, 점이 이동하는 것을 관찰할 수 있어 배리어블 폰트의 원리를 이해하기 좋다.

[3] 데이비드 조너선 로스. 「핏」.

[4] 닉 셔먼. 〈배리어블 폰트 아카이브〉. https://v-fonts.com

[5] 아서 라인더스 폴머. 〈Typearture〉. https://www.typearture.com

[6] 디나모. 〈다크룸〉. https://dinamodarkroom.com

배리어블 폰트와 한글

2. 한글 배리어블 폰트 작업 소개

《2019 타이포잔치》에서는 노은유, 함민주가 큐레이터로서 참여한 '식물들: 순환의 사물, 순환의 타이포그래피' 섹션에서 국내외 22팀의 작가가 참여하여 다국어 타이포그래피와 배리어블 폰트에 대한 다채로운 작업을 펼쳤다. 그중 김동관, 노은유, 류양희, 윤민구, 이노을×로리스 올리비에, 채희준, 최정호(AG 타이포그라피연구소), 하형원, 함민주 총 9팀의 작가가 한글로 된 배리어블 폰트 작업을 진행했다. 작가들의 이해를 돕기 위해 사전에 간단한 배리어블 폰트 워크숍을 진행했으며 작가들은 기존에 출시한 글꼴을 배리어블 폰트로 구현하거나 배리어블 폰트를 위해 특별히 고안된 새로운 작품을 선보이기도 했다. 참여 작가들은 '식물'과 관련된 단어를 선택하여 배리어블 폰트로 표현하고, 독일 글꼴 디자이너이자 개발자인 마르크 프룀베르크Mark Frömberg가 HTML 과 CSS를 사용하여 작업과 어울리는 영상을 표현했다.

배리어블 폰트 작업 원리

배리어블 폰트의 작업 원리는 [9]와 같다. 예를 들어서 '빛'이라는 글자의 가는 마스터와 굵은 마스터를 그린다. 그려진 두 글자는 점의 숫자, 방향 등 모든 성격이 일치해야 한다. 두 마스터가 완성되면 '배리어블 축'으로 연결시켜 디자인 스페이스를 이어준다. 마지막으로 배리어블 폰트로 내보내기하면 축을 조절함에 따라 형태가 변화하는 글자가 탄생하게 된다. 이때 배리어블 축은 굵기 외에도 글자 너비, 기울기, 시각적 크기 등 디자이너의 상상력에 따라 다양하게 설정할 수 있다.

[7] 로렌스 페니. 〈액시스프락시스〉. https://www.axis-praxis.org

[8] 로렌스 페니의 〈삼사〉에서 본 데이비드 벌로우의 「암스텔바」 폰트. https://www.axis-praxis.org/samsa/

[9] 배리어블 폰트 작업 원리.

함민주, 「블레이즈페이스 한글」[10]
배리어블 축: 굵기

「블레이즈페이스 한글」은 제임스 에드먼슨James Edmondson의 라틴 폰트 「오노 블레이즈페이스
Ohno Blazeface」에 어울리도록 만든 제목용 한글 서체이다. 라틴 폰트 디자인의 유기적인
곡선의 형태를 한글의 구조에 어울리게 반영해 개성 있는 표정을 가지고 있다.
「블레이즈페이스 한글」은 '굵기'를 축으로 빛을 가장 많이 받는 순간은 획을 가늘게 하고
빛이 사라진 어두운 순간은 굵게 표현했다. 시간의 흐름과 빛의 강도에 따라 글자는
가는 획에서 굵은 획으로 순환하는 모습을 보여준다.

김동관, 「버섯」[11]
배리어블 축: 기울기

「버섯」은 《2019 타이포잔치》를 위해서 새롭게 제작된 드로잉으로 버섯을 닮은 부드러운
곡선으로 그려진 획이 인상적이다. 「버섯」 배리어블 폰트는 기울기 축을 활용하여
제작했다. 주목할 점은 일반적인 기울임 글꼴의 경우 오른쪽으로만 비스듬하게 눕는
형태인데 이 글꼴은 왼쪽과 오른쪽으로 모두 기울어지도록 설계하여 움직임의 범위를
한층 넓힌 것이다. 배리어블 폰트로 구현된 최종 영상을 살펴보면 단순히 기울기의
변화만을 나타낸 것이 아니라 자연스러운 탄성까지 느껴질 수 있도록 하여 버섯이
춤추는 모습을 연상시킨다.

[10] 함민주. 「블레이즈페이스 한글」.

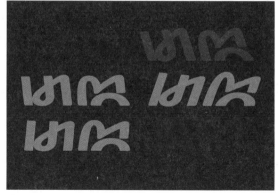

[11] 김동관. 「버섯」.

채희준, 「청조」[12]
배리어블 축: 민부리-부리(Winter-Spring)

「청조」는 목활자를 바탕으로 붓의 긴장감과 생명력을 더해 만든 부리 글꼴이다. 배리어블 폰트 작업을 위해서 민부리 드로잉을 새롭게 더했다. 「청조」 배리어블 폰트는 활자에 온도가 존재한다면 부리가 민부리보다 높은 온도를 지닌다고 가정하고, 'Winter' 축에는 「청조 민부리」를 'Spring' 축에는 「청조 부리」를 넣어 구성했다. 이로써 앙상한 민부리체가 두툼한 부리체로 변화하는 과정을 배리어블 폰트로 만들었다. 최종 영상에서는 민부리에서 부리로 연결되는 움직임이 마치 꽃이 피어나는 모습처럼 보이도록 제작했다. 이 작업은 별도의 존재로 분리해서 생각하는 부리와 민부리를 연결해서 하나의 축으로 엮었다. 이처럼 '민부리-부리'를 축으로 하는 배리어블 폰트가 나온다면 사용자가 상황에 따라 부리의 크기를 조절할 수 있는 활용성이 높은 폰트를 기대할 수 있을 것이다.

하형원, 「유령난초」[13]
배리어블 축: 형태

「유령난초」 배리어블 폰트는 실제 유령난초를 글자 형태로 치환한 두 가지 버전의 드로잉을 축의 양극값으로 설정하여 배리어블 폰트를 만들었다. 배리어블 축의 움직임을 이용해 시간이 흐름에 따라 유령난초가 생장하는 듯한 모습을 표현했다. 이 작업에서 주의깊게 볼 점은 식물을 연상시키는 유기적인 획의 미세한 형태 변화를 축으로 삼은

[12] 채희준. 「청조」.

[13] 하형원. 「유령난초」.

것이다. 배리어블 폰트의 일반적인 축인 굵기, 너비, 기울기 등을 벗어나 작가의 상상력을 발휘한 새로운 유형의 글자가족을 발견한 작업으로서 정적이고 흑백인 글자 디자인에 생명력을 불어넣은 것이다.

윤민구, 「크로탈라리아」[14]
배리어블 축: 공간

「크로탈라리아」는 공간 변화를 축으로 하는 배리어블 폰트이다. 숫자 혹은 라틴 알파벳처럼 보이는 도형이 모여서 한글의 형상을 하고 있다. 마치 식물의 줄기와 잎이 공간을 따라 자라듯 글자 너비에 따라 획의 형태를 유기적으로 변화시키는 모습을 보여주는 작업이다. 배리어블 폰트의 축은 디자이너의 정의에 따라 다양한 개념이 될 수 있다. 언뜻 보면 이 작업이 너비 축을 사용한 것으로 보이지만 자세히 보면 축의 변화에 따라 단순히 글자의 폭을 줄이거나 늘이지 않고, 좁아진 공간에 맞게 글자의 형태가 변하거나, 줄기의 개수가 늘어나고, 곁줄기의 위치가 이동하는 등 적극적인 변화를 보인다.

류양희, 「윌로우」[15]
배리어블 축: 굵기, 너비

「윌로우」는 목판 인쇄물의 글자들에서 영감을 받아 손으로 쓴 글씨의 유연함과 칼로 새긴 글씨의 날카로움이 공존하는 글꼴이다. 「윌로우」 배리어블 폰트 작업은 글자의

[14] 윤민구. 「크로탈라리아」.

[15] 류양희. 「윌로우」.

배리어블 폰트와 한글

뼈대에 해당하는 '가는 선'에서 시작해 '굵기'와 '너비'의 축을 따라 획의 굵기와 강약,
글자 너비가 변하는 모습을 구현했다. 배리어블 축이 2개로 늘어나면 디자이너는 최소
4개 마스터를 드로잉하게 된다. 이에 따라 구현될 수 있는 형태는 '가는-넓은' '가는-좁은'
'굵은-넓은' '굵은-좁은'과 같이 각 축의 사이를 복합적으로 넘나들 수 있기 때문에
유연하고 다채로운 글꼴로 나타나게 된다.

최정호(AG 타이포그라피연구소), 「초특태고딕」[16]
배리어블 축: 굵기, 너비
AG 타이포그라피연구소에서 만든 최정호의 「초특태고딕」은 과감한 굵기 보정, 인쇄
여분띠 현상, 섬세한 공간 분배가 돋보이는 강렬한 표정의 민부리 글꼴이다. 「초특태고딕」
배리어블 폰트는 최정호의 초기 민부리체와 초특태고딕을 굵기와 너비 축으로 엮어서
움직임을 표현했다. 최종 작업은 최정호의 글꼴이 한글 디자인의 '씨앗'이라는 의미로
영상을 구성했다.

노은유, 「옵티크」[17]
배리어블 축: 굵기, 시각적
「옵티크」는 한글과 라틴 문자를 위한 다국어 글꼴 디자인 프로젝트로서 각 문자 고유의
쓰기 도구, 즉 한글은 붓, 라틴 문자는 넓은 펜을 바탕으로 서로 다른 두 문자의 인상을

[16] 최정호. 「초특태고딕」.

[17] 노은유. 「옵티크」.

조화롭게 만들었다. 「옵티크」 배리어블 폰트는 굵기 축과 시각적 축으로 구성되었으며 시각적 축의 경우 '본문용–제목용'에 따라서 획의 대비, 세리프의 형태, 속공간이 동시에 변화하는 것을 볼 수 있다. 따라서 작은 크기로 사용되는 본문용의 경우 가로획에 굵기가 더해지고 부리가 도톰해지며 속공간은 커지는 변화를 관찰할 수 있다. 최종 영상 작업은 「옵티크 제목용」 '나무'가 모여서 「옵티크 본문용」 '숲'이 되어가는 과정을 보여준다.

이노을×로리스 올리비에, 「뿌리」[18]
배리어블 축: 굵기, 선, 씨앗

이노을과 로리스 올리비에Loris Olivier 작가의 「뿌리」는 '굵기, 선, 씨앗'이라는 세 가지 배리어블 축을 활용해 식물이 몸을 지탱할 수 있도록 단단하게 받쳐주는 뿌리의 역할을 표현했다. 「뿌리」는 두껍기도 하고 가늘기도 하며 구불구불하거나 빳빳한 형태를 지니기도 한다. 또한 씨앗이 자라서 뿌리를 내리는 모습을 글자에 담아보았다. 글자의 순수한 형태 위에 '씨앗'이라는 새로운 축을 더한 것이 특징적인 작업으로 배리어블 폰트값이 변화함에 따라 얼마나 다양한 디자인 스페이스를 넘나들 수 있는지 보여주는 좋은 예이다.

배리어블 폰트와 한글의 미래

배리어블 폰트의 유연성과 확장성은 특히 한글과 같이 글자수가 많은 문자에서 더 큰 힘을 발휘한다. 한글은 폰트 굵기 1개의 총 글자수가 11,172자이다. 글자가족을 확장하려면 수만 자를 제작해야 하는 큰 수고가 필요하다. 예를 들어서 9종의 글자가족이 있다면 11,172자×9종이 되어서 총 글자 수는 10만 자가 넘게 된다. 만드는 것도 힘들지만 이로써 폰트의 용량 또한 지나치게 커진다. 이는 사용자들에게 부담이 되기도 하고 웹과 같은 속도가 생명인 환경에서도 걸림돌이 된다. 배리어블 폰트의 압축성은 이를 해결할 수 있는 좋은 방법이다. 배리어블 폰트 기술을 잘 활용하면 한글 글자가족의 다양성을 가속화할 수 있을 것이다. 한글 폰트는 굵기 외에는 아직 글자가족의 유형이 다양하지 않다. 배리어블 폰트의 '축'은 무한한 가능성을 갖고 있다. 《2019 타이포잔치》에서 작가들은 '빛의 움직임' '시각적 보정' '기울기' '공간 변화' '시간의 흐름' '부리의 변화' '굵기와 너비' '형태의 변화'와 같이 다양한 실험적인 축을 소개했다. 이와 같이 앞으로 다양한 글자가족을 상상해 볼 수 있을 것이다.

[18] 이노을×로리스 올리비에. 「뿌리」.

웹사이트

닉 셔먼. 〈배리어블 폰트 아카이브〉. 2020년 6월 9일 접속. https://v-fonts.com

데이비드 조너선 로스. 2020년 6월 9일 접속. http://djr.com

디나모. 〈다크룸〉. 2020년 6월 9일 접속. https://dinamodarkroom.com

로렌스 페니. 〈삼사〉. 2020년 6월 9일 접속. https://www.axis-praxis.org/samsa

로렌스 페니. 〈액시스 프락시스〉. 2020년 6월 9일 접속. https://www.axis-praxis.org

〈배리어블 타입쇼〉. 2020년 6월 9일 접속.
 https://youtu.be/17HmyM1slBw, https://youtu.be/i9d1owrmhrM

아서 라인더스 폴머. 〈Typearture〉. 2020년 6월 9일 접속. https://www.typearture.com

《타이포잔치 2019》. 2020년 6월 9일 접속. http://typojanchi.org/2019

『이것저것』 이모저모:
《2019 타이포잔치》 온라인 일간지
『이것저것』의 구성과 내용을 중심으로

윤충근
그래픽 디자이너, 서울

이것저것

『이것저것』은 《2019 타이포잔치》의 소식을 전하는 온라인 일간지이자
인스타그램 플랫폼을 활용해 진행한 미디어 프로젝트이다. 이 프로젝트는
《2019 타이포잔치》의 예술감독 진달래 & 박우혁이 기획 및 총괄하고
윤충근이 기획·편집과 디자인을, 김도헌이 기술을 맡았다.

　　『이것저것』은 타이포잔치 인스타그램 계정(@typojanchi)의
스토리**1**를 통해 매일 한 권씩 발행해, 2019년 10월 4일 창간준비호를
시작으로 10월 5일부터 11월 3일까지 총 30호가 발행되었다. 『이것저것』의
주된 내용은 행사에 대한 정보 안내, 전시 작품 소개 등으로 관람객이 전시장을
직접 방문하지 않고도 온라인으로 행사를 경험할 수 있도록 했다.

　　온라인으로 발행한 『이것저것』은 《2019 타이포잔치》가 열린 문화역서울284
1층 중앙홀에서 실시간으로 상영되었다. 55인치 TV 모니터를 세로로 설치해 만든
'〈이것저것〉 모음곳'은 전시장 입구에 위치해 최근 3–4일 간 발행한 『이것저것』을 보여주며
온라인과 오프라인을 연결했다. 관람객은 TV 스탠드에 부착한 센서와의 인터랙션을 통해
머리와 다리를 움직이며 실시간으로 발행 중인 소식과 지난 호를 볼 수 있었다.

　　『이것저것』은 예술감독, 큐레이터, 작가, 관람객을 《2019 타이포잔치》에
적극적으로 개입하도록 함으로써 전시 공간을 온라인으로 확장하고 전시를 경험하는
다른 방식을 선보였다.

1. 인스타그램의 게시물 형태
중 하나로 1:1 비율로 프로필
그리드에 저장하는 게시물과
달리 9:16 비율로 피드 상단에
저장하는 게시물을 말한다.
업로드 한 뒤 24시간이 지나면
자동적으로 지워지는 특성이 있어
많은 양의 이미지를 비교적 부담
없이 올릴 수 있다.

이모 1

'이것저것'이라는 이름은 《2018–2019 타이포잔치 사이사이》의 소주제인 '둥근 것,
네모난 것, 세모난 것, 모양이 없는 것'**2**에서 착안했다. 여기서 반복적으로 쓰인 단어 '것'이
이번 행사의 주제였던 사물(事物)의 순우리말쯤에 해당한다고 생각했다. 사물이라는 뜻을
담으면서도 행사와 관련한 소식, 관객의 반응 등 잡다한 내용을 아우를 수 있다는 점에서
'이것저것'은 일간지의 이름으로 적절했다.

인스타그램의 스토리에서 발행하는 간행물이라는 콘셉트가 사용자들에게 다소
낯설 수 있기 때문에 『이것저것』은 앞표지, 차례, 본문, 뒷표지 순서의 책의 일반적인
구성을 따라 친숙하게 다가가고자 했다. 내용적으로는 정기적인 콘텐츠를 마련해
운영상의 안정성을 확보하고 비정기적인 콘텐츠를 통해 활력과 의외성을 더했다.
내용은 각각의 성격에 따라 일곱 가지로 분류한 뒤 '이것저것'에서 파생해 '볼것' '알것'
'들을것' '올것' '만든것' '물을것' '말할것'이라는 이름을 붙였다. 다음은 『이것저것』의
구성과 내용에 대한 설명이다.

이것
책의 앞표지에 해당한다. 발행 호수를 표기한다.

볼것
책의 차례에 해당한다. 당일에 올라올 게시물의 순서와
게시하는 시간을 함께 안내한다.

알것
행사와 관련한 안내사항을 공지한다. 『이것저것』에 대한 소개,
모바일 도슨트 이용 방법 등 전시를 관람하는 데 필요한 내용을 전달한다.

들을것
전시 기간 중 총 세 차례 진행한 토크 프로그램의 일정 및 연사에 관해 소개한다.

올것
행사와 관련한 이벤트를 안내한다. 두 번 이상 전시를 보러 온 관람객에게 굿즈를
증정하는 이벤트, 한글날에 한글이 쓰인 티셔츠를 입고 전시장에 오는 관람객에게
선물을 증정하는 이벤트 등을 진행했다.

만든것
《2019 타이포잔치》에 출품된 작품을 사진과 함께 소개한다. 매일 하루 평균
5-6개의 작업을 소개해 전시 기간 동안 약 200개의 작품을 소개했다.

물을것
일상에서 흔히 쓰이는 사물과 그 이름의 유래를 매일 하나씩 소개하며
사물과 이름 사이의 관계에 대해 질문한다.

말할것
《2019 타이포잔치》의 큐레이터 및 작가를 온라인으로 실시간 인터뷰한다.
온라인 관람객은 인스타그램 스토리의 질문받기 스티커 기능을 활용해
인터뷰이로 선정된 큐레이터 및 작가에게 궁금한 점을 글로 입력하고 인터뷰이는
질문들을 확인해 실시간으로 글과 이미지로 답하는 방식으로 진행했다.

저것
책의 뒷표지에 해당한다. 펴낸날, 펴낸곳, 디자인, 기술, 도움 등의 크레딧을 표기한다.

이 외에 관람객들이 올린 사진과 동영상도 『이것저것』에서 큰 비중을 차지했다.
전시장을 방문한 뒤 사진이나 동영상을 찍어 GIF 스티커나 태그를 추가해 게시물을
올리는 것은 인스타그램에서 일어나는 보편적인 현상으로 일종의 놀이 문화이다.
이러한 놀이를 통해 관람객들은 자신의 취향을 드러내고 기꺼이 홍보의 매개체가
되기를 원한다. 『이것저것』은 이에 호응해 관람객들이 올린 포스트에 GIF 스티커를 붙여
리포스트Repost[3] 함으로써 관람객들과 소통했다.

2. 사물의 형태에 따른 유형을
빌어 《2018-2019 타이포잔치
사이사이》를 구성하는 프로그램에
이름을 붙인 것으로 각각 리서치,
강연, 워크숍, 출판에 해당한다.

3. 다른 사람이 올린 인스타그램
게시물을 자신의 피드에
공유하는 것.

이모 2

『이것저것』은 매일 오전 9시에 발행을 시작해 오후 10시에 발행을 마쳤다. 이러한 운영 시간 체계를 마련한 이유는 『이것저것』이 오프라인에서 발행하는 일반적인 형태의 일간지와는 달리 인스타그램 계정관리자가 개별적으로 게시물을 올려 발행하는 일간지였기 때문이다. 오전 9시에는 '이것' '볼것' '알것' '올것' '만든것'을 순서대로 올려 전시장이 문을 열기 전 행사에 관한 내용을 알렸고 오전 10시부터는 관람객이 촬영한 사진 또는 영상을 당일 발행하는 내용의 양을 고려해 발행 시간 안에서 자유롭게 리포스트해 배치했다. 하루 동안 발행한 게시물의 양은 대략 20개 내외였다. 24시간이 지나 읽을 수 없게 된 지난 게시물은 스토리 하이라이트**4**를 만들어 '만든것' '물을것' '말할것' 등 부분별로 모아 영구적으로 열람할 수 있도록 했다.

저모 1

『이것저것』을 발행하며 흥미로웠던 부분은 타이포그래피와 시간이 만나는 지점이었다. 이번 타이포잔치의 전시 서문에서 진달래 & 박우혁 예술감독은 다음과 같이 말한다.

우리는 타이포그래피의 핵심인 분해와 조립을 단서로 글자와 사물의 관계를 새롭게 바라보려 한다. 타이포그래피는 원래 글자 사용법이지만, 그 행위를 중심에 놓고 본다면, 사물로 하는 타이포그래피도 가능할 것이다. 왜냐하면 오늘날의 타이포그래피는 더 이상 글자 사용 유무만을 가지고 판단할 수 없는 분야이기 때문이다. 글자가 유일한 재료였던 타이포그래피는 이제 그림, 사진, 기호, 움직임, 소리 등 모든 것을 재료로 삼는다.

타이포그래피의 재료는 더 이상 글자에 한정되지 않고 그 행위 역시 2차원의 평면을 넘어 3차원의 공간, 4차원의 시공간에서 일어난다. 『이것저것』은 글과 사진, 영상을 재료로 삼아 24시간이라는 그리드 체계 위에 게시물을 배치했다. 책의 차례에 해당하는 '볼것'에는

쪽번호 대신 게시물이 올라오는 시각을 표시했다. 사용자들은 '볼것'에
공지된 시각을 보고 때를 맞춰 게시물을 확인할 수 있었다. 24시간이
지나면 게시물이 사라지는 점, 게시물 사이의 이동이 자유롭지 못한 점 등
인스타그램 스토리가 자체적으로 갖고 있는 시간적·인터페이스적 제약으로
시간이라는 체계를 적극적으로 활용하지 못한 점은 아쉬움으로 남는다.
만약 인스타그램 플랫폼을 활용하지 않고 독립적인 플랫폼을
구축했다면 어떤 방식으로 작업이 전개되었을지 궁금하기도 하다.

4. 스토리 게시물 중 24시간이
지난 지워진 게시물을 다시
볼 수 있도록 영구적으로 보관하는
기능. 인스타그램 계정의 프로필
페이지에서 확인할 수 있다.

저모 2

『이것저것』의 내용 중 하나인 '물을것'은 시간이 지남에 따라 굳어진 체계를 분해해 다시
조합해 보려는 시도로, '타이포그래피와 사물'이라는 주제 안에서 '이름'이라는 키워드를
가지고 진행한 작업이다. '이름을 붙이다'라는 표현에서 볼 수 있듯, 사물에 붙여진 이름을
반대로 '떼어' 다른 이름을 붙이는 상상에서 시작했다. '물을것'에서는 일상에서 흔히
쓰이는 사물과 그 이름의 유래를 매일 하나씩 소개했다.

　　　예를 들어, 사과(沙果)는 한자어로 그 뜻을 직역하면 '모래 과일'이다. 사과의 열매
부분이 모래와 같이 작은 입자들로 구성되어 있기 때문에 붙여진 이름이다. 만약 사과의
질감이 아닌 색이나 형태적인 특성에 주목을 한다면 지금과는 다른 이름으로 불릴지도
모른다. 또 다른 예로 양갱(羊羹) 역시 한자어로 그 뜻을 직역하면 '양고기 국'이다.
중국에는 팥과 설탕을 쪄서 양의 간 모양과 비슷하게 만든 양간병(羊肝)이라는
떡이 있었다. 이 떡이 일본에 전해지는 과정에서 '간 간(肝)' 자가 같은 발음을 가진
'국 갱(羹)' 자로 와전되어 지금의 이름으로 불리고 있다고 한다.

　　　이처럼 '물을것'은 사물의 이름을 빌어 사회라는 체계가 갖는 임의성을 드러내고,
그 타당성에 대해 질문을 던지며 체계에 대한 분해와 조합의 가능성을 상상하게 한다.
아래는 '물을것'에서 소개한 사물들의 목록이다. 일상에서 흔히 쓰이는 사물을 모은 뒤
그 어원을 찾아보며 상식이나 통념을 벗어나는 지점이 있는 이름들을 추렸다.

영문	국문	한자	한자 직역(국문)	한자 직역(영문)
objects	사물	事物	일과 물건	thing and objects
socks	양말	洋襪	서양 버선	western Beoseon
ring finger	약지	藥指	약 손가락	medicine finger
wash face	세수	洗手	손 씻다	wash hands
type	활자	活字	움직이는 글자	movable letter
bag	가방	—	—	—
yokan	양갱	羊羹	양고기 국	sheep meet soup
for a moment	잠간	暫間	짧은 시간	short time
glasses	안경	眼鏡	눈 거울	eyes mirror
ring	반지	半指	반쪽 가락지	half of a set of twin rings
wallet	지갑	紙匣	종이 작은 상자	small paper box
lunch	점심	點心	마음에 점을 찍다	dot on mind
novel	소설	小說	작은 얘기	small story
not really	별로	別로	다르 게	differently
soju	소주	燒酒	불태운 술	burn down liquor
kimchi	김치	沈菜	채소를 담그다	pickling vegetables
sungnyung	숭늉	熟冷	찬물을 익히다	heat cold water
match	성냥	石硫黃	돌 유황	stone sulfur
sled	썰매	雪馬	눈 말	snow horse
candy	사탕	沙糖	모래 엿	sand taffy
neck and neck	박빙	薄氷	얇은 얼음	thin ice
blanket	이불	離佛	불심이 떠나가다	leave buddhism
small octopus	낙지	絡蹄	발이 얽히다	entagle foot
hunting	사냥	山行	산에 가다	go to a mountain
chill pepper	고추	苦椒	쓴 풀	bitter herb
beast	짐승	衆生	무리지어 살다	live in groups
brushing teeth	양치	楊枝	버들 가지	willow branch
conflict	갈등	葛藤	칡나무 등나무	arrowroot tree wisteria tree
apple	사과	沙果	모래 과일	sand fruit

마치며

『이것저것』은 구성과 내용 외에도 인스타그램의 스토리 기능을 활용했다는 점에서 형식과
운영 측면에서도 이야기할 거리가 있다. 물론 인스타그램 스토리 인터페이스가
가진 제약이 다소 불편했을 수도, 매일 올라오는 수십 개의 게시물이 피로했을 수도 있다.
그럼에도 『이것저것』의 내용과 구성이 관람객들에게 잘 전달되었기를 바라며,
어딘가에 있었을지도 모르는 『이것저것』 구독자의 피드백은 여전히 환영이다.

대화

'대화'는 누군가와의 대화를 기록한 것이다.
'대화'는 주제에 대해 이야기를 주고받고, 좀 더 실제적이고 깊은 담론을 이끌어낸다.
『글짜씨』 18에서는 3월부터 9월까지 서울시립북서울미술관에서 열린
김영나의 개인전《둘체 주머니》에 대한 대화를 나누었다.

물체주머니

김영나
테이블유니온, 한국

물체주머니	김영나	Bottomless Bag	Na Kim
서울시립 북서울미술관 어린이갤러리 2020.3.26.–9.13.		SeMA, Buk-Seoul Museum of Art Children's Gallery Mar. 26–Sept. 13, 2020	I·SEOUL·U

유현선　《물체주머니Bottomless Bag》가 〈SET〉의 20번째 버전이라고
들었습니다. 꾸준히 〈SET〉를 작업하고 계시는데요, 이번에는 어떻게
변주되었는지 궁금합니다.

김영나　정확히 말하면 이번 전시가 〈SET〉의 20번째 버전이라기보다
전시의 큰 골자를 이루는 것 정도로 생각을 하시는 것이 좋을 것 같습니다.
이제까지 제가 해왔던 작업을 보여주는 개인전이기 때문에 〈SET〉가
큰 비중으로 다루어졌어요. 〈가변판형〉이나 〈2분 13초, 4.6미터〉와 같은
작업도 같이 포함하기 위해서 '물체주머니'라는 제목을 사용했습니다.
그리고 이번 전시를 준비하면서 디자이너로서 혹은 작가로서 〈SET〉를
'어떤 목적을 가지고 어떤 방향으로 계속할 것인가?'라는 질문을 하게
되었습니다. 〈SET〉는 제게 작업을 생산하기 위한 플랫폼이고 매뉴얼의
역할을 하는데, 어떤 순간에 너무 반복적이거나 흥미로운 지점을 찾지
못하면 좀 나른해지는 느낌도 있어요. 그래서 이번에는 기존과는
조금 다르게 적극적으로 공간에 개입하고 다른 작업과 연계되는 지점을
찾아서 경계를 더 넓히고 싶었습니다. 앞으로 이 작업이 더 진화 할 수
있을 것인지 아니면 다른 출발점으로 삼을지를 생각하는 계기로
삼고 싶습니다.

유현선　『SET』의 표지를 전시장 입구 공간에 물리적으로 구현하여
설치하셨습니다. 이전에 《지산 밸리록 뮤직앤드아츠 페스티벌》에서도
풍선과 철재 프레임을 사용하여 그래픽을 공간으로 변환하신 적이
있습니다. 이번에는 어떤 부분에 주안점을 두고 소재와 구조를
선택했나요?

김영나　평면이 입체나 공간이 되는 지점은 계속 관심이 있었습니다.
공간이 되는 순간부터 경험이 되는 것 같아요. 평면 작업은 시각적으로
느끼는 차원이라면 공간 작업은 시간과 행동이 더해지면서 경험의
차원으로 확장됩니다. 그래서 항상 '공간에 시각 평면이 어떻게 관여할
수 있을까? 혹은 그 반대의 경우는 어떨까?'를 생각합니다. 무엇보다
전시야말로 경험을 극대화해서 실험해 볼 수 있는 무대이지 않을까
싶습니다. 이번 전시는 특히 어린이 전시이기도 했고요. 그러나
어린이뿐 아니라 다른 연령층의 사람들도 와서 충분히 즐길 수 있는
여러 요소를 가질 수 있게 고민했어요.

유현선　《물체주머니》의 또 다른 특이점이 어린이 전시라는 점입니다.
특별히 달라지거나 신경 쓴 부분이 있으신가요?

김영나　최대한 제약이 없는 미술관을 만드는 것이 목표였습니다.
몇몇 작품은 만지지 못하게 할 수밖에 없었지만, 최대한 그런 부분의
비중을 적게 만들고 어떤 것이든 실제로 만들어보고, 만져보고,
경험해보는 전시를 만드는 것이 관건이었어요. 그래서 '배낭 탐험가'의

물체주머니

물체주머니를 만들 때도 도구를 이용해서 실제로 벽화의 요소를 자로 측정해보거나 가방 안에 있는 물건들을 직접 만질 수 있어 전시의 경험을 확대하는 방식을 고민했습니다. 그리고 전시 공간에서 어린이가 안전하게 만지고 뒹굴며 시간을 보낼 수 있도록 질감에도 신경을 썼습니다. 그러다 보니 제가 주로 사용했던 철재나 목재보다는 더 친근감 있고 부드러운 소재를 사용했습니다. 아이들이 시간을 보내는 놀이방, 키즈 카페, 집 이런 곳은 대부분 표면이 충격을 완화하는 조건을 가질 수밖에 없잖아요. 재질도 설치의 일부로 볼 수 있기 때문에 중요한 요소라고 생각했습니다.

유현선 이번 전시를 통해 〈SET〉의 미래에 대해서 생각해보는 계기가 되었다고 하셨습니다. 다음 계획도 있으신가요?

김영나 이제 생각해 봐야죠. 그사이에 전시를 몇 번 진행해보면서 느낀 점은 전시 설치가 끝났다고 끝난 것이 아니라는 점입니다. 전시 중간에 받게 되는 피드백도 큰 부분을 차지합니다. 그리고 특히 이번에는 미술관 휴관으로 의도치 않게 제가 전시 공간에 머물러 있는 시간이 많았는데, '코로나 시대에서 전시와 작품은 어떤 의미를 갖고 이를 어떻게 보여줄 수 있을까?' 이런 고민도 하게 되었습니다. 또는 예전에 다른 전시에서는 제가 공간에 머무는 행위를 작업의 일부러 포함한 적도 있었어요. 그래서 작업을 설치하고 전시를 오픈 한 뒤에도 작업 스스로 의미를 만들면서 커가는 상황을 많이 목격했습니다. 이번에 새로 시도한 〈조각〉 같은 경우는 뉴욕에서 〈SET〉 첫 번째 전시를 할 때부터 아이디어를 생각했습니다. 처음 전시장에 벽화를 설치하고 나서 레지던시에서 습작으로 그 벽의 부분을 한번 캔버스에 옮겨 그려 봤었어요. 5년이 지나서야 실제 〈조각〉 작업을 구현하는데, 예상보다 많은 실마리를 던져주었습니다. 전시 후에는 당분간 이 생각들을 잘 정리해 보고 싶습니다.

유현선 참여형 작업을 해 본 적이 있으신가요?

김영나 완전하게 참여형이라고 하기는 어렵지만 전시 기간 동안 문화역서울284 공간을 스튜디오로 활용했던 〈일시적인 작업실, 53〉이 있습니다. 미술관이라는 공공장소를 제가 작업실로 사용하고 관람객들이 그 공간에 들어오는 상황에서 많은 발견이 있었습니다. 예를 들어, 미술관 일정에 맞춰 저의 스케줄이 조정되기도 하고 공간 안에서 마음대로 음식을 먹을 수도 없는 등 이런 공공장소에 부여되는 여러 가지의 제약이 제 삶으로 들어오는 것을 경험했습니다. 이런 상황에서는 모든 부분을 미리 계획할 수 없었어요. 관객과 나눴던 예상하지 못한 대화와 그들의 반응이 제 작업을 일종의 참여형 작업으로 만들었습니다. 예전에 철저히 의도대로 제어할 수 없는 상황들을 제가 어떻게 받아들일 수 있을지를 고민한 적이 있는데, 지금까지 내린 결론은

[p82 왼쪽 위]
《물체주머니》전시장 입구 설치 전경.

[p82 오른쪽 위]
『SET』 표지.

[p82 아래]
《지산 밸리록 뮤직앤드아츠 페스티벌》.
〈SET v.5〉.

대화

참여형 작업은 제약을 느슨하게 던져주고 그곳에서 예상하지 못했던 것들을 발견하면서 작업의 맥락을 넓히는 작업이지 머릿속에 계획을 전부 세워두고 모델링이나 렌더링처럼 그대로 나오는 작업은 아니라는 것입니다.

유현선 작업의 기반이 되는 '수집'에 대해서 이야기해주실 수 있을까요?

김영나 저는 기본적으로 누구나 하는 게 수집이라고 생각합니다. 수집하는 것이 없다고 이야기하는 사람도 사실은 수집의 기준을 어떻게 생각을 하느냐에 따라 다르게 말할 수 있을 것 같습니다. 무의식중에 같은 형식의 사진만을 찍는다던가, 특정 물건을 주머니에 넣는다던가 이런 것까지도 저는 수집이라고 생각합니다. 진지하게 우표를 모으는 것만 수집이라고 생각하지 않아요. 그래서 누구나 정도의 차이는 있지만 나름대로 수집을 하고 있습니다. 제 관심사는 개개인에게 수집이 갖는 의미입니다. 수집은 사물에 연결된 시간과 공간의 맥락을 모으는 행위라고 생각합니다. 수집하는 사물은 그냥 단순한 사물이 아닙니다. 학생들과 워크숍을 할 때 수집품을 언급하는 이유도 개개인의 기억을 다시 되짚어보고 자연스럽게 공유하게 만드는 상황을 연출할 수 있기 때문이에요. 그리고 그 기억을 구구절절 설명하기보다 어떤 사물로 대체하면서 다양한 맥락을 볼 수 있거든요. 사물에 관련된 본인의 기억을 이야기할 수도 있지만, 타인이 그 사물을 다른 방식으로 바라볼

〈SET v.20: 페이지 벽〉.

물체주머니

수도 있어서 수집에 매력을 느낍니다. 저는 사물과 기억을 연결할 때 자서전을 쓰는 과정과 연결짓는 편이에요. 자서전은 사실 굉장히 허구가 많이 개입하는 글입니다. 최대한 자신의 과거 기억과 사실 위주로 쓴다고는 하지만 정확하지 않을 때는 자기한테 유리한 쪽으로 쓰거나 덧붙이는 경우가 많은 거죠. 그 과정에서 픽션을 계속 생산합니다. 어떤 면에서 디자인하는 과정과도 비슷한 것 같습니다.

유현선 〈발견된 구성〉에서도 수집하신 사물을 가지고 재구성해서 제작하셨습니다. 손으로 작업하신 것 같은데, 수작업을 선호하시나요?

김영나 수작업이 가진 장점이 있고 디지털이 가진 장점이 각각 있고 서로 대체할 수 없는 것 같아요. 저는 수작업에 조금 더 무게를 두고 있습니다. 예를 들면, 도록을 만들 때 컴퓨터의 미리보기 이미지로 확인하고 선택하는 것이 어떤 면에서 제일 편리한 방법이잖아요. 그런데 저는 그렇게 잘 못하겠더라고요. 그래서 미리보기 이미지를 모두 출력하고 잘라서 책상에 늘어놓고 확인합니다. 그렇게 보면 이 사진은 이 사진이랑 같이 있으니까 좋다, 또는 이 순서대로 놓아 보니까 좋다, 아니면 이걸 뒤집어 보니까 좋다는 생각이 들어요. 저는 이런 작업 방식은 컴퓨터로는 못 하는 것 같습니다. 그래서 굳이 손의 감각까지는 모르겠지만 눈으로 보고 손으로 만지며 구조를 상상하는 것은 아날로그 방식이 아니고서는 어렵습니다. 〈발견된 구성〉은 그런

〈발견된 구성〉
설치 전경.

대화

시간을 일부러 가지려고 시작한 것도 있어요. 계속 컴퓨터 앞에 앉아 있기보다 종이에 출력하고 잘라보면서 안정을 느끼게 됩니다. 저는 여전히 글자의 간격 같은 것을 확인할 때 항상 출력해서 1:1 크기로 봐야 판단을 할 수 있는 사람이에요. 직접 눈으로 확인하고 하나씩 다듬어 가면 느끼고 얻는 것이 많아서 계속 그렇게 진행하고 있습니다. 〈SET〉 설치 작업의 경우에도 매번 페인트로 직접 벽화를 그려냅니다. 사진으로 보기에는 시트지로 제작하는 것과 큰 차이가 없어보일 수 있지만, 실제 공간이 주는 경험은 무척 다르다고 생각해요. 성신여대입구역에 설치된 〈SET v.9: 패턴〉만 벽화를 할 수 없는 구조여서 유일하게 시트지로 설치했습니다. 이외의 다른 작업은 웬만하면 다 페인트로 작업했어요.

유현선 　전시 포스터에 있는 주머니도 실제로 제작했는지와 용도가 있는지 궁금합니다.

　　　　김영나 　전시 그래픽 디자인은 유명상 디자이너가 진행했습니다. 파티에서 유명상 디자이너를 처음 만났는데, 수작업을 기반으로 아이디어를 구현하는 방식이 무척 흥미로웠습니다. 그래서 이번에 함께 작업을 해보고 싶었습니다. 포스터 속의 주머니는 유명상 디자이너가 촬영을 위해 손수 제작했습니다.

유현선 　전시 도록은 어떻게 계획 중이신가요?

　　　　김영나 　넓게 보면 책의 구조가 공간으로 구현된 전시라, 전시 전경을 그냥 보여주는 도록은 의미가 없다고 생각했습니다. 대신 어린이 전시에 어울릴만한 어린이 책을 만들고 싶었어요. 전시에서 발견할 수 있는 장면을 최대한 추상적인 일러스트레이션처럼 사진을 촬영해서 그 사진을 기반으로 어떤 이야기를 만들려고 합니다. 그래서 오은 시인에게 어린이를 위한 시를 부탁드리고, 사진은 언리얼 스튜디오가 맡아주었습니다. 책의 표지를 재해석한 공간을 제일 많이 촬영했고, 벽화도 비치는 성질을 가진 바닥과 높은 층고 등 해당 공간의 특징을 이용해서 다른 방식으로 해석하는 사진을 촬영했습니다. 그리고 제 작업에 대한 글은 김성원 큐레이터가 써주었습니다.

유현선 　전시에 사용된 가구나 의상도 협업하신 것으로 들었습니다.

　　　　김영나 　모두 오랜 협업자들과 함께 작업했습니다. 정말 감사하고 운이 좋다고 생각합니다. 제가 네덜란드에서 돌아온 시점인 2012년부터 큰 설치 작업을 항상 함께했던 곰 디자인에서 전시 공간 전체를 맡아 주었고, 전시 공간에 필요한 가구랑 〈물체그리기〉 공간은 전산시스템에서 제작했습니다. 전산시스템은 에이랜드 매장과 두루두루 아티스트 컴퍼니 사무실 공간 작업을 함께 했습니다. 의상은 포스트디셈버에서 작업했는데 예전에 '에이랜드 그래피커 프로젝트'에서 머플러 작업을

같이한 경험이 있습니다. 포스트디셈버는 예전에 제 작업실이 부암동에 있었을 때 같은 건물 1층에 스튜디오를 갖고 계셔서 동네 친구로 시작했어요. 앞서 말씀드린 언리얼 스튜디오는 제가 코스 프로젝트 스페이스의 전시를 기획했을 때 협력한 적이 있습니다. 모두 다 같이 작업했던 기억이 좋아서 함께하고 있는 협업자들입니다.

유현선　《물체주머니》전시 이외의 다른 작업에 대해서 여쭤보겠습니다. 〈셀린〉과 〈가젯 nr.1: 머플러〉는 작업이 실용성과 결합하는 부분이 있습니다. 전시를 위한 작업과는 다른 측면으로 고민이 많으셨을 것 같은데 그 부분에 대해서 듣고 싶습니다.

김영나　작품과 상품으로 정리해서 생각해보면 그 사이의 불분명한 지점을 오히려 극대화하는 것에 관심이 있습니다. 〈셀린〉은 사실 실제로 사용되는 초콜릿 패키지는 아닙니다. 제가 아랍에미리트 샤르자에 오래 머물렀던 적이 있었는데 하루는 동네 식료품 가게에 갔어요. 그런데 초콜릿이 큰 박스 안에 막 쌓여 있더라구요. 다양한 컬러의 은박지로 쌓여 있고 로고가 인쇄된 스티커가 붙어 있었는데 초콜릿의 크기와 스티커의 크기가 전부 달랐습니다. 특별한 이유 없이 예뻐서 종류별로 샀습니다. 구입해 온 초콜릿을 보다가 왜 같은 브랜드에서 제작도 쉽지 않았을 텐데 이런 식으로 만들었을까 궁금해하면서 개인 작업으로 만들어 본 패키지입니다. 크기가 다르고 높이가 다른 초콜릿을 하나의 〈발견된 구성〉.

물체주머니

박스에 넣는 것을 상상하며 다른 크기의 구멍이 뚫린 레이어로 구성된 패키지를 생각했어요. 여러 색상의 아크릴 레이어가 쌓여 있는 모습을 상상하며 제작했습니다. 〈가젯 nr.1: 머플러〉은 '에이랜드 그래피커 프로젝트'로 진행한 작업입니다. '그래피커 프로젝트'는 그래픽 디자이너가 에이랜드가 거래하는 거래처와 협업하여 상품을 만드는 프로젝트입니다. 저는 의상 디자이너가 아니기 때문에 옷 패턴을 가져와서 무언가를 만들기보다 인체와 관련이 있고 재미있는 소재가 없을까를 고민했습니다. 그러다가 어느 순간 사람 키에 따라 길이가 달라지는 머플러를 떠올렸습니다. 키가 작은 사람은 길게 착용하고 키가 큰 사람은 짧게 착용하는 상상을 했어요. 혹은 그 반대일 수도 있고요. 그래서 60×25cm 머플러 유닛을 만들어서 양쪽에 지퍼를 달았습니다. 유닛을 계속 연결하면 120cm가 될 수 있고 180cm가 될 수 있는 방식입니다. 만들고 사용해보면서 발견한 것은 스스로 착용 방법을 개발할 수 있었다는 점입니다. 그때 지퍼가 재미있는 소재라고 생각했어요. 그래서 이번 전시에서 포스트디셈버와 만든 의상의 뒷면에 25cm 길이의 지퍼를 달았습니다. 이 작업복에서 제시된 특별한 기능은 없지만, 또 다른 사용법을 제시할 가능성에 매력을 느낍니다.

[p88]
도록을 위해
공간을 추상적으로
촬영한 전시 전경.

유현선 공간에도 관심이 많으신데 작업하신 것 중에
제일 기억에 남는 공간이 있으신지요?

[p89]
전시 전경.

대화

김영나 공간에 대해 처음 고민해본 순간은 갤러리 팩토리에서 했던 《발견된 개요》 전시였습니다. 그때 해당 공간에서 이미 주어진 구조를 살펴보는 방식을 처음 시도했습니다. 제가 설정한 그리드에 맞추어 작업을 배치했는데, 그리드를 팩토리의 기둥과 보 치수를 측정해서 만들었습니다. 또, 이 전시에서 처음 선보였던 〈자화상〉 연작은 사진가와 협업을 통해 사물이 배열된 공간을 평면에 담아 다시 공간에 설치했던 작업입니다. 이 때 평면과 공간의 유기적인 연결지점이 무척 흥미로웠습니다. 그리고 〈일시적인 작업실, 53〉도 저에게 의미가 있는 작업입니다. 유동적인 구조의 전시도 처음이었고 공간에서 일어나는 활동과 사건이 중요한 작업도 처음이었습니다. 그래서 공간은 단순한 물리적인 구조 이상이라고 생각하게 되었습니다. 마지막으로 에이랜드 매장 작업은 실제로 기능하는 공간에 대해서 생각하게 된 기회였어요. 저에게 공간 디자인 작업을 의뢰하는 클라이언트는 보통 기능이 강조된 상업 공간을 요청하기보다는 제 방식대로 해석하는 공간을 원해서 꽤 많은 자유도가 주어집니다. 그래도 매장 공간의 특성상 옷을 보관하고 상품을 디스플레이하고 손님들의 동선을 유도하는 것이 중요한 요소이기 때문에 공간을 설계할 때 이를 함께 고려해야 합니다. 어려운 부분이 있지만 오히려 그런 제약이 도움이 되었어요. 세 가지 모두 각각 다른 경험이었고 기억에 남습니다.

〈물체그리기〉 전경.

기록

'기록'은 학술적으로 의미 있는 대상에 대한 기록이다. 누군가의 발표나 기사, 행사 등을 기록한다.
내용과 형식에 특별한 제약은 없으나, 기록 대상에 대한 목적의식이 분명해야 한다.
『글짜씨』 18에서는 한국타이포그라피학회 10주년을 맞아 지난 10년간의 활동을 돌아보고 정리했다.

한국타이포그라피학회 10년의 기록

한국타이포그라피학회
편집부

학회 소개

한국타이포그라피학회는 시각 문화의 성장을 위해 2008년 9월 17일에 발기하여 2009년에 창립되었다. 글자와 타이포그래피를 바탕으로 한 다양한 활동을 목표로 한다. 각자의 분야에서 활동하고 있는 회원들과의 협력을 통해 매년 학술대회를 개최하고, 작품을 전시하며, 학술논문집『글짜씨』를 발간하고 있다. 2019년에는 활동을 쉬고 재정비하여 2020년 실질적인 창립 10주년을 맞이하였다.

창립선언

시각문화는.글자로.촉발되었고.
……………..활자를.통해.폭발적이.되었습니다...
작은.것이.아름답습니다..

작고.단순하고.소박하게.학회를.시작하려.합니다..

글자/타이포그라피/는.사맛.멋짓의.뿌리입니다..
그.멋.배움의.바탕입니다..

글자/타이포그라피/의.터전에.시각문화가.자랍니다..

우리.글짜멋짓(타이포그라피)의.가운데.한글이.있습니다..
한글은.우리.제다움의.등뼈입니다..

작게..조용히..깊이.
제대로.선.
애지음뜻이.깃든.모임이.우리.바람입니다..

ㅇㅅㅅ.모심.
네즈믄.세온.마흔.두.해.
2008.9.17

회원 구성

한국타이포그라피학회는 교수, 학생, 직장인, 프리랜서 등 다양한 소속의 회원 294명으로 구성된다. 2020년 7월 30일 기준, 직장인이 36%, 교수가 23%로 가장 많다. 웹사이트 또는 이메일을 통해 입회 신청을 할 수 있으며 기존 정회원 2인의 추천이 필요하고, 이사회의 승인을 거쳐 학회의 회원이 될 수 있다. 회원의 종류는 정회원, 명예회원, 특별회원이 있다.

교수	강사	학생	직장인	프리랜서	기타
67명	14명	16명	105명	21명	71명
23%	5%	5%	36%	7%	24%

역대 임원

한국타이포그라피학회 임원은 회장, 부회장,
사무총장, 이사, 감사로 구성된다. 회장은 총회의
선거를 통해 선출하고 부회장과 사무총장, 이사는
회장이 임명한다. 임원의 임기는 2년이며 회장은
중임할 수 없다. 임원은 각자의 역할에 따라 학회
운영에 필요한 업무를 수행하고 정기적으로 열리는
이사회와 총회에 참가한다. 다음은 2020년 임원
구성원을 기준으로 각 역할에 대한 설명이다.

회장: 학회의 대표로서 주요 활동의 방향을 설정하고 위상 확립을
　　　위한 대외 소통을 담당한다.
부회장: 회장과 함께 주요 활동의 방향을 설정하고 제도를 정비하며
　　　각 분과의 운영에 협조한다.
정책기획이사: 학회 사업의 기획과 운영을 담당한다.
대외협력이사: 학회와 현업의 연계를 담당한다.
학술출판이사: 학회의 교육, 연구, 출판 활동을 담당한다.
대외전시이사: 학회의 전시 활동을 담당한다.
국제교류이사: 학회의 국제 교류 활동을 담당한다.
논문편집위원장: 학술지의 논고 규정을 관리하고 학술지의
　　　등재 후보지 승격을 준비한다.
논문편집위원: 투고 논고를 편집 규정에 따라 운영한다.
윤리위원장: 학회와 회원의 연구 활동 상 윤리 행위 규정 및
　　　문제에 관한 대응을 담당한다.
윤리위원: 학회와 회원의 연구 활동 상 위법 행위 감시 및
　　　관련 문제에 대응한다.
한글특별위원회 위원장: 학회 내 한글 연구 관련 활동을 실행한다.
용어사전특별위원회 위원장: 타이포그래피 용어 사전 편찬과
　　　개정 활동을 계획하고 담당한다.
타이포잔치특별위원회 위원장: 타이포잔치의 기획과 운영을 자문한다.
타이포잔치 총감독: 타이포잔치의 기획 및 운영을 전반적으로 책임진다.
다양성특별위원회 위원장: 학회의 활동상 다양성을 유지할 수
　　　있도록 관련 문제에 대응한다.
감사: 학회 활동 평가와 운영 회계를 감사한다.
사무총장: 학회 일정 전반을 운영하고 예산 및 지출을 주관한다.
사무국장: 회원 활동(가입, 탈퇴)을 관리하고 이사회와 사무국 간
　　　소통을 담당한다.
홍보국장: 홍보채널 운영을 통해 학회의 대외 소통을 도모한다.
출판국장: 『글짜씨』의 편집과 디자인을 담당한다.

1대 임원 (2008–2010)

회장	안상수	홍익대학교
부회장	원유홍	상명대학교
대외협력이사	한재준	서울여자대학교
정책기획이사	송성재	호서대학교
학술출판이사	김지현	한성대학교
대외전시이사	김경선	서울대학교
국제교류이사	최성민	서울시립대학교
감사	류명식	홍익대학교
	서기흔	경원대학교
사무총장	민병걸	서울여자대학교
사무국장	김나연	
사무총장	이용제	계원예술대학교

2대 임원 (2011–2012)

회장	원유홍	상명대학교
부회장	송성재	호서대학교
대외협력이사	한재준	서울여자대학교
정책기획이사	김주성	명지전문대학
학술출판이사	김지현	한성대학교
대외전시이사	이병주	한세대학교
국제교류이사	한창호	건국대학교
감사	류명식	홍익대학교
	정계문	단국대학교
사무총장	서승연	유한대학교
출판국장	김병조	
사무국장	김지원	

3대 임원 (2013–2014)

회장	김지현	한성대학교
정책기획이사	유정미	대전대학교
	임진욱	㈜타입포디자인그룹
대외협력이사	조현	에스오프로젝트
	이재민	스튜디오 에프엔티
학술출판이사	크리스로	홍익대학교
대외전시이사	안병학	울산대학교
	박연주	헤적프레스
국제교류이사	김현미	SADI
	성재혁	국민대학교
해외위원(미국)	김진숙	잭슨빌주립대학교
해외위원(일본)	이지은	홋카이도교육대학
해외위원(영국)	민본	레딩대학교
한글특별위원회 위원장	한재준	서울여자대학교
용어사전특별위원회 위원장	원유홍	상명대학교
타이포잔치특별위원회 위원장	이병주	한세대학교
타이포잔치특별위원회 총감독	최성민	서울시립대학교
감사	정병규	정병규학교
	류명식	홍익대학교
사무국장	함성아	한성대학교
출판국장	김병조	

4대 임원 (2015 – 2016)

회장	한재준	서울여자대학교
부회장/편집위원	이병주	한세대학교
정책기획이사	김두섭	눈디자인
	민병걸	서울여자대학교
대외협력이사	안병학	홍익대학교
	이재민	스튜디오 에프엔티
학술출판이사	크리스로	홍익대학교
	박수진	이화여자대학교
대외전시이사	이지원	국민대학교
	김나무	한경대학교
국제교류이사	김경균	한국예술종합학교
	김현미	SADI
한글특별위원회 위원장	이용제	계원예술대학교
용어사전특별위원회 위원장	원유홍	상명대학교
타이포잔치특별위원회 위원장/	최성민	서울시립대학교
윤리위원		
타이포잔치특별위원회 총감독	김경선	서울대학교
감사	송성재	호서대학교
	홍성택	홍디자인
사무총장	선우현승	에이앤에이컴퍼니
사무국장	김한솔	서울여자대학교
홍보국장	한아람	홍익대학교
출판국장	이재영	6699press
논문편집위원장	김지현	한성대학교
편집위원	홍동식	부경대학교
	유정미	대전대학교
	이지은	홋카이도교육대학
윤리위원장	김주성	명지전문대학교

5대 임원 (2017 – 2018)

회장	유정미	대전대학교
부회장/편집위원	조현	한국예술종합학교
정책기획이사	이충호	울산대학교
교육연구이사	정재완	영남대학교
	김영나	테이블유니온
대외전시이사	심대기	대기앤준
	전재운	홍익대학교
국제교류이사	최슬기	계원예술대학교
	이재원	서울여자대학교
한글특별위원회 위원장	박재홍	경희대학교
용어사전특별위원회 위원장	원유홍	상명대학교
타이포잔치특별위원회 위원장/	김경선	서울대학교
윤리위원		
타이포잔치특별위원회 총감독	안병학	홍익대학교
감사	송성재	호서대학교
	홍성택	홍디자인
사무총장	이원재	단국대학교
사무국장	강영현	
	정영훈	
홍보국장	강승연	GIGIC TMC
논문편집위원장	김동빈	동덕여자대학교
윤리위원장	김주성	명지전문대학

6대 임원 (2020 – 2021)

회장	김경선	서울대학교
부회장	김현미	SADI
	석재원	홍익대학교
정책기획이사	문장현	제너럴그래픽스
	최문경	파주타이포그라피배곳
국제교류이사	박경식	프리랜서
	채병록	CBR Graphic
대외협력이사	박영하	스타벅스 코리아
	박이랑	현대백화점
대외전시이사	신해옥	Shin Shin
	홍은주	홍은주 김형재
학술출판이사	민본	홍익대학교
	심우진	㈜산돌
논문편집위원장/윤리위원장	이병학	한경대학교
논문편집위원	정희숙	서울대학교
	하주현	한경대학교
한글특별위원회 위원장	구자은	프리랜서
용어사전특별위원회 위원장	서승연	상명대학교
타이포잔치특별위원회 위원장	박우혁	서울과학기술대학교
다양성특별위원회 위원장	이기섭	땡스북스
감사	민병걸	서울여자대학교
	임진욱	㈜타입포디자인그룹
사무총장	문해원	서울대학교
사무국장	김수은	서울대학교
	정영신	서울대학교
홍보국장	남영욱	서울대학교
	윤충근	프리랜서
출판국장	유현선	워크룸

학술대회

한국타이포그라피학회는 매년 여름과 겨울에 한 번씩 총 2회의 학술대회를 개최한다. 학회의 가장 본질적인 활동으로, 타이포그래피 분야의 연구 성과나 사례를 학회 구성원과 학생, 신청자를 대상으로 발표하는 자리이다. 학술대회는 학문과 산업을 폭넓게 다루며 각 분야 간 교류를 활발하게 한다. 학술대회의 내용은 초청 강연과 논고 또는 연구 발표, 작업 소개로 구성되고, 발표 내용 일부는 『글짜씨』의 원고가 된다. 기본적으로는 대면으로 발표하는 것이 원칙이지만, 2020년에는 코로나19로 대면과 유튜브 라이브를 통한 비대면도 병행되었다.

한국타이포그라피학회 창립총회

2008. 9. 12. 16:00
상상마당 5층 대강의실
포스터 디자인: 민병걸

한국타이포그라피학회 학술대회 + 총회

2009. 12. 18. 14:00 – 18:00
상상마당 5층 대강의실
포스터 디자인: 이용제

1. 유지원: 라틴 알파벳의 이탤릭체와 한글의 흘림체 비교연구
2. 김나연: 활자의 형태변별요소 조합에 따른 활자추출에 관한 연구
3. 구자은: 인쇄물에서의 친환경 타이포그래피
4. 이용제: 잉크를 아끼는 글자
5. 한재준: 지속가능한 한글의 가치
6. 안상수: 회의, 몽타주, 그리고 생명평화무늬

한국타이포그라피학회
학술대회 + 총회

2010. 6. 18. 14:00 – 18:00
상상마당 5층 대강의실
포스터 디자인: 김병조

한국타이포그라피학회
학술대회 + 총회

2010. 12. 17. 14:00 – 18:00
홍익대학교 E103호
포스터 디자인: 심우진

1. 임성신: 이상 날다
2. 권은선: 서울서체
3. 이용제: 타이포그라피에서
'글자, 활자, 글씨' 쓰임새 제안
4. 최정화: 굴림체의 선호도와
그 원인 분석
5. 강고니: 타이포그라피
관점에서 본 노면안전표지
개선에 관한 연구
6. 선우현승: 이상한 책—
구조적 해석

한국타이포그라피학회
학술대회 + 임시총회

2011. 6. 18. 14:00 – 18:00
명지전문대학 예체능관
지하 1층 뮤즈홀
포스터 디자인: 이희영

1. 민본: 흑백균형을 통한
문자 연구 작업
2. 이용제: 한글타이포그래피
교육의 공유와 연대 제안
3. 김병조: 타이포그래피의 정의
4. 구본영: 본문용 한글서체의
구조와 인지요인 상관성 연구
5. 유지원: 라이프치히 서체와
서체수업 100년
6. 이영미: 기업전용서체 인지도
및 선호도 조사

한국타이포그라피학회
학술대회 + 정기총회

2011. 12. 17. 14:00 – 18:00
한성대학교 미래관 지하 1층

1. 홍윤표: 훈민정음 제자원리와
그 과학성
2. 구본영: 본문용 한글서체의
구조와 인지요인 상관성 연구
3. 김병조: 타이포그래피 교육
4. 이용제: 문장방향에 따른
한글꼴의 변화
5. 심우진: 한글타이포그래피
문장 부호 표준 제안

한국타이포그라피학회
여름학술대회 + 임시총회

2012. 6. 16. 14:00 – 18:00
건국대학교 학생회관 중강당
포스터 디자인: 서진수

1. 김성규: 한글과 레오나르도
다빈치
2. 박지나: 기능주의 담론으로
살펴본 모던타이포그래피의 역사
1890 – 1950
3. 구슬기: 한글꼴과 표의성
4. 김영호: 글과 그림의 상호관계에
따른 커뮤니케이션의 변화
5. 노은유: 최정호 한글꼴의 계보

한국타이포그라피학회
겨울학술대회 + 정기총회

2012. 12. 15. 14:00 – 18:00
명지전문대학 예체능관
지하 1층 뮤즈홀

1. 김성규: 훈민정음을 죽인
한글의 죽살이
2. 유지원: 2012 ATypI 리포트

한국타이포그라피학회
여름 학술대회

2013. 6. 15. 14:00 – 16:30
한성대학교 미래관 지하 1층

1. 유지원: 서구 근대, 동아시아,
이슬람 공간과 컴포지션
2. 이용제: 한글 유니코드 내
문장부호와 약물의 표준화 연구

한국타이포그라피학회
2013년 겨울 학술대회

2013. 12. 14. 14:00 – 17:00
국민대학교 본부관 학술회의장
포스터 디자인: 김병조

1. 박현수: 한국 근대시의 조건과
타이포그래피적 상상력
2. 정영훈: 한글 폰트에서 강조
및 인용을 표시하기 위한
글자체 디자인
3. 이병학: 인쇄가의 꽃,
플러런과 아라베스크의 역사
4. 김지현, 김병조: 새로운
『글짜씨』

● 한국타이포그라
피학회 2013년 겨울 학술대회 ● 2013년 12
월 14일 14:00–18:10 ● 연구 발표 \ 국민대학
교 본부관 학술회의장 ○ 14:10–15:10 박현
수: 한국 근대시의 조건과 타이포그래피적 상
상력 ○ 15:30–16:00 정영훈: 한글 폰트에서
강조 및 인용을 표시하기 위한 글자체 디자인
○ 16:00–16:30 이병학: 인쇄가의 꽃–플러런
에 대하여 ○ 16:30–16:50 김지현 김병조: «
글짜씨» 8호 ● 총회 17:00–17:30 ● 기획전 \
국민대학교 조형관 1층 조형갤러리 ○ 개전식
: 17:40–18:10(12월 14–22일 전시) ○ 참여
작가: 김나영 고선 김재민 김창석 안병학 박연
주 민병걸 이지원 김지현 김병조 박수진 정영
훈 구본명 선우현승 허민재 구슬기 김지원 서
승연 김도수 서진수 김현경 이재민 한재준 민
구홍 김동신 김진숙 함성아 황준필 이행주 정
재완 + 전가경 최기웅 김진 크리스로 성재혁 김
선화 박우혁 박지나 ○ 기획: 안병학 박연주 ●

한국타이포그라피학회
2014년 여름 학술대회

2014. 6. 13. 14:00–19:00
부산 부경대학교
대연캠퍼스 장보고관
포스터 디자인: 김병조

1. 남송우: 한국 시인들의 자필 시
작품에 나타난 한글 글꼴의 양상
2. 정재완: 한글 레터링 디자인의
기본 구조
3. 안상수: 타이포그라피
학교 디자인
4. 홍동식: 글꼴을 보다 부산을 읽다

한국타이포그라피학회
학술대회 11

2014. 12. 12. 14:00–18:00
한성대학교 미래관 지하 1층
포스터 디자인: 김병조

1. 석금호, 장수영: 한글 폰트가
나아가야 할 방향—본고딕
사례를 중심으로
2. 박경식: 얀 치홀트와 막스 빌의
1946년 논쟁
3. 이예주: 얀 치홀트와
라이프치히 독일 국립 도서관
4. 노은유: 한글 디자이너 최정호
5. 이재민, 박해천: 타이포잔치
2015 프리비엔날레
6. 김병조: 『글짜씨 10: 얀 치홀트』

한국타이포그라피학회
2015년 학술대회

2015. 6. 27. 14:00–17:30
성신여자대학교 돈암
수정캠퍼스 수정관 415호
포스터 디자인: 심예리

1. 김민수: 한국 타이포그래피의
현안들
2. 김초롱: 태국 폰트에 대한
오해와 진실
3. 박재홍: 가로짜기 글줄
기준선을 적용한 한글 글자틀
구조 연구
4. 임경용, 신해옥, 신동혁:
타이포잔치 프리비엔날레 리뷰

한국타이포그라피학회
학술대회 13

2015. 12. 11. 13:30–18:00
서울여자대학교 대학로 캠퍼스
아름관 501호
포스터 디자인: 이재영

1. 최범: 한글의 풍경
2. 전가경: 『볼만한 꼴불견』을 통해
본 1970년대 한국의 언어 경관
3. 노민지: KS코드 완성형 한글의
추가 글자 제안
4. 권준호: 발언으로서의
타이포그래피

한국타이포그라피학회
학술대회 14

2016. 6. 25. 13:00 – 16:50
이화여자대학교 ECC B146호
포스터 디자인: 이재영

1. 임진욱: 정부 상징 글자체
개발 과정
2. 최재영: Metafont
프로그래밍을 이용한 한글/한자
생성에 관한 연구
3. 김병조: 다국어 타이포그래피의
기술적 문제
4. 배민기: 여러가지 방법을 통해
퍼뜨리기—비스듬한 퍼블리싱
5. 김린: 국제 학술지로서의
글짜씨 논문 작성 규정 개정 방안
6. 이지원: 프로그래밍을
기반으로 한 타이포그래피 교육
과정 개발

한국타이포그라피학회
학술대회 15

2016. 12. 17. 13:00 – 17:00
서울여자대학교 대학로 캠퍼스
아름관 501호
포스터 디자인: 이재영

1. 이용제: 한글 닿자의
시각적 공간이 조합 규칙 설계에
미치는 영향
2. 김현미: 해외 활자 주조소의
옛글자 복원
3. 정하린: AG 초특태고딕
제작 과정
4. 김영나: 커먼센터 브랜딩
5. 제임스 채: Contradiction
as Strategy
6. 안병학: 타이포잔치
프리비엔날레
7. 김지현: 해외 타이포그래피
관련 단체의 현황과 활동 조사
8. 민병걸: 타이포그래피가
아름다운 책

한국타이포그라피학회
학술대회 16

2017. 6. 17. 13:00 – 18:00
서울여자대학교 대학로 캠퍼스
아름관 501호
포스터 디자인: 이재영

1. 강현주: 한국 그래픽 디자이너
제3세대의 전형—안상수
2. 전가경: 안상수의 잡지 아트
디렉팅: 『꾸밈』, 『마당』 그리고 『멋』
3. 민구홍: 심심풀이
4. 박하얀: 날으는 배곳, 파티
5. 김형재: 계획과 실행의
플랫폼으로서 기능적 공간의
아이덴티티를 재맥락화하는
문서의 타이포그래피: 시청각의
시각 정책
6. 배민기: 스크린 매체와
인쇄 매체의 관계 설정을 전제한
그래픽 디자인 교육 과정의
결과와 확장 가능성: 작업 소개
7. 박연주: 터치 타입
8. 조현열: 몸 사전
9. 김나무: 몸과 타이포그래피:
붉게 쓰기

한국타이포그라피학회
학술대회 17

2017. 12. 16. 13:00 – 17:30
한국예술종합학교
대학로 캠퍼스 1층 강당
포스터 디자인: 이재영

1. 유지원: 폰트 디자인 교육
2. 최문경:
파주타이포그라피학교의 글자
디자인 수업과 관련 타이포그래피
커리큘럼
3. 양장점: 펜바탕체
4. 강영화, 김동휘: 스포카
한 산스—사용자 입장에서
타입페이스 커스터마이징
5. 노민지: 아리따 흑체를 통해 본
중문 글자체 개발 과정

**한국타이포그라피학회
학술대회 18**

2018. 6. 16. 13:00 – 17:30
이화여자대학교 ECC B146

1. 김랜저: 페미니스트와
퀴어들의 텀블벅 프로젝트
2. 우유니게: 유럽에서 만난
페미니즘의 도구들
3. 이도진: 모든 젠더를 위한
시각 언어
4. 박철희: 햇빛서점과 녹색 포스터
5. 이경민: LGBTAIQ+ 가시화와
연대하기
6. 월간 『디자인』: 월간 『디자인』
의 여성주의 정책
7. 『글짜씨』 출판/학술팀:
젠더 운동과 동시대 그래픽
디자인의 문법―『글짜씨』17의
아카이브 라운드테이블

**한국타이포그라피학회
학술대회 19**

2020. 7. 18. 14:00 – 18:00
서울대학교 미술대학
74동 2층 오디토리엄
포스터 디자인: 윤충근

1. 민본: Fonts at Apple
2. 이건하: 김기림 시의 시각화 실험
3. 강연민: 국립한글박물관의
글꼴 연구 현황과 과제
4. 박이랑: 현대백화점 브랜딩
5. 채희준: 1인 한글디자인
프로세스
6. 신해옥: 월간디자인 리디자인
7. 한재준: 광화문 현판과
훈민정음 꼴

전시

한국타이포그라피학회는 2010년 이상 탄생 100주년 기념전《시:시》를 시작으로 1년에 1회 또는 2회의 전시를 기획한다. 대외전시이사의 주도로 주제를 선정하고 작가를 모집한다. 전시의 주제는 매번 다르거나 자유 주제이기도 하지만 타이포그래피에 실험적으로 접근한다는 점에서 목적은 같다. 1회 전시에는 45명의 작가가 참여했고, 12회 전시에는 83명의 작가가 참여하여 가장 많은 작품을 선보였다. 12회와 13회는 해외작가가 각각 10명, 6명 참가하여 한국타이포그라피학회 정기 회원전에 국제적인 다양성을 더했다.

**2010 한국타이포그라피학회
첫번째 전시
이상 탄생 100주년 기념전
《시:시》**

2010. 2. 1. – 2. 10.
한국디자인문화재단 갤러리D+
포스터 디자인: 김경선

한국타이포그라피학회는 2010년, 한국최초의 시각 시인 이상 탄생 100주년을 맞이하여 학회 회원들의 시각시 展을 열었다. '활자성'을 시의 표현에 적극적으로 활용한 시인 이상을 기리며, 회원 각자가 짓거나 고른 시를 타이포그래피 언어로 시각화한 작업들을 전시했다.

강유선, 강은선, 고선, 구자은, 권은선, 김경선, 김동신, 김두섭, 김묘수, 김상도, 김은경, 김장우, 김종건, 김주성, 김지원, 김지현, 김현경, 김현미, 노은유, 류명식, 박금준, 박찬신, 서승연, 송성재, 심우진, 안병학, 안상수, 여태명, 오진경, 유정미, 유정숙, 유지원, 이기준, 이병주, 이영미, 이용제, 이재원, 이진구, 임진욱, 장성환, 정재완, 조현, 최성민, 최슬기, 한재준

**2010 한국타이포그라피학회
두번째 전시
제6회 서울와우북페스티벌 탄생
100주년 초대기획전
《이상한 책》**

2010. 9. 7. – 9. 12.
서교예술실험센터
포스터 디자인: 신명섭

시인 이상을 주제로, 그의 시에 대해 동시대인들이 느끼는 교감과 다양한 반응, 해석을 책의 형식으로 풀어보는 전시이다.

구자은, 김장우, 김주성, 김지현, 김현경, 노승관, 노은유, 류명식, 민병걸, 박금준, 변사범＋박시형, 서승연, 선우현승, 성재혁, 송명민, 송성재, 송호성, 신명섭, 안마노, 안상수, 원유홍, 이기준, 이병주, 이선영, 이용제, 이재민＋길우경, 이재원, 이충호, 임성신, 정재완, 조현열, 최성민＋최슬기, 최아영, 한재준

2011년 한국타이포그라피학회
정기회원전
《독설》

2011. 4. 9. – 4. 22.
두성 인더페이퍼 갤러리
포스터 디자인: 신명섭

독설은 강한 메시지를 강한
어조로 말하는 것이다. 독설은
듣는 이에게 마음의 상처를
남기기도 하지만, 자각을
일으키기도 한다.
《독설》은 타이포그래피적 상상을
통해 사회문화 현상에 대한
디자이너의 주체적이고 창조적인
반응을 보여주었다.

권은선, 김경균, 김병조, 김주성,
김지원, 김지현, 김창식, 김현경,
김현경, 김희용, 박민성, 서기훈,
서승연, 서진수, 선우현승, 송명민,
송성재, 신명섭, 원유홍, 이기준,
이병옥, 이병주, 이영미, 이희영,
장성환, 전가경, 정재완, 정진열,
한윤경

2011년 한국타이포그라피학회
정기회원전
제7회 서울와우북페스티벌의
초대기획전
《만화 타이포그래피》

2011. 9. 28. – 10. 3.
서교예술실험센터
포스터 디자인: 성재혁

만화 속에 보여지는 의태어,
의성어, 말풍선 등의
타이포그래피 요소를 디자이너의
시각으로 재해석하여 만화
타이포그래피의 새로운 가능성을
실험했다.

강나나, 구자은, 김나연, 김동환,
김미현, 김병조, 김유진, 김지원,
김지현, 김현경, 박연미, 서승연,
서진수, 선우현승, 성재혁, 송명민,
원유홍, 이병주, 이영미, 이용제,
이지원, 이희영, 정진열, 토어
테라시, 한윤경

2012 한국타이포그라피학회
다섯 번째 전시
《타이포그래피 실험전》

2012. 12. 15. – 12. 21.
명지전문대학 뮤즈홀

이번 전시는 타이포그래피적
상상을 통해 디자이너의
주체적이고 창조적인 작품을
보여주는 실험의 장으로서
그 형식과 의미에 있어서
회원들의 창의성과 학회의
정체성을 보여주었다.

한국타이포그라피학회
여섯 번째 전시
《타이포그래피 실험전》

2013. 6. 29. – 7. 11.
두성 인더페이퍼 갤러리
갤러리 사각형
포스터 디자인: 박연주

타이포그래피의 본질적
문제에 대한 탐구를 비롯,
타이포그래피가 주변 영역과
만나는 경계를 실험하는
전시이다.

고선, 구슬기, 권준호 + 김경철 +
김어진, 길우경 + 이재민,
김경선, 김병조, 김성계, 김성현,
김윤태, 김장우, 김주성, 김지현,
김진숙, 김현미, 민구홍, 민병걸,
박금준, 박민성, 박연주, 박우혁,
서경원, 서기훈, 서진수, 석재원,
선우현승, 성재혁, 성지연, 슬기와
민, 신동윤 + 박선하, 안병학,
안삼열, 원유홍, 유정숙, 이병주,
이재원, 이지원, 이충호, 임진욱,
전가경, 정재완, 정진열, 조성원,
조현, 조현열, 크리스 로, 한재준,
허민재, 홍동식, 황준필

**2013년 한국타이포그라피학회
일곱 번째 전시**

2013. 12. 14. – 12. 22.
국민대학교 조형갤러리

이번 기획전은 최소한의 조건
위에서 텍스트와 의미의 관계를
탐험했다. 35명의 신청자를
선착순으로 받고 학회에서
35개의 단어로 된 문장의
각 단어를 작가들에게 무작위로
배포했다. 작가는 주어진 단어로
자유롭게 작업하고 이렇게 제작된
작품은 문장 순서대로 전시장에
설치되었다.

한국타이포그라피학회 전시 9

2014. 6. 10. – 6. 14.
부산 부경대학교
대연캠퍼스 장보고관
포스터 디자인: 김병조

아홉 번째 학회 전시는 자유
전시로서 부산 부경대학교에서
여름 학술대회와 함께 열렸다.

고선, 고인숙, 구슬기, 권보람,
김경연, 김두섭, 김병조, 김선화,
김성재, 김성현, 김장우, 김지현,
김지호, 김현미, 김희용, 류진,
문혜정, 박경식, 박소정, 박우혁,
박창훈, 서경원, 서수연, 서승연,
선우현승, 성재혁, 신덕호,
신믿음 + 이재욱, 안병학,
안호은, 양필석, 이미진, 이영미,
이재민, 이주영, 이지원, 이현송,
정영훈, 정유경, 정이숙, 정재완,
정진열, 조현, 채병록, 채혜선,
최가영, 크리스 로, 한재준,
허민재 + 박소현, 홍동식

**한국타이포그라피학회
열 번째 전시
《교차(交叉)》**

2015. 6. 27. – 7. 4.
성신여자대학교 돈암수정캠퍼스
난향관 파이룸

'교차'라는 주제를 바탕으로
다국어 타이포그래피에 대한
자유로운 해석을 다양한 매체로
보여주었다.

김경균, 김나무, 김두섭, 김민수,
김병조, 김보은, 김성현, 김수정,
김윤신+이원재, 김장우, 김주성,
김택현, 김현미, 김형민, 남수인,
남영욱, 남주현, 민병걸, 박영하,
박유선, 백지선, 서경원, 서진수 +
김지원, 석재원, 선우현승,
성재혁, 손범영, 손영은, 송성재,
신동윤, 신믿음 + 이재욱,
심대기 + 심효준 + 키이스 웡,
안병학, 안효진, 어민선, 원유홍,
이병주, 이영미, 이윤정, 이지원,
이진우, 이현송, 임진욱, 장혜진,
장효진, 정대인, 정영훈, 정진열,
채병록, 크리스 로, 하로, 한재준,
허민재 + 이성균, 홍동식,
황준필,강구룡

**한국타이포그라피학회
열한 번째 전시
《솜씨》**

2016. 8. 19. – 9. 8.
두성 인더페이퍼 갤러리
포스터 디자인: 권수진,
이혜윤, 한승희

열한 번째 전시는 학술대회의
화두인 '타이포그래피와 기술'과
연관해 '솜씨'라는 주제를 다루고,
인쇄 매체뿐 아니라 비디오,
인터랙티브 작품으로 보여주었다.

줄은 무한한 점으로
구성되어 있다.
그리고 면은 무한한
줄로 되어 있고, 권(卷)은
무한한 면으로 되어 있다.
그리고 전집(全集)은
무한한 권으로 되어 있다.
아니 단호히 말하건대
이건 아니다.
내 이야기를 시작하는
가장 좋은 방법은 좀더
기하학적이 되어야 한다.

**한국타이포그라피학회
정기 회원전 tE12**

2017. 7. 21. - 8. 4.
두성 인더페이퍼 갤러리
포스터 디자인: 이재영

강은미 + 김기창 + 이리 오플라텍,
강주현, 권기홍, 권혜은, 김경원,
김경주, 김기창, 김나무, 김나영,
김민수, 김민주, 김민지 + 조혜은,
김영나, 김주성, 김지원, 김한솔,
남영욱, 마사키 미와 + 잉 통 탄,
문장현, 문정주, 박우혁, 박지훈,
박찬욱, 발렌틴 고에탈스 +
토마스 로텐스, 서진솔, 서진수,
석재원, 선우현승, 선주연, 성재혁,
송민주, 슬기와 민, 신동윤,
심대기, 심아연, 심효준, 아리안
포타피에프, 안병학, 안진영,
안효진, 양정은, 양한슬,
어민선, 오디너리피플, 유예원,
유정미, 유화란, 이윤성, 이재원,
이지수, 이철웅, 이충호,
일상의 실천, 임학래, 전재운 +
현 에이비, 정영훈, 정재완,
제갈선 + 유효진 + 스미스 라이언,
제임스 채, 조현, 채병록, 최현호 +
지석민, 쿠스 브린, 크리스 로, 팀
써스데이, 한재준, 허민재, 홍동식,
황규선, 황준필

**한국타이포그라피학회
정기 회원전 tE13
《사진과 타이포그래피》**

2018. 5. 23. - 6. 5.
두성 인더페이퍼 갤러리
포스터 디자인: 대기앤준, 임수연

강우진, 강진주, 구자은, 권기홍,
김경주, 김나무, 김린, 김민재,
김상현, 김수정, 김한솔, 노성일,
더 로디나, 문장현, 박영하,
박우혁, 박지연, 발렌티진 고탈스,
배민기, 배소현, 서경원, 석재원,
선우현승, 성재혁, 슬기와 민,
신동윤, 신수항, 신재호, 심대기,
심세연, 심효준, 안병학, 양장점,
양정은, 어민선, 에릭 브란트,
유정미, 유화란, 윤우진, 이규락,
이원재, 이재경, 이재원, 이재진,
이충호, 일상의 실천, 임성신,
임수경, 임수연, 전재운, 정영훈,
정재완 + 전가경, 정진열,
제갈선 + 스미스 라이언, 제이 림,
제임스 채, 조혜연, 이리 오플라텍,
지한신, 차상민, 채병록, 최석환 +
조현, 츠바키, 크리스 로, 토마스
로텐스, 페이퍼프레스, 한기현,
한만오, 한재준, 허민재 + 안진영,
홍동식, 황준필, 강승연 + 이강현

글짜씨

『글짜씨』는 한국타이포그라피학회에서 2009년
12월부터 발간한 타이포그래피 저널이다.
글자와 타이포그래피 연구라는 학회의 목적이
학술대회에서는 발표로 구현된다면, 『글짜씨』에서는
책으로 구현된다. 『글짜씨』는 학회지로서
타이포그래피 연구 관련 논문을 담고 있고,
『글짜씨』 8(5권 2호)부터는 선정한 주제와 관련된
다양한 글과 기획을 추가하여 잡지로서의 성격도
가지게 되었다. 그리고 해외 연구자들과의 학문적
논의와 교류를 위해 『글짜씨』 8부터 한국어와
영어를 병기했다. 학회 회원에게 보내는 책과
안그라픽스에서 발간하는 책 두 가지 유형이 있으며
각각 학회와 안그라픽스 로고가 들어가 있다.

글짜씨 창간호 (1권 1호)

2009. 12. 31.
145 × 210 mm, 192쪽
발행인: 안상수
자료정리: 구자은
디자인: 민병걸

글짜씨 1 (2권 1호)

2010. 2. 1.
148 × 200 mm, 280쪽
ISBN 978-89-7059-436-1
펴낸이: 김옥철
주간: 문지숙
편집: 정은주
디자인: 민병걸
제호 디자인: 김경선
펴낸곳: 안그라픽스

글짜씨 2 (2권 2호)

2010. 9. 1.
148 × 200 mm, 264쪽
ISBN 978-89-7059-562-7
펴낸이: 김옥철
주간: 문지숙
편집: 신혜정, 정은주
디자인: 민병걸 + 정재완
제호 디자인: 김경선(학회용 책),
민병걸(안그라픽스용 책)
펴낸곳: 안그라픽스

글짜씨 3 (3권 1호)

2011. 4. 9.
148 × 200 mm, 192쪽
ISBN 978-89-7059-576-4
펴낸이: 김옥철
주간: 문지숙
편집: 정은주
디자인: 김지원
제호 디자인: 김경선
펴낸곳: 안그라픽스

글짜씨 4 (3권 2호)

2011. 9. 28.
148 × 200 mm, 256쪽
ISBN 978-89-7059-601-3
펴낸이: 김옥철
주간: 문지숙
편집: 정은주
디자인: 김병조
제호 디자인: 김경선
펴낸곳: 안그라픽스

글짜씨 5 (4권 1호)

2012. 3. 20.
148 × 200 mm, 184쪽
ISBN 978-89-7059-626-6
펴낸이: 김옥철
주간: 문지숙
편집: 신혜정, 정은주
디자인: 김병조
제호 디자인: 김경선
사진: 박기수
펴낸곳: 안그라픽스

글짜씨 6 (4권 2호)

2012. 11. 30.
148 × 200 mm, 130쪽
ISBN 978-89-7059-658-7
펴낸이: 김옥철
주간: 문지숙
편집: 신혜정
디자인: 김병조
제호 디자인: 김경선
펴낸곳: 안그라픽스

글짜씨 7 (5권 1호)

2013. 6. 17.
148 × 200 mm, 160쪽
ISBN 978-89-7059-576-4
펴낸이: 김옥철
주간: 문지숙
기획: 한국타이포그라피학회
편집: 신혜정, 정은주, 민구홍
디자인: 성재혁, 성예슬, 한나은
제호 디자인: 김경선
펴낸곳: 안그라픽스

글짜씨 8 (5권 2호)
슈퍼텍스트 이후의 텍스트

2013. 12. 28.
170 × 240 mm, 160쪽
ISBN 978-89-7059-719-5
펴낸이: 김옥철
주간: 문지숙
기획: 한국타이포그라피학회
편집: 민구홍
사진: 박기수, 김경태, 임학현,
남기용
디자인: 김병조
펴낸곳: 안그라픽스

글짜씨 9 (6권 1호)
오너먼트

2014. 9. 24.
170 × 240 mm, 160쪽
ISBN 978-89-7059-752-2
펴낸이: 김옥철
주간: 문지숙
편집: 정은주
디자인: 김병조
사진: 박기수
펴낸곳: 안그라픽스

글짜씨 10 (6권 2호)
얀 치홀트

2015. 2. 6.
170 × 240 mm, 440쪽
ISBN 978-89-7059-785-0
펴낸이: 김옥철
주간: 문지숙
기획: 김지현, 김병조
편집: 김병조, 민구홍, 김한아
디자인: 김병조
디자인 협력: 이현송
사진: 박기수
펴낸곳: 안그라픽스

글짜씨 11 (7권 1호)
다국어 타이포그래피

2015. 6. 30.
170 × 240 mm, 276쪽
ISBN 978-89-7059-810-9
펴낸이: 김옥철
주간: 문지숙
기획: 박수진, 크리스 로, 이재영
편집: 김린, 김연임, 김한아,
민구홍, 심예리
디자인: 이재영
펴낸곳: 안그라픽스

글짜씨 12 (7권 2호)
도시와 문자

2015. 12. 31.
170 × 240 mm, 316쪽
ISBN 978-89-7059-842-0
펴낸이: 김옥철
주간: 문지숙
기획: 박수진, 크리스 로, 이재영
편집: 김린, 김한아, 민구홍
사진: 김진솔, 싸우나 스튜디오
디자인: 이재영
펴낸곳: 안그라픽스

글짜씨 13 (8권 1호)
기술과 타이포그래피

2016. 7. 15.
170 × 240 mm, 284쪽
ISBN 978-89-7059-858-1
펴낸이: 김옥철
주간: 문지숙
기획: 박수진, 이재영, 크리스 로
편집 및 교정교열: 김린, 김한아
사진: 김진솔
디자인: 이재영
펴낸곳: 안그라픽스

글짜씨 14 (8권 2호)
브랜딩과 타이포그래피

2016. 12. 31
170×240 mm, 204쪽
ISBN 978-89-7059-884-0
펴낸이: 김옥철
주간: 문지숙
기획: 박수진, 크리스 로, 이재영
편집 및 교정교열: 김린, 김소영
사진: 김진솔
디자인: 이재영
펴낸곳: 안그라픽스

글짜씨 15 (9권 1호)
안상수

2017. 10. 20
170×240 mm, 616쪽
ISBN 978-89-7059-925-0
펴낸이: 김옥철
주간: 문지숙
기획: 김형진, 박수진, 이재영
편집 및 교정교열: 김린, 박은지
사진: 김경태
디자인: 이재영
펴낸곳: 안그라픽스

글짜씨 16 (9권 2호)
타입 디자인

2018. 3. 9
170×240 mm, 444쪽
ISBN 978-89-7059-948-9
펴낸이: 김옥철
주간: 문지숙
기획: 김형진, 박수진, 이재영
편집 및 교정교열: 김린, 남수빈
사진: 김진솔, 나씽 스튜디오
디자인: 이재영
펴낸곳: 안그라픽스

글짜씨 17 (10권 1호)
젠더와 타이포그래피

2018. 12. 18
170×240 mm, 124쪽
ISBN 978-89-7059-982-3
펴낸이: 김옥철
주간: 문지숙
기획: 김린, 김형진,
박수진, 이재영
편집 및 교정교열: 남수빈
사진: 파일드
디자인: 이재영
펴낸곳: 안그라픽스

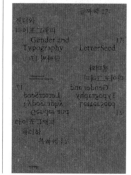

첫 번째 제호 디자인

글짜씨 1 (2권 1호)
제호 디자인: 김경선

두 번째 제호 디자인

글짜씨 2 (2권 2호)
제호 디자인: 민병걸

세 번째 제호 디자인

글짜씨 18 (10권 2호)
제호 디자인: 유현선

글짜씨 창간호 (1권 1호)
논문
1. 유지원: 라틴 알파벳의 이탤릭체와
한글의 흘림체 비교연구
2. 김나연: 활자의 형태변별요소 조합에 따른
활자추출에 관한 연구
3. 구자은: 인쇄물에서의 친환경 타이포그라피
4. 이용제: 잉크를 아끼는 글자
5. 한재준: 지속가능한 한글의 가치
대화
1. 김지현, 박해천, 안상수, 원유홍, 이용제,
송성재, 최성민: 타이포그라피 교육
2. 아르망 메비스와의 대화
서평
1. 이병주: 한글＋한글디자인＋디자이너
2. 홍성택: 북디자인 교과서

글짜씨 1 (2권 1호)
논문
1. 구자은: 인쇄물에서의 친환경 타이포그라피
2. 김나연: 활자의 형태변별요소 조합에 따른
활자추출에 관한 연구
3. 안상수: 회의, 몽타주, 생명평화무니
4. 유지원: 라틴 알파벳의 이탤릭체와
한글의 흘림체
5. 이용제: 잉크를 아끼는 글자
6. 한재준: 지속가능한 한글의 가치
대화
1. 김지현, 박해천, 안상수, 원유홍, 이용제,
송성재, 최성민: 타이포그라피 교육
2. 아르망 메비스와의 대화
서평
1. 이병주: 한글＋한글디자인＋디자이너
2. 홍성택: 북디자인 교과서

글짜씨 2 (2권 2호)
논문
1. 노은유: 일본어 음성 표기를 위한 한글
2. 쑨밍위안, 이하라 히사야스, 사토 마사루:
1910－30년대 중국인 기업에 의한
활자 제작의 융성과 원인
3. 유정미: 훈민정음에 담긴 디자인
철학의 현대성
4. 유정숙: 한글 디지털 바탕체 조형 요소의
변화와 타이포그라피 특징에 관한 연구
5. 이용제: 한글에서 문장 부호 '.'과 ','의 문제
좌담
김지원, 김지현, 송유민, 유지원, 이영미,
최문경: 국외 타이포그래피 교육
대화
1. 노름과의 대화
2. 헬무트 슈미트와의 대화
서평

1. 민병걸: 타이포그래피의 탄생
2. 김형진: 타이포그래피 투데이
이용제 / 한글공감

글짜씨 3 (3권 1호)
논문
1. 민본: 흑백 균형을 통한 문자 연구
2. 이용제: 타이포그래피에서 '글자, 활자, 글씨'
쓰임새 제안
3. 선우현승: 이상한 책―구조적 해석
4. 이지은, 하야시 미쓰코, 노사카 마사시:
키네틱 타이포그래피에서 전공에 따른
감성의 차이
5. 임성신: 이상 날다
좌담
구자은, 김나연, 김묘수, 김병조, 김주성,
김지현, 노은유, 민병걸, 서승연, 송성재,
송유민, 심우진, 원유홍, 이영미, 이용제,
한재준: 타이포그래피 용어 표준화
대화
에도 스미추이젠, 후다 스미추이젠과의 대화
서평
1. 유지원: 라이프치히 서체와 서체 수업 100년
2. 프레드 스메이어스: 서문―활자란
집어 들어서 손에 쥘 수 있는 어떤 것
3. 김현미: 얀 치홀트

글짜씨 4 (3권 2호)
논문
1. 구본영: 본문용 한글 서체의 구조와
인지요인 상관성연구
2. 권은선: 글자너비 변화와 가독성의 상관관계
3. 민본: 타이포그래피와 치수
4. 박지훈: 새 활자 시대 초기의 한글 활자에
대한 연구
5. 오재희, 김지현: 오브제티미지 실험
연구 영상과 오브제를 활용한 키네틱
타이포그래피
6. 이영미: 전용서체 인지도 및 선호도 조사
7. 이용제: 한글 타이포그래피 교육의
공유와 연대 제안
8. 최정화, 김지현: 굴림체의 조형적 특징과
선호도 분석
좌담
홍석일, 강고니, 권은선, 김경균, 신동윤,
조현주: 공공.디자인.타이포그래피
서평
1. 박활성: 타이포그래피의 숲으로 다섯 발자국
2. 유지원: 한 줄의 활자
3. 이용제: 파울 레너, 2011년 그가 대한민국에
살고 있다면

글짜씨 5 (4권 1호)

논문
1. 강고니: 노면 안전표지용 글자의 개선에
관한 연구
2. 이지은, 노사카 마사시: 키네틱
타이포그래피와 인쇄 매체 타이포그래피의
감성 구조의 차이
3. 심우진: 한글 타이포그래피 환경으로서의
문장 부호에 대하여
4. 노사카 마사시: 문자에서의 미적 가치
판단 기준
5. 이용제: 문장 방향과 한글 글자꼴의 관계
좌담
김지현, 원유홍, 한재준, 이병주:
한글특별위원회 발족에 앞서
대화
카를로스 세구라, 한창호, 김지원:
카를로스 세구라와의 대화
서평
1. 김주성: 타이포그래피의 빈 공간
2. 유정미: 전집디자인

글짜씨 6 (4권 2호)
논문
1. 구슬기: 한글꼴과 표의성
2. 이지원: 바른지원체
3. 이지은: 키네틱 타이포그래피에서 제작자에
따른 감성 전달의 차이
4. 이용제: 효율적인 한글 활자 디자인을 위한
대표 글자 연구
좌담
한글특별위원회: 한글특별위원회의
운영과 추진 방향
대화
왕 훙웨이, 김지현: 왕 훙웨이와의 대화
서평
박지훈: 레터링 타이포그래피

글짜씨 7 (5권 1호)
논고
1. 안상수, 노민지, 노은유: 안상수체2012의
한글 그룹 커닝
2. 크리스 로: 아키타입 & 아키타이플
3. 이안 리넘: 현재 진행 중
좌담
1. 구슬기, 노은유, 류명식, 유지원, 이용제,
한재준: 한글 디자이너로 심리적·경제적 보상을
충분히 받으며 생계를 이어 나가는 방법
2. 김두섭, 김장우, 문장현, 유지원, 이용제,
이재민, 조현, 조현열: 기업 폰트가 브랜딩 및
타이포그래피 문화에 미치는 순기능과 역기능
대화
이지원: 데이비드 카비앙카
서평

박우혁: 타이포그래피 천일야화
오진경: 좌충우돌 펭귄의 북 디자인 이야기
유정숙: 좋은 문서 디자인 기본 원리
해외 리뷰
민본: 영국 레딩대학교

글짜씨 8 (5권 2호)
1. 김지현: 새로운 글짜씨
2. 유지원: 슈퍼텍스트 이후의 텍스트
논고
1. 김현미: 타이포그래피 송시
2. 노민지: 한글 문장부호의 흐름
3. 올리버 레이첸스테인: 반응형
타이포그래피의 기본 원칙
타이포잔치 2013
1. 이병주, 최성민, 김영나, 유지원, 이민아,
김병조, 김형진, 박연주, 조현, 이재민:
슈퍼텍스트로서 타이포잔치 2013
2. 최성민: 타이포잔치 2013 비공식 FAQ
기록
1. 아스트리트 제메
2. 마크 오언스
서평
1. 이지원: 도록 서평
2. 유진민: 디자인 초년생에게 추천하는
서체 경험기
3. 임진욱: 친절한 타이포그래피
전시
박지훈: 타이포그래피의 두 흐름

글짜씨 9 (6권 1호)
작업 중
타이포그래피 챕터 99: 장식 컴포지션
논고
1. 이병학: 인쇄가의 꽃: 플러런과 아라베스크
2. 안상수, 노민지, 노은유: 불경 언해본과
한글 디자인
3. 정영훈: 강조 및 인용 표시를 위한
한글 글자체 디자인
좌담
크리스 로, 유지원, 이병학, 이재민, 전종현:
돌아온 오너먼트
수집
김병조, 강미연: 공간의 질서: 오너먼트
대화
엘리엇 얼스, 크리스 로: 엘리엇 얼스와
크랜브룩 스타일의 그래픽 디자인 교육
서평
1. 김희용: 마리안 반티예스의 그래픽 원더
2. 전가경: 여기 한 권의 책이 있다
3. 유지원: 글꼴에 내려진 지령, 읽히려거든
보이지 마라!
4. 김현미: 복스의 분류법 그 이후 50년:

분류법의 진화
프로젝트
김경선: 타이포잔치 2015 프리 비엔날레

글짜씨 10 (6권 2호)
논고
1. 안진수: 사봉
2. 박경식: 막스 빌과 얀 치홀트의 1946년 논쟁
3. 함성아: 한국 타이포그래피 연구 아카이브
4. 김병조: 『글짜씨』 편집과 디자인
수집
1. 유지원: 저술들
2. 얀 치홀트: 펭귄 조판 규칙
3. 디자인하우스: 한국의 얀 치홀트 1
4. 김수정, 김병조, 유지원, 이현송, 최성민:
한국의 얀 치홀트 2
대화
1. 크리스토퍼 버크, 박경식: 얀 치홀트,
활자 디자인과 책 쓰기
2. 안상수, 김병조: 안녕 치홀트, 안녕 치홀트
3. 권터 칼 보제, 최문경: 타이포그래피의 끝과
문자의 시작으로부터
전시
강문식, 김병조 + 이현송, 박지원, 박찬신,
박철희, 손범영 + 김진, 슬기와 민,
신해옥 + 신동혁, 안상수, 양상미, 오디너리피플,
윤민구, 이재민, 일상의 실천, 장수영, 조규형,
조현, 채병록, 크리스 로: 전시 9: 얀 치홀트
좌담
김광철, 김병조, 김신, 문지숙, 이재민, 전은경,
조현: 『글짜씨』 99
비평
1. 김동신: 『타이포그{라, 래}픽 디자인』을 읽고
2. 민구홍: 친애하는 독자께
3. 김은영: 책의 형태가 변한 지금도 여전히
유효한, 얀 치홀트의 『책의 형태』
4. 이현송: 새로운 책의 형태
5. 안마노: 『TM』을 통해 엿보는
타이포그래피 번영기
6. 박우혁: W는 한 마리 날아가는 새
7. 이예주, 이함: 얀 치홀트와 라이프치히
독일 국립 도서관
8. 박찬신, 민구홍: 바인가르트 타이포그래피
9. 전가경: 본다는 것의 의미
프로젝트
강예린, 구본준, 김경선, 김형재, 고토 데쓰야,
박재현, 박해천, 이치훈, 자빈 모: 타이포잔치
2015 프리비엔날레

글짜씨 11 (7권 1호)
논고
1. 마리코 다카기: 간지 그래피: 로마자와
일본어 문자 간의 시각적 변환

2. 김초롱: 태국 글자체 제작에 기반을 둔
다국어 글자체 제작의 실제
3. 김의래, 이지န : 한글과 로마자의
섞어짜기를 위한 로마자 형태 연구
4. 신시아 아리아든, 성재혁:
다국어 타이포그래피를 위한 한글―로마자
하이브리드 글자체 디자인
좌담
1. 로만 빌헬름, 요아힘 뮐러랑세, 우다야
쿠마르, 안병학, 이재민, 유지원: 내부자의
잠재력을 일깨우는 타자의 시선: 글로벌리티에
대항하는 인터로컬리티
작업 중
1. 로만 빌헬름: 좁 HEUNG: '시각적 지역색'과
홍콩의 지역 문화가 지닌 다양성의 힘을
옹호하다
2. 데이비드 브레지나, 타이터스 네메스, 카작
아펠리안: 로제타 글자체 회사: 조화의 난점
3. 박재홍: 각필구결을 이용한 새로운
한글 문장부호
4. 장수영: 본고딕
5. 마리코 다카기: 기온
6. 크리스타 라도에바: 아마니타: 다국어
제목용 글자체를 향한 도전
수집
유윤석, 전용완, 김다희, 신해옥과 신동혁,
이기준, 김형진, 조현열, 김나무와 김민수,
김병조, 안마노, 이경수, 정진열, 슬기와 민, 이언
리넘, 존 워위커, 정재완: 열여섯 명의 섞어짜기
대화
석금호, 김현미: 다국어 타이포그래피와
21세기 글자체 디자인
서평
1. 윤여경: 나쁜 글자체는 없다.
나쁜 디자이너만 있을 뿐이다.
2. 김린: 텍스트를 구출하라

글짜씨 12 (7권 2호)
논고
1. 최성민: 뒤늦게 밝히자면:
《타이포잔치 2013》 기획 의도에 관해
2. 전가경: 『볼 만한 꼴불견』을 통해 본
1970년대 한국의 언어 경관
3. 홍동식: 풍토적 타이포그래피:
부산 지역을 중심으로
4. 레이첼 심, 크리스 로: 무장소성의 매핑:
모방과 실험의 타이포그래피를 통해
도시 공간 분절을 표현하기
5. 이재원: 대각선 쓰기: 한글의 형태와
방향성을 고려한 쓰기 방법 실험
6. 노민지, 윤민구: KS 코드 완성형 한글의
추가 글자 제안
비평 1

타이포잔치

《타이포잔치: 국제 타이포그래피 비엔날레》는
한글의 우수한 조형성과 문화적 가치를 세계에
알리고, 한국 디자인문화의 가치 확산을 위한
교류의 장을 마련하고자 문화체육관광부가
주최하고 한국공예·디자인문화진흥원과 국제
타이포그래피 비엔날레 조직위원회가 공동주관하는
국제 비엔날레이다. 《타이포잔치》는 2년마다
격년으로 개최되며, 홀수년도에 비엔날레
본행사를, 짝수년도에 프리비엔날레를 개최하고
있다. 세계디자인협회 ico-D(International
Council of Design)가 공인하는 명실상부한 국제
비엔날레이다. 《타이포잔치》는 2001년 예술의전당
한가람디자인미술관에서 처음 개최되었으며,
당시 타이포그래피를 주제로 한 유일한
국제행사라는 점에서 국내외의 큰 호응을 얻었다.
이후 행사 조직시스템을 재정비 하여 2011년부터
국제 비엔날레로 정례화 되어 지금의 모습이 되었다.

한국타이포그라피학회와 《타이포잔치》는
타이포그래피를 다루는 학회와 전시라는 점에서
상호보완적인 역할을 한다. 《타이포잔치》가 열렸던
해의 다음에 발간되는 『글짜씨』는 《타이포잔치》의
주제를 다룬다. 그리고 《타이포잔치》가
'타이포그래피와 사물'과 같이 타이포그래피와
타이포그래피의 외부 대상을 다룬다면 『글짜씨』는
타이포그래피와 그 내부 대상에 대해 다룬다. 전시와
책을 통해서 타이포그래피를 기준으로 안과 밖을
고루 살피게 되는 구조이다.

제1회 타이포잔치:
서울 타이포그라피 비엔날레
《새로운 상상》

2001. 10. 16. – 12. 4.
예술의전당 디자인미술관

조직위원장: 안상수
포스터 디자인: 안상수
도록 디자인: 안상수,
이세영, 김영나(안그라픽스)

타이포잔치 2011:
국제 타이포그래피 비엔날레
《동아시아의 불꽃》

2011. 8. 30. – 9. 14.
문화역서울284, 서울스퀘어

예술감독: 이병주
포스터 디자인: 김두섭
도록 디자인: 김성훈(안그라픽스)

타이포잔치 2013:
국제 **타이포그래피 비엔날레**
《슈퍼텍스트》
———
2013. 8. 30. – 10. 11.
문화역서울284, 서울스퀘어
———
예술감독: 최성민
포스터 디자인: 프랙티스
도록 디자인: 프랙티스

타이포잔치 2015:
국제 **타이포그래피 비엔날레**
《C()T()》
———
2015. 11. 11. – 12. 27.
문화역서울284,
네이버 그린팩토리,
스몰하우스빅도어,
인더페이퍼 갤러리, 땡스북스
———
예술감독: 김경선
포스터 디자인: 이재민
도록 디자인: 이경수, 전용완
(워크룸)

타이포잔치 2017:
국제 **타이포그래피 비엔날레**
〈몸과 타이포그래피〉
———
2017. 9. 15. – 10. 29.
문화역서울284, 서울시내
버스정류장 150곳, 우이신설선
역사, 현대카드 디자인
라이브러리, 019 겐트(벨기에),
네이버 그린팩토리 커넥트홀,
더북소사이어티,
파주타이포그라피배곳
———
예술감독: 안병학
포스터 디자인: 오디너리피플
도록 디자인: 정준기(안그라픽스)

타이포잔치 2019:
국제 **타이포그래피 비엔날레**
〈**타이포그래피와 사물**〉
———
2019. 10. 5. – 11. 3.
문화역서울284
———
예술감독: 진달래 & 박우혁
포스터 디자인: 유명상
도록 디자인: 유명상

타이포그래피가 아름다운 책

한국타이포그라피학회는 책이라는 함축된 공간 안에서 문자를 통해 소통과 표현의 균형을 시도하는 많은 디자이너의 노고를 기리고 뛰어난 조형적 성과를 보인 책을 발굴하여 그 가치를 알리기 위해 '타이포그래피가 아름다운 책'을 선정하여 발표한다. 디자이너뿐 아니라 편집자와 독자에게 '타이포그래피가 아름다운 책'의 의미 있는 사례를 제시함으로써 책의 가치를 더욱 높이는 문자 표현에 대한 세밀한 관심을 유도하고 나아가 좋은 책과 디자이너를 발굴하는 것을 목표로 한다. 2016년과 2017년, 총 2회를 진행했고 각각 3명의 심사위원이 심사했다. 2016년에는 3권의 책이, 2017년에는 2권의 책이 최우수 작품으로 선정되었다.

타이포그래피가 아름다운 책 2016

추천: 2016. 11. 25.까지
심사: 2016. 11. 25. – 12. 15.
발표: 2016. 12. 15.

타이포그래피가 아름다운 책 2017

추천: 2018. 4. 30.까지
1차 심사: 2018. 5. 1. – 5. 10.
2차 심사, 전시: 2018. 5. 23. – 6. 5.
발표: 2018. 6. 11.

**회원들의 추천으로 선정한
최종 심사 도서 2016**

① 『가난한 콜렉터가 훌륭한 작품을 사는 법』
출판사: 디자인하우스
저자: 엘링 카게
디자이너: 김희정

② 『글짜씨 12: 도시와 문자』
출판사: 안그라픽스
저자: 타이포그라피학회
디자이너: 이재영

③ 『디자인뮤지엄, 여기』
출판사: 안그라픽스
저자: 이현경
디자이너: 유명상

④ 『문봉선의 강산여화』
출판사: 수류산방중심
저자: 문봉선
디자이너: 수류산방

⑤ 『민메이 어택: 리-리-캐스트』
출판사: 시청각
저자: 김기웅 외
디자이너: 신신(신동혁, 신해옥)

⑥ 『세계의 북 디자이너 10』
출판사: 안그라픽스
저자: 전가경, 정재완
디자이너: 정재완

⑦ 『셰익스피어 전집』(최종 선정 도서)
출판사: 문학과지성사
저자: 셰익스피어
디자이너: 박연주, 이미연

⑧ 『시각디자인』(최종 선정 도서)
출판사: 홍디자인
저자: 리카르도 팔치넬리(윤병언 옮김)
디자이너: 채승원

⑨ 『아파트 글자』
출판사: 사월의눈
저자: 강예린, 윤민구, 전가경
디자이너: 정재완

⑩ 『우리의 병은 오래전에 시작되었다』
(최종 선정 도서)
출판사: 자음과모음
저자: 알랭 바디우
디자이너: 오진경

⑪ 『인덱스카드 인덱스 2』
출판사: 동신사
저자: 김동신, 정지돈
디자이너: 김동신

⑫ 『종의 기원』
출판사: 은행나무출판사
저자: 정유정
디자이너: 오진경, 이승욱, 김서영 등

⑬ 『죽은 머리들 소멸자, 다시 끝내기
위하여 그리고 다른 실패작들』
출판사: 워크룸
저자: 사뮈엘 메케트
디자이너: 김형진

⑭ 『탐방서점』
출판사: 프로파간다
저자: 마포 디자인·출판 진흥지구 협의회
디자이너: 유명상

⑮ 『폭력의 궁극』
출판사: cmyk
저자: 프랑수아 로베르
디자이너: 박경식

**타이포그래피가 아름다운 책 2016
최종 선정 도서**

『셰익스피어 전집』
『시각디자인』
『우리의 병은 오래전에 시작되었다』

회원들의 추천으로 선정한
최종 심사 도서 2017

① 『READ』
출판사: 그리고갤러리
저자: 김윤기
디자이너: 안마노

② 『의성어 의태어 건축』
출판사: 안그라픽스
저자: 구마 겐고(隈研吾)
디자이너: 남수빈(도움: 박민수)

③ 『CopyCat』
출판사: 초타원형 출판
저자: 강정석, 길형진, 김건호, 김영준,
김형재, 깡통, 듀나, 박세진, 박준수,
복길, 유진, 이상우, 정현, 초타원형 출판,
최재형, 최준혁, 최효기, 팝콘, 한소휘,
홍은주, Danjyon Kimura, EH(김경태)
디자이너: 홍은주, 김형재(도움: 유연주)

④ 『타이포잔치 2017:
5회 국제 타이포그래피 비엔날레』
출판사: 안그라픽스
저자: 한국공예·디자인문화진흥원
디자이너: 정준기

⑤ 『옵.신』 7호
출판사: 스펙터 프레스
편저자: 서동진, 서현석, 김성희
디자이너: 슬기와 민

⑥ 『대한항공 박스 프로젝트 2016:
양지앙 그룹—서예, 가장 원시적인
힘의 교류』
발행인: 국립현대미술관
디자이너: 오디너리피플

⑦ 『탈[tel]』 2호
출판사: 안그라픽스
저자: 안그라픽스 편집부
디자이너: 정준기, 최슬기, 윤진, 김태호

⑧ 『손동현 孫東鉉 DONGHYUN SON
2005 - 2016』
출판사: G&Press
저자: 손동현, 이나연, 김재석
디자이너: 홍은주, 김형재

⑨ 『최정호체 글꼴보기집』
출판사: 안그라픽스
저자: 노민지, 정하린, 요아힘 뮐러랑세
디자이너: 이윤서

⑩ 『Bookabinet』
출판사: 책구멍
저자: 최현호, 지석민, 조세희, 우유니게
디자이너: 최현호, 지석민, 조세희,
우유니게

⑪ 『집시』
출판사: 한미사진미술관
저자: 요세프 쿠델카
디자이너: 김성훈

타이포그래피가 아름다운 책 2017
최종 선정 도서

『CopyCat』
『탈[tel]』 2호

수집

'수집'은 어떤 이미지나 대상을 수집하여 새로운 맥락으로 보여준다. 이는 대상에 대한 유희적 접근이 될 수도 있고, 연구의 기반이 될 수도 있다. 『글짜씨』 18에서는 '똑같은 손글씨'라는 주제로 소장하고 있는 특별하고 의미 있는 손글씨를 수집하여 손글씨에 얽힌 이야기와 함께 보여준다.

일러스트레이터 크리스토프 니먼
(Christoph Niemann)의 글씨

소유자
박이랑

손글씨 주체와의 관계
협업 동료

손글씨가 담긴 매체
엽서

손글씨와 얽힌 이야기
디렉터로서 함께 일하는
아티스트와 작업이 마무리된 후
서로에 대한 피드백을 주고받는
것은 가장 기쁜 순간 중 하나이다.
특히 손으로 직접 쓴 메시지를
받는 것은 드물고 신나는 일이다.
크리스토프 니먼의 손글씨를 보면
그의 아이디어 스케치가 떠올라
재미있다. 기발한 아이디어를
아름다운 직관력으로 표현하는
작가의 손글씨는 작가가 전하고자
한 메시지와 닮아 있다.

Berlin 18.12.19

Dear Ee,

thank you so much for
working with me on
the Hyundai series.

Your insight and gui-
dance are incredible, and
have made this project
a true highlight of the
year.

Yours truly

Christoph

沈愚珍さんへ / 友情をこめて

杉浦康平

040805

스기우라플러스아이즈의
북 디자이너 스기우라
고헤이(杉浦康平)의 서명

소유자
심우진

손글씨 주체와의 관계
정서적 사제지간

손글씨가 담긴 매체
선생님께서 아트디렉션하신
단행본,『표상의 예술공학』

손글씨와 얽힌 이야기
선생님은 책에 사인하는 것을
좋아하시지 않는다. 여럿이
공들여 만든 것에 대한 예의일까.
선생님 사무실을 무작정 찾아뵙고
뭐라도 시켜달라며 조르던 때,
용기를 내어 알면서도 모르는
척 사인을 부탁드렸다. 살짝
머뭇거리시더니 책의 가장
후미진 곳(표지 뒷면)을 펼치고
신중히 펜을 고르신 후 이렇게
적어주셨다.
"심우진 상에게" 그리고 펜을
바꾸어
"우정을 담아…"를 넣어주셨다.
沈愚珍さんへ
/ 友情をこめて…
杉浦康平
040806

우정이라는 말이 이렇게 극적으로
다가온 적은 없었다. 당시 나는
흔하디흔한 무명씨 외국인
노동자였기 때문이다. 2004년
8월 6일은 지금도 되새기는
삶의 사건이 되어, 힘들 때마다
펼쳐보는 부적이 되었다.

To Bon
01/05/13
READING
Gerard U

네덜란드 글자체 디자이너
헤라르트 윙어르(Gerard
Unger)의 서명

소유자
민본

손글씨 주체와의 관계
영국 레딩대학교 타입 디자인
석사과정 강사와 학생

손글씨가 담긴 매체
본인 저서 『Terwijl je leest』의
한국어 번역본 『당신이 읽는 동안』

손글씨와 얽힌 이야기
당시 국내에 『Terwijl je
leest』의 번역본이 발간되어
헤라르트 윙어르가 출판사로부터
기념으로 받은 몇 권 중 한 권을
(읽을 수 있다는 이유만으로)
받았다. 주변에 한국인 라틴
글자체 디자이너가 많지 않다는
생각에 외로움을 느끼던 시절,

네덜란드와 한국, 영국을 오가는
커뮤니케이션의 결과물을
당사자에게 직접 받아 들고서
실은 모두가 연결되어 있음을
실감했던 묘한 추억이다.

뜻깊은 손글씨

아버지의 글씨

소유자
민본

손글씨 주체와의 관계
아버지

손글씨가 담긴 매체
장서 내지

손글씨와 얽힌 이야기
아버지는 오래전부터 서예와
글자 도안을 즐기신다. 물려주신
책의 내지를 보면 권마다 독특한
구성의 서명이 남겨져 있어 감상의
즐거움을 준다. 아들은 아버지의
이러한 취미를 이어 업으로 삼았다.

그림체 작가 이언 포크너(Ian Falconer)의 그림과 글씨

소유자
최문경

손글씨 주체와의 관계
지인의 지인

손글씨가 담긴 매체
그림책

손글씨와 얽힌 이야기
아이가 태어난 해, 우리 가족과 가까이 지내던 지인에게 선물로 받은 책. 뜻밖에 저자의 친필 메시지와 그림이 그려져 있었다. 평소 이언 포크너와 친하게 지내던 지인은 우리 아이의 이름이 올리비아 책의 저자와 그림책 속 올리비아의 동생 이름과 같다는 사실을 알고는 뜻깊은 선물을 준비한 것이었다.

아이가 크면 보여줘야지 하고 잘 간직하고 있었는데, 이제 그 시간이 온 것 같다.

뜻깊은 손글씨

김묘주의 편지

소유자
김현미

손글씨 주체와의 관계
외할머니와 손녀

손글씨가 담긴 매체
편지지에 남긴 기록

손글씨와 얽힌 이야기
일곱 살 때 외할머니께 간밤에 꾼 꿈 이야기를 해드렸더니 이런 길몽은 기록해야 한다며 편지지에 "병진년 음력 십일월 육일 밤⋯ 꿈을 꾸다. 천상에 올라갔다 용을 타고 금돈을 많이 가지고 내려왔다⋯ 경술생 길몽이다 평생 잘 살 것이다"라고 적어주셨다.

남동생을 더 귀여워하시는 할머니의 관심을 얻어보려 과장된, 어쩌면 꾸며낸 이야기를 했을 수도 있는데 할머니의 뜻밖의 행동에 짐짓 놀랐던 기억이 있다. 당시 80세의 할머니 글씨에서 기둥을 중심으로 줄을 잘 맞추어 쓴 세로쓰기 궁서체 반흘림체를 볼 수 있다.

영국 글자체 디자이너이자 그래픽
디자이너 네빌 브로디(Neville
Brody)의 서명

소유자
박영하

손글씨 주체와의 관계
SPC그룹 디자인센터에서 디자인
개발을 의뢰한 디자이너와
디자인센터 디자인팀장 재직시절

손글씨가 담긴 매체
『The Graphic Language of
Neville Brody』

손글씨와 얽힌 이야기
2017년 2월 23일. 8년 만의
파리바게뜨 BI 리뉴얼 및 최초의
전용서체 개발을 담당한 그와의

세 번째 만남에서 예전부터
교과서처럼 가지고 있던 그의
저서에 사인을 요청했다.

날카로운 눈과 디테일에 신경 쓰는
그의 성격, 그리고 글자체
디자이너라는 직업을 떠올렸을 때
글씨체도 뭔가 독특할 거라
기대했는데 생각 외로 (악필에
가까울 정도로) 너무 평범해서
놀랐다. 계약서 작성 시 매
페이지마다 일일이 사인을 해야
하는 것에 대해 귀찮다고 투정
부리던 그의 귀여운 모습이
기억난다.

이탈리아 산업디자이너이자
건축가 알레산드로 멘디니
(Alessandro Mendini)의 서명

소유자
박영하

손글씨 주체와의 관계
당시 SPC그룹과 계약을 맺은
디자인 고문과 디자인센터
디자인팀장 재직시절

손글씨가 담긴 매체
『알레산드로 멘디니 일 벨 디자인』

손글씨와 얽힌 이야기
2017년 3월 15일. 당시 SPC
그룹과 디자인 고문 계약을 맺고
있던 그와 주기적으로 디자인 개발
관련 회의를 진행했었고 두 번째

만남이었을 때 사인을 요청했다.

타계하시기 불과 2년 전 85세의
나이임에도 불구하고 정정한
편이었고 수전증으로 손을 많이
떨었지만 무언가 아이디어를
이야기할 땐 그 떨리는 손으로
늘 직접 스케치를 하던 모습이
매우 인상적이었다. 그리고 회의
중간중간 농담을 던져서 분위기를
즐겁게 해주었다. 그의 서명에서
그 떨림이 그대로 전해지는데,
그 동적인 필치가 오히려 유쾌하고
발랄한 그의 작업 색깔을 보여주는
듯해서 좋다.

호지의 글씨

소유자
정영훈

손글씨 주체와의 관계
둘째 아들

손글씨가 담긴 매체
색종이에 매직펜

손글씨와 얽힌 이야기
6살. 둘째 아이는 유난하게 이름을
거꾸로 쓴다. 오늘도 어김없이 녹색
색종이에 이름을 거꾸로 적었다.
문득, '이름을 올바르게 적게 될
때가 오면 어쩌나 ⋯. 이 아쉬운
순간을 어쩌나 ⋯.' 싶었다.

호지, 6살, 대한민국, 2020년

뜻깊은 손글씨

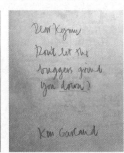

영국 그래픽디자이너이자 교육자 켄 갈런드(Ken Garland)의 친필 메시지

소유자
김경선

손글씨 주체와의 관계
1999년 당시 영국 센트럴세인트마틴즈대학교 석사과정 재학 중이던 학생과 특강 연사

손글씨가 담긴 매체
학생의 썸네일 노트

손글씨와 얽힌 이야기
1999년, 런던에서 공부하던 때에 손뜨개질 모자를 쓰고 오셔서 어린이 교구와 장난감 디자인에 대한 강의를 해주신 할아버지 디자이너의 특강을 들은 후 왠지 사인을 받아야 할 것 같아 나가서 받은 메시지. (켄 갈런드는 당시 71세. 현재 91세)

특강 내내 교구와 장난감 디자인 이야길 하신 분이 왜 이런 글을 적어주셨지 하는 생각이 들어 그분에 대해서 알아가다 보니 이분은 1964년, 그러니까 제2차 세계 대전 이후 부흥한 미국의 문화가 점점 유럽으로 유입되며 유럽의 디자인들이 상업주의 중심으로 치우쳐갈 즈음, 디자이너의 사회적 역할을

강조하는 'First Things First' 선언을 주도하셨던 장본인. 그리고 2000년, 뉴 밀레니엄 시대를 맞아 미국과 유럽의 그래픽 디자이너들이 그 선언의 정신을 이어받아 다시 한번 세상을 향해 디자이너의 책임성을 주장하게 된다. 이후로 나는 그 bugger들에게 (나도 모르게) 갇혀서 먹혀가고 있는지 아닌지 문득문득 되새기게 된다.

Dear Kegmmr

Don't let the buggers grind you down?

Ken Garland

공병우 자서전
나는 내 식대로 살아 왔다

한 재준 교수님께
드립니다.
1989. 11. 8.
공병우

안과 의사이자 한글 기계화 선구자, 그리고 전 한글문화원 원장 공병우의 글씨

소유자
한재준

손글씨 주체와의 관계
스승

손글씨가 담긴 매체
공병우 자서전
『나는 내 식대로 살아왔다』

손글씨와 얽힌 이야기
공병우 박사님을 처음 뵌 것은 제5공화국 청문회가 열리던 1988년 가을, 한글회관 학술발표 대회장에서 였다. 대학원을 다닐 때 뵙고 싶었지만, 그때는 미국에 계셨기에 기회를 놓쳤다. 그런데 뜻밖에도 그분이 바로 코앞에 앉아계셨다. 너무나 반가운 마음에 짧은 인사와 함께 내가 만든 글자꼴을 보여드렸다. 반응은 찰나였다.
"무엇으로 만드셨소? 매킨토시 컴퓨터를 모르시오? 폰타스틱 이라는 폰트 에디터를 써보시오." 그때 내 나이는 30세, 박사님은 80이셨다.
그때부터 박사님 뒤를 바짝 따랐다.
"박사님께 배우고 싶습니다."
"언제부터 시작하겠소."
"지금 당장에라도 좋습니다."
"그럼 내일부터 나오시오."
몇 단계의 시행착오 끝에 처음으로 세벌식 윤곽선 디지털 한글 활자꼴 (Outline Font)이 뼈대를 갖추었다. 인쇄용 글자꼴이었다.

"박사님, 이 글자꼴의 이름을 생각해봤습니다. 박사님의 성인 '공' 자와 제 성인 '한' 자를 따서 공한체라고 하면 어떨지요."
"허허. 그거 좋소."
1989년 초겨울 어느 날, 공한체는 이렇게 시작되었다. 기본원리와 구조는 공병우 세벌식을 따랐다. 궁극적으로는 한글의 가치를 제대로 살려보자는 뜻이었다. 이 시기에 공병우 선생님은 자서전을 내셨는데 그 책을 내게 주시며 책 앞머리에 쓰셨던 글씨다. 선생님은 이로부터 7년 후에 돌아가셨다.

한 재준 교수님께
드립니다.
1989. 11. 8.
공 병 우

뜻깊은 손글씨

사토 고이치(佐藤晃一)의 손글씨

소유자
채병록

손글씨 주체와의 관계
스승

손글씨가 담긴 매체
학생들에게 남긴 메모를 엮어
만든 소책자

손글씨와 얽힌 이야기
돌아가시고 작업실에 남겨져 있던
메모를 모아 스튜디오 제자들이
엮어 만든 책. 그래픽 디자이너
사토 고이치의 디자인에 대한
생각들과 방법론을 엿볼 수 있다.

?

（日本では「イラスト」）

イラスト・クラブ / アニメ・クラブ / カレンダーセンター
「コンペ / チョイス」キャラ、マニガ

絵画の歴史的流れを無視した自由な
個人的立場で描かれた、職業にならな
い趣味的な絵。らくがき。マスメディア
の影響が大きい反面、文化風土的。

絵画や（特に）イラストレーションの卵であり、泉。

북 디자이너
마생(Massin)의 서명

소유자
문장현

손글씨 주체와의 관계
세미나를 위해 회사를 방문한
강연자와 청중

손글씨가 담긴 매체
마생이 디자인한 외젠 이오네스코
(Eugene Ionesco)의 희곡집
『대머리 여가수(La Cantatrice
Chauve)』

손글씨와 얽힌 이야기
『대머리 여가수』는 기념비적인
북 디자인으로 유명하다.
대학원 재학시절 이 책을 프랑스
아마존에서 구해서 실물을 접하고
큰 충격을 받았다. 이후, 그의
손을 거친 책을 몇 권 더 구해서
소장했고, 마생이라는 디자이너를
흠모했다. 안그라픽스에서
재직하던 2005년의 어느 날,
놀랍게도 마생이 세미나를 위해
회사를 방문했다. 인상적이었던
강연이 끝나고 나는 이 책에
마생의 서명을 받았다. 그는 마치
『대머리 여가수』의 한 페이지처럼
서명을 해주었다. 올해 초 그는
세상을 떠났다.

비스듬히

생명은 그래요
어디 기대지 않으면 살아갈 수 있나요
공기에 기대고 서 있는 나무들 좀 보세요
우리는 기대는 데가 많은데
기대는 게 맑기도 하고 흐리기도 하니
우리 또한 맑기도 흐리기도 하지요
비스듬히 다른 비스듬히를 받치고 있는 이여

정현종

건축가 이민의 글씨

소유자
유정미

손글씨 주체와의 관계
남편

손글씨가 담긴 매체
종이

손글씨와 얽힌 이야기
2010년 2월, 한국타이포그라피
학회 첫 번째 전시를 준비할 때
남편이 옆에서 이 시는 손글씨가
더 좋을 것 같다며 직접 써준
글씨다. 시인 이상 탄생
100주년 기념전, 《시각시 展》에
출품하려고 정현종 시인의
「비스듬히」를 선정했다.
손글씨로 표현하는 게 잘 맞을
듯해 남편 손글씨로 작업했다.
원본을 잘 보관해 둔다고 했는데
어디 두었는지 못찾고 스캔본만
남아 아쉬움이 있다.

디자이너 카럴 마르턴스(Karel Martens)의 서명

소유자
석재원

손글씨 주체와의 관계
선생님

손글씨가 담긴 매체
카럴 마르턴스의 저서
『Printed matter \ Drukwerk』

손글씨와 얽힌 이야기
2010년, 유학 생활에서 만난 카럴 마르턴스는 적지 않은 나이임에도 늘 발랄했다. '불필요한 진지'를 진지하게 경계하는—그러나 냉소와는 거리가 먼—이성적 유머로 가득 찬 태도가 나로서는 몹시 새로웠다. 팬심으로 서명을 부탁하자 자신의 저서 『Printed matter \ Drukwerk』를 펼치고 'good luck' 두 단어를 남겨 주었다. 재치 있지만 가볍지는 않은 그다운 인사. 8년이 흐르고 다시 만난 날에도 발랄하게 'more' 만 살짝 보태어 인사말을 고쳐 지어주었다.

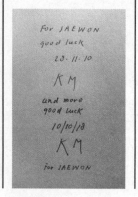

For JAEWON

good luck

28. 11. 10

KM

and more

good luck

10/10/18

KM

For JAEWON

뜻깊은 손글씨

'비평'은 기본적으로 '책', '학교', '전시', '활자' 등의 다양한 분야를 다루고 있다. 대상을 다각도로 분석하여 더 나은 시각 문화 향상을 위해 유의미한 정보를 제공한다. 『글짜씨』 18에는 안그라픽스에서 출간된 책 『타이포그래피 첫 원칙』에 대한 김현미의 비평이 실렸다.

스탠리 모리슨의
『타이포그래피 첫 원칙』과 그 배경

김현미
SADI, 한국

STANLEY MORISON · FIRST PRINCIPLES OF TYPOGRAPHY

스탠리 모리슨 · 타이포그래피 첫 원칙 · 1936

전설적인 글이 우리말로 번역되어 우리 곁에 오기까지 참 오랜 시간이 걸렸다.

스탠리 모리슨의 『타이포그래피 첫 원칙 First Principles of Typography』. 이 책에 대해 들어본 사람은 많아도 읽어본 사람은 많지 않을 것이다. 모리슨의 서문에 따르면 이 글은 1929년, 『브리태니커 백과사전』 14판(시카고와 런던)의 '타이포그래피' 항목에 들어가는 글로 처음 기획되었고 이듬해 타이포그래피 연구 간행물 『더 플러런 The Fleuron』 7호에 실렸다. 잡지가 절판된 뒤에도 이 글에 대한 지속적인 수요가 있자 1936년 케임브리지 대학 출판사에서 책으로 출판하였다. 이후 1967년 다시 출판되었으나 내용에는 변화가 없었고 '30여 년 이상 세월이 흐른 뒤에도 아무런 수정 없이 책을 다시 인쇄하는 것에 대한 정당성을 설명하는' 모리슨의 후기가 첨부되었다. 2020년 안그라픽스에서 출판한 『타이포그래피 첫 원칙』은 이 후기까지 포함하고 있으니 이 책의 역사를 모두 보여주는 셈이다.

이 책은 1920–1930년대 영국의 출판과 인쇄 문화를 배경으로 서적 타이포그래피에 있어서 지켜야 할 어떤 고전적 지침들이 있었는지를 보여준다. 『브리태니커 백과사전』에서 '타이포그래피'란 무엇인가를 설명하기 위한 글로서 서적 타이포그래피를 구현하기 위한 섬세한 지침이 소개되었다는 것은 타이포그래피란 원칙적으로 텍스트를 잘 이해할 수 있도록 도와주는 시각적 기술이며 서구 타이포그래피의 역사는 결국 '책'이 견인해 왔다는 사실을 인식하게 한다.

스탠리 모리슨 Stanley Morison(1889–1967)은 영국의 타이포그래피 연구가이자 글자체 디자이너로 30년 이상 모노타입 Monotype 사에서 근무하는 동안 수많은 유럽의 고전 글자체를 모노타입 기계용 서체로 재현하였고 「길산스 Gill Sans」 「퍼페추아 Perpetua」 등 동시대 정신을 반영한 독창적인 글자체들의 산파 역할로서, 그리고 그 자신이 디자인한 「타임즈뉴로만 Times New Roman」의 디자인 등을 통해 타이포그래피 분야에 많은 귀중한 유산을 남겼다. 모리슨은 독학으로 서적 디자인, 출판의 역사 등을 공부하였고 출판사의 편집 보조와 서적 디자이너로서의 경력을 발판으로 1922년, 서른세 살에 모노타입 사의 타이포그래피 고문으로 임명되었다.

모노타입은 미국의 공학자 톨버트 랜스턴 Tolbert Lanston이 발명한 기계로, 글줄 단위로 활자를 주조하고 조판하는 라이노타입 Linotype 기계와 달리 개별 활자를 주조하고 조판하는 기계였다. 랜스턴은 선견지명을 가진 영국의 투자자들을 만나게 되었고 1897년 영국과 아일랜드, 영연방 국가에서의 독점적 사업권을 가진 영국의 모노타입 사가 설립되었다. 미국에서의 회사 설립은 이후에 이루어졌다. 모노타입의 장점은, 개별 활자 단위로 주조되어 수정이 용이한 점, 미세한 공간 조정이 가능하여 고급 출판에 적합하다는 점, 1분에 100개 이상의 활자가 주조되는 속도로 조판 시간이 절약되는 점, 활자 서랍장을 따로 보관하지 않아 공간을 절약할 수 있어 비용이 절감되는 점 등 가히 혁명적이었다. 라이노타입이 잡지나 신문과 같은 속도가 중요한 매체 인쇄 시장을 선점했다면 모노타입은 출판 인쇄 시장을 공략하였다. 고급 출판물의 인쇄 수요를 만족하기 위해 모노타입 기계에서 활용할 수 있는 우수한 글자체의 개발은 1910년대 이후 중요한 과제로 부상했다. 초기의 모노타입 글자체는 기존 활자들을 베끼거나 활자 주조소에 대가를 지불하지 않고 도용한 것들이 많았고 양과 질, 모든 면에서 출판계를 만족시키지 못했다. 모리슨이 영입된 것은 이러한 맥락에서였다. 그는 활판 인쇄술 발명 이후 인쇄와 타이포그래피 역사에서 중요한 글자체를 규명하고 이들을 새로운 기계에서 활용할 수 있는 글자체로 되살리는 장기 프로그램을 진행하였다. 이 책의 출간 전까지 그의 지휘 아래 기록과 자료에 근거하여 개발한 글자체로는 「폴리필리 Poliphili」(1923), 「배스커빌 Baskerville」(1923), 「푸르니에 Fournier」(1925), 「벰보 Bembo」(1929), 「벨로만 Bell Roman」(1930) 등이 있었다.

[1] 스탠리 모리슨. 『활자기록』. 런던: 케임브리지대학 출판사, 1953. p87. / 모노타입 「벨로만」에 관한 기록. 「벨로만」으로 조판되었다. 모노타입에서 「배스커빌」 이후 두 번째로 재현한 18세기 영국 글자체라고 써 있다. 「벨로만」은 「배스커빌」로부터 영감을 받았으나 글자의 비례는 프랑스의 「디도」 「푸르니에」처럼 날씬하다.

[2] 스탠리 모리슨. 『타이포그래피 첫 원칙』. 김현경 옮김. 파주: 안그라픽스, 2020. p14. / 펼침면과 수학적으로 유기적 관계를 가지는 활자면의 정의. 얀 치홀트 드로잉. "여백을 넉넉하게 주는 전통적 여백 주기 방식은 그 자체로 보기 좋아서 특정 종류의 책에는 적합하다."

『타이포그래피 첫 원칙』의 1936년 인쇄에 사용한 「벨로만」의 개발 과정은 그중 하나의 사례로서 모리슨의 학자적 면모를 보여준다. 모리슨은 『인쇄활자 Printing Types』(1922)의 저자로 유명한 미국의 다니엘 업다이크D.B.Updike 등과의 교류를 통해 이전에는 몰랐던 18세기 영국 활자체의 존재를 알게 되었다. 또한 그 활자체가 18세기 영국의 출판인 존 벨John Bell의 의지로 주조되었고 그가 발행한 신문 『오라클 Oracle』에 활용되었다는 사실을 알게 되었다. 그는 벨이라는 새로운 인물을 연구하면서 그 활자체의 소재를 파악하였고 '스티븐슨 블레이크 활자주조소Stephenson, Blake and Company'가 보유하고 있던 활자의 자모를 찾아내어 마침내 그 옛 모습을 재현하였다. 프랑스에서 유행하던 「디도 Didot」에서 영향을 받아 '영국에 등장한 최초의 모던 스타일 글자체'라는 연구 결과와 함께 모노타입 「벨로만」을 세상에 선보였다. 이 글자체로 그가 연구한 인물, 존 벨에 관한 책을 인쇄하고 그가 남긴 출판물들을 전시하였다. 글자체 하나를 복원하는 데 비단 그 형태뿐 아니라 그를 둘러싼 시대와 인물까지 깊이 있게 연구한 모리슨의 의지와 역량은 차차 모노타입의 활자 개발에 여러 전문가의 관심과 권위를 불러왔다.

『타이포그래피 첫 원칙』을 출판한 케임브리지대학 출판사는 모리슨이 모노타입에서 고전적 글자체 개발 프로그램을 10여 년간 지속할 수 있게 한 동반자였다. 아무리 역사적으로 의미 있고 형태적으로 우수한 글자체를 개발했더라도 수익이 발생하지 않으면 회사로서는 반갑지 않을 일이었다. 모리슨이 출판사에서 일하던 시절 인연을 맺었던 인쇄 전문가 월터 루이스Walter Lewis가 케임브리지대학 출판사의 인쇄소 수장을 맡게 되면서 그의 추천으로 모리슨은 대학 출판사의 타이포그래피 고문 역할을 겸하게 되었다. 모노타입용 새로운 고전 글자체가 나올 때마다 이를 대학 출판사의 유수의 출판물 인쇄에 활용하고 품격 있는 서적 타이포그래피와 책 만듦새를 보여주었기에 모리슨의 글자체들이 업계에 영향을 끼칠 수 있었다. 1920–1930년대 모노타입에서 모리슨의 지휘 아래 수많은 글자체가

만들어졌지만 「길산스」와 「타임즈뉴로만」 등의 상업적 성공이 없었다면 그의 자리가 유지되기는 어려운 상황이었다 한다. 모리슨은 이러한 관계에 대한 감사의 표시로 1953년, 『활자 기록 A Tally of Types』이라는 책을 엮어내어 소량 출판했는데 이는 1922년부터 1932년까지 모노타입에서 재현하고 케임브리지대학 출판사에서 활용한 열일곱 벌 고전적 활자체와 그 복원 과정에 관한 이야기를 담고 있다.[1]

　　『타이포그래피 첫 원칙』은 로마자 숫자로 표기한 크고 작은 7개의 장으로 구성되어 있다. 장 제목은 없지만 안그라픽스의 번역서에는 오른쪽 페이지 헤딩에 해당 부분의 주제어를 표시하고 있어 이해를 돕는다. 다음은 각 장의 주요 내용과 인용문이다.

[3] 월턴 세인트 로렌스. 『사복음서(The Four Gospels)』. 골든코커렐출판사, 1926. / 작품의 첫 페이지와 문장을 인상적으로 만들기 위한 여러 시각적 장치를 활용하였다. 그림과 결합한 장식적 두문자, 큰 대문자로 시작하여 점차 작아지는 대문자의 문장이 비로소 본문을 이루는 소문자의 문장으로 연결된다. 일러스트레이션: 에릭 길.

1　　서적 타이포그래피의 역할과 이 글의 취지
　　"타이포그래피는 … 독자가 텍스트를 최대한 잘 이해하도록 글자를 나열하고 공간을 분할하며 활자를 조정하는 일을 가리킨다."

2　　서적 타이포그래피의 구성요소: 서체, 공간, 조판, 터잡기, 눌러찍기, 종이의 선택
　　"(서적)타이포그래피를 지배하는 법칙은 … 인쇄업자가 속한 사회에서 직간접적으로 널리 퍼져 있는 전통에 바탕을 둔다."
　　"인쇄업자가 자주 사용하는 서체 디자인은 일반적인 잡지나 신문, 책을 보는 독자에게 친숙한 개념과 더욱 일치해야 한다. … 이 사실을 인지하며 서체 선택에 신중해야 한다."
　　"조판과 터잡기를 활용하여 텍스트 영역에 비례하는 적절한 여백을 남겨야 한다."[2]

3　　조판의 구성요소: 단어 수와 글줄의 길이, 서체 성격에 따른 행간, 문단과 들여쓰기, 표제 Running Head와 쪽번호 위치와 타이포그래피
　　"글자 크기가 반드시 행 길이와 연관되어야 한다 … 독자들은 10－12개의 단어로 구성된 행을 가장 편안하게 읽는다."
　　"디센더가 짧은 글자는 반드시 행간을 주어야 한다."
　　"문단을 만들 때 한 작품의 첫 문장은 자동적으로 뚜렷이 드러나야 한다는 인식이 중요하다."[3]

4　　도입부 Preliminaries(본문 앞 부분), 표제지의 타이포그래피
　　"이 첫 페이지는, … 타이포그래픽 디자인을 위한 기회가 최대한으로 주어지는 셈이다. 인쇄의 역사는 대부분 표제지 Title Page의 역사로도 볼 수 있다."[4, 5, 6]
　　"본문 글자의 두 배 이상 큰 활자로 이루어진 글줄을 표제지에 넣을 이유가 전혀 없다."
　　"제목의 주요 글줄은 대문자로 조판해야 하며 모든 대문자가 그렇듯이 글자 사이는 넉넉한 것이 좋다."

5　　도입부 디자인에서 유의할 점
　　"텍스트를 상자 모양으로 압축하고 억지로 모래시계 혹은 다이아몬드 모양으로

[4] 모노타입 「개러몬드」 활자견본책,
크라운 옥타보(127×190 mm), 1926.

[5] 모노타입 「푸르니에」 활자견본책, 크라운 옥타보(127×190 mm),
1927. / 전통적 여백을 가진 활자면을 규정하여 조판하였고 푸르니에 장식
폰트를 활용하여 보더를 만들었다. 표제지 타이포그래피는 모두 대문자로
조판하고 글자 사이 공간을 여유 있게 배정하였다. 디자이너 이름은
대문자와 작은 대문자(Small Capitals)를 활용하여 변화를 주고 이탤릭
서체 또한 활용하여 활기를 더했다.

조판하는 것은 매우 부적절한 행위이다."
"타이포그래퍼의 유일한 목적은 그 자신이 아닌 지은이를 표현하는 것이다. …
　장식이나 도판에 대한 욕심을 앞세우고, 독자의 편의를 위한 열정을 억누르면 안 된다."

6　　도입부의 구성, 순서와 타이포그래피
"도입부의 논리적 순서는 약표제지 혹은 헌사, 표제지, 차례, 서문, 개요 순이다."
"표제지 뒷면에 오는(이 책에서는 표제지 왼쪽 면에 온다고 번역되었으나
　Verso of the Title Page는 표제지 뒷면이다) 저작권 표시만 빼고
　모두 오른쪽 페이지에서 시작하면 좋다."
"서문, 차례, 개요 등 제목은 장 제목과 동일한 크기와 폰트로 조판 되어야 한다."

7　　판형과 부피, 종이
"127×190 mm의 크라운 옥타보 Crown Octavo 는 휴대하기 좋은 크기로 출판되는
　소설의 변함없는 규칙이다."
"부피는 일반적으로 출판사가 예상 판매량을 파악한 다음 쪽수 그리고 책 두께와
　관련해 특정 판매 가격에 익숙한 대중의 막연한 구매 심리까지 고려해 계산한다."
"이렇게 하면 책의 부피를 16쪽 이상 늘릴 수 있다. 능력 있는 타이포그래퍼라면
　누구든 손쉽게 해내는 일이다."
"수제 종이는 호화로운 양장본에만 사용하는 것이 일반적이다."

이 책은 서적 타이포그래피에 관한 원칙을 정리한 것이고 대상은 '서적 인쇄업자' '북
디자이너'라고 본문에서 명시하고 있다. 디자이너의 손끝에서 모든 타이포그래피
디테일이 결정되는 지금과 달리 당시 모리슨과 같은 '북 디자이너'는 케임브리지대학

[6] 모노타입 「배스커빌」 활자견본책 표제지 펼침면, 크라운 옥타보
(127×190 mm), 1926. / 표제지 타이포그래피는 모두 대문자로
조판하였다. 제목에서 중요한 단어들을 더 큰 대문자로 강조하였고
배스커빌의 이름만 이탤릭체로 변화를 주었다.

[7] 『더 플러런』 표제지, 220×280 mm, 1923. /
플러런은 A4 정도 되는 큰 판형과 부피의 양장본
책으로, 타이포그래피에 관한 에세이들 외에 다양한
종류와 디자인의 고품질 인쇄물들을 페이지에 붙여
종이와 인쇄의 질을 실제로 경험하게 하였다. 제작
비용 등의 문제로 7호를 마지막으로 종간되었다.

출판사 인쇄소의 월터 루이스와 같은 '인쇄업자'의 실제 구현력이 뒷받침되어야 좋은
타이포그래피의 서적을 만들 수 있었다. 이 책의 원칙들은 얼마나 신뢰할 만한 것일까?
모리슨은 모노타입의 타이포그래피 고문 역할을 하는 동시에 양질의 출판 디자인에 뜻을
같이하는 프랜시스 메이넬 Francis Maynell, 올리버 사이몬 Oliver Simon 등과 함께 '더 플러런
소사이어티 The Fleuron Society'라는 연구 공동체를 만들었다. 이들은 1년에 한 번 책을
발행하는 것을 목표로 했는데 당시 모노타입 기계로 조판하고 인쇄한 출판물이 유명 사설
인쇄소의 제작물 못지않은 완성도를 갖출 수 있음을 보여주고자 했다. 이 발행물이 『더
플러런』[7]이었고, 이름같이 아름다운 일곱 권의 책들은 1920-1930년대, 모노타입으로
생산 효율성을 갖춘 인쇄, 출판계와 활자와 타이포그래피 연구의 선순환적 발전의 결실과
같았다. 『타이포그래피 첫 원칙』은 당시 북 디자인에서 최고 수준의 감식안과 심미안을
갖춘 전문가가 규정한 서적 타이포그래피에 대한 지침으로 이해할 수 있다.
　　스탠리 모리슨은 "공공성은 타이포그래피의 본질이며 인쇄된 책의 본성이다."
"타이포그래피는 문명 사회에 봉사해야 하는 '봉사자의 예술'이다."라고 하면서 서적
디자인은 그것이 속한 사회의 관습을 따르는 것이 중요함을 강조했다. 사회의 관습은
"한 사람의 생애 그 이상으로 축적되었으며 후대가 입증한 경험의 총합을 아무렇지 않게
버릴 수는 없는 것"이라 하면서 영국의 북 디자인에서 합의된 전통과 원칙을 알리고자
하였다. 유럽 대륙에서 바우하우스와 모던 타이포그래피가 시각 디자인의 풍경을 퍽 많이
바꾸었지만 그 선봉에 섰던 얀 치홀트가 스위스 출판사의 서적 디자이너로 종사하면서부터
다시금 고전적 서체들과 전통적 타이포그래피의 연구에 힘쓰게 된 사실과 서로 무관하지
않아 보인다. 인쇄되는 책의 형식, 독서의 관습이 크게 변하지 않았다고 해서 지금의
서적 디자인이 아직도 이 책에서 말하는 구체적인 타이포그래피 지침을 따르지는 않겠지만
분명한 것은 이 책에서 서구 서적 타이포그래피의 기본형을 찾을 수 있다는 점이다.
　　2020년 한국의 서적 디자이너에게 1920-1930년대 영국의 서적 타이포그래피의

지침을 살펴보는 것은 어떤 의미가 있을까? 모리슨은 서적 디자인이란 그것이 속한 문화의 관습에 바탕을 둔다고 하였다. 우리의 서적 디자인은 광복 이후 점진적으로 세로쓰기에서 가로쓰기 문장으로, 왼쪽으로 넘기는 책에서 오른쪽으로 넘기는 서양의 책의 형식을 받아들여 발전해왔다. 비록 사용하는 문자는 다르지만 우리가 채택한 책의 형식에서 서적 디자인의 기본형은 무엇이었나를 확인해 보는 데 의미가 있을 것이다. 또한 이 책이 반 세기 이상 발전해온 우리의 출판 역사에서 좋은 서적 타이포그래피의 원칙을 정리해 보는 시발점이 되어주지 않을까 하는 생각도 가져본다. 이 책에 등장하는 책과 페이지를 구성하는 부분의 한국어 명칭도 도입부, 책 앞부분, 반 표제, 약 표제, 속표지 등 서로 다른 용어들이 혼용되며 인쇄소에서 쓰는 용어는 따로 있다고 한다. 용어의 통일을 포함하여 한국의 좋은 서적 타이포그래피의 원칙을 만드는 일을 디자이너들에게 기대해 본다.

스탠리 모리슨의 『타이포그래피 첫 원칙』과 그 배경

인물

'인물'은 디자인 분야에서 의미 있고 기억할 만한 사람을 선정하여 다룬다. 해당 인물의 작업과 삶 전반을 살펴보며 그가 이룬 직업적 성취를 함께 공유한다. 『글짜씨』 18에서는 S/O 프로젝트 창립자이자 전 한국타이포그라피학회 부회장이었던 디자이너 조현을 다루었다.

조현 (1969-2019)

김경선
서울대학교, 서울

「조현. 디자인. 50」. 월간 『디자인』 499호(2020년 1월)
발췌 및 재구성

서울에서 태어난 조현은 대학에서 시각 디자인을 공부하던 당시 아이앤아이I&I 대표이자 지도 교수였던 서기흔 교수의 눈에 띄어 자연스럽게 아이앤아이에서 일을 하게 되었고, 그곳에 7년 동안 근무하며 삼성그룹을 포함한 당시 대기업들의 홍보물들의 그래픽을 도맡아 디자인했다.

1999년, 서른의 나이에 인터랙티브 디자인을 배우고 싶어 뉴욕으로 떠났고 그곳에서 일러스트레이터 이인수를 만나 예일대학교를 알게 되어 지원하게 된다. 예일대학교 대학원에 입학해서 카럴 마르턴스Karel Martens, 폴 엘리먼Paul Elliman 등의 디자이너에게 지도받으며 최성민, 최슬기, 김상도, 이재원 등의 한국인 친구들과 어울리며 함께 공부했다. 우연히 팩스 용지에서 발견한 해상도 낮은 비트맵 타입페이스를 발전시켜 최성민과 함께 「FF 트로닉FF Tronic」이라는 폰트를 만들기도 했으며 일상 속 쓰레기 혹은 쓸모없는 공간, 버려진 것을 재해석해 졸업 작품으로 발표했다.

미국으로 유학을 가기 전 김두섭의 제안으로 참여해온 진달래 동인 활동으로 1998년《Mailing Art》, 2004년 한전아트센터에서 열린《진달래發展》, 2006년 일민미술관에서의《시집 금강산》, 2008년 도큐먼트 형식으로 발간된《진달래 스케치북》 시리즈가 있었고, 2012년 통의동 팔레드서울에서 열린《진달래 도큐먼트 04 열두 풍경》에서는 〈U&lc: 대문자와 소문자의 입체적 대화〉라는 입체적인 작업을 선보였다.

2003년, 'S/O 프로젝트'라는 이름으로 스튜디오를 만들고. SK텔레콤, 현대카드, LG전자, NHN, 배상면주가, 유니베라 등 많은 클라이언트와 다양한 작업을 진행했다. 그래픽 디자인의 기반은 인쇄홍보물이었지만 조현의 관심은 브랜딩, 재료, 가구, 공간 등에 넓게 분포되어 문화역서울284와 사우스케이프 리조트, 계원예술대학 등의 공간 및 브랜딩 작업 등을 하며 틈틈이 자신의 영역을 넓혀나갔고 2009년에는 안국동에 'EST.1894'라는 이름의 햄버거 가게를 런칭하는데, 비록 오래가지는 못했지만 브랜드 디자인은 물론 메뉴의 선정과 패키지, 고객 소통과 공간 디자인까지 맡아 토탈 디자인을 시도하기도 하였다.

2010년, 논현동에서 이태원으로 사옥을 옮겼고 정신, 사이이다, 황애리, 장진우 등의 이웃과

〈이태원 주민일기〉라는 동네 프로젝트를
진행했으며, 다양한 전공과 취향의 이웃들과 지역
문화를 만드는 역할을 했다. 같은 시기에 그는
브랜드 디자인 작업을 의뢰받은 '알렉스더커피'를
자신이 론칭한 라이프스타일 브랜드 '앤드'의
공간에 공존시킴으로써 협업과 분업을 통해 수익을
나누는 비즈니스 형태를 구현했다. 이어서 레스토랑
'앤드다이닝'을 공동 설립·운영하며 디자인을 통한
종속적인 수익에서 벗어나 함께 상품을 제작하고
판매하며 능동적으로 수익을 창출하는 꿈을
구체화시키기 시작했다.

2016년엔 그와 S/O 프로젝트의 철학과 작업을
총망라한 전시를 《플랫-폼: 서브젝트 & 오브젝트》라는
이름으로 홍콩에서 열었고, 스튜디오의 이름
S/O를 숫자로 형상화해 50개의 주제가 어떤 단서를
거쳐 시각화, 구체화, 상품화되어 글자체, 그래픽
모티브, 포스터, 책, 제품으로 나오는지 그 프로세스를
보여주었다.

패션 브랜드 펜디의 〈10+ 프로젝트〉에 참여했고
〈아우디 디자인 챌린지〉의 아이덴티티 디자인을 맡아
포스터, 트로피, 홍보물 등을 총괄했으며 푸르지오
아파트의 브랜드 디자인 리뉴얼 프로젝트와 취항
예정인 항공사 '에어 프레미아 Air Premia'의 브랜딩도
진행하던 조현은 여태까지의 다양한 디자인 경험을
토대로 리빙 브랜드를 만들고 싶어했다.

교육자로서 조현은 10년 이상 강의했고,
2015년 8월 한국예술종합학교 미술원 디자인과에
전임 교원으로 임용되어 2018년에는 미술원 부원장을
맡기도 했다. 또한 2017년에는 한국타이포그라피학회
부회장을 역임했고, 2018년에는 국제그래픽연맹
(AGI) 회원이 되어 2019년 5월 동대문디자인
플라자에서 개최한 《그래픽 디자인 아시아 2019—
가까운 곳에서》에서 공개 강연을 했으며 2019년
9월 4일 갑자기 우리 곁을 떠났다.

약력 1969 / 서울 출생
 1987 / 경원대학교 시각디자인학과 입학
 1993 / 경원대학교 시각디자인학과 졸업
 1993 / 아이앤아이 입사
 2000 / 미국 예일대학원 입학
 2002 / 예일대학원 졸업
 2003 / 귀국, 더디(THE-D) 입사
 2003 / S/O 프로젝트 설립
 2015 / 한국예술종합학교 디자인과 전임교원 임용
 2019 / 소천

 디자인 그룹 '진달래' 회원
 독일 FSI사 등록 디자이너
 〈Fendi 10+ 프로젝트〉 아티스트 선정
 한국의 북 디자이너 19인 선정
 ARC Awards 심사위원

출강 서울대학교 대학원
 가천대학교 시각디자인과 겸임교수
 계원예술대학교
 서울여자대학교
 서울여자대학교 타이포그라피 대학원
 국민대학교 시각디자인과
 한양대학교

수상 iF 디자인 어워드 / 플랫-폼 서브젝트 & 오브젝트 / 2018
 ARC 어워드, Grand Winner / 계원예술대학교 연간 리포트 / 2016
 TDC 어워드 뉴욕 / 훗, 향 그래픽 심포니아 / 2015
 레드닷 디자인 어워드 / 사우스 케이프 오너스 클럽 / 2014
 레드닷 디자인 어워드 / SK 텔레콤 LTE / 2013
 레드닷 디자인 어워드 / 알렉스 더 커피 / 2013
 한국디자인기업협회 잇-어워드, Grand Winner /
 문화역서울284 / 2012
 ARC 어워드, Gold 5, Bronze 2, Honor 1 /
 SK 텔레콤 연간 리포트 / 2011

전시 플랫-폼: 서브젝트 & 오브젝트 / 홍콩 / 2016
 타이페이 국제 도서 전시회 / 타이페이 / 2009
 북디자이너 19인 전 / 서울 / 2008
 FENDI 10+ 프로젝트 / 서울 / 2007
 TDC Tokyo (타입 디렉터스 클럽 도쿄) / 도쿄, 오사카 /
 2004, 2006, 2007
 진달래도큐먼트2: 금강산시집 / 서울 / 2004
 Trnava 포스터 트리엔날레 / 슬로바키아 / 2000
 TDC New York (타입 디렉터스 클럽 뉴욕) / 뉴욕 / 1999

인물

플랫-폼: 서브젝트 & 오브젝트

이지혜
전 S/O 프로젝트 근무
현 베르크 대표, 서울

민병걸
서울여자대학교, 서울

❶ FF 트로닉, 2002

FF Tronic

「FF 트로닉」은 조현과 최성민의 공동 작업으로, 팩스 송신 후 출력되는 전송 확인서에서 발견한 저품질 프린트 현상을 모듈화하여 만든 서체이다. 기본 7×9px 타입으로, 45°로 만나는 픽셀의 경계에는 저품질 프린터에서 나타나는 뭉침, 번짐의 모듈을 적용하였으며, 이탤릭체는 분절되어 기울어지는 방식으로 제작하였다. 이후 베를린의 폰트숍 인터내셔널에 등록되었다. S/O 프로젝트의 명함과 웹사이트 등에 사용되어 조현을 대표하는 글자체가 되었다.

❷ 디스-커넥티드, 2008

This-connected

「FF 트로닉」이 수직, 수평, 사선만으로 구성되었다면 이 글자체는 곡선으로 이루어져 있다. 「디스-커넥티드」에서 풍기는 「FF 트로닉」과 정반대인 인상은 어쩌면 아무도 조현에게 기대했거나 예상하기 어려웠던 결과물이지 않을까. 말랑말랑한 율동감, 여리여리한 굵기와 함께 기울여진 형태는 평소 교류가 있던 정신, 사이이다의 소개로 작업하게 된 모델 장윤주의 자전적인 음악을 프로모션하는 첫 번째 콘서트의 포스터에 사용되었다. 「디스-커넥티드」는 글자의 외곽선을 분절하고 연결하여 만든 흔적이 보인다. 조현은 자신만의 조건과 규칙을 만드는 방법론을 추구하는데, 낱자의 획(어센더, 디센더 혹은 슬랩)이 연결되어 있을 만한 위치가 아닌 엉뚱한 획이 연결되어 있는 대담성과 의외성은 그의 남다른 감각을 다시 떠오르게 한다. 「디스-커넥티드」는 'Dis'를 'This'로 바꿔 '연결'을 이중적으로 표현한 방식은 일상 속에서 위트 넘치는 그의 성향과도 많이 닮았다.

❸ 에이-레터, 2009

A Letter

「에이-레터」 혹은 「어-레터」. 현재까지 파악된 파일명 그대로 글자체의 이름을 붙였으나, 어떻게 읽고 표기해야 하는지 명확하게 확인되지 않았다. 「에이-레터」는 조현이 가장 최근까지 진행한 작업으로 많은 양의 스케치와 작업 파일들이 곳곳에 남아 있다. 다양한 경우의 수로 조합된 낱자를 구성하는 면과 색상의 흔적들을 통해 그의 면밀했던 고민과 더불어 이 작업에 대한 애정이 유난히 특별했음을 알 수 있다. 각 낱자를 만드는 과정에 망점이 겹쳐져 색상을 만드는 인쇄 방식을 대입해 평면끼리 겹치고 쌓아 올려 생성된 면과 색상의 밀도로 서체의 형태를 완성했다. 가시적으로는 평면을 유지하고 있지만 묘한 입체감을 느낄 수 있다. 「에이-레터」는 글자체의 꼴로 작업되어 있지만 사실상 메시지를 표현하고 전달하는 글과 말로서의 기능보다 낱자 하나하나가 마스터 피스로서 역할을 다하고 있다. 그가 남긴 무채색으로 채워진 대부분의 작업들 중 가장 화려한 그래픽의 형태와 컬러로 존재감을 드러낸다.

❹ U&lc: 대문자와 소문자의 입체적 대화, 2012

U&lc: Architectural Dialogue

《진달래 도큐먼트 4: 열두풍경》에 출품한 작업으로, 알파벳을 이루는 2개의 레이어인 대문자와 소문자를 공간 안에서 서로 연결하고 그 과정에서 만들어지는 선과 면을 구조적으로 보여주는 문자 조형물이다. 조현은 이 작업을 기점으로 평면과 입체, 형태와 물성을 결합하여 차원을 넘나들기 시작했다. 주로 메시지 전달을 위해 사용하던 문자와 도형 등의 평면적 그래픽과 물성의 특징을 절묘하게 뒤섞어 차원을 뒤흔드는 자신만의 방법론을 만들어내었으며, 단순히 조형물이 아닌 '제품'으로 접근하는 시도가 점차 늘어난다.

❺ 플랫-폼: 서브젝트 & 오브젝트, 2016

Flat-Form: Subject & Object

홍콩에서 열린 S/O 프로젝트의 작업과 철학을 총망라한 전시. 《플랫-폼: 서브젝트 & 오브젝트》 전시명은 그 자체로 S/O 프로젝트의 프로세스를 나타내고 있다. 물성은 서브젝트를 가진 상태에서 항상 어떤 대상들을 대변하고 있고, 그 반대로 오브젝트 또한 항상 서브젝트와 연결되어 있을 수밖에 없다는 개념이다. 스튜디오의 이름 S/O를 숫자로 형상화해 50개의 주제가 어떤 단서를 거쳐 시각화, 구체화, 상품화되어 글자체, 그래픽 모티브, 포스터, 책, 제품으로 나오는지 그 프로세스를 보여주었다. 이 프로세스는 타이포그래피의 평면적인 상태에 경험과 물성을 넣는 과정이다. 3D 프린터는 도포된

평면이 쌓여 적층 방식으로 형태를 만드는데, 이와 같이 과거의 종이 중심 매체가 경험적이고 입체적인 방향으로 발전하고 있다는 것을 나타낸다.

❻ 슬라이스 오브 라이프, 2011
Slice of Life

문서 세단기를 사용하는 행위와 그 소음이 무차별적으로 벌목하고 종이를 소비하는 사람들의 행동과 유사하다는 아이디어에서 시작한 작업이다. 세단된 종이는 재생이 어려운데 이를 역설적으로 표현했다. 세단된 종이를 손으로 말아 나이테를 만들어 새로운 생명에 대한 경각심을 주고자 했다. 이는 조현이 계속 연구했던 평면의 입체화의 한 사례이다.

❼ 2014 아우디 디자인 챌린지, 2014
2014 Audi Design Challenge

〈U&lc: 대문자와 소문자의 입체적 대화〉를 대중적인 접점으로 풀어낸 작업이다. 〈2014 아우디 디자인 챌린지〉를 위한 트로피로 공모전 슬로건인 '기술을 통한 진보'를 표현하기 위해 소문자가 적층되어 대문자가 되는 형상을 이용해 트로피로 만들었다. 3D 프린터가 상용화되기 전에 앞서 적용하고 세라믹을 붓는 방식도 개발하는 등 여러 시도가 이루어졌던 작업이다. 61회 타입 디렉터스 클럽 공모전 수상작으로 선정되었다.

❽ M+C, 2018

두성페이퍼갤러리에서 민병걸과 함께 진행했던 2인전. 오래전부터 자신이 디자인한 제품으로 구성된 리빙 디자인 브랜드를 준비하고 있던 조현은 이 전시를 통해 테이블과 스툴 등 브랜드를 구성할 '제품'일부의 프로토타입을 전시하였다. 조현은 타입 패밀리를 구성하는 획의 두께, 글자의 너비 변화가 만들어내는 '뉘앙스 스펙트럼'을 자신이 만든 테이블과 스툴의 재료로 철, 목재, 콘크리트 등 물성의 '뉘앙스 스펙트럼'으로 대체함으로써, 형태와 물성이 혼합되어 만들어내는 '미세한 선택의 순간'을 담고 있는 제품을 구상하였다. 그는 이미 오브젝트라는 브랜드를 구체화하고 있었으며, 브랜드의 프로모션을 위해 같은 이름의 잡지 창간을 앞두고 있기도 했다.

❾ 오브젝트, 2019
Object

조현은 종이에 머물러 있는 그래픽(Flat)이 사물화(Form)되어 쓰임(경험)의 가치가 더해지는 순간을 늘 준비하고 기다렸다. 오브젝트는 S/O 프로젝트 사명과 플랫-폼이라는 방법론의 '오브젝트'가 개념적인 의미를 벗어나 일상에서 만지고 사용할 수 있는 실재하는 물건으로서 조현의 이상과 꿈이 점철되는 지점에 있다. 오브젝트의 첫 번째 시리즈로 카페트를 제작했는데, 「에이-레터」에 새로운 물성을 더해 카페트라는 제품으로 판매했다. 카페트는 고가임에도 가정과 기업에 비공식적이지만 빠른 입소문이 나 추가 생산을 진행하던 때가 2019년 8월쯤이다. 당시 그는 이 프로젝트를 주제로 개인전을 앞두고 있었으며 전시장 레이아웃의 설계와 목업 작업까지 끝낸 상태였다. 이 작업에 대해 이야기하는 그의 표정과 목소리의 톤을 통해 기대와 떨림, 약간은 상기된 모습이 고스란히 생각이 난다. 그저 그래픽 자체가 아름다워 '발밑에 깔고 써야 할 카페트를 다시 벽에 걸고 감상하는 태도로 경험해야 하는 게 아닌가' 하는 그와 나눈 농담들이 귓가를 맴돈다. 당장 이 다음의 시리즈를 눈으로 손으로 느낄 수 없다는 것이 아쉽다.

트로닉의 맥락

최성민
서울시립대학교, 서울

「FF 트로닉(이하 '트로닉')」은 2001년 무렵 예일대학교 미술대학원에서 조현이 디자인한 「트랜스 모노」에 내가 디자인한 이탤릭을 더해 2002년 완성된 활자체다. 2003년 베를린에 본사를 둔 활자 제조사 폰트폰트에서 정식 발매했고, 지금도 폰트숍 인터내셔널을 통해 판매되고 있다. 네 가지 굵기에 이탤릭까지 갖추고 50개 언어를 지원하는 본격 라틴 활자 패밀리이지만, 상업적으로 별 성공은 거두지 못했다. 이 디자인을 비평적으로 분석하는 작업도 아직 이루어지지 않았는데, 나는 「트로닉」이 진지하게 평가받을 가치가 있다고 생각하지만, 관련 당사자인 내가 그런 작업을 할 수는 없으니, 이 메모에서는 「트로닉」을 논하는 데 유익하게 고려할 만한 몇 가지 역사적 맥락을 개괄하는 것에 만족할 생각이다.

구성 문자로서 트로닉
「트로닉」은 필기 흔적을 일절 배제하고 간단한 기하학적 원리에 따라 구성한 활자체다. 획은 곡선 없이 수직선과 수평선, 45° 사선만으로 이루어졌다. 이탤릭 문자의 경사조차 한정된 요소들이 격자를 따라 계단처럼 지그재그 이동하며 생성하는 착시 효과를 통해 표현된다.

조현. 「FF 트로닉」
활자 견본(부분).
2011년.

초보자도 어렵지 않게 응용할 수 있고 디지털 기술로 처리하기도 쉬운 기하학적 구성이 오늘날 가장 흔한 활자 디자인 방법이 된 점은 놀랍지 않다. 그러나 서체를 수학적으로 해석하고 작도하려는 시도는 역사상 비교적 최근에야 나타난 현상이다. 초기 사례로는 17세기 말 프랑스 과학 한림원에서 개발한 '왕의 로만'이 흔히 꼽힌다. 20세기 전반기 유럽에서 요스트 슈미트, 헤르베르트 바이어, 쿠르트 슈비터스, 얀 치홀트 등 현대주의자들이 발표한 실험 문자 역시 구성적 성격을 드러냈다. 1960년대 말 빔 크라우얼이 제안한 '뉴 알파벳'이나 1990년대에 한국에서 안상수가 디자인한 「미르체」(1992년)와 「마노체」(1993년)도 이 범주에 속한다.

이들 사례에서 수학적 명료성은 계몽과 합리성이라는 가치를 표현하는 요소로 간주되었다. 오늘날 구성 문자에서 그런 정신을 읽는 이는 아마 드물 것이다. 하지만 유한해 보이는 요소들이 꾸준히 새로운 규칙과 조합을 찾아내는 모습은 여전히 매혹적이다. 각진 수직 수평 획을 조금 가는 사선으로 연결하는 「트로닉」도 그런 감각을 자극한다.

최근 들어 이 범주에 더해진 작품 중, 제임스 고긴의 「LL 프리즈마세트」(2017년)와 드리스 비바우터르스의 「펩」(2019년)은 특히 흥미롭다. 전자는 다양한 윤곽선 문자 버전이 독특하고, 후자는 색채를 활자의 속성으로 포함하는 '컬러 폰트' 기능이 새롭다.

격자 양식 활자로서 트로닉

「트로닉」 문자는 모두 단순한 격자를 바탕으로 구성되었다. 격자를 통해 문자 형태를 표현하는 방법은 컴퓨터 시대 이전부터 십자수나 벽면 타일, 전광판 등에 쓰이곤 했지만, 오늘날 이런 서체는 '픽셀 폰트'나 '비트맵 폰트'라는 이름으로 더 널리 통용되는 듯하다. 초기 컴퓨터 비트맵 시스템의 제약을 디자인에 활용한 예로는 주자나 리치코가 1980년대 중반에 디자인한 에미그레 폰트 시리즈가 대표적이다. 1990년대를 거치며 디지털 출판에는 벡터 형식 '윤곽선' 폰트가 쓰이게 됐고, 비트맵 폰트는 저해상도 화면용 활자로 제한됐다. 2000년대 초에 격자 활자는 기술적 해결책이 아니라 복고적 인상을 풍기는 양식적 선택이 됐다. 이를 인정하듯, 2001년에는 리치코 자신이 1980년대의 에미그레

비트맵 활자체를 벡터 형식으로 되살린 「로레스」 시리즈를 내놓기도 했다.

「트로닉」은 이와 같은 격자 양식 활자체 리바이벌의 흐름에 있었다. 2000년대 초 이후에는 이 범주에서 흥미로운 사례가 별로 나오지 않았지만, 최근 들어 모노타입 활자체 디자이너 오마가리 도시가 초기 '전자오락'에 쓰인 픽셀 문자를 연구해 펴낸 책 『아케이드 게임 타이포그래피』(2019년)가 인기를 끈 사실로 보건대, 극심한 제약 조건에서 펼쳐지는 변주의 재미는 여전한 듯하다.

장치 기반 활자로서 트로닉

「트로닉」은 조현이 미국 뉴헤이븐 모처에서 팩스로 문서를 보내고 받은 전송 확인서의 저해상도 출력 문자에 바탕을 둔다. 확인서가 정확히 어떤 팩스에서 나왔는지는 모르지만, 원본 문자는 해당 팩스 기계에 내장된 비트맵 문자가 감열지 출력을 거치며 왜곡된 형태를 띠었을 것이다. 이에 쓰인 비트맵 문자는 우리가 아는 디지털 폰트처럼 이 컴퓨터에서 저 컴퓨터로 쉽게 옮겨 쓸 수 있는 독립 소프트웨어가 아니라, 해당 기기에 마치 붙박이처럼 내장된 데이터였을 것이다.

텍스트 표출이 필요한 전자 장치에는 고유한 문자 정보가 내장되곤 하는데, 이들 서체는 대체로 기계적 제약에 맞춰 최소한의 가독성만 확보한 투박한 특징을 보인다. 그러나 이런 기계적 단순성과 장치별 특성이 바로 여러 디자이너를 매료시키고 파생 활자체를 낳은 요소다. 예컨대 스위스 디자이너 코르넬 빈들린은 현금 인출기(「FF 스크린 매트릭스」, 1993년), 도트 프린터(「FF 도트 매트릭스」, 1994년), 베를린 공항 탑승 안내판(「FF 게이트웨이」, 1997년), 수하물 꼬리표(「FF 러기지태그」, 1997년), 비디오 게임 콘솔(「벡트렉스」, 1999년) 등 다양한 장치에 고유한 문자를 디지털 폰트로 해석해 발표했다. 이들이 공통으로 보여 주는 일종의 '기계 미학'은 「트로닉」에서도 분명히 확인된다. 장치에 특유한 기술적 조건이 빚어내는 서체 변화, 구성적 명료성이 창출하는 불완전하고 불규칙한—전도된 의미에서 '유기적'인—질감 등이 그런 미학을 뒷받침한다.

장치 기반 문자를 활자화하는 작업은 유한한 천연 자원을 채굴하는 일과도 같아서, 가용 자원 (차용할 만한 문자)은 언젠가 바닥을 드러낼 수밖에

없다. 점점 많은 장치가 iOS나 안드로이드 같은 공통 운영 체제를 바탕으로 작동하고, 같은 디지털 폰트로 문자 정보를 표출하는 상황에서, 자원 고갈은 한층 가속한다. 지난 10여 년 사이에 이 범주에서 흥미로운 사례는 본 기억이 없다.

한국인이 디자인한 라틴 활자체로서 트로닉

한국어 또는 한글 타이포그래피와 구별해, 한국인 디자이너가 외래 문자로 창작한 타이포그래피의 역사를 생각해 볼 만하다. 한글 활자체에 포함된 한글 외 (로마자나 숫자) 글리프의 디자인도 흥미로운 연구 주제겠고, 기업이나 상품 로마자 로고타이프, 포스터나 책 표지에 쓰인 한자나 라틴 알파벳 레터링도 이런 맥락에서 검토해 볼 수 있겠다. 나아가, 한국인이 디자인한 라틴 알파벳 활자체도 살펴볼 수 있을 것이다. 이런 연구를 통해 어쩌면 우리는 어설픈 이해와 모방에서 창의적 해석과 실질적 공헌에 이르는 풍부한 역사를 통찰할 수 있을지도 모른다.

월간 『디자인』 2004년 2월 호에는 '한국 디자이너가 개발한 영문 폰트, 해외 첫 로열티 계약'이라는 제호로 「트로닉」에 관한 기사가 실렸다. 그렇게 맺은 계약에 따라 실제로 들어온 로열티가 얼마나 되는지는 잘 모른다. 아마 무시할 만한 수준이었을 것이다. 「트로닉」의 국제 시장 발매에 의미가 있었다면, 그 의미는 아마 상징적인 쪽에 가까울 것이다. 그러나 최근에는 충실하고 독창적인 라틴 활자체로 국제적으로 인정받는 한국인 디자이너도 적지 않다. 김정훈, 노은유, 양희재, 윤민구, 이노을, 이정명, 함민주 등이 떠오르는데, 이 목록은 금세 자라날 수도 있다. 「트로닉」은 이런 흐름의 첫머리에—다소 고립된 모습으로나마—자리 잡고 있다.

개인 필체로서 트로닉

활자체는 본성상 공적 성격을 띤다. 개인 필체를 바탕으로 만든 작품이라 해도, 일단 활자체로 나오는 순간 사적 성격을 잃고 누구나 목소리를 실을 수 있는 매체가 된다. 그러나 어떤 활자체는 디자이너의 개성과 불가분한 연상 관계를 맺기도 한다. 네빌 브로디가 만든 활자체가 그렇고, 제프리 키디, P. 스콧 머켈라, 폴 엘리먼, 카를 나브로의

활자체도 그렇다. 안상수체도 얼마간은 이런 성격을 띤다. 아무튼, 안상수 본인만큼 안상수체를 잘 쓰는 디자이너는 없는 듯하다. 그의 활자체를 쓰는 이상, 결과물에서 '안상수'의 흔적을 지우기는 쉽지 않다.

「트로닉」에도 이렇게 개인적인 성격이 있다. 사적이거나 유기적인 형태가 아니라 기하학적이고 기계적인 서체인데도 그렇다. 그래픽 디자이너 조현은 「트로닉」을 즐겨 썼고, 이 활자의 특징을 누구보다 잘 활용했다. 폰트숍 홈페이지에 게시된 「트로닉」 사용 작품 사례(많지는 않다!)와 조현 자신의 작품을 비교해 보면 알 수 있다. 전자에서 「트로닉」은 여느 비트맵 양식 활자체로 바꿔 써도 큰 차이가 없을 듯한 인상이다. 그러나 후자에서는 대체 불가능한 개성을 명확히 드러낸다. 어떤 의미에서, 「트로닉」을 쓰면 어쩔 수 없이 조현과 경쟁하는 처지가 되고 만다. 내가—공동 창작자인데도— 정작 이 활자를 한 번도 쓰지 않은 데는 이유가 있다. 「트로닉」은 이른바 '시대에 구애받지 않는' 디자인과 거리가 있지만, 누구든 이 활자체를 새롭게, 즉 조현과 다른 방식으로 사용하려면 시간이 좀 더 필요할 것 같다.

조현. 「트로닉」의 전신인 「트랜스 모노」를 이용해 만든 포스터. 2001년경.

조현. 디자인. 50

추모 전시
2019. 12. 13. – 14. 10:00 – 18:00
두성종이 인더페이퍼 갤러리 2층

추모 행사
2019. 12. 12. 17:30
두성종이 인더페이퍼 갤러리 1층
진행: 김경선
18:00 시작
18:05 about 조현 (이지혜)
18:10 추모영상 (이철민)
18:20 기억의 말 (이철민, 이종국, 최성민,
 조민석, 신소연, 서기훈)
18:55 감사의 말씀 (동생 조정욱, 큰아들 조영훈)
19:10 추모공연 (정신+사이이다, 황애리)
19:30 끝

포스터에 사용된 이미지: 김두섭
추모 전시 사진: 이호승

"브랜딩이다 뭐다 얘기하지만
 결국 타이포그래피를 입체화하는 게
 아닐까 싶어요. 플랫한 것은
 입체적으로 만들고 입체적인 것은
 반대로 플랫한 방식을 넣고요.
 타이포그래피는 명료해요.
 이미지가 불러오는 오해가 없잖아요.
 내용을 직접 전달하는 매체니까요.
 그리고 아름답죠."

『타이포그래피 서울』. 2013년 2월.

"S/O 프로젝트 구성원의 미래가
저의 미래라고 생각해 이들을 좋은
디자이너로 양성하는 것이 목표입니다.
이웃 디자이너들과 함께 상생할 수 있는
프로그램을 만들어 현실화하는 게 꿈이고요."

월간 『디자인』. 2016년 6월.

"지금의 화두는 결국 '지속가능성'이라고 생각해요.
학교도, 회사도, 스튜디오도 모두 마찬가지죠.
단순히 졸업생을, 디자이너를 배출하는 데서
역할이 그쳐서는 안 됩니다. 어떻게 하면 그들이
나가서도 잘할지, 잘살 수 있을지 고민해야겠죠."

『K-Arts』. 2017년 1월.

"저는 무엇이든지 수집합니다.
메모도 붙여놓고 오브제도 붙여놓고,
그렇게 작업들을 정기적으로
정리하고 분류하면서 영감을 받습니다.
결과적으로만 보면 어떤 종이 한 장이
영감을 준 것이지만 거기엔
관심을 어떻게 확장할 것인가
계속 고민한 시간이 담겨 있는 것이죠."

『K-Arts』. 2017년 1월.

"가만히 있다가 번뜩 떠오르는 아이디어를 영감이라고
말하는 사람이 있는데, 저는 그렇게 생각하지 않습니다.
스스로 움직이지 않으면 영감은 오지 않아요.
무언가를 시작해야 돼요. 저는 스타크래프트를 할 줄
모르지만 게임 속 환경을 보며 깨달았어요.
캐릭터가 움직이는 만큼 주변이 밝아지면서 앞에
무엇이 있는지 볼 수 있더라고요. 앞이 깜깜하다고
무서워서 가만히 있으면 아무것도 볼 수 없어요.
그런데 조금만 움직이면 새로운 가능성을 발견할 수
있죠. 영감을 찾는 방법이 이와 비슷하다고 생각해요."

월간 『디자인』. 2014년 6월.

학회

학회 규정

논문 투고 규정

목적
이 규정은 본 학회가 발간하는 학술지『글짜씨』
투고에 대한 사항을 정함을 목적으로 한다.

투고 자격
『글짜씨』에 투고 가능한 자는 본 학회의 정회원과
명예회원이며, 공동 연구자도 동일한 자격을
갖추어야 한다.

논문 인정 기준
『글짜씨』에 게재되는 논문은 미발표 원고를 원칙으로
한다. 다만, 본 학회의 학술대회나 다른 심포지움
등에서 발표했거나 대학의 논총, 연구소나 기업
등에서 발표한 것도 국내에 논문으로 발표되지
않았다면 출처를 밝히고『글짜씨』에 게재할 수 있다.

투고 유형
『글짜씨』에 게재되는 논문의 유형은 다음과 같다.
1 연구 논문: 타이포그래피 관련 주제에 대해
　이론적 또는 실증적으로 논술한 것
　예: 가설의 증명, 역사적 사실의 조사 및 정리,
　잘못된 관습의 재정립, 제대로 알려지지 않은
　사안의 재조명, 새로운 관점이나 방법론의
　제안, 국내외 타이포그래피 경향 분석 등
2 프로젝트 논문: 프로젝트의 결과가
　독창적이고 완성도를 갖추고 있으며,
　전개 과정이 논리적인 것
　예: 실용화 된 대규모 프로젝트의 과정 및
　결과 기록, 의미있는 작품활동의 과정 및
　결과 기록 등

투고 절차
논문은 다음과 같은 절차를 거쳐 투고, 게재할 수 있다.
1 학회 사무국으로 논문 투고 신청
2 학회 규정에 따라 작성된 원고를 사무국에 제출
3 심사료 60,000원을 입금
4 편집위원회에서 심사위원 위촉, 심사 진행
5 투고자에게 결과 통지

(결과에 이의가 있을 시 이의 신청서 제출)
6 완성된 원고를 이메일로 제출,
　게재비 140,000원 입금
7 학술지는 회원 1권, 필자 2권 씩 우송
8 학술지 발행은 6월 30일, 12월 31일 연2회

저작권, 편집출판권, 배타적발행권
저작권은 저자에 속하며,『글짜씨』의 편집출판권,
배타적발행권은 학회에 영구 귀속된다.

[규정 제정: 2009년 10월 1일]
[개정: 2020년 4월 17일]

논문 작성 규정

작성 방법
1 원고는 편집 작업 및 오류 확인을 위해 TXT/
　DOC 파일과 PDF 파일을 함께 제출한다.
　특수한 경우 INDD 파일을 제출할 수 있다.
2 이미지는 별도의 폴더에 정리하여 제출해야 한다.
3 공동 저술의 경우 제1연구자는 상단에 표기하고
　제2연구자, 제3연구자 순으로 그 아래에 표기한다.
4 초록은 논문 전체를 요약해야 하며, 한글
　기준으로 800글자 안팎으로 작성해야 한다.
5 주제어는 3개 이상, 5개 이하로 수록한다.
6 논문 형식은 서론, 본론, 결론, 주석, 참고문헌을
　명확히 구분하여 작성하는 것을 기본으로 하며,
　연구 성격에 따라 자유롭게 작성할 수도 있다.
　그러나 반드시 주석과 참고문헌을 수록해야 한다.
7 외국어 및 한자는 원칙적으로 한글로 표기하고
　뜻이 분명치 않을 때는 괄호 안에 원어 또는
　한자로 표기한다. 단, 처음 등장하는 외국어
　고유명사의 표기는 한글 표기(외국어 표기)로
　하고 그 다음부터는 한글만 표기한다.
8 각종 기호 및 단위의 표기는 국제적인
　관용에 따른다.
9 그림이나 표는 고해상도로 작성하며, 그림 및
　표의 제목과 설명은 본문 또는 그림, 표에 함께
　기재한다.
10 참고 문헌의 나열은 매체 구분 없이 한국어,
　중국어, 영어 순서로 하며 이 구분 안에서는
　가나다순, 알파벳순으로 나열한다. 각 문헌은

저자, 논문명(서적명), 학술지명(저서일 경우 해당없음), 학회명(출판사명), 출판연도 순으로 기술한다.

분량
본문 활자 10포인트를 기준으로 표지, 차례 및 참고문헌을 제외하고 6쪽 이상 작성한다.

인쇄 원고 작성
1 디자인된 원고를 투고자가 확인한 다음 인쇄한다. 원고 확인 후 원고에 대한 책임은 투고자에게 있다.
2 학회지의 크기는 171×240mm로 한다. (2013년 12월 이전에 발행된 학회지의 크기는 148×200mm)
3 원고는 흑백을 기본으로 한다.

[규정 제정: 2009년 10월 1일]
[개정: 2020년 4월 17일]

논문 심사 규정

목적
본 규정은 한국타이포그라피학회 학술지 『글짜씨』에 투고된 논문의 채택 여부를 판정하기 위한 심사 내용을 규정한다.

논문 심사
논문의 채택 여부는 편집위원회가 심사를 실시하여 다음과 같이 결정한다.
1 심사위원 3인 중 2인이 '통과'를 판정할 경우 게재할 수 있다.
2 심사위원 3인 중 2인이 '수정 후 게재' 이상의 판정을 하면 편집위원회가 수정 사항을 심의하고 통과 판정하여 논문을 게재할 수 있다.
3 심사위원 3인 중 2인이 '수정 후 재심사' 이하의 판정을 하면 재심사 후 게재 여부가 결정된다.
4 심사위원 3인 중 2명 이상이 '게재 불가'로 판정하면 논문을 게재할 수 없다.

편집위원회
1 편집위원회의 위원장은 회장이 위촉하며,
편집위원은 편집위원장이 추천하여 이사회의 승인을 받는다. 편집위원장과 위원의 임기는 2년으로 한다.
2 편집위원회는 투고 된 논문에 대해 심사위원을 위촉하고 심사를 실시하며, 필자에게 수정을 요구한다. 수정을 요구받은 논문이 제출 지정일까지 제출되지 않으면 투고의 의지가 없는 것으로 간주한다. 또한 제출된 논문은 편집위원회의 승인을 얻지 않고 변경할 수 없다.

심사위원
1 『글짜씨』에 게재되는 논문은 심사위원 3인 이상의 심사를 거쳐야 한다.
2 심사위원은 투고된 논문 관련 전문가 중에서 논문편집위원회의 결정에 따라 위촉한다.
3 논문심사의 결과는 아래와 같이 판정한다. 통과 / 수정 후 게재 / 수정 후 재심사 / 불가

심사 내용
1 연구 내용이 학회의 취지에 적합하며 타이포그래피 발전에 기여하는가?
2 주장이 명확하고 학문적 독창성을 가지고 있는가?
3 논문의 구성이 논리적인가?
4 학회의 작성 규정에 따라 기술되었는가?
5 국문 및 영문 요약의 내용이 정확한가?
6 참고문헌 및 주석이 정확하게 작성되었는가?
7 제목과 주제어가 연구 내용과 일치하는가?

[규정 제정: 2009년 10월 1일]
[개정: 2013년 3월 1일]

연구 윤리 규정

목적
본 연구 윤리 규정은 한국타이포그라피학회 회원이 연구 활동과 교육 활동을 하면서 지켜야 할 연구 윤리의 원칙을 규정한다.

윤리 규정 위반 보고
회원은 다른 회원이 윤리 규정을 위반한 것을 인지할 경우 해당자로 하여금 윤리 규정을 환기시킴으로써 문제를 바로잡도록 노력해야 한다. 그러나 문제가

바로잡히지 않거나 명백한 윤리 규정 위반 사례가 드러날 경우에는 학회 윤리위원회에 보고할 수 있다. 윤리위원회는 문제를 학회에 보고한 회원의 신원을 외부에 공개해서는 안 된다.

연구자의 순서
연구자의 순서는 상대적 지위에 관계없이 연구에 기여한 정도에 따라 정한다.

표절
논문 투고자는 자신이 행하지 않은 연구나 주장의 일부분을 자신의 연구 결과이거나 주장인 것처럼 논문에 제시해서는 안 된다. 타인의 연구 결과를 출처를 명시함과 더불어 여러 차례 참조할 수는 있을지라도, 그 일부분을 자신의 연구 결과이거나 주장인 것처럼 제시하는 것은 표절이 된다.

연구물의 중복 게재
논문 투고자는 국내외를 막론하고 이전에 출판된 자신의 연구물(게재 예정인 연구물 포함)을 사용하여 논문 게재를 할 수 없다. 단, 국외에서 발표한 내용의 일부를 한글로 발표하고자 할 경우 그 출처를 밝혀야 하며, 이에 대해 편집위원회는 연구 내용의 중요도에 따라 게재를 허가할 수 있다. 그러나 이 경우, 연구자는 중복 연구실적으로 사용할 수 없다.

인용 및 참고 표시
1. 공개된 학술 자료를 인용할 경우에는 정확하게 기술해야 하고, 반드시 그 출처를 명확히 밝혀야 한다. 개인적인 접촉을 통해서 얻은 자료의 경우에는 그 정보를 제공한 사람의 동의를 받은 후에만 인용할 수 있다.
2. 다른 사람의 글을 인용할 경우에는 반드시 주석을 통해 출처를 밝혀야 하며, 이러한 표기를 통해 어떤 부분이 선행 연구의 결과이고 어떤 부분이 본인의 독창적인 생각인지를 독자가 알 수 있도록 해야 한다.

공평한 대우
편집위원은 학술지 게재를 위해 투고된 논문을 저자의 성별, 나이, 소속 기관 및 어떤 선입견이나 사적인 친분과 무관하게 오직 논문의 질적 수준과 투고 규정에 근거하여 공평하게 취급하여야 한다.

공정한 심사 의뢰
편집위원은 투고된 논문의 평가를 해당 분야의 전문적 지식과 공정한 판단 능력을 지닌 심사위원에게 의뢰해야 한다. 심사 의뢰 시에는 저자와 지나치게 친분이 있거나 지나치게 적대적인 심사위원을 피함으로써 가능한 한 객관적인 평가가 이루어질 수 있도록 노력한다. 단, 같은 논문에 대한 평가가 심사위원 간에 현저하게 차이가 날 경우에는 해당 분야 제3의 전문가에게 자문을 받을 수 있다.

공정한 심사
심사위원은 논문을 개인적인 학술적 신념이나 저자와의 사적인 친분 관계를 떠나 공정하게 평가해야 한다. 근거를 명시하지 않은 채 논문을 탈락시키거나, 심사자 본인의 생각과 상충된다는 이유로 논문을 탈락시켜서는 안 되며, 심사 대상 논문을 제대로 읽지 않고 평가해도 안 된다.

저자 존중
심사위원은 전문 지식인으로서의 저자의 인격과 독립성을 존중해야 한다. 평가 의견서에는 논문에 대한 자신의 판단을 밝히되, 보완이 필요한 부분에 대해서는 그 이유도 함께 상세하게 설명해야 한다. 정중하게 표현하고, 저자를 비하하거나 모욕적인 표현은 삼간다.

비밀 유지
편집위원과 심사위원은 심사 대상 논문에 대한 비밀을 지켜야 한다. 논문 평가를 위해 특별히 조언을 구하는 경우가 아니라면 논문을 다른 사람에게 보여주거나 논문 내용을 놓고 다른 사람과 논의하는 것도 바람직하지 않다. 또한 논문이 게재된 학술지가 출판되기 전에 저자의 동의 없이 논문의 내용을 인용해서는 안 된다.

윤리위원회의 구성과 의결
1. 윤리위원회는 회원 5인 이상으로 구성되며, 위원은 논문편집위원회의 추천을 받아 회장이 임명한다.

2 윤리위원회에는 위원장 1인을 두며,
 위원장은 호선한다.
3 윤리위원회는 재적위원 3분의 2의
 찬성으로 의결한다.

윤리위원회의 권한
1 윤리위원회는 윤리 규정 위반으로 보고된
 사안에 대해 증거자료 등을 통하여 조사를
 실시하고, 그 결과를 회장에게 보고한다.
2 윤리규정 위반이 사실로 판정되면 윤리위원장은
 회장에게 제재 조치를 건의할 수 있다.

윤리위원회의 조사 및 심의
윤리 규정을 위반한 회원은 윤리위원회의 조사에
협조해야 한다. 윤리위원회는 윤리 규정을 위반한
회원에게 충분한 소명 기회를 주어야 하며, 윤리 규정
위반에 대해 윤리위원회가 최종 결정할 때까지
해당 회원의 신원을 외부에 공개하면 안 된다.

윤리 규정 위반에 대한 제재
1 윤리위원회는 위반 행위의 경중에 따라서
 아래와 같은 제재를 할 수 있으며, 각 항의
 제재가 병과될 수 있다.
ㄱ 논문이 학술지에 게재되기 이전인 경우 또는
 학술대회 발표 이전인 경우에는 당해 논문의
 게재 또는 발표의 불허
ㄴ 논문이 학술지에 게재되었거나 학술대회에서
 발표된 경우에는 당해 논문의 학술지 게재 또는
 학술대회 발표의 소급적 무효화
ㄷ 향후 3년간 논문 게재 또는 학술대회 발표 및
 토론 금지
2 윤리위원회가 제재를 결정하면 그 사실을
 연구 업적 관리 기관에 통보하며, 기타
 적절한 방법으로 공표한다.

[규정 제정: 2009년 10월 1일]

김경선 (서울대학교, 서울)

건국대학교에서 그래픽 디자인을 공부하고 뒤이어 제일기획에서 일했다. 이후 런던예술대학교에서 『거리의 간판을 통해 도시 읽기』에 대한 논문을 쓰고 시각적으로 재해석하는 작업을 하였으며, 석사를 마친후 홍디자인에서 다양한 기업 프로젝트와 문화 행사 관련 디자인을 했고 지금은 서울대학교에 근무한다. 그래픽 디자인 클럽 진달래의 동인으로서, 2017년 AGI 회원이 되었고, '도시(CITY)와 타이포그래피: C()T()'를 주제로 한 《타이포잔치 2015: 4회 국제 타이포그래피 비엔날레》(2015)의 총감독을 맡았으며, 《진달래 도큐먼트 02: visual poetry 視集 금강산》(2006)을 기획했다.

김노을 (번역가, 삼척)

서울대학교에서 국제학 석사를 마치고 예술 및 과학 분야 전문 번역가로 활동 중이다. 한국타이포그라피학회의 『글짜씨』 16: 타입 디자인(2018)과 안그라픽스의 『타이포잔치 2017』(2017) 번역에 참여했다.

김영나 (테이블유니온, 서울·베를린)

한국과학기술대학, 홍익대학교, 네덜란드 타이포그래피 공방에서 수학했다. 《픽크라 그래픽 디자인 비엔날레》(2018), 《타이포잔치》(2013), 《브루노 비엔날레》(2012) 등의 큐레이터로 활동하였으며 그의 작업은 국립현대미술관, 국제갤러리, 서울시립미술관, V&A 런던, MoMA 뉴욕, 밀라노 트리엔날레 뮤지엄 등의 전시에 초대되었다.

김요한 (번역가, 서울)

뉴질랜드 코넬 경영대학원에서 수학하고 현재 서울에서 프리랜스 번역가로 예술, 인문학 분야에서 활동 중이다. 최근 앤드류 톰슨의 『아랍 에미레이트 연합내의 기독교와 문화유산』 번역에 참여하였다.

You Hyunsun (Workroom, Seoul)
You Hyunsun is a graphic designer and received a BFA in Visual Communication Design at Hongik University. She has been working as a designer for Workroom, after working for Studio fnt and AABB. Some of her works have been featured in 《No Space, Just a Place. Eterotopia》 (2020), 《TYPOJANCHI saisai 2018 – 2019》 (2018) and Int'l. Society of TypoGraphic Designers》 (2017). Also, she founded the project group Filed to explore the weird meeting between photography and graphic design and took part in the planning and design of 《Filed SS 2020》 (2019).

Yu Jeongmi (Daejeon University, Daejeon)
She is a professor in the Department of Communication Design at Daejeon University. She studied design at the Ewha Womans University and Central Saint Martins. Her books include 『Graphic Designers』 (2015), 『Design Meets Brand』 (2008), 『Magazine is a Magazine』 (2002), and 『Typography Dictionary』 (2012) as a co-author. She believes that improving the quality of life is the best thing in design, and since 2016, has been continuing the original city research project 《O! Daejeon》 with students.

김현미 (SADI, 서울)
SADI(삼성디자인교육원) 커뮤니케이션 디자인 전공 교수이다. 서울대학교와 로드아일랜드 스쿨 오브 디자인에서 그래픽 디자인을 공부했다. 저서로 『타이포그래피 송시』(2014), 『좋은 디자인을 만드는 33가지 서체이야기』(2007) 공저로 『바우하우스』(2019), 『타이포그래피 사전』(2012) 등이 있다. 타이포그래피에 대한 글을 쓰고 교육하는 것 외에 동서고금의 가치 있는 텍스트를 타이포그래피로 전달하는 책을 만들고 있다.

노은유 (노타입, 서울)
홍익대학교에서 『최정호의 한글꼴에 관한 연구』로 박사 학위를 받고 이를 바탕으로 『한글 디자이너 최정호』(2014)를 집필했다. 네덜란드 헤이그왕립예술학교에서 라틴 글자 디자인을 수학하고 돌아와 『옵티크』(2019)를 출시했다. 현재 노타입을 운영 중이다.

문장현 (제너럴그래픽스, 서울)
그래픽 디자이너. 동아시아의 전통과 문화에서 비롯된 형식과 형태에 관심을 갖고 있다. 디자인이라는 용어가 생기기 이전의 디자인을 관찰하고 이를 작업에 접목할 방식을 모색한다. 홍익대학교에서 시각 디자인을 전공했으며 안그라픽스에서 일했다. 현재는 상업 스튜디오인 제너럴그래픽스를 운영한다.

민병걸 (서울여자대학교, 서울)
2003년부터 서울여자대학교에서 그래픽 디자인을 가르쳐오고 있으며, 주로 문자 또는 모듈구조가 연계된 작업을 진행하고 있다.

민본 (홍익대학교, 서울)
홍익대학교 시각 디자인과 조교수. 레딩대학교 타입페이스 디자인 석사. 바르셀로나대학교 타이포그래피 석사. 서울대학교 시각 디자인 학사. 전 미국 애플 본사 수석디자인팀 디자이너. 전 미국 애플 본사 폰트팀 서체 디자이너. 전 한겨레신문사 기자직 디자이너.

박경식 (그래픽 디자이너, 경기)
SADI를 거쳐 미국 밀워키 인스티튜트 오브 아트 앤드 디자인에서 커뮤니케이션 디자인을 전공하고, 홍익대학교 국제디자인 전문대학원(IDAS)에서 디자인 경영으로 석사 학위를 받았다. 타이포그래피 전문지 『히읗』의 편집장으로 일했고, 『글짜씨』 등 국내외 학술지와 국제타이포그래피협회 등 학회의에서 논문을 발표했다. 2017년부터 포스터 페스티벌 《빌트포메트 국제 포스터 페스티벌》(2017 –)을 매년 공동 기획하고 있고, 《타이포잔치 2015: 4회 국제 타이포그래피 비엔날레》(2015)에 큐레이터 겸 작가로 참여했으며, SADI와 건국대학교에서 타이포그래피와 그래픽 디자인을 가르쳤다.

Noh Eunyou (NohType, Seoul)
Noh Eunyou received Ph.D., with the dissertation on "Choi Jeongho's Hangeul type design», from Hongik University and she published a book based on her dissertation (Ahn Graphics, 2014). She studied Latin Type Design at the Royal Academy of Arts, The Hague (Netherlands) and she released her typeface "Optique, (2019). She is currently running her type design studio NohType.

Park Ee-rang
(Hyundai Department Store, Seoul)
Park Ee-rang is a graphic designer and an art director. After studying graphic design, she established her creative studio in 2009, Studio Hertz, where she worked on a diverse range of projects on graphic identities, publications, etc. for companies, cultural institutions, or individuals. She also worked on all five volumes of "Encyclopedia Planches, published by Propaganda in 2017 after five years of work. She is actively engaged in lectures and self-discipline explorations. She is currently in charge of Brand Design as a creative director at Hyundai Department Store Group.
www.eepark.net

Park Youngha (Starbucks korea, Seoul)
He has served as Senior Designer at Karim Rashid Studio (NVC), Chief Designer at Interbrand korea, Design Director at SPC Group, and is currently in charge of design as Creative Director at Starbucks Korea. He has worked at global design agencies for a diverse range of clients and projects from broadcasting, product design, and branding to where he is currently realizing visual brand experiences for the glocal F&B sector. He participated in the «Gwangju Design Biennale» «Typojanchi»: The International Typography Biennale» as well as received numerous design awards such as Red Dot Award, TDC New York, etc. He taught Branding at the Kookmin University, Visual Hertz, and Visual Methodology at the Ewha Womans University.

Seok Jaewon
(Hongik University · AABB, Seoul)
Graphic Designer × Assistant Professor of Visual Communication Design at Hongik University × Director of AABB Group ★ MFA in Graphic Design from Yale University × BFA in Visual Communication Design from Hongik University ★ Fonts: ideology × Nerd × Old Campus × GoogleBet × Noto Remix and etc.

Sim Wujin (Sandoll Co., Ltd., Seoul)
Sim Wujin works in education and publishing, focusing on the design methodology of books and type. He is an author of "Manual of Body Text Typesetting, (2015), "Hiut, Magazine issues 6 and 7 (2014), and "Easy-to-Find InDesign Dictionary, (2011), and the co-author of "MicrotypoGraphy: Punctuation Marks and Numerals, (2015) and "Typography Dictionary, (2012). He published "Type Trace: A History of Modern Hangul Type, (2015) and translated "Hara Hiromu and Modern Typography: Type, Photo, and Print of Japan in the 1930s, (2017). He has been a type-director of Sandoll Jeongche, the representative body text font of Sandoll since 2017. He is currently the head of Sandoll Type Design Institute.

Yoon Choong-geun
(Graphic Designer, Seoul)
Yoon Choong-geun runs the design studio Choong-geun and works to place visual elements appropriately and beautifully on screen, through space, and in time. He has been questioning what is taken for granted in society and works on visualizing it through typography. He is interested in history, Hangeul (Korean Alphabet), and writing. Recently, he has become interested in points where English is ok but Hangeul is not (or vice versa), and the attitude of how Koreans experience Hangeul and English differently. He participated in exhibitions such as "Typojanchi 2019» and «100 Films 100 Posters, (2020).

박영하 (스타벅스 코리아, 서울)
뉴욕 카림 라시드 스튜디오 책임디자이너,
인터브랜드 한국법인 수석디자이너,
SPC그룹 디자인디렉터 등을 거쳐 현재
스타벅스 코리아의 크리에이티브 디렉터로서
디자인을 총괄하고 있다. 방송, 제품디자인,
브랜딩 등 글로벌 디자인 전문 에이전시에서
다양한 클라이언트 프로젝트를 진행했고
국내외 F&B 대기업 인하우스에서 브랜드의
시각적인 경험을 만들어오고 있다.
《광주디자인비엔날레》《타이포잔치: 국제
타이포그래피 비엔날레》 등에 참가했으며
레드닷, TDC 뉴욕 등 유수의 해외 디자인
어워드에서 수상했다. 국민대학교
조형대학에서 브랜딩과 이화여자대학교
디자인대학원에서 시각화방법론을 가르쳤다.

박이랑 (현대백화점, 서울)
그래픽 디자이너이자 아트 디렉터이다.
시각 디자인을 공부하고 2009년 독립 디자인
스튜디오 스튜디오 헤르쯔를 설립하여
기업, 문화 기관 혹은 개인의 그래픽
아이덴티티, 홍보물, 출판물 등을 디자인했다.
동시에 독립출판사 스윔퍼블리셔스를
설립하여 책을 기획하고 출판하기도 하였으며
프로파간다가 2017년 출간한 『백과전서
도판집』 전 5권을 5년에 걸쳐 작업한 바 있다.
현재는 현대백화점 디자인팀 브랜드 디자인
총괄로 회사의 주요 아이덴티티를 기획 및
총괄하여 개발하였으며 주요 브랜드 캠페인과
그래픽 전반을 담당하여 일하고 있다.
www.eepark.net

석재원 (홍익대학교·에이에이비비, 서울)
그래픽 디자이너 × 홍익대학교 시각 디자인과
조교수 × 에이에이비비 디렉터 ★ 예일대학교
그래픽 디자인 석사 × 홍익대학교 시각 디자인
학사 ★ 서체 작업: 이데올로기 × 너드 ×
올드 캠퍼스 × 구글벳 × 노토 리믹스 등

심우진 (산돌, 서울)
책과 활자의 디자인 방법론에 중점을 둔 교육과
출판에 집중하고 있다. 저서로 『찾아보는 본문
조판 참고서』(2015), 타이포그래피 교양지
『히읗』 6호, 7호(2014), 『찾기 쉬운 인디자인
사전』(2011), 공저로 『마이크로 타이포그래피』
(2015), 『타이포그래피 사전』(2012)이 있으며,
역서로 『하라 히로무와 근대 타이포그래피:
1930년대 일본의 활자·사진·인쇄』(2015)가
있다. 2017년부터 타입 디렉터로서 산돌을
대표하는 본문 활자인 『정체』를 개발하고
있으며, 현재 산돌연구소장을 맡고 있다.

유정미 (대전대학교, 대전)
대전대학교 커뮤니케이션 디자인학과 교수이다.
이화여자대학교와 센트럴세인트마틴스에서
디자인을 공부했다. 저서로 『그래픽디자이너』
(2015), 『디자인이 브랜드와 만나다』(2008),
『잡지는 매거진이다』(2002), 공저로
『타이포그래피 사전』(2012) 등이 있다.
삶의 질을 높이는 일이 디자인의 최고선이라고
믿으며 2016년부터 학생들과 원도심 리서치
프로젝트 《오!대전》을 이어오고 있다.

Moon Janghyun (General Graphics, Seoul)
Graphic designer Moon Janghyun has
long been interested in formats and
forms inspired by the traditions and
cultures of East Asia. Based on his
observations of designs created even
before the emergence of the term design,
he sought ways to graft these elements
into modern-day design processes.
He majored in Visual Communication
Design at Hongik University in Korea and
worked at Ahn Byunggeol design
based design and publishing house.
Currently, he is the president of General
Graphics, a commercial design studio
that he founded in 2011.

Na Kim (Table Union, Seoul · Berlin)
Studied at the Seoul National University
Of Science And Technology, Hongik
University, and Werkplaats Typografie.
She was a curator of the 《Fikra Graphic
Design Biennial》(2018), 《International
Biennial of Graphic Design Brno》(2012),
and 《Typojanchi》(2013), and her work
was invited to exhibitions such as
the MMCA, kukje Gallery, SeMA,
V&A London, MoMA New York, and
the Triennale di Milano Design Museum.

Mikie Jae
(Translator · Freelance Artist,
Seoul · Toronto)
Attended Toronto's Ryerson School of
Creative Industries with a focus in
Business and Professional Communi-
cations. Currently living in Seoul as
a freelance designer and video artist.

Min Byunggeol
(Seoul Women's University, Seoul)
taught graphic design
at seoul women's university since 2003.
He explores the visual resonance of
modular structures and typeface.

Lee Noheul
(Type Designer · lo-ol foundry, Geneva)
Passionated by type design, Lee Noheul
graduated from the Type and Media
program at the KABK, The Hague.
Currently working as a multi-script type
foundry, she is a partner of lo-ol type
foundry, a studio based in Switzerland.
She won the 6th Bang Il Young Cultural
Foundation Fund Competition for Hangul
typeface and received a gold prize
from Morisawa type competition 2019.

Min Bon (Hongik University, Seoul)
Assistant Professor, Hongik University
Visual Communication Design /
University of Reading, MA in Typeface
Design / University of Barcelona, MFA
in Typography: Discipline & Uses /
Seoul National University, BFA in Visual
Communication Design / Former Designer,
Apple Design Team, Apple Inc. /
Former Type Designer, Font Team,
Apple Inc. / Former Journalist Designer,
Hankyoreh Newspaper

유현선 (워크룸, 서울)
홍익대학교에서 공부했으며 스튜디오 에프엔티, 에이에이비비를 거쳐 워크룸의 디자이너로 일하고 있다. 《이 공간, 그 장소: 헤테로토피아》(2020), 《타이포잔치 사이사이 2018 – 2019》(2018), 《국제 타이포그래피 디자이너 소사이어티》(2017) 등의 전시에 참여했다. 또한 프로젝트 그룹 파일드를 만들어 사진과 그래픽 디자인의 기묘한 만남을 지속적으로 탐구하고 있고, 《파일드 SS 2020》(2019)를 기획·디자인했다.

윤충근 (그래픽 디자이너, 서울)
디자인 스튜디오 충근을 운영하며 화면, 공간, 시간 위에 시각적인 요소를 적절하고 아름답게 배치하는 일을 한다. 그는 역사, 한글, 글쓰기 등에 관심을 갖고 사회에서 당연하게 여겨지는 것들에 의문을 품고 이를 타이포그래피를 통해 시각화하는 작업을 해오고 있다. 최근에는 한국인이 한글과 영어를 다르게 대하는 태도에 관한 '영어는 되지만 한글은 안 되는(혹은 그 반대인)' 지점에 관심이 있다. 《100 Films 100 Posters》(2020), 《2019 타이포잔치》(2019) 등의 전시에 참여했다.

이건하 (그래픽하, 파주)
홍익대학교 대학원에서 시각 디자인을 전공하고 파주타이포그라피배곳 더배곳 과정을 마쳤다. 디자인 스튜디오 그래픽하를 운영하며 대학에서 타이포그래피를 가르친다. TDC, ADC, Graphis 등에서 수상했다.

이노을 (글자 디자이너·lo-ol foundry, 제네바)
국민대학교 대학원 커뮤니케이션 디자인, 네덜란드 헤이그 왕립예술학교 타입미디어 (Type and Media) 석사과정을 마쳤다. 대표 글꼴로는 「아리온(Areon)」, 「아르바나(Arvana)」가 있다. 로리스 올리비에와 lo-ol type foundry를 운영한다.

이병학 (한경대학교, 서울)
한경대학교 디자인 전공 조교수.

이지혜 (베르크, 서울)
서울을 기반으로 한 그래픽 디자이너 이지혜는 서울여자대학교에서 시각 디자인을 공부했다. 2005년 S/O 프로젝트에 입사 후 2019년까지 아트 디렉터로서 주요 프로젝트를 진행하였으며 타이포그래피를 기반으로 한 폭넓은 스펙트럼으로, 2015년 그래픽 디자인 스튜디오 베르크(WERK)를 설립하여 매우 공예적이고 경험적인 디자인을 이어가고 있다.

정영훈 (영남대학교, 서울)
홍익대학교에서 박사 과정 중이며, 안병학 선생님께 지도 받고 있다. 글자 형태에 변화를 주는 작업으로 꾸준히 자신만의 세계를 구축해 나가고 있으며, 특히 한글에 관심이 많다. 현재 실기활동 스튜디오를 운영하며, 영남대학교 시각 디자인과 겸임교수로 재직중이며, 타이포그래피와 타입 디자인을 가르치고 있다.

Lee Jihye (WERK, Seoul)
Lee Jihye, a graphic designer based in Seoul, graduated from Seoul Women's University majoring in Visual Communication Design. Since joining S/O Project in 2005, she directed various key projects as an art director where she developed a broad spectrum in typography. She founded graphic design studio, WERK, in 2015 and has been working on very crafty and experiential designs.

Lee Kunha (GRAPHICHA, Paju)
Lee Kunha majored in Visual Design at Hongik University graduate school and completed Paju Typography Institute (PaTI) Deobeagot. He runs a design studio called GRAPHICHA and teaches typography at a college. He won awards at TDC, ADC, Graphis and more.

Kymn Kyungsun (Seoul National University, Seoul)
After studied Visual Communication Design at Konkuk University, successively worked at an advertising company. At the company, Cheil Worldwide, he experienced a variety of design works, varying from flyers to brand identity. Soon after this job, he began to study M.A. Communication Design at Central Saint Martins in London. "Reading a City through Street Signs, is a dissertation. Coming back to Seoul and working in Hong Design led to many opportunities to work on diverse corporate projects and cultural events. Currently teach visual communication design at Seoul National University. in 2006, as a member of the graphic designers club, Jindallae, he conducted 《Jindallae Document 02: Visual Poetry—Kumgangsan》. In 2015, he directed 《Typojanchi 2015: The 4th International Typography Biennale》, with the theme of 'CITY' and Typography: C()T(). in 2017, became an AGI member.

Lee Byounghak (Hankyong National University, Seoul)
Assistant Professor, Hankyong National University

Kim Johan (Translator, Seoul)
Completed studies at Cornell Institute of Business and Technology, New Zealand. Currently active as a freelance translator in the fields of art and anthropology. Recently participated in translation of "Christianity in the United Arab Emirates Culture and Heritage, by Andrew Thompson.

Kim Noheul (Translator, Samcheok)
Graduated from Graduate School of International Studies, Seoul National University. Actively working in the field of art and science. Recently participated in translating 《Typojanchi 2017》 (Ahn Graphics, 2017) and 『LetterSeed』 16: Type Design (The Korean Society of Typography, 2016).

Fritz K.Park (Graphic Designer, Seoul)
Fritz K. Park studied Communication
Design at the Milwaukee Institute of Art
& Design (Milwaukee WI., USA, BFA) and
received his MFA in Design Management
from the International Design school
for Advanced Studies (IDAS) at Hongik
University in Seoul, Korea. He was
the editor for the 「Hiut」, a journal on
Korean typography (2012 – 2015) and
presented papers at ATypI (Association
Typographique International) and
the Korean Society of Typography among
others. He taught typography and graphic
design at SADI and Konkuk University.
He participated in the 《Typojanchi
2015: The 4th International Typography
Biennale》 (2015) as a curator and
an artist, also has been co-organizing
the poster festival, 《Weltformat Graphic
Design Festival》, every year since 2017.

Ham Minjoo (Type Designer, Seoul · Berlin)
Ham Minjoo studied Visual Communi-
cation at Seoul Women's University and
finished the MA Type and Media course
at the Royal Academy of Arts (KABK)
in The Hague, The Netherlands. With
monotype, she designed 「Seol Sans」,
which is a counterpart hangeul typeface
for latin typeface 「Neue Frutiger」 by Adrian
Frutiger. For retail fonts, she released
「Dunkel Sans」 and 「Blazeface Hangeul」.
In 2019, Minjoo Ham attended 《Typojanchi
2019: The 6th International Typography
Biennale》 as a curator.

Han Jaejoon
(Seoul Women's Unviersity, Seoul)
In order to attract and share the value of
Hangeul's characteristics and excellence,
he has been engaged in activities such
as developing typeface, research and
writing, planning exhibitions, presenting
works, and developing products.
He emphasizes that Hangeul is a new
type of communication system that has
never existed in human history. Through
《Hangeul, Teacher》 (2008) at the Paju
Publishing City and Gyeongbokgung
Palace, he threw a question about today
and tomorrow of Hangeul. The 《2009
Gwangju Design Biennale》 (2009) drew
the value of "Hunminjeongeum" and
"Sejong Ido" from the perspective of
design, and recently, he is seeking
the infinite scalability and possibilities
of Hangeul by creating a system of
combinations of consonants and vowels
that apply the principles of creating
Hangeul.

Hong Khia (Translator, Seoul)
Jennifer, Translator
Translate art (and everything else).
khiahong@gmail.com

Jung Younghun
(Yeungnam University, Seoul)
I am in the Ph.D. course at Hongik
University and learning from professor
Ahn Byunghak. Constantly building my
own world by changing the form of letters,
and especially interested in Hangeul. I am
currently running the 'Practical Activity'
studio and currently teaching typography
and type design as an adjunct professor in
the Department of Visual Communication
Design at Yeungnam University.

Kim Hyunmee (SADI, Seoul)
Kim Hyunmee is professor of Communi-
cation Design at SADI (Samsung Art &
Design Institute). She majored in Graphic
Design at Seoul National University and
RISD(Rhode Island School of Design).
She is an author of 「33 Essential Typefaces
for Good Design」 (2007), 「Ode to
Typography」 (2014) and co-author of
「Typography Dictionary」 (2012) and
「Bauhaus」 (2019) et al. Beyond teaching
and writing about typography she likes
to interpret the text of timeless value
in typography and book design.

박경식 (그래픽 디자이너, 서울)
밀워키 미술대학교에서 커뮤니케이션
디자인을 전공하고 홍익대학교 IDAS에서
디자인경영으로 석사학위를 받았다. 한국
타이포그래피 학회지 『히읗』의 편집장
(2012–2015)을 역임했고, 『히읗』 외에도
디자인 칼럼 등을 여러 매체에 기고하고
있다. 《타이포잔치 2015: 제4회 국제
타이포그래피 비엔날레》에 큐레이터로
참여했다.

함민주 (글자 디자이너, 서울 · 베를린)
서울여자대학교에서 시각디자인을 전공
하고 네덜란드 헤이그 왕립예술학교(KABK)
타이포미디어(Type and Media)에서
석사과정을 마쳤다. 모노타입과 협업하여
아드리안 프루티거(Neue Frutiger)의 대응
한글 『설 산스(Seol Sans)』를 디자인했고,
『둥켈산스(Dunkel Sans)』, 『블레이즈페이스
한글(Blazeface Hangeul)』 등을 발표했다.
《타이포잔치 2019: 제6회 국제 타이포그래피
비엔날레》에 큐레이터로 참가하였다.

한재준 (CBR Graphic, 서울)
한글의 가치와 아름다움을 함께 나누고자,
2014년부터 디자인 스튜디오 CBR Graphic을
운영했다. 글꼴 디자인과 연구하고 글쓰고
전시기획하고 작품발표 그리고 다양한
상품 개발 활동을 하고 있다. 그는 한글을
인류가 아직 경험한 적이 없는 새로운
소통체계(Die Neue
Sammlung)라고 강조한다. 그리고 파주
출판도시와 경복궁에서 열린 《한글이 스승
이다》(2008)를 통해 한글의 어제와 내일을
물었다. 그리고 《2009 광주디자인비엔날레》
(2009)에서는 디자인 관점으로 '훈민정음'과
'세종 이도'의 가치를 끌어냈고, 최근에는
한글 창제 원리에 바탕을 둔 한글
자음과 모음의 조합체계를 만들어 한글의
무궁무진한 확장성과 가능성을 찾고 있다.

홍키아 (번역가, 서울)
제니퍼, 번역가
예술을 (그리고 모든 것을) 번역한다.
khiahong@gmail.com

정용훈 (영남대학교, 서울)
홍익대학교에서 박사과정을 밟으며 안병학
교수에게 배우고 있다. 글자의 형태를 바꾸어
나만의 세상을 꾸준히 만들고 있고, 특히
한글에 관심이 많다. 현재 '실용적 활동'
스튜디오를 운영하고 있고, 그 외에도
영남대학교 시각디자인과에서 타이포그래피와
타입디자인을 겸임교수로 가르치고 있다.

김현미 (SADI, 서울)
SADI(삼성디자인교육원) 커뮤니케이션
디자인과 교수이다. 서울대학교에서 시각
디자인을 전공했고, 미국 RISD에서 그래픽
디자인으로 석사학위를 받았다. 『좋은
디자인을 만드는 33가지 서체 이야기』
(2007), 『타이포그래피 편지』(2014),
『타이포그래피 사전』(공저, 2012),
『바우하우스』(공저, 2019)
등을 집필했다.

acquainted with or hostile to the author should be avoided for fait assessment. However, when the assessments on the same paper show remarkable difference, another expert could be employed for consultation.

Fair Assessment
Judges should make a fair assessment of a paper regardless of their personal academic beliefs or the acquaintance with its author. They should not reject a paper without any supportive reasons or only because it is against their own opinion. They should not assess a paper before reading it properly.

Respect for the Author
Judges should respect the personality and individuality of authors as intellectuals. The assessment should include the evaluation of the judges, plus why they think which part of the paper needs revision if necessary. The evaluation should be delivered in respectful expression and free of any offense or insult to the author.

Confidentiality
The editors and judges should protect confidentiality of the submitted papers. A side from the case of consultation, it is not appropriate to show the papers to others or discuss the contents with others. It is not allowed to quote any part of the submitted papers before they are published in the journal.

Composition of the Ethics Commission and Election
1 The ethics commission is composed of more than five members. The commissioners are recommended by the working committee and appointed by the president.
2 The commission has one chief commissioner, who is elected by the commission.
3 The commission makes decisions by a majority of two-thirds or more.

Authority of the Ethical Commission
1 The ethical commission conducts investigation on the reported case in which the code of ethics was allegedly violated and reports the result to the president.
2 If the violation is proved true, the chief commissioner can ask the president for approval of sanctions against the member.

Investigation and Deliberation of the Ethical Commission
A member who allegedly violated the code of ethics should cooperate with the ethics commission in the investigation. The commission should give the member ample opportunity for selfdefense and should not reveal his or her identity until the final decision is made.

Sanctions for Violation of the Code of Ethics
1 The ethical commission can impose the sanctions below against those who violated the code of ethics. Plural sanctions can be enforced for a single case.
A If the paper is not published in the journal or presented at a conference yet, the paper is not permitted to be published or presented.
B If the paper is published in the journal or presented at a conference, the paper is retracted.
C The member is banned to publish the paper or to participate in the conference or in a discussion for the next three years.
2 Once the ethics commission decides to apply sanctions, the commission informs the decision to the institution which manages the researcher's achievements and announces the decision to the public in a proper way.

[Declaration: 1 October 2009]

screened by more than three judges.

2 The editorial board members appoint the judges among the experts on the subject of the submitted paper.

3 There are four assessment results: pass, acceptable after revision, reassessment required after revision, fail.

Assessment Criteria

1 Is the subject of the paper relevant to the tenets of the society and contributable to the advancement of typography?

2 Does the paper make a clear point and have academic originality?

3 Is the paper logically written?

4 Is the paper written according to the guidelines provided by the society?

5 Does the Korean and English summary exactly correspond to the paper?

6 Does the paper contain references and footnotes?

7 Do the title and keywords correspond with the content of the paper?

[Declaration: 1 October 2009]

The Code of Ethics

Purpose

The code of ethics below establishes the ethical framework for the members of Korean Society of Typography in doing their research and providing education.

Report of the Violation of the Code of Ethics

If a member of the society witnessed another member's violation of the code of ethics, he or she should tell the member about the code and try to rectify the fault. If the member does not remedy the wrong or the case of violation is flagrant, the witness can report to the ethics commission the case. The ethics commission should not reveal the identity of the reporter.

Order of Researchers

The order of researchers is determined by the level of contributors to the rsearch, regardless of their relative status.

Plagiarism

Authors should not represent any research results or opinions of others as their own original work in their papers. Results of other researches can be referred to in a paper several times when its source is clarified, but if any of the results are given as if they are the author's own, it is plagiarism.

Redundant Publication

Any works that are previously published (or soon to be published) in any foreign or domestic media cannot be published in the journal. An exceptional case can be made for work that was presented on foreign media when the author wants to publish part of it in the journal. In this case, the editorial board can approve its publication according to the significance of its content. But the author cannot use the publication as his or her double research achievements.

Quotation and Reference

1 When using the public research results, authors should accurately quote them and disclose their source. If the data is gained from a personal contact, it can be quoted only if the provider agrees to its use in the paper.

2 Authors should reveal the source through footnotes when quoting another author's language and expressions, by which the readers could distinguish the precedent research from the original thought developed by the author in the paper.

Equal Treatment

The editors of the journal should treat the submitted papers equally regardless of gender or age of the author, or the institution to which the author belongs. All the papers should be properly assessed only based on their quality and the rules of submission The assessment should not be affected by any prejudice or personal acquaintance of editors.

Appointment of Judges

The editorial board should commission as judges of a paper those who are with fairness and have expertise. Those who are closely

body, conclusion, footnotes and reference, parts that are clearly distinguished from each other. Papers of special types can be written in free style, but footnotes and references cannot be missed.

7 Chinese and other foreign words should be translated into Korean, when the meaning is not delivered clearly by Korean words only, the original words or Chinese characters can be put beside the Korean words in parenthesis. After the first appears with the foreign word in the form of a Korean word (the corresponding foreign word)', only the Korean word should be used in the rest of the paper.

8 Symbols and measures are to be written following the international standard practice.

9 Images and figures should be included in high-resolution. Captions should be included either in the body of the paper or on the image or figure.

10 References should be listed in order of Korean and English. All the works should be arranged in alphabetical order. Information of each work should include the name of the author, the title, the name of the journal (not applicable to books), the publisher, and the year of publication.

Length

Papers should be more than six pages in a 10-point font except for over, table of contents and references.

Printing

1 Once manuscript file is typeset, the corresponding author checks the layout. From this point, the author is accountable for the published paper and responsible for any error in it.

2 The size of the journal is 171×240mm (it was 148×200mm before December 2013).

3 The basic color is black for the printed papers.

[Declaration: 1 October 2009]
[Amendment: 17 April 2020]

Paper Assessment Policy

Purpose

The policy below defines the framework of the assessment practice at the Korean Society of Typography of papers submitted to 『LetterSeed』.

Paper Assessment Principles

Whether the paper is accepted or not is decided by the editorial board.

1 If two of three judges give a paper a 'pass,' the paper can be published in the journal.

2 If two of three judges consider a paper better than 'acceptable if revised,' the editorial board asks the author for a revision and publishes it if it meets the requirements.

3 If two of three judges consider a paper poorer than 'reassessment required after revision,' the paper has to be revised and the judges reassess to determine whether it is qualified to publish.

4 If more than two of three judges give a paper a 'fail, the paper is rejected to be published in the journal.

The Editorial Board

1 The chief of the editorial board is appointed by the president of the society and the chief of the editorial board recommends the editorial board members for the board of directors to approve. The chief and members of the editorial board serve a two year term.

2 The editorial board appoints the judges for a submited paper who will make the assessment and ask the author for revision if necessary. If the author does not send the revised paper until the given date, it is regarded he or she does not want the paper to be published. The submitted papers cannot be altered unless the author gets approval from the editorial board.

Judges

1 The papers should be assessed and

Korean Society of Typography Regulations

Regulations for Paper Submission

Purpose

These regulations are to establish a framework for paper submission to 『LetterSeed』, the journal published by the Korean Society of Typography.

Qualification of Authors

Only regular or honorary members of the society are qualified for paper submission to 『LetterSeed』. Co-authors should hold the same qualification.

Regulation for Acceptance

It is the principle that authors should not submit previously published work. However, if a paper has been presented at a conference of the society or symposiums or printed in journals of colleges, research centers or companies, but never published as a paper on any media in Korea, it can be published in 『LetterSeed』 when the author discloses the source.

Category of Papers

The categories for publication are as follows

1 Research papers: Papers that describe either empirical or theoretical studies on subjects related to typography. Example: proof of theory, research or organization of historic events, redefining tradition or culture, redefining past theories or events, offering new perspectives or methodology, analyzing typographic trends (both local and international)
2 Project reports: Full length reports of which the results are original and logically delivered. Example: archive of process and results of an actual large scale event, archive of process and results of a related artwork or project

Submission Procedure

Papers can be submitted and published following the procedure:

1 Authors apply at any time for paper submission via e-mail.
2 Authors submit the paper to the office according to the guidelines for paper submission.
3 Authors send 100,000 won for assessment fee.
4 The society appoints judges according to the procedure established by the editorial board.
5 The society notifies the author the result of the assessment (if there is any objection to the result, the author sends the statement of protest to the society).
6 The author sends the final version of the paper via e-mail and 100,000 won for publishing fee.
7 The author receives two volumes of the journal (regular members receive one volume).
8 The journal is published twice a year, on 30 June and 31 December.

Copyright, Publishing Rights, Editing Rights (for Content)

Authors retain copyright and grant the society right of editing and publication of the paper in 『LetterSeed』.

[Declaration: 1 October 2009]
[Amendment: 17 April 2020]

Guidelines of Writing a Paper

Preparation of Manuscript

1 The paper should be sent in the form of both TXT/DOC file and PDF file in order for the society to check errors in the paper and edit it. INDD files can be submitted in particular cases.
2 Image files should be submitted in a separate folder.
3 As to jointly written papers, the name of the main writer should be written at the top and the second and the third have to follow on the next lines.
4 The abstract, plus or minus 800 Korean characters, has to summarize the whole paper.
5 The number of keywords should be between three and five.
6 The paper should contain introduction,

society

"Some say a sudden idea out of nowhere is inspiration but I don't think so. Inspiration never shows up until doing something myself. We should start doing something. I don't play StarCraft but observed the game's setting and realized. Only when a character moves, it brightens up around and the character can see what's in front of it. We cannot see anything, standing still for fear of darkness. But just a little move discovers a new possibility. I think that is like how to find inspiration."

Monthly 『Design』. June 2014.

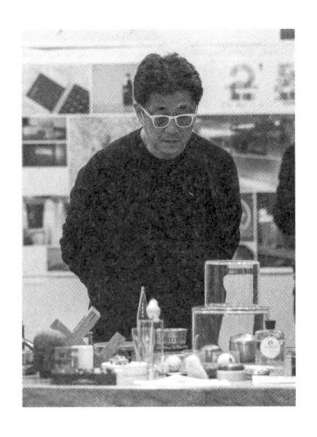

"I simply collect everything.
I put memos and objets everywhere and
regularly organize and classify the works.
That's how I am inspired. A piece of
paper seems to inspire me as a result but
it embraces the time for thinking how to
expand interests."

「K-Arts」. January 2017.

"I think the present topic is 'sustainability' after all.
All the same for schools, companies and studios.
We should do more than just producing graduates and
designers. How would they do their work and live well
after graduation—that's the issue."

『K-Arts』. January 2017.

Cho Hyun

"I see the future of S/O Project members as mine so it is my goal to foster them as good designers. My dream is to realize programs through which they can mutually grow up with neighboring desgienrs."

Monthly 『Design』. June 2016.

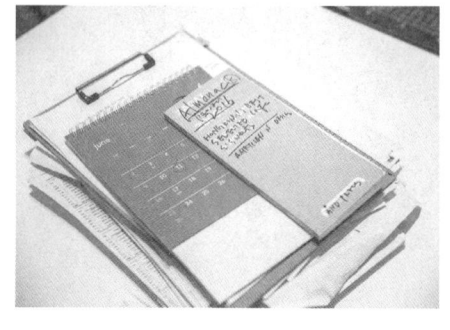

Cho Hyun. Design. 50

Memorial Exhibition
13–14 December 2019 10:00–18:00
2F, Doosung Paper Gallery

Memorial Ceremony
12. 12. 2019 17:30
1st floor, Doosung Paper Gallery
MC: Kymn Kyungsun
18:00 Opening
18:05 About Cho Hyun (Lee Jihye)
18:10 Memorial Video (Lee Cheolmin)
18:20 Eulogy (Lee Cheolmin, Lee Jongguk,
 Choi Sungmin, Jo Minseok,
 Shin Soyeon, Shur Kiheun)
18:55 Words of Gratitude
 (Younger brother Cho Jeongwook,
 Eldest son Cho Younghun)
19:10 Memorial performance
 (Jeong Sin+Saiida, Hwang Aeri)
19:30 End

Image used on poster: Kim Doosup
Photos of memorial exhibition: Lee Hoseung

"Everyone's talking about branding
but I think it is ultimately to make
typography a solid one. Making
the flat into solid and making
the solid into flat. Typography
is clear because it has no
misunderstanding as images do.
It is a direct media to deliver
messages. And beautiful."

『Typography Seoul』. February 2013.

CHO DESIGN 50
HYUN

12
13
14
december
2019

inthepaper
gallery

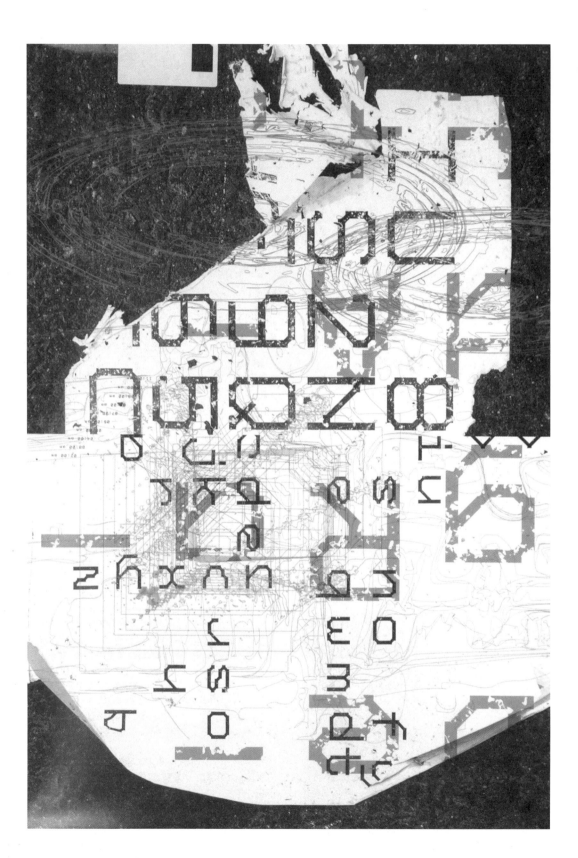

commonly display is also evident in 「Tronic」: the variations in the letterforms informed by the display technology specific to the device, and the imperfect and irregular visual texture created by constructive clarity—an inverted "organic" effect, as it were.

Appropriating device-specific letterforms for typefaces is akin to mining natural resources, and the available materials (exploitable letterforms) will be exhausted sooner or later. As more and more devices are running on the same operating system like iOS or Android, using the same digital fonts for their text display, the depletion may happen sooner than later. I do not recall any interesting addition to this category from the last decade.

Tronic as a Latin Typeface by a Korean Designer

Distinct from Korean typography, it might be possible to conceive a history of foreign-language typography by Korean designers. The design of non-Korean glyphs (like Latin or numerals) included in Korean typefaces could be an interesting subject; the logotypes for corporations or brands, and Chinese or Latin lettering on posters and book covers could be examined in this context. Furthermore, one could consider the Latin typefaces created by Korean designers. Studies like these might provide an insight into a rich history of misunderstandings, poor imitations, ingenious interpretations, and substantial contributions.

There was an article about "the first Latin font by Korean designers licensed overseas" in 『Design』, February 2004. The font was 「Tronic」, and I do not know how much royalty has been paid. The amount must be negligible, I presume. If there were any meaning to the release of 「Tronic」 in the international market, it would be more symbolic than anything else. Today, however, we are witnessing an increasing number of Korean designers who are internationally recognized for their substantial and original contributions to Latin typography: Kim Jeong Hoon, Noh Eunyou, Yang Heejae, Yoon Mingoo, Lee Noeul, Lee Jungmyung, and Ham Minjoo—and the list may grow quickly. 「Tronic」 is at the first of this line, even if as a rather isolated instance.

Tronic as a Personal Handwriting

By nature, a typeface has public dimensions. Its characters may be based on a person's handwriting, but once it is released as a typeface, it loses its personality and becomes a medium for anyone to express themselves. Some typefaces, however, seem to forge an inseparable association with their designers. Neville Brody's typefaces are a case in point; so are Jeffery Keedy's, P. Scott Makela's, Paul Elliman's, and Karl Nawrot's. You may say the same thing about Ahnsangsoo font. After all, I would argue, no other designers have treated the typeface better than Ahn Sang-soo himself. And you cannot easily erase the traces of "Ahn Sang-soo" as long as you are using his typeface in your work. 「Tronic」, too, has smilier personal traits. It is despite that the letterform is not personal or organic but geometric and mechanical. Cho Hyun the graphic designer used 「Tronic」 quite often, and he was able to express its characteristics better than anyone else could. This judgment will be supported by a comparison of any of the "fonts in use" examples published on the Font Shop website (there are only a few!) with his work: in the former, the text set in 「Tronic」 would appear as if it could have been in any other bitmap-inspired font; in the latter, it would be evident that the typeface is irreplaceable. In a sense, if you decided to use 「Tronic」 in your work, you are putting yourself in a position to compete with Cho Hyun. There is a good reason why I, a co-creator of the typeface, have never used it for myself. 「Tronic」 is far from being a "timeless" design, but it might take some time before anyone can use it in a fresh, non-Cho way.

Choi Hyun. a poster using 「Trans Mono」 before it became 「Tronic」. c. 2001.

construction—easy to apply for beginners and simple to process digitally—is one of the most commonplace ways of making letterforms today. Historically, however, attempts to interpret and draw letters according to mathematical principles have been a relatively recent phenomenon. An earlier example would be "romain du roi," developed at the Académie des Sciences in late-seventeenth-century France. Many of the experimental alphabets by interwar European modernists—Joost Schmidt, Herbert Bayer, Kurt Schwitters, and Jan Tschichold—also displayed constructed forms. The New Alphabet proposed by Wim Crouwel in the late 1960s, as well as Ahn Sang-soo's 1990s Korean typefaces such as 「Myrrh」 (1992) and 「Mano」 (1993), also belong to this category.

In these examples, the mathematical clarity was considered as an expression of the spirit of enlightenment and rationality. One would be hard-pressed to read the same ideas in today's constructed letters. It is, however, fascinating to see the seemingly finite elements still discovering new principles and combinations. 「Tronic」 evokes that feeling with the slightly thinner diagonals that joint the otherwise squarish vertical and horizontal strokes.

Notable among more recent contributions to this genre are 「LL Prismaset」 (2017) by James Goggin and 「Pep」 (2019) by Dries Wiewauters: the former for its various multiple-lined cuts, the latter for the "color font" technology that adds color as a type property.

Tronic as a Matrix-Based Typeface

「Tronic」's glyphs were constructed against a simple matrix. Today, this kind of letterform may be commonly called a "pixel font" or "bitmap font," although the technique of rendering letters on a matrix dates back to the times before computers, used in cross stitch patterns, wall tiling, or electronic display boards. An early example of type design that exploited the limitations of computer's bitmap display technology is a series of fonts designed by Zuzana Licko in the mid-1980s for Emigre. By the 1990s, the standard in typography for desktop publishing was vector-based "outline" fonts,

and the use of bitmap counterparts was limited to low-resolution onscreen display. By the early 2000s, the matrix-based typeface had become less a technical solution than a retro-tinged stylistic option. As if to acknowledge this, Licko herself released 「Lo-Res」 series in 2001 by reviving her early Emigre bitmap designs as outline fonts.

「Tronic」 was part of this matrix-based letterform revival. Not so many interesting examples have been seen in this category since the early 2000s, but the recent success of 『Arcade Game Typography』 (London: Thames & Hudson, 2019), a book by the Monotype designer Toshi Omigari on the pixelated typography of early video games, may testify to the enduring attraction of variations within the extreme constraints.

Tronic as a Device-Inspired Typeface

「Tronic」 was derived from the low-resolution characters that Cho Hyun found on a transmission verification report from a fax machine located somewhere in New Haven. It is unknown exactly what machine issued the report, but the text would have been rendered from a set of built-in bitmap glyphs and degraded by the machine's thermal printing process. The original bitmap glyphs must have been stored in the fax machine like a fixture, rather than existing as an independent software like a common digital font that could be easily transported from one computer to another.

Electronic devices that need to display text are often equipped with native character sets, whose crude forms usually display minimum legibility under severe mechanical constraints. It is this combination of mechanical simplicity and equipment-specific features that capture many designers' imagination and inspire their typefaces. The Swiss designer Cornel Windlin, for example, created a series of device-inspired digital fonts, based on the letterforms used in cash dispensers (「FF Screen Matrix」, 1993), dot matrix printers (「FF Dot Matrix」, 1994), information display systems in Berlin airports (「FF Gateway」, 1997), printed tags (「FF Luggagetag」, 1997), and a video game console (「Vetrex」, 1999). The kind of "machine aesthetics" that these typefaces

The Contexts of Tronic

Choi Sung Min
University of Seoul, Seoul

「FF Tronic」is a typeface completed in 2002 with the addition of my italic variations to Cho Hyun's original design, the then-called 「Trans Mono」. It was released by the Berlin-based digital type foundry Font Font in 2003 and is still available through the Font Shop International. It is a full-fledged Latin type family, consisting of four weights and matching italics, supporting up to fifty languages, but its commercial success has been limited. There has been no critical examination of its design, and while I believe it merits serious discussions, I—as a directly interested person—should not be the one who carries out the task. This note, therefore, simply outlines several historical contexts of 「Tronic」, which might be usefully considered in studying the typeface.

Tronic as a Constructed Typeface

The characters of 「Tronic」 are constructed by simple geometric principles, with no traces of handwriting. The strokes have no curved parts: they only consist of vertical, horizontal, and 45 degree straight lines. Even the italic glyphs are rendered by gradually offsetting the limited set of elements along the grid to create an optical illusion of slant.

It is no surprise that geometric

Cho Hyun. 「FF Tronic」
type specimen (detail). 2011.

Technische [01]
Buchstaben- [02]
formen [03] aus [04] Fax-
Kopfzeilen [05] und [06]
Schnelldruckern [07]
dienten [08]

which implies that the conventional paper-centered media is developing into an empirical and three-dimensional direction.

❻ Slice of Life, 2011

This work was initiated when he thought that the act of using a paper shredder and the noise was similar with people's indiscriminate logging and paper consumption. He paradoxically expressed the fact that it is hard to recycle shredded paper. He rolled up shredded paper by hand to make growth rings, arousing awareness of new life.
This is one of research cases that Cho Hyun had continuously investigated—making flat surface into a solid body.

❼ 2014 Audi Design Challenge, 2014

This work is a plain version of ⟨U&lc: Architectural Dialogue⟩for a contact point with the public. To express the slogan 'advance through technology' of ⟨2014 Audi Design Challenge⟩ on its trophy, he used a form that accumulated lower case makes upper case. He made various attempts to apply a 3D printer before its commercialization and develop a method of pouring ceramic for this work. Award-winning work at the 61st Annual Typography Competition of Type Directors Club.

❽ M+C, 2018

A collective exhibition with Min Byunggul held at Doosung Paper Gallery. Cho Hyun had long prepared for a living design brand that consisted of his own design works and through this exhibition, he displayed prototypes of some "product" lineup like tables and stools. Cho Hyun substituted the "nuance spectrum" generated with varying thickness of strokes and width of letters that form a type family with the "nuance spectrum" of physical properties such as iron, wood and concrete used for the tables and stools he made, which was to come up with products that grasped "the moment of fine choice" created with mixed forms and physical properties. He was shaping up a brand named Object and about to publish a magazine with the same title for promoting the brand.

❾ Object, 2019

Cho Hyun was always preparing for and awaiting the moment when graphic staying on a sheet of paper (flat) would get a form and the value of use (experience) would be added. The Object is at a point studded with Cho Hyun's ideals and dreams where the "object" with the mission of S/O Project and the methodology of flat-form deviated from its conceptual meaning and it finally turned into a tangible and usable stuff in everyday life. He produced carpet for the first series of Object—he added new physical properties to 「A Letter」 and sold it as a product named carpet. Even though the carpet was high in price, it unofficially but quickly went viral among households and businesses and extra production was underway around August 2019. He had his solo, carpet-themed exhibition ahead and had already finished the design of exhibition hall's layout and mockup work. I can vividly remember his look and voice when talking about this project and expectation, thrill and little flush as well. We joked around like "Should this carpet really be appreciated on the wall, not laid down on the floor simply because of its design beauty?" It is a pity that our eyes or hands cannot ever see or touch his next series.

❶ FF Tronic, 2002

「FF Tronic」is a collaborative work of Cho Hyun and Choi Sung Min, a typeface made through modularization of low-quality printing found from a transmission confirmation printed after sending faxes. The default is 7 × 9 px type; they applied the module of lump and smudge made by a low-quality printer to the border of pixels bent at a 45-degree angle and made its italics in a way that they were segmented and tilted. Subsequently registered at Fontshop International, Berlin. Served as a representative typeface for Cho Hyun, used for business card and website of S/O Project.

❷ This-connected, 2008

While 「FF Tronic」is composed only of verticality, horizontality and diagonal lines, This-connected typeface is of curves. The impression of 「This-connected」opposite to that of 「FF Tronic」might be something nobody would have expected or predicted from Cho Hyun. This thin, tilted typeface with a soft, rhythmic sense was used for the poster to promote the first concert of a model Jang Yoonju's autobiographical music. He got to work with Jang Yoonju as Jeong Sin and Saiida made them acquainted with each other. 「This-connected」shows traces of segmenting and connecting a letter's outer contour. Cho Hyun pursues a methodology to set up his own conditions and rules; the boldness and unexpectedness that strokes of a letter (ascender, descender or slab) are at a point where they are not likely to be connected but rather a line is whimsically attached remind us of his unique sense yet again. He converted "Dis" to "This" for the typeface 「This-connected」with twofold expressions of "connection" and it is so like this witty guy.

❸ A Letter, 2009

Though this typeface is named as what has been currently identified from the file name, it hasn't been clearly figured out how to read or write. 「A Letter」is the most recent work that Cho Hyun has worked and a number of sketches and working files remain here and there. The traces from sides and colors that form a letter combined with many cases prove his profound thinking and affection about this work. To a process of making each letter, he applied a printing method that color is made with halftone overlapped and; completed the form of typeface with density of sides and colors made with flat surfaces overlapped and piled up. The type visually maintains the flat surface but subtly gives cubic effect. 「A Letter」is seemingly of a typeface form but each letter is fully functioning as a masterpiece actually rather than working as a written and oral messenger. Among most of his works filled with achromatic colors, this one outstands with the most glamorous graphic forms and colors.

❹ U&lc: Architectural Dialogue, 2012

Submitted to 《Jindalrae Document 4: Twelve Landscapes》, this work is a three dimensional artwork with letters that connects upper and lower case, the two layers that compose the alphabet, in space and structurally shows the consequently formed lines and sides. Starting with this work, Cho Hyun combined flat surfaces and solid bodies and; forms and physical properties and crossed different dimensions. He made his own methodology to exquisitely mix features of both flat graphic—such as letters and figures that had been mainly used for delivering messages—and physical properties in order to shake up dimensions and increased his attempts to approach them as a "product" rather than merely as a formative artwork.

❺ Flat-Form Subject & Object, 2016

An exhibition held in Hong Kong which featured the entire philosophy and works of S/O Project. The title 《Flat-Form: Subject & Object》itself demonstrates the process of S/O Project. It is a notion that physical properties are always representative of some objects and in return, objects are destined to be connected with the subject at all times. He represented the studio name S/O with numbers and showed a process of how fifty themes were visualized, concretized and commercialized through what type of clues and then came out as typefaces, graphic motives, posters, books and goods. This process is to infuse experiences and physical properties into typography's flat status. A 3D printer makes a stacking form with the applied flat surfaces accumulated,

Flat-Form: Subject & Object

Lee Jihye
Formerly worked for S/O Project
Currently CEO of Berg, Seoul

Min Byeonggeol
Seoul Women's University, Seoul

FF
Tronic

phamburger

Flat-Form

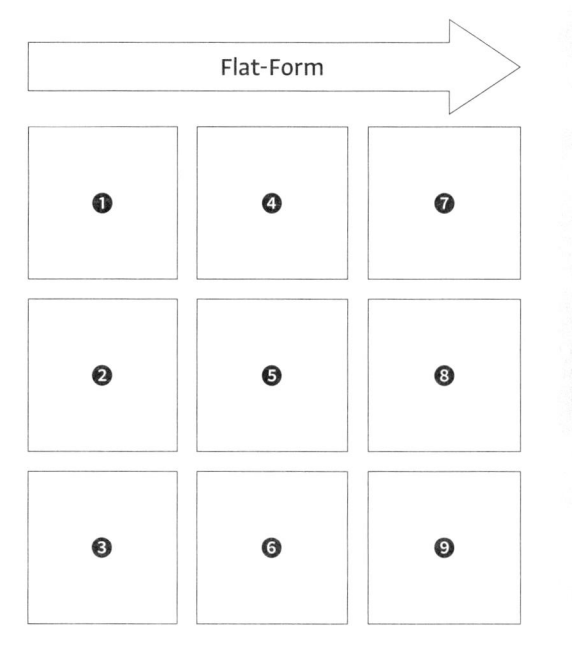

attempt total design from menu selection and package to communication with customers and space design as well as the brand design.

He relocated the company building that had been in Nonhyeon-dong to Itaewon in 2010; started a neighborhood project called 〈Itaewon Resident Journal〉 with his neighbors of Jeong Sin, Saiida, Hwang Aeri and Jang Jinwoo, which played a role for creating community culture with neighbors with different specialties and preferences. At the time he made Alex The Coffee that asked him for brand design work coexist with the space of 'AND', a lifestyle brand he launched and consequently realized a business form that profits were divided through collaboration and division of labor. He then cofounded and operated a restaurant AND Dining and shaped up his dream to make and sell goods all together and to create profits actively, out of generating income dependent upon design works.

He held an exhibition 《Flat-Form: Subject & Object》 in Hong Kong which featured the entire philosophy and works of his and S/O Project in 2016; he represented the studio name S/O with numbers and showed a process of how fifty themes were visualized, concretized and commercialized through what type of clues and then came out as typefaces, graphic motives, posters, books and goods.

He was in charge of identity design of Audi Design Challenge to direct production of poster, trophy, promotional materials and the like and; also worked on a brand design renewal project for the apartment brand Prugio and branding for Air Premia that was soon to enter the service. Based on his diverse design experiences, Cho Hyun wanted to found a living design brand.

He had lectured for more than a decade as an educator; appointed as a full-time faculty at Department of Design, School of Visual Art, Korea National University of Arts in August 2015 and then Vice Dean of School of Visual Art in 2018. He also served as the Vice President of The Korean Society of Typography in 2017; joined a membership at Alliance Graphique Internationale (AGI) in 2018 and gave a public lecture 〈Graphic Design Asia 2019—Close to Home〉 at Dongdaemun Design Plaza (DDP) in May 2019. Then, all of a sudden, he left us on 4 September 2019.

Profile
1969 / Born in Seoul
1987 / Entered Department of Visual Communication Design, Kyungwon University
1993 / Graduated from Department of Visual Communication Design, Kyungwon University
1993 / Entered I&I
2000 / Entered Yale Graduate School, US
2002 / Graduated from Yale Graduate School, US
2003 / Returned to Korea, Entered THE-D
2003 / Founded S/O Project
2015 / Appointed as full-time faculty at Department of Design, Korea National University of Arts
2019 / Passed away

Member of a design group 'Jindalrae'
Designer registered at FSI Germany
Selected as an artist for 〈Fendi 10+ Project〉
Selected as an artist for Korean Book Design Now 2008
Judge of ARC Awards

Lectures
Graduate School, Seoul National University
Adjunct professor, Department of Visual Communication Design, Gachon University
Kaywon University of Art & Design
Seoul Women's University
Graduate School of Typography, Seoul Women's University
Department of Visual Communication Design, Kookmin University
Hanyang University

Awards
iF Design Award / Flat-Form: Subject & Object / 2018
ARC Award, Grand Winner / Kaywon University of Art & Design Annual Report / 2016
TDC Award New York / Graphic Symphonia / 2015
Red Dot Design Award / Southcape Owners Club / 2014
Red Dot Design Award / SK Telecom LTE / 2013
Red Dot Design Award / Alex The Coffee / 2013
Design Leader's Choice it-Award, Grand Winner / Culture Station Seoul 284 / 2012
ARC Award, Gold5 Bronze2 Honor1 / SK Telecom Annual Report / 2011

Exhibitions
Flat-Form: Subject & Object / Hong Kong / 2016
Taipei International Book Exhibition / Taipei / 2009
Korean Book Design Now 2008 / Seoul / 2008
FENDI 10+ Project / Seoul / 2007
TDC Tokyo (Type Directors Club Tokyo) / Tokyo, Osaka / 2004, 2006, 2007
Jindalrae Document 2: Visual Poetry Kumgangsan / Seoul / 2004
Trnava Poster Triennial / Slovakia / 2000
TDC New York (Type Directors Club New York) / New York / 1999

Cho Hyun (1969 – 2019)

Kymn Kyungsun
Seoul National University, Seoul

Quoted and reorganized from 「Cho Hyun. Design. 50」.
Monthly 『Design』 Vol. 499 (January 2020)

Cho Hyun, a graphic designer born in Seoul, studied visual communication design at college and then he caught his professor Shur Kiheun's eye who also was the president of I&I, which naturally led him to work for I&I for seven years, taking full charge of designing promotional materials for Samsung Group and many other major companies.

In the year of 1999 at the age of thirty, he wanted to learn interactive design and left for New York; he met the illustrator Lee Insu there who told him about Yale and consequently applied for it. While studying at Yale Graduate School, he was instructed by designers such as Karel Martens and Paul Elliman and socialized and learned with Korean friends like Choi Sung Min, Choi Sulki, Kim Sangdo and Lee Chae. He developed a low-resolution bitmap typeface he found on a piece of fax paper by chance and created a font titled 「FF Tronic」 with Choi Sung Min. In addition, he also reinterpreted everyday waste, useless space or discarded materials and presented them as his graduation work.

Before he went off to America, Kim Doosup had proposed him to be a member of Jindalrae, a graphic designers club, and his activity there was introduced through exhibitions including 《Mailing Art》 in 1998, 《Jindalrae Evolution (Jindalrae 發展)》 held at KEPCO Art Center in 2004, 《Visual Poetry Kumgangsan》 at Ilmin Museum of Art in 2006 and 《Jindalrae Sketchbook》 series published in the form of document in 2008. At 《Jindalrae Document 04 Twelve Landscapes》 at Tongui-dong Palais de Seoul in 2012 he presented a three-dimensional work of 〈U&lc: Architectural Dialogue〉.

He established a studio named "S/O Project" in 2003 and worked for diverse projects with a host of clients like SK Telecom, Hyundai Card, LG Electronics, NHN, Baesangmyun Brewery, Univera, etc. Even though the basis of graphic design was printed promotional materials, Cho Hyun had varied interests of branding, material, furniture and space and thus, he was engaged in space and branding works of Culture Station Seoul 284, Southcape Resort and Kaywon University of Art & Design to expand his field whenever he got a chance. He launched a hamburger place in Anguk-dong named 'EST.1894' in 2009— which did not last long but he still could

people

"people" focuses on individuals who had an impact on design, and discuss their life and accomplishments. For this issue we look at the life and impact of Cho Hyun, founder of S/O Project, and a former vice chairperson of our organization.

the same since then, but one thing that is for sure is that the basic form of Western book typography can be found in this book.

What value does a 1920s–1930s British manual of book typography have for Korean book designers in the 2020s? Morison wrote that book design is based upon the traditions of the culture it belongs to. Since the liberation from Japan, Korean book design has gradually adopted Western standards—vertical text to horizontal, right-to-left scripts to left-to-right. Although the alphabets may be different, it has value in learning the basic form of the publication format we adopted. Furthermore, this book could become the starting point of establishing the principles of book typography in our history of publishing that has developed for over half a century. The Korean name of the part that constitutes the book and its pages is interchanged with terms like 'preliminaries' 'front page' 'title leaf' 'half title' and 'title page' and printers even share their own private terms. I expect for book designers to establish—including a standardization of terminology—a proper set of Korean principles of book typography.

Stanley Morison's 『First Principles of Typography』

[6] Title page of the type specimen book of Monotype 『Baskerville』, crown octavo (127×190mm), 1926. / Typography of the title page is in all caps. Keywords in the title are emphasized with larger capitals, and italicized 'Baskerville' adds variety.

[7] Title page of 『The Fleuron』, 220×280mm, 1923. / 『The Fleuron』, a hardcover book about the size of A4, contains essays on typography along with high-quality prints in various types and designs—so that readers could physically experience the quality of the paper and print. The journal went out of print after seven volumes due to financial difficulties.

This book states that it formulates principles of book typography and targets 'book printers' and 'book designers'. Unlike today where every detail of typography is in the hands of the designer, 'book designers' like Morison needed support by 'printers' like Walter Lewis to make quality publications of typography. Just how reliable are the principles in this book? While Morison was the typographic consultant for Monotype Corporation, he also founded a research group for quality book arts entitled 'The Fleuron Society' with like-minded scholars like Francis Maynell and Oliver Simon. Publishing journals once a year, they wanted to show that the Monotype System was capable of producing publications with quality no less than that of famous private print shops of the time. The journal was 『The Fleuron』[7], and its seven volumes as lavish as its title were fruitions of printing made efficient by the Monotype machines and virtuous cycle of improvement of the publishing world and the study of typefaces and typography. 『First Principles of Typography』 can be understood as a set of rules for book typography defined by professionals with utmost taste in book design at the time.

Morison stated, "It is of the essence of typography and of the nature of the printed book, that it perform a public service" and "Typography is a minor technicality of civilized life"—stressing the importance in book design to obey social conventions. He wanted to acknowledge the tradition and principles of British book design, saying that social convention is "accumulation of more than one person's life, and we thus cannot disregard the accumulated experiences of past generations". Bauhaus and modern typography may have transformed the aesthetics of visual design in Europe, but Jan Tschichold—who was on the frontier of the movement—started re-examining historic typefaces and traditional typography as he became a book designer for a Swiss publishing company. Today's book design may not follow the specific rules of typography now that the format of printed books and way of reading have stayed mostly

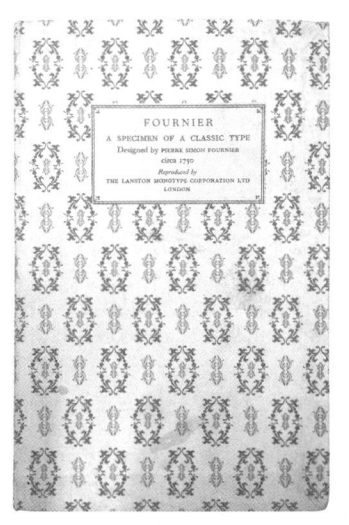

[4] Type specimen book of Monotype 「Garamond」, crown octavo (127×190mm), 1926.

[5] Type specimen book of Monotype 「Fournier」, crown octavo (127×190mm), 1927. / A typeface with traditional leading was cast, and the borders were created with decorated Fournier fonts. Typography of the title page is in all caps, with wide spacing between the letters. The name of the designer is written with variations of capitals, small capitals, and the Italic typeface to add animation.

5 Directions for Designing Preliminaries
 "To twist one's text into a triangle, squeeze it into a box, torture it
 into the shape of an hour-glass or a diamond is an offence."
 "The typographer's only purpose is to express, not himself, but his author.
 It is not allowable to the printer to relax his zeal for the reader's comfort
 in order to satisfy an ambition to decorate or to illustrate."

6 Content, Order, and Typography of Preliminaries
 "The logical order of the preliminary pages is
 Half-title or Dedication, Title, Contents, Preface, Introduction."
 "With the exception of the copyright notice, which may be set on
 the verso of the title-page, all should begin on a recto."
 "The headings to Preface, Table of Contents, Introduction, etc.
 should be in the same size and fount as the chapter heads."

7 Size, Bulk, and Paper of the Book
 "Crown octavo (5 by 7½ in.) is the invariable rule
 for novels published as portable formats."
 "Bulk is calculated in accordance with the publisher's notion,
 first, of the general sense of trade expectation and, secondly,
 of the purchasing psychology of a public habituated to
 certain selling prices vaguely related to number of pages and
 thickness of volume."
 "The volume of the book can be inflated to an extra sixteen pages
 and sometimes more—which is a feat the able typographer is
 expected to accomplish without showing his hand."
 "Handmade paper is generally used for editions de luxe."

「Gill Sans」 and 「Times New Roman」. As a token of appreciation for his relationship with the publisher, he published 「A Tally of Types」 (Cambridge University Press) in 1953. The book exhibits seventeen historical typefaces produced at Monotype and used by Cambridge University Press and stories in the process of rediscovering the designs.[1]

「First Principles of Typography」 consists of seven chapters, written in Roman figures. Though the chapters are untitled, the Korean version by Ahn Graphics has right-page headings of the keywords of each section for clarification.
The following are the main ideas and excerpts from each chapter.

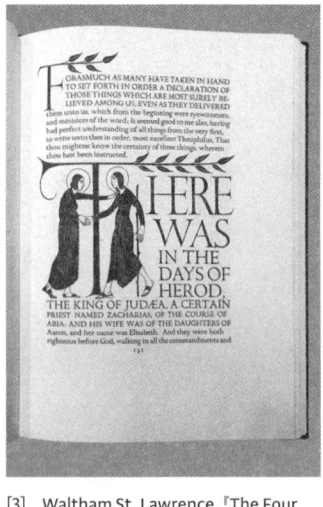

[3] Waltham St. Lawrence. 「The Four Gospels」. Golden Cockerel Press, 1926. / Various design elements were applied to visually strike the first page of the book and its first sentence. An illustrated initial letter and a fully capitalized sentence that gradually decreases in size leads to a sentence in small letters. Illustration: Eric Gill

1 The Role of Book Typography and the Purpose of
 the Essay
 "Typography may be defined as the art of ... arranging
 the letters, distributing the space and controlling
 the type as to aid to the maximum the reader's
 comprehension of the text."

2 Elements of Book Typography: Font, Space,
 Composition, Imposition, Impression, Paper Selection
 "The laws governing the typography of books ...
 are based upon the traditions for which the printer
 is working."
 "The printer needs to be very careful in choosing
 his type, realising that the more often he is going to
 use it, the more closely its design must approximate to
 the general idea held in the mind of the reader."
 "The margins should be proportionate to the area of
 the text by modifying composition and imposition."[2]

3 Elements of Composition: Number of Words and Length
 of Line, Leading in Conformity with Typeface Character,
 Paragraphs and Indention, Running Head, Position of
 Page Number, and Typography
 "The size of the letter must be related to the length of line ...
 the average line of words which the reader's eye can conveniently seize
 is between ten and twelve."
 "There exist letters with short descenders designed rather to sustain
 leading by rule than by exception."
 "In paragraphing, it is important to realise that the opening sentence of
 a work should automatically manifest itself as such."[3]

4 Preliminaries, Typography of Title Page
 "These first pages...consequently offer the maximum opportunity for
 typographic design. The history of printing is in large measure
 the history of the title-page."[4, 5, 6]
 "There is no reason ... to bear any line of type larger than twice the size
 of the text letter."
 "The main line of a title should be set in capitals and, like all capitals,
 should be spaced."

[1] Stanley Morrison. 『Tally of Types』.
London: Cambridge University Pres, 1953.
p87. / Notes on the Monotype 「Bell Roman」.
The notes are typed in 「Bell Roman」.
It is written that the type is the second
18th-century British typeface produced by
Monotype after 「Baskerville」. Bell Roman
was inspired by 「Baskerville」, but the
proportions of the types are slender as in
the French typefaces 「Didot」 or 「Fournier」.

[2] Stanley Morrison. 『First Principles of
Typography』. Translated by Kim Hyunkyung.
Seoul: Ahn Graphics, 2020. p14. /
The definition of a typeface mathematically
organic to the pages. A drawing by Jan
Tschichold. "The old-style margins are
handsome in themselves and agreeable to
the purpose of a certain kind of book."

The development process of the typeface 「Bell Roman」—used in the 1936 edition of 『First Principles of Typography』—is an example of Morison's scholarly approach to typography. Morison learned the existence of the 18th-century British typeface by networking with men like D.B. Updike, known for writing 『Printing Types』 (1922). He also learned that Bell Roman was commissioned by 18th-century publisher John Bell and was used for the newspaper 『Oracle』— published by Bell. Studying the life and accomplishments of John Bell, Morison was able to track down the location of the Bell typeface; the original matrices owned by Stephenson Blake and Company were discovered and recreated. The Monotype 「Bell Roman」 was introduced to the world, with the release of a study that states that it is 'Britain's first modern typeface' influenced by France's then-popular typeface 「Didot」. Morison's research on John Bell was published as a book, and Bell's publications were showcased. Morison's commitment and ability to study not only the design but also the time period and people surrounding the typeface drew attention to the production of Monotype typefaces from the experts in the field.

Cambridge University Press, publisher of 『First Principles of Typography』, supported the program of adapting historical typefaces, allowing it to continue for over ten years. Even if historic and aesthetic typefaces were being designed, the company would not have been so pleased if they did not generate much profit. When Walter Lewis, who Morison worked with at a publication, was appointed as Master Printer at Cambridge University Press, he chose Morison to work as their typographic consultant. Morison's typefaces influenced the field as Cambridge University Press used every new Monotype typeface for their top publications and presented elegant book typography and quality book printing and binding. Scores of typefaces were developed under Morison at Monotype in the 1920s and 1930s, but his position was insecure until the financial success of

It took quite an amount of time for this legendary essay to reach us in Korean translation. Stanley Morison's 『First Principles of Typography』. Many have probably heard of but not read the book. According to the preface by Morison, the essay was first attempted as an article under the term "typography" in 『Encyclopedia Britannica』 14th Edition of 1929 (Chicago and London) and appeared in Volume 7 of 『The Fleuron』, a journal of typography, in the following year. In 1936, Cambridge University Press published it as a book as there was a constant demand even after the journal went out of print. It was reprinted in 1967 without any alteration but added a postscript by Morison to "explain why the reprinting of this essay in unaltered form could be justified by its author after the passage of more than thirty years". The Korean translation published in 2020 by Ahn Graphics includes this postscript—summing up the entire history of the book.

This book lets us take a look at what the principles of book typography were in the past, with the culture of British publishing and printing in the 1920s and 1930s as its background. The fact that 『Encyclopedia Britannica』 presented a delicate guideline for book typography as the explanation of "typography" makes us realize that typography, in principle, is a visual means to help us understand the text, and we are reminded that history of Western typography was led ultimately by "books".

Stanley Morison (1889–1967) was a British typography scholar and type designer. For over 30 years he worked at Monotype Corporation, he revived many of the historical European typefaces into Monotype typefaces for their machines. Morison left a mark in the field of typography by commissioning original typefaces like 「Gill Sans」 and 「Perpetua」 and developing 「Times New Roman」, a work of his own design. He self-taught book design and studied the history of publishing on his own, and with work experience as an assistant editor and a book designer, he was appointed as typographic consultant at Monotype Corporation in 1922, at the age of thirty-three.

Monotype was a machine, patented by American engineer Tolbert Lanston, that cast individual pieces of type—unlike the Linotype machine that cast complete line of types. Lanston met with foresighted British investors, and in 1897 the company set up a British branch with exclusive commercial rights in the U.K., Ireland, and the Commonwealth of Nations. The American branch was established in later years. The advantages of the Monotype System were revolutionary: casting the types in individual pieces facilitated corrections, sophistication of spacing capabilities allowed more complex typesetting, and the casting speed of over 100 types per minute saved typesetting time, no need to store metal types in drawers and cabinets—which all saved costs tremendously. While the Linotype dominated the market for quick printing such as magazines and newspapers, the Monotype targeted the print publishing market. An emerging task of the 1910s was to develop Monotype typefaces to meet the demands for fine printing. Early Monotype typefaces were mere plagiarism of existing typefaces or taken from other type foundries without just reimbursement—leaving the publishing world unsatisfied with both their quantity and quality. In this background, Morison came to the picture. He conducted a long-term research and program to bring to life significant typefaces in the history of printing and typography after the invention of type printing for the use in Monotype machines. Before Morison published this book, he had already directed archive-based development of several typefaces such as 「Poliphili」 (1923), 「Baskerville」 (1923), 「Fournier」 (1925), 「Bembo」 (1929), and 「Bell Roman」 (1930).

Stanley Morison's 『First Principles of Typography』 and Its Background

Kim Hyunmee
SADI, Seoul

STANLEY MORISON · FIRST PRINCIPLES OF TYPOGRAPHY

스탠리 모리슨 · 타이포그래피 첫 원칙 · 1936

Translation: Hong Khia

"Review" focuses on books, school, exhibition, and typefaces.
The review is approached from multiple views to provide a broader
and meaningful discussion in wider visual culture perspectives.
Kim Hyunmee's perspective of 『First Principles of Typography』
published by Ahn Graphics is this issue's topic.

**Signature by Karl Martens,
a Graphic Designer**

Owner
Seok Jaewon

**Relationship to
the Owner of Handwriting**
Teacher

**Media that Contains
the Handwriting**
Karl Martens' book,
『Printed matter \ Drukwerk』

**Story of How One
Intertwined with
the Handwriting**
Karel Martens, who
I had met in grad school,
was a designer who was
always cheerful regardless
of his age. His rational
sense of humor, seriously
rejecting "the unnecessary
seriousness" yet far from
sarcasm, interested me.
When I asked him for an
autograph as I was approa-
ching a rockstar, he flicked
open the cover of his
book the Printed matter \
Drukwerk and wrote down
two words; good luck.
Witty yet not plain,
the greeting seemed like
the typical Karel Martens.
Eight years later when we
met again, he fixed the
message by adding 'more';
typical Karel Martens.

For JAEWON

good luck

28 · 11 · 10

KM

and more
good luck

10/10/18

KM

For JAEWON

비스듬히

생명은 그래요
어디 기대지 않으면 살아갈 수 있나요
공기에 기대고 서 있는 나무들 좀 보세요
우리는 기대는 데가 많은데
기대는 제 맑기도 하고 흐리기도 하니
우리 또한 맑기도 흐리기도 하지요
비스듬히 다른 비스듬히를 받치고 있는 이여

정현종

**Handwriting of
Lee Min, an Architect**

Owner
Yu Jeongmi

**Relationship to
the Owner of Handwriting**
Husband

**Media that Contains
the Handwriting**
Paper

**Story of How One
Intertwined with
the Handwriting**
February 2010, as I prepared
for the first Korean Society
of Typography's exhibition,
my husband wrote it
down for me saying that
this poem will look better
handwritten. I chose Poet
Jung Hyunjong's 「Oblique」
to display at the Visual
Poetry Exhibition,
Lee Sang's centennial
exhibition. I worked with
my husband's handwritten
letters. I told myself to
keep the original copy, but
it's a shame that I had to
use the scanned version
because I lost it.

**Signature of Massin,
a Book Designer**

<u>Owner</u>
Moon Janghyun

<u>Relationship to
the Owner of Handwriting</u>
**Lecturer who visited
the company for a seminar
and the participant**

<u>Media that Contains
the Handwriting</u>
**Eugene Ionesco's playbook
『La Cantatrice Chauve』
which Massin designed.**

<u>Story of How One
Intertwined with
the Handwriting</u>
**『La Cantatrice Chauve』 is
well known for its monu-
mental book design. When
I was at graduate school,
I was shocked when I held
the physical copy which
I ordered from the French
Amazon. I adored Massin
after that I bought a few
more of his books. One
day in 2005, when I was
working for Ahn Graphics,
Massin surprisingly visited
to give a lecture. After an
insightful lecture, I received
his autograph. He signed it
like it originally belonged on
the page of 『La Cantatrice
Chauve』. Massin passed
away earlier this year.**

（名言だけ「ラジエス」）

パステルカラー / アニメ・ラジア / アンメ / マテリアル / ラインカラーから。

「コンパ / ラインアップ / キャッチ、って。

装置の側面から活かって無着色して 自由な
(OKない）な読者に描かれて、端素になさら
い機能的なら出来る。ことなどで、マスメディア
の読者が大きい意味、そこに面して居る。

装置が側に（グラフィケーション）っていうのいいます。

Sato Koichi (佐藤晃一)'s Handwriting

Owner
Chae ByungRok

Relationship to the Owner of Handwriting
Teacher

Media that Contains the Handwriting
A booklet bound with notes left to students

Story of How One Intertwined with the Handwriting
Studio students gathered the leftover memos at his workspace after his death. I can look into Sato Koichi's thoughts and methodology about design.

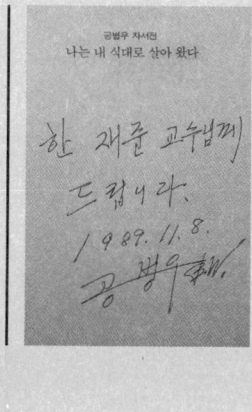

Handwriting of Gong Byungwoo, an Ophthalmologist, Pioneer of Hangeul Mechanization, and ex Hangeul Cultural Center Director

Owner
Han Jaejoon

Relationship to the Owner of Handwriting
Teacher

Media that Contains the Handwriting
Gong Byungwoo's autobiography, 「I have lived my way」

Story of How One Intertwined with the Handwriting
The first time meeting Doctor Gong Byungwoo was at the opening of the 5th Republic Confirmation Hearing in 1988 fall at the conference hall of academic presentation inside the Hangeul Center. I wanted to meet him in my university years, but I missed my chance because he was in the US. However, he was now sitting right in front of me. After a short greeting with great excitement, I showed him the typeface I created. He instantly reacted.
"What did you make it with? Do you not know about Macintosh computers? Use a font editor called Fontastic"
I was 30, and he was 80 at the time. Since then I chased him closely.
"I want to learn from you"
"When would you like to start?"
"I'm more than happy to start right this instant"
"Come out tomorrow then"
After a few trials and errors, the three-set of digital hangeul outline font contours held its framework. This font was for printing. "Doctor, I have come up with a name for this font. Taking your surname 'Gong' and adding my surname 'Han' how does Gong Han Font sound?"
"Haha. That is good"
That is how 「Gong Han」 began in the early winter of 1989. The fundamental principle and structure followed Gong Byungwoo's three-set, but the ultimate meaning was to restore the value of hangeul. Gong Byungwoo published his autobiography around this time and he signed this at the front of the book for me. He passed away 7 years later.

한 재준 교수님께
드립니다.
1989. 11. 8.
공병우

Handwritten Message from Ken Garland, a British Graphic Designer and Educator

Owner
Kymn Kyungsun

Relationship to the Owner of Handwriting
1999 UK Central Saints Martins University Graduate student and special lecturer

Media that Contains the Handwriting
Student's thumbnail note

Story of How One Intertwined with the Handwriting
when I was studying in London in 1999, I felt the need to get an autograph from Ken Garland as he delivered a lecture about children's teaching tools and toys while wearing a hand-knitted hat. (He was 71 at the time currently 91)

I wondered during the lecture why this man who speaks of teaching tools and toys would write these words. As I got to know him more, I realized that in 1964, when American culture revived after World War 2 and European designers leaned towards commercialism, he was the one who initiated the First Things First declaration which emphasized the role of a designer in our society. And in 2000 as we stepped into the New Millennium Era, American and European graphic designers took over that spirit and once again asserted the responsibility as a designer. Since then I always reflect and wonder if I'm being ground down by those buggers.

Hoji's Letter

<u>Owner</u>
Jung Younghun

<u>Relationship to
the Owner of Handwriting</u>
Second son

<u>Media that Contains
the Handwriting</u>
Colored paper and a marker

<u>Story of How One
Intertwined with
the Handwriting</u>
6 years old. The second-
born uniquely writes his
name backward. Today's
not an exception. He wrote
it on a green-colored paper.
Suddenly I wonder what
if the day comes when
he writes it properly…
I will miss this moment…
Hoji, 6 years old, South
Korea, 2020

Signature of Alessandro Mendini, an Italian Industrial Designer and Architect

Owner
Park Youngha

Relationship to the Owner of Handwriting
A design adviser contracted to SPC Group, and the design team leader of the Design Center

Media that Contains the Handwriting
'Alessandro Mendini (Il Bel Design)'

Story of How One Intertwined with the Handwriting
15 March 2017. As a contract design adviser of SPC Group,

we periodically met up for design development meetings. It was during the second meeting that I asked for his autograph.

It was just 2 years ago at the age of 85 before he passed away. He was a hale and hearty man; it was remarkable to witness him sketch his ideas despite having shaky hands. He often threw jokes in the middle of a meeting to brighten the mood. I can see the shakiness in his autograph, but I like it because his youthful and colorful dynamic is revealed through his handwriting.

Signature of Neville Brody, a British Type Designer and Graphic Designer

Owner
Park Youngha

Relationship to the Owner of Handwriting
The designer whom the SPC Group Design Center asked a design development to, and the design team leader of the Design Center

Media that Contains the Handwriting
『The Graphic Language of Neville Brody』

Story of How One Intertwined with the Handwriting
23 February 2017. It was our 3rd time meeting for Paris Baguette's Brand Identity renewal and the first corporate typeface development of which he was in charge of. I asked for his autograph on his book that I've been carrying around as if it was a textbook.

For someone who has a sharp eye, attention to detail, and a job as a font designer, I expected a distinctive handwriting. However, I was surprised at how unordinary it was (in fact, it was close to poor penmanship). I remember thinking it was so cute how he used to complain about the tediousness of signing every single contract page.

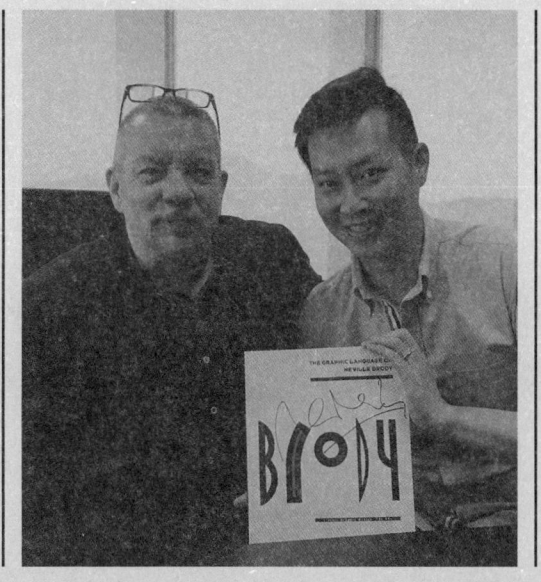

정을셩
쓰미라

질즈쓰븍화

외 그 ㄴ

Kim Myojoo's Letter

Owner
Kim Hyunmee

**Relationship to
the Owner of Handwriting**
Grandmother and
granddaughter

**Media that Contains
the Handwriting**
A record of the letter

**Story of How One
Intertwined with
the Handwriting**
When I was 7, I told my
grandmother of the dream
I had, and she told me that
she had to record this dream
of good luck, so she wrote
"Byeongjin-year (1976) night
6 November of the lunar
calendar … she dreams.
Went above the sky then
descended on a dragon
holding great quantities of
gold … this dream will bring
you good luck and you will
live a happy life."

I remember being shocked
at my grandmother's
unexpected response
because I exaggerated and
possibly made up the dream
to gain my grandmother's
attention because she
loved my younger brother
more. She was 80 when
she wrote these semi-
script letters in Gungseo
style (the court style of
writing the Korean script)
which vertically centered
the pillars.

Illustration and Handwriting of Ian Falconer, the Illustrator

Owner
Choi Moonkyung

Relationship to the Owner of Handwriting
Friend of a friend

Media that Contains the Handwriting
Illustration book

Story of How One Intertwined with the Handwriting
The year our baby was born, a family friend gifted us a book which contained the author's autograph and his illustration.
Our friend who is close to Ian Falconer prepared this gift knowing our child's name was Olivia, which was also the character's name in the book.

I kept it well to show Olivia when she grew older and I think the time has come.

Owner
Min Bon

**Relationship to
the Owner of Handwriting**
Father

**Media that Contains
the Handwriting**
Flyleaves of his books

**Story of How One
Intertwined with
the Handwriting**
'Seo-ye (brush calligraphy)'
and Lettering are my dad's
favorite hobbies. I enjoy
and appreciate the distinc-
tive composition of
signatures whenever
I look into the book that
he passed down to me.
I, his son, took this hobby
as a profession.

To Bon
01/05/13
READING
Gerard U

Signature of Gerard Unger, a Dutch Font Designer

Owner
Min Bon

Relationship to the Owner of Handwriting
UK University of Reading Type Design Master's program lecturer and student

Media that Contains the Handwriting
Korean translation of Gerard Unger's book 『Terwijl je leest (While you are Reading)』

Story of How One Intertwined with the Handwriting
When Gerard Unger was provided a few Korean translation copies of his book 『Terwijl je leest』 from the publisher, he gave me one copy just because I was the only person who could understand the Korean text around him at that moment. At that time, I was the sole Korean student in the faculty, feeling some kind of loneliness that might come from the cultural difference I faced in the European type design community and the physical disconnection from the Korean design society. And that book, a communication result between Holland, South Korea, and England prompted me to realise that everybody was interconnected this closely in fact.

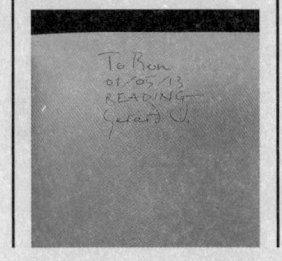

沈愚珍さんへ / 友情をこめて

杉浦康平

040806

Signature of Kohei Sugiura
(杉浦康平), a Book Designer
from Sugiura Plus Eyes

Owner
Sim Wujin

**Relationship to
the Owner of Handwriting
Emotional**
teacher - student

**Media that Contains
the Handwriting**
『Art Engineering of Repre-
sentation』 which Kohei took
part as an art director

**Story of How One
Intertwined with
the Handwriting**
Kohei does not like signing
on books. It's his way of
respecting the piece of work
created with the efforts of
many. I remember the day
I blindly visited his office
begging him to give me
some work to do. With
courage, I asked for his
autograph on the back cover
of the book pretending
as if I was unaware of his
philosophy. Without a word,
he deli-berately picked up
his pen and wrote this.
"To Sim Wujin" and with
a different pen he added
"With friendship..."
沈愚珍さんへ
/ 友情をこめて...
杉浦康平
040806

The word friendship never
came across as dramatic
as this because at the time
I was an anonymous
common foreign laborer.
The life event of 6 August
2004 has been one that
I reflect upon in times
of trouble and has since
become an amulet
in my life.

Handwriting of Christoph Niemann, an Illustrator

Owner
Park Ee-rang

Relationship to the Owner of Handwriting
Collaboration colleague

Media that Contains the Handwriting
Postcard

Story of How One Intertwined with the Handwriting
Following a collaborative project between artists, giving and receiving feedback is one of the most joyful moments as a director. Receiving a handwritten note is especially a rare and exciting thing, it's fun to see Christoph Niemann's handwriting because his sketch ideas come to mind. The handwriting and the message strongly resemble the artist's work as it intuitively and beautifully expresses his brilliant ideas.

Berlin 18.12.19

Dear Ee,

thank you so much for working with me on the Rhymander Series.

Your insight and guidance are invaluable, and have made this project a true highlight of the year.

Yours truly,

Christoph

collection

"Collection" is an array of images or objects shown in a different light. This can take an aesthetic angle or the basis for research. We show "Meaningful Handwriting" from people we hold dear or in high regard, and reveal the hidden moments.

**Shortlist of Books Recommended
by the Members 2017**

① 『READ』
Publisher: Grigo Gallery
Author: Kim Yoonkee
Designer: An Mano

② 『Onomatopoeia Mimetic Word
Architecture』
Publisher: Ahn Graphics
Author: Kuma Kengo
Designer: Nam Subin
(Assistant: Park Minsoo)

③ 『CopyCat』
Publisher: Superellipse
Author: Kang Jungsuk, Gil Hyungjin,
Kim Gunho, Kim Youngjun,
Kim Hyungjae, Kkangtong, Duna,
Park S-jin, Park Joonsoo, Bokgil,
Yujin, Lee Sangwoo, Jung Hyun,
Superellipse Publishing,
Choi Jaehyung, Choi Joonhyuk,
Choi Hyoki, Popcorn, Han Sohwi,
Hong Eunjoo, Danjyon Kimura,
EH (Kim Kyungtae)
Designer: Hong Eunju, Kim Hyungjae
(Assistant: Yoo Yeonju)

④ 『Typojanchi 2017: International
Typography Biennale』
Publisher: Ahn Graphics
Author: Korea Craft & Design
Foundation
Designer: Jeong Junki

⑤ 『Ob.scene』 No. 7
Publisher: Specter Press
Compiler: Seo Dongjin,
Seo HyunSuk, Kim Seong Hee
Designer: Sulki and Min

⑥ 『Korean Air Box Project 2016:
Yangjiang Group—Calligraphy is
the Way to Communicate with the
Most Primal Power』
Publisher: National Museum of
Modern and Contemporary Art
Designer: Ordinary People

⑦ 『tel』 Vol. 2
Publisher: Ahn Graphics
Author: Ahn Graphics Editorial
Department
Designer: Jeong Junki, Choi Seulgi,
Yoon Jin, Kim Taeho

⑧ 『손동현 孫東鉉 DONGHYUN SON
2005 – 2016』
Publisher: G&Press
Author: Son Donghyun, Lee Nayeon,
Kim Jaeseok
Designer: Hong Eunju, Kim Hyungjae

⑨ 『Choijeongho Type Specimen』
Publisher: Ahn Graphics
Author: Noh Minji, Jeong Harin,
Joachim Muller-lance
Designer: Lee Yoonseo

⑩ 『Bookabinet』
Publisher: Bookhole
Author: Choi Hyeonho, Ji Seokmin,
Cho Saehee, Woo Yunige
Designer: Choi Hyeonho, Ji Seokmin,
Cho Saehee, Woo Yunige

⑪ 『Gypsies』
Publisher: The Museum of
Photography Seoul
Author: Josef Koudelka
Designer: Kim Seonghoon

**The Book with Beautiful
Typography 2017**

『CopyCat』
『tel』 Vol. 2

Shortlist of Books Recommended by the Members 2016

① 『A Poor Collector's Guide to Buying Great Art』
Publisher: Design House
Author: Erling Kagge
Designer: Kim Heejung

② 『LetterSeed 12: City and Typography』
Publisher: Ahn Graphics
Author: Korean Society of Typography
Designer: Lee Jaeyoung

③ 『Design Museum, Here』
Publisher: Ahn Graphics
Author: Lee Hyunkyung
Designer: Yu Myungsang

④ 『Gangsang yeohwa of Moon Bongsan』
Publisher: Suryusanbang
Author: Moon Bongsun
Designer: Suryusanbang

⑤ 『Minmay Attack: ReRe-Cast』
Publisher: Audio Visual Pavillion
Author: Kim Kwoong and more
Designer: ShinShin

⑥ 『10 Book Designers of the World』
Publisher: Ahn Graphics
Author: Kay Jun, Jeong Jaewan
Designer: Jeong Jaewan

⑦ 『The Complete Works of Shakespeare』
(Final Selected Book)
Publisher: Moonji Publications
Author: William Shakespeare
Designer: Park Yeounjoo, Lee Miyeon

⑧ 『Visual Design』 (Final Selected Book)
Publisher: Hong Design
Author: Riccardo Falcinelli
Designer: Chae Sungwon

⑨ 『Apartment Letters』
Publisher. Aprillsnow Press
Author: Kang Yerin, Yoon Mingoo, Kay Jun
Designer: Jeong Jaewan

⑩ 『Our Wound is Not So Recent』
(Final Selected Book)
Publisher: Jaeum & Moeum Publishing
Author: Alain Badiou
Designer: Oh Jinkyung

⑪ 『Index Card Index 2』
Publisher: Dongshinsa
Author: Kim Dongshin, Jeong Jidon
Designer: Kim Dongshin

⑫ 『On the Origin of Species』
Publisher: Eunhaengnamu Publishing
Author: Jun Youjung
Designer: Oh Jinkyung, Lee Seungok, Kim Suhyoung and more

⑬ 『Pour Finir Encore Et Autres Foirades』
Publisher: Workroom Press
Author: Samuel Beckett
Designer: Kim Hyungjin

⑭ 『Bookstores Visit』
Publisher: Propaganda Press
Author: DPPA
Designer: Yu Myungsang

⑮ 『Stop the Violence』
Publisher: CMYK Books
Author: Francois Robert
Designer: mykc

The Book with Beautiful Typography 2016

『The Complete Works of Shakespeare』
『Visual Design』
『Our Wound is Not So Recent』

The Beautiful Typography Book
of the Year

The Korean Society of Typography selects
"The Beautiful Typography Book of the Year"
to honor the efforts of many designers
who try to balance communication and
expression through text messages and to
promote its value by discovering books that
have shown outstanding formative results.
By offering meaningful examples of "The
Beautiful Typography Book of the Year" to
editors and readers as well as designers,
the goal is to induce detailed attention to
textual expressions that further draw the
value of books and further discover good
books and designers. Both in 2016 and 2017,
there were two events and 3 judges.
In 2016, 3 books were selected, and in 2017,
2 books were selected as the best work.

The Beautiful Typography Book of the Year 2016

Recommendation: Untill 25 November 2016
Judge: 25 November – 15 December 2016
Annoucement: 15 December 2016

The Beautiful Typography Book of the Year 2017

Recommendation: Untill 30 Aprill 2018
1st Judge: 1 – 10 May 2018
2nd Judge, Exhibition: 23 May – 5 June 2018
Annoucement: 11 June 2018

Typojanchi 2013: International Typography Biennale 《Supertext》

30 Augustt – 11 October 2013
Culture Station Seoul 284,
Seoul Square

Art Director: Choi Sung Min
Poster Design: Practice
Catalog Design: Practice

Typojanchi 2015: International Typography Biennale 《C()T()》

11 Novembert –
27 December 2015
Culture Station Seoul 284,
NAVER Green Factory,
Small House Big Door,
Paper Gallery, Thanks Books

Art Director: Kymn Kyungsun
Poster Design: Lee Jaemin
Catalog Design:
Lee Kyeongsoo,
Jeon Yongwan (Workroom)

Typojanchi 2017: International Typography Biennale 《Mohm & Typography》

Culture Station Seoul 284,
Seoul downtown 150 bus
stops, Ui-Line Subway Station,
Hyundai Card Design Library,
019 (Ghent, Belgium),
NAVER Green Factory Connect
Hall, The Book Society,
Paju Typography Institute
(PaTI)

Art Director: Ahn Byunghak
Poster Design: Ordinary
People
Catalog Design: Jung Joonki
(Ahn Graphics)

Typojanchi 2019: International Typography Biennale 《Typography and Objects》

5 October – 3 November 2019
Culture Station Seoul 284

Art Director: Jin Dallae &
Park Wookhyuk
Poster Design: Yu Myungsang
Catalog Design: Yu Myungsang

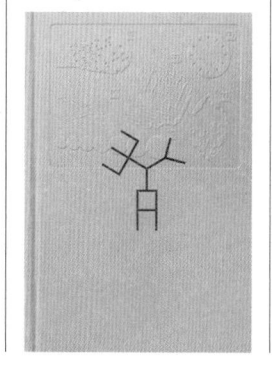

Typojanchi

《Typojanchi》 is an international biennale hosted by the Ministry of Culture, Sports and Tourism and supervised jointly by the Korea Craft & Design Foundation and the organization committee of international typography biennale in order to tell the world of the excellent modeling of Hangeul and its cultural value and to prepare an exchanging center for the expan-sion of the value of Korean design culture.《Typojanchi》 has been held biannually. In odd year, the main event is held for biennale and in even year, the pre-biennale is held. It is the international biennale officiated by the ico-D (International Council of Design) worthy of its name. 《Typojanchi》 was held for the first time in 2001 at Hangaram Design & Arts Hall of Seoul Arts Center. At that time, as it was the unique international event with a theme of typography, it received a great response in Korea and overseas countries. Later, reorganizing the structural system for event, it became a regular international biennale from the year 2011 to have become the present.

The Korean Society of Typography and 《Typojanchi》 realize the need to play a complementary role to address typography and exhibitions together. Following the year when the 《Typojanchi》 was held, 『LetterSeed』 deals with the theme of the 《Typojanchi》. And if 《Typojanchi》 is about external subjects of typography, such as 'Typography and Objects', 『LetterSeed』 is about internal subjects of typography. Through exhibitions and books, people can look inside and outside of typography.

Typojanchi: Seoul Typography Biennale 《New Imagination》

16 October 4 – December 2001
Seoul Arts Center,
Design Art Hall

Chairperson: Ahn Sang-soo
Poster Design: Ahn Sang-soo
Catalog Design: Ahn Sang-soo,
Lee Seyoung, Kim Youngna
(Ahn Graphics)

Typojanchi 2011: International Typography Biennale 《Fire Flower of East Asia》

30 August – 14 September 2011
Culture Station Seoul 284,
Seoul Square

Art Director: Lee Byeongju
Poster Design: Kim Dooseop
Catalog Design:
Kim Sunghoon (Ahn Graphics)

Archive

LetterSeed 1st Issue (Vol. 1 No. 1)
Paper
1. Yu Jiwon: A comparative Study on Italic of the Latin Alphabet and Cursive of Hangeul
2. Kim Nayoun: A Study on the Type Extraction Based on the Combination of Morphological Descrimination Element of Type
3. Ku Jaeun: Green Typography for Printed Materials
4. Lee Yongje: Ink-Saving Typeface
5. Han Jaejoon: The Sustainable Value of Hangeul
Conversation
1. Kim Jeehyun, Park Haechun, Ahn Sang-soo, Won Youhong, Lee Yongje, Song Seongjae, Choi Sung Min: Typography Education
2. Conversation with Armand Mevis
Review
1. Lee Byungjoo: Hangeul + Hangeul Design + Designer
2. Hong Sungtaek: Book Design

LetterSeed 1 (Vol. 2 No. 1)
Paper
1. Ku Jaeun: Green Typography for Printed Material
2. Kim Nayoun: A Study on the Type Extraction Based on the Combination of Morphological Descrimination Element of Type
3. Ahn Sang-soo: Huiyi, Montage, Lifepeace.Symbol
4. Yu Jiwon: A comparative Study on Italic of the Latin Alphabet and Cursive of Hangeul
5. Lee Yongje: Ink-Saving Typeface
6. Han Jaejoon: The Sustainable Value of Hangeul
Conversation
1. Kim Jeehyun, Park Haechun, Ahn Sang-soo, Won Youhong, Lee Yongje, Song Seongjae, Choi Sung Min: Typography Education
2. Conversation with Armand Mevis
Review
1. Lee Byungjoo: Hangeul + Hangeul Design + Designer
2. Hong Sungtaek: Book Design

LetterSeed 2 (Vol. 2 No. 2)
Paper
1. Noh Eunyou: Hangeul for Phonetic Transcription of Japanese
2. Sung Ming-yuan, Ihara Hisayasu and Satou Masaru: The Convergence and Causes of Type Production by Chinese Companies in the 1910-30s
3. Yu Jeongmi: Modernity of the Design Philosophy Containted in Hunmin-jeongeum
4. Yoo Jungsook: A Study on the Change in the Formative Elements and the Characteristics of Typography of Digital Typeface 'Batang' in Hangeul
5. Lee Yongje: The Issue of '.' and ','

Punctuation Marks in Hangeul
Discussion
Kim Jiwon, Kim Jeehyun, Song Yumin, Yu Jiwon, Lee Youngmi, Choi Moonkyung: Overseas Typography Education
Conversation
1. Conversation with Norm
2. Conversation with Helmut Schmidt
Review
1. Min Byunggeol: From Gutenberg to OpenType
2. Kim Hyungjin: Typography Today
3. Lee Yongje: Hangeul Gonggam

LetterSeed 3 (Vol. 3 No. 1)
Paper
1. Min Bon: The Letter as Equilibrium of Black and White: an Intercultural Synthesis
2. Lee Yongje: A Proposal About the Use of 'Letter, Type, Handwriting' in Typography
3. Sunwoo Hyunseung: A Strange Book— Structural Interpretation
4. Lee Jieun, Hayashi Mitsuko, Nosaka Masashi: Emotional Disparity Between a Design Specialty and Other Specialties on Kinetic Typography
5. Yim Sungshin: Lee Sang Flies Away
Discussion
Ku Jaeun, Kim Nayeon, Kim Myosu, Kim Byungjo, Kim Juseong, Kim Jeehyun, Noh Eunyou, Min Byunggeol, Seo Seungyeon, Song Seongjae, Son Yumin, Sim Wujin, Won Youhong, Lee Youngmi, Lee Yongjae, Han Jaejoon: Standardization of Typography Terms
Conversation
Conversation with Edo Smitshuijzen and Huda Smitshuijzen
Review
1. Yu Jiwon: Ein Jahrhundert Schrisft und Schriftunterricht in Leipzig
2. Fred Smeijers: Preface—A Type is Something You Can Pick Up and Hold in Your Hand
3. Kim Hyunmee: Jan Tschichold, Master Typographer: His life, Work and Legacy

LetterSeed 3 (Vol. 3 No. 2)
Paper
1. Koo Bonyoung: Associations Between the Structures of Hangeul Fonts for Text and the Factors of Recognition
2. Kwon Eunsun: The Correlation Between the Spacing of Letters and Readability
3. Min Bon: Typometry
4. Park Jihoon: Research Into Hangeul Type in the Early Modern Era
5. Oh Jaehee, Kim Jeehyun: Study on Experiment of Objectimage
6. Lee Youngmi: Research on Awareness and Preference of Corporate Typeface
7. Lee Yongje: Suggestion of Sharing and Solidarity of Hangeul Typography Education
8. Choi Junghwa and Kim Jeehyun:

The Formative Characteristics and the Preference Analysis of Gulim
Discussion
Hong Seokil, Kang Koni, Kwon Eunsun, Kim Kyoungkyun, Shin Dongyun, Cho Hyunju: Public.Design.Typography
Review
1. Park Hwalsung: Five Steps to the Forest of Typography
2. Yu Jiwon: A Line of Type
3. Lee Yongje: Paul Renner, If He Lives in South Korea in 2011

LetterSeed 5 (Vol. 4 No. 1)
Paper
1. Kang Koni: Study on the Improvement of Pavement Word Marking Seen from Typographic Viewpoints
2. Lee Jieun, Nosaka Masashi: The Difference of Emotional Structures Between the Kinetic Typography and the Printed Typography
3. Sim Wujin: Punctuations as an Environment of Hangeul Typography
4. Nosaka Masashi: A Criterion of Aesthetic Value Judgement in Characters: On Visual Poetry and Calligraphy
5. Lee Yongje: A Relationship Between Direction of Writing and Hangeul Letter Form
Discussion
Kim Jeehyun, Won Youhong, Han Jaejoon, Lee Byungjoo: Prior to the launch of the Hangeul Committee
Conversation
Carlos Segura, Han Changho, Kim Jiwon: Coversation with Carlos Segura
Review
1. Kim Jusung: Blank Space of Typography
2. Yu Jeongmi: Complete Collection Design

LetterSeed 6 (Vol. 4 No. 2)
Paper
1. Gu Seulgi: Shape of Hangeul Letter and Semantic Elements
2. Lee Jiwon: The Making of Hangeul Typeface: Barun Jiwon
3. Lee Jieun: The Difference of the Emotional Communication by Makers on the Kinetic Typography
4. Lee Yongje: Research On Representative Letterforms for Developing Effective Hangeul Fonts
Discussion
Hangeul Committee: The Operation and Direction of the Hangeul Committee
Conversation
Wang Hongwei, Kim Jeehyun: Coversation with Wang Hongwei
Review
Park Jihoon: Lettering Typography

LetterSeed 7 (Vol. 5 No. 1)
Paper
1. Ahn Sang-soo, Noh Minji, Noh Eunyou: Hangeul Group Kerning of 「AhnFont2012」
2. Chris Ro: Archetype & Archetypal

1st Title Design	**2nd Title Design**	**3rd Title Design**
LetterSeed 1 (Vol. 2 No. 1) Title Design: Kymn Kyungsun	LetterSeed 2 (Vol. 2 No. 2) Title Design: Min Byunggeol	LetterSeed 18 (Vol. 10 No. 2) Title Design: You Hyunsun

**LetterSeed 14
(Vol. 8 No. 2)
Branding and Typography**

31 December 2016
170×240mm, p204
ISBN 978-89-7059-884-0
President: Kim Okcheol
Editor-in-chief: Moon jisook
Concept: Park Soojin,
Chris Ro, Lee Jaeyoung
Editor & Proofreader:
Kim Lynn, Kim Soyoung
Photography: Kim Jinsol
Design: Lee Jaeyoung
Publisher: Ahn Graphics

**LetterSeed 15
(Vol. 9 No. 1)
Ahn Sangsoo**

20 October 2017
170×240mm, p616
ISBN 978-89-7059-925-0
President: Kim Okcheol
Editor-in-chief: Moon jisook
Concept: Kim Hyungjin,
Park Soojin, Lee Jaeyoung
Editor & Proofreader:
Kim Lynn, Park Eunji
Photography: Kim Kyoungtae
Design: Lee Jaeyoung
Publisher: Ahn Graphics

**LetterSeed 16
(Vol. 9 No. 2)
Type Design**

9 March 2018
170×240mm, p444
ISBN 978-89-7059-948-9
President: Kim Okcheol
Editor-in-chief: Moon jisook
Concept: Kim Hyungjin,
Park Soojin, Lee Jaeyoung
Editor & Proofreader:
Kim Lynn, Nam Subin
Photography: Kim Jinsol,
Nathing Studio
Design: Lee Jaeyoung
Publisher: Ahn Graphics

**LetterSeed 17
(Vol. 10 No. 1)
Gender and Typograhy**

18 December 2018
170×240mm, p124
ISBN 978-89-7059-982-3
President: Kim Okcheol
Editor-in-chief: Moon jisook
Concept: Kim Lynn,
Kim Hyungjin, Park Soojin,
Lee Jaeyoung
Editor & Proofreader:
Nam Subin
Photography: Filed
Design: Lee Jaeyoung
Publisher: Ahn Graphics

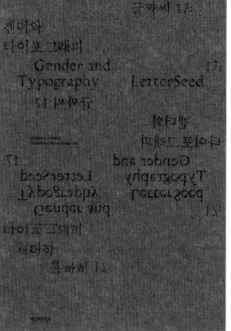

**LetterSeed 10
(Vol. 6 No. 2)
Jan Tschichold**

6 February 2015
170×240 mm, p440
ISBN 978-89-7059-785-0
President: Kim Okcheol
Editor-in-chief: Moon jisook
Concept: Kim Jeehyun,
Kim Byungjo
Editor: Kim Byungjo,
Min Guhong, Kim Hanah
Design: Kim Byungjo
Design Cooperation:
Lee Hyun Song
Photography: Park Kisu
Publisher: Ahn Graphics

**LetterSeed 11
(Vol. 7 No. 1)
Multilingual Typography**

30 June 2015
170×240 mm, p276
ISBN 978-89-7059-810-9
President: Kim Okcheol
Editor-in-chief: Moon jisook
Concept: Park Soojin, Chris
Ro, Lee Jaeyoung
Editor: Kim Lynn, Kim Yeonim,
Kim Hanah, Min Guhong,
Shim Yeri
Design: Lee Jaeyoung
Publisher: Ahn Graphics

**LetterSeed 12
(Vol. 7 No. 2)
City and Typography**

31 December 2015
170×240 mm, p316
ISBN 978-89-7059-842-0
President: Kim Okcheol
Editor-in-chief: Moon jisook
Concept: Park Soojin, Chris
Ro, Lee Jaeyoung
Editor: Kim Lynn, Kim Hanah,
Min Guhong
Photography: Kim Jinsol,
Sssauna Studio
Design: Lee Jaeyoung
Publisher: Ahn Graphics

**LetterSeed 13
(Vol. 8 No. 1)
Technology and
Typography**

15 July 2016
170×240 mm, p284
ISBN 978-89-7059-858-1
President: Kim Okcheol
Editor-in-chief: Moon jisook
Concept: Park Soojin,
Lee Jaeyoung, Chris Ro
Editor & Proofreader:
Kim Lynn, Kim Hanah
Photography: Kim Jinsol
Design: Lee Jaeyoung
Publisher: Ahn Graphics

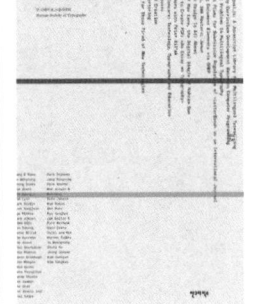

LetterSeed 6
(Vol. 4 No. 2)

30 November 2012
148×200 mm, p130
ISBN 978-89-7059-658-7
President: Kim Okcheol
Editor-in-chief: Moon jisook
Editor: Shin Hyejung
Design: Kim Byungjo
Title Design: Kymn Kyungsun
Publisher: Ahn Graphics

LetterSeed 7
(Vol. 5 No. 1)

17 June 2013
148×200 mm, p160
ISBN 978-89-7059-576-4
President: Kim Okcheol
Editor-in-chief: Moon jisook
Concept: Korean Society
of Typography
Editor: Shin Hyejung,
Jung Eunjoo, Min Guhong
Design: Sung Jaehyouk,
Sung Yeseul, Han Naeun
Title Design: Kymn Kyungsun
Publisher: Ahn Graphics

LetterSeed 8
(Vol. 5 No. 2)
Text After Supertext

28 December 2013
170×240 mm, p160
ISBN 978-89-7059-719-5
President: Kim Okcheol
Editor-in-chief: Moon jisook
Concept: Korean Society
of Typography
Editor: Min Guhong
Photography: Park Kisu, Kim
Kyongtae, Lim Hakhyun,
Nam Kiyong
Design: Kim Byungjo
Publisher: Ahn Graphics

LetterSeed 9
(Vol. 6 No. 1)
Ornament

24 September 2014
170×240 mm, p160
ISBN 978-89-7059-752-2
President: Kim Okcheol
Editor-in-chief: Moon jisook
Editor: Jung Eunjoo
Design: Kim Byungjo
Photography: Park Kisu
Publisher: Ahn Graphics

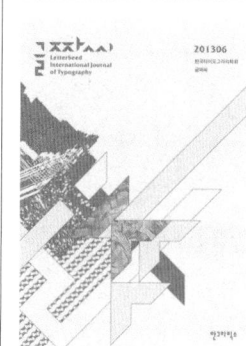

LetterSeed 2
(Vol. 2 No. 2)

1 September 2010
148 × 200 mm, p264
ISBN 978-89-7059-562-7
President: Kim Okcheol
Editor-in-chief: Moon jisook
Editor: Shin Hyejung,
Jung Eunjoo
Design: Min Byunggeol +
Jeon Jaewan
Title Design: Kymn Kyungsun
(Book for Korean Society of
Typography), Min Byunggeol
(Book for Ahn Graphics)
Publisher: Ahn Graphics

LetterSeed 3
(Vol. 3 No. 1)

9 April 2011
148 × 200 mm, p192
ISBN 978-89-7059-576-4
President: Kim Okcheol
Editor-in-chief: Moon jisook
Editor: Jung Eunjoo
Design: Kim Jiwon
Title Design: Kymn Kyungsun
Publisher: Ahn Graphics

LetterSeed 4
(Vol. 3 No. 2)

28 September 2011
148 × 200 mm, p256
ISBN 978-89-7059-601-3
President: Kim Okcheol
Editor-in-chief: Moon jisook
Editor: Jung Eunjoo
Design: Kim Byungjo
Title Design: Kymn Kyungsun
Publisher: Ahn Graphics

LetterSeed 5
(Vol. 4 No. 1)

30 March 2012
148 × 200 mm, p184
ISBN 978-89-7059-626-6
President: Kim Okcheol
Editor-in-chief: Moon jisook
Editor: Shin Hyejung,
Jung Eunjoo
Design: Kim Byungjo
Title Design: Kymn Kyungsun
Photography: Park Kisu
Publisher: Ahn Graphics

LetterSeed

『LetterSeed』 is a typography journal published by the Korean Society of Typography since December 2009. If the purpose of the society, the study of letters and typography, is embodied in presentations at academic conferences, it is embodied in books at 『LetterSeed』. Since the 8th issue, the journal not only researched typography and contained a thesis but also held the characteristics of a magazine with its various writings and plans related to the theme. Since the 8th issue (Vol. 5 No. 2), the academic discussions and exchanges in 『LetterSeed』 were written concurrently in both Korean and English. There is a version that is sent to the members of the Society and another version published by Ahn Graphics. Both have the logos of the Korean Typography Society and Ahn Graphics. It contains the society's logo and the Ahn Graphics' logo, respectively.

LetterSeed 0
(Vol. 1 No. 1)

31 December 2009
145 × 210 mm, p192
Publisher: Ahn Sang-soo
Data Organizer: Ku Jaeun
Design: Min Byunggeol

LetterSeed 1
(Vol. 2 No. 1)

1 February 2010
148 × 200 mm, p280
ISBN 978-89-7059-436-1
President: Kim Okcheol
Editor-in-chief: Moon jisook
Editor. Jung Eunjoo
Design: Min Byunggeol
Title Design: Kymn Kyungsun
Publisher: Ahn Graphics

**Korean Society of
Typogrpahy
Regular Membership
Exhibition tE12**

21 July – 4 August 2017
Doosung In the Paper Gallery
Poster Design: Lee Jaeyoung

Ahn Byunghak, An Hyojin,
An Jinyoung, Ariane Potapieff,
Chae Byungrok, Cho Hyun,
Choi Hyunho + Ji Sukmin,
Chris Ro, Eo MinSun, Everyday
Practice, Han Jaejoon, Hong
Dongsik, Huh Minjae, Hwang
Joonpil, Hwang Kyusun, Jaegal
Sun + Yoo Hyojin + Smith
Ryan, James Chae, Jeon
Jaeun + Huynh Abi, Jeong
Jaewan, Jiri Oplatek, Jung
Younghun, Kang Eunmi +
Kim Kichang + Jiri Oplatek,
Kang Juhyun, Kim Hansol,
Kim Jiwon, Kim Joosung, Kim
Kichang, Kim Kyongju, Kim
Kyungwon, Kim Minji + Cho
Hyeeun, Kim Minjoo, Kim
Minsu, Kim Na, Kim Namoo,
Kim Nayoung, Koos Breen,
Kwon Hyeun, Kwon Kihong,
Lee Chae, Lee Choongho,
Lee Chulwoong, Lee Jisu,
Lee Yoonseong, Lim Haklae,
Masaki Miwa + Ying Tong
Tan, Moon Janghyun, Moon
Jeongju, Nam Youngwook,
Ordinary People, Park
Chanuk, Park Jihoon, Park
Woohyuk, Seo Jinsol, Seo
Jinsoo, Seok Jaewon, Shim
Daeki, Shim Hyojun, Shin
Dongyun, Sim Ayeon, Simone
Trum + Loes van Esch, Song
Minjoo, Sulki and Min, Sun
Jooyoun, Sung Jaehyouk,
Sunwoo Hyunseung, Valentijn
Goethals + Tomas Lootens,
Yang Hanseul, Yang Jungeun,
Yoo Yewon, Yu Hwaran,
Yu Jeongmi

**Korean Society of
Typogrpahy
Regular Membership
Exhibition tE13
《Photo & Typography》**

23 May – 5 June 2018
Doosung In the Paper Gallery
Poster Design: DAEKI & JUN,
Lim Sooyeon

Ahn Byunghak, Bae Minkee,
Bae Sohyeon, Cha Sangmin,
Chae Byungrok, Cho Hyeyeon,
Choi Seokhwan + Cho
Hyun, Chris Ro, Ee Jaejin, Eo
Minsun, Erik Brandt, Everyday
Practice, Han Jaejoon, Han
Kihyun, Han Mano, Hong
Dongsik, Huh Minjae + An
Jinyoung, Hwang Joonpil,
Jaegal Sun + Ryan Smith,
James Chae, Jay Lim, Jeon
Jaeun, Jeong Jaewan + Kay
Jun, Ji Hanshin, Jiri Oplatek,
Jung Jin, Jung Younghun, Kang
Jinju, Kang Sungyoun +
Lee Kanghyun, Kang Ujean,
Kim Hansol, Kim Kyongju, Kim
Lynn, Kim Minjae, Kim Namoo,
Kim Sanghyun, Kim Sujeong,
Ku Jaeun, Kwon Kihong, Lee
Chae, Lee Choongho, Lee
Jaekyung, Lee Kyurag, Lee
Wonjae, Lim Suekyoung,
Lim Suyeon, Moon Janghyun,
Noh Sungil, Paper Press,
Park Jiyeon, Park Woohyuk,
Park Youngha, Seok Jaewon,
Shim Daeki, Shim Hyojun,
Shin Dongyun, Shin Jaeho,
Shin Suhang, Sim Seyeon,
Suh Kyungwon, Sulki and
Min, Sung Jaehyouk, Sunwoo
Hyunseung, TSUBAKI,
The Rodina, Tomas Lootens,
Valentijn Goethals, Yang
Jungeun, YangJang, Yim
Sungshin, Yu Hwaran,
Yu Jeongmi, Yoon Woojin

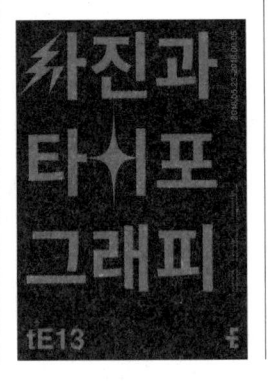

2013 Korean Society of Typogrpahy 7th Exhibition

14–22 December 2013
Kookmin University
Chohyung Gallery

The 7th exhibition explored the relationship between text and meaning under the minimum conditions. Each word in the sentence of 35 words was randomly distributed to 35 exhibition participants. The artist freely works with given words, and the works produced in this way were installed in the exhibition hall in the order of sentences.

Korean Society of Typogrpahy Exhibition 9

10–14 June 2014
Busan Pukyong National University Daeyeon Campus Janbogogwan
Poster Design: Kim Byungjo

The 9th exhibition was held at Pukyong National University in Busan with a summer conference.

Ahn Byunghak, Ahn Hoeun, Chae Byungrok, Chae Hyesun, Cho Hyun, Choi Gayoung, Chris Ro, Chung Yookyung, Gu Seulgi, Han Jaejoon, Hong Dongsik, Huh Minjae + Park Sohyun, Jeong Jaewan, Jeong Yeesook, Jung Jin, Jung Younghun, Kim Byungjo, Kim Doosup, Kim Heeyong, Kim Hyunmee, Kim Jangwoo, Kim Jeehyun, Kim Jiho, Kim Kyungyeon, Kim Sunghyun, Kim Sungjae, Kim Sunhwa, Ko Insuk, Ko Seon, Kwon Boram, Lee Hyunsong, Lee Jaemin, Lee Jiwon, Lee Juyoung, Lee Mijin, Lee Youngmi, Moon Hyejung, PaTI Digital Design Lab (Shin Mideum + Lee Jaeok), Park Changhoon, Park Kyungsik, Park Sojung, Park Woohyuk, Ryujin, Seo Sooyeon, Shin Dokho, Suh Kyungwon, Suh Seungyoun, Sung Jaehyouk, Sunwoo Hyunseung, Yang Pilseok

Korean Society of Typogrpahy 10th Exhibition 《Intersection》

27 June–4 July 2015
Sungshin Women's University Donam Soojung Campus Nanhyang Hall
π Room

Based on the theme of 'Intersection', the free interpretation of multilingual typography was shown in various media.

Ahn Byunghak, An Hyojin, Baik Jisun, Chae Byungrok, Chang Hyejin, Chris Ro, Chung Daein, Eo MinSun, Han Jaejoon, Hong Dongsik, Huh Minjae + Lee Seongkyun, Hwang Joonpil, Jang Hyojin, Jung Jin, Jung Younghun, Kang Gooryong, Kim Boeun, Kim Byungjo, Kim Doosup, Kim Hyungmin, Kim Hyunmee, Kim Jangwoo, Kim Joosung, Kim Kyoungkyun, Kim Minsu, Kim Namoo, Kim Sujeong, Kim Sunghyun, Kim Taekhyun, Kim Yoonshin + Lee Wonjae, Lee Byungjoo, Lee Hyunsong, Lee Jinwoo, Lee Jiwon, Lee Youngmi, Lee Yunjung, Lim Jinwook, Luhe, Min Byunggeol, Nam Juhyun, Nam Suin, Nam Youngwook, Park Youngha, Park Yuseon, Seo Jinsoo + Kim Jiwon, Seok Jaewon, Shim Daeki + Shim Hyojun + Keith Wong, Shin Dongyun, Shin Mideum + Lee Jaeok, Sohn Beomyoung, Sohn Youngeun, Song Seongjae, Suh Kyungwon, Sung Jaehyouk, Sunwoo Hyunseung, Won Youhong

Korean Society of Typogrpahy 11th Exhibition 《Good Hands》

19 August – 8 September 2016
Doosung In the Paper Gallery
Poster Design: Kwon Soojin, Lee Hyeyoon, Han Seunghee

The 11th exhibition is about the topic of the conference: Typography and Technology. Related to this, it dealt with the theme of "Good Hands" and showed it as a video and interactive work as well as a print media.

줄은 무한한 점으로
구성되어 있다.
그리고 면은 무한한
줄로 되어 있고, 권(卷)은
무한한 면으로 되어 있다.
그리고 전집(全集)은
무한한 권으로 되어 있다.
아니 단호히 말하건대
이건 아니다.
내 이야기를 시작하는
가장 좋은 방법은 좀더
기하학적이 되어야 한다.

한국타이포그라피학회
열 번째 전시

2011 Korean Society of Typogrpahy Regular Membership Exhibition 《Biting Remark》

9 – 22 April 2011
Doosung In the Paper Gallery
Poster Design: Shin Myungsup

A Biting Remark is the expression of a strong message in a strong tone. Biting Remarks can make a scar on the listeners, but also cause awareness. 《Biting Remark》 showed the designer's autonomous and creative response to social and cultural phenomena through typographic imagination.

Han Yoonkyung, Jang Sunghwan, Jeong Jaewan, Jung Jin, Kay Jun, Kim Byungjo, Kim Changsik, Kim Heeyong, Kim Hyunkyung, Kim Hyunkyung, Kim Jeehyun, Kim Jiwon, Kim Joosung, Kim Kyoungkyun, Kwon Eunsun, Lee Byoungok, Lee Byungjoo, Lee Heeyoung, Lee Kijoon, Lee Youngmi, Park Minseong, Seo Jinsoo, Shin Myungsup, Shur Kiheun, Song Myungmin, Song Seongjae, Suh Seungyoun, Sunwoo Hyunseung, Won Youhong

2011 Korean Society of Typogrpahy Regular Membership Exhibition The 7th Seoul Wow Book Festival's Invitational Exhibition 《Cartoon Typography》

29 September – 3 October 2011
Seoul Art Space Seogyo
Poster Design: Sung Jaehyouk

The new possibilities of cartoon typography were experimented by reinterpreting the typographic elements of mimetic words, onomatopoeia, and speech balloons shown in the cartoon from the designer's perspective.

Gang Nana, Han Yoonkyung, Jung Jin, Kim Byungjo, Kim Donghwan, Kim Hyunkyung, Kim Jeehyun, Kim Jiwon, Kim Mihyun, Kim Nayoun, Kim Yujin, Ku Jaeun, Lee Byungjoo, Lee Heeyoung, Lee Jiwon, Lee Yongje, Lee Youngmi, Park Yeonmi, Seo Jinsoo, Song Myungmin, Suh Seungyoun, Sung Jaehyouk, Sunwoo Hyunseung, Tore Terrasi, Won Youhong

2012 Korean Society of Typogrpahy 5th Exhibition 《Typography Experiment》

15 – 21 December 2012
Myongji College Muse Hall

As a venue for experiments showing the self-reliant and creative works of designers through typographic imagination, it showed the creativity of its members and the identity of the Korean Society of Typography in its form and meaning.

Korean Society of Typogrpahy 6th Exhibition 《Typography Experiment》

29 – 11 June 2013
Doosung In the Paper Gallery
Gallery Square
Poster Design: Park Yeounjoo

It is an exhibition that experiments with the boundaries of typography, where it meets the surrounding areas, includ-ing exploration of the essential problems of typography.

Ahn Byunghak, Ahn Samyeol, Cho Hyun, Chris Ro, Geel Woogyung + Lee Jaemin, Gu Seulgi, Han Jaejoon, Hong Dongsik, Huh Minjae, Hwang Joonpil, Jeong Jaewan, Jo Sungwon, Joe Hyounyoul, Kay Jun, Jung Jin, Kim Byungjo, Kim Hyunmee, Kim Jangwoo, Kim Jeehyun, Kim Jinsuk, Kim Joosung, Kim Seonggye, Kim Sunghyun, Kim Yuntae, Ko Seon, Kwon Joonho + Kim Kyungchul + Kim Eojin, Kymn Kyungsun, Lee Byungjoo, Lee Chae, Lee Choongho, Lee Jiwon, Lim Jinwook, Min Byunggeol, Min Guhong, Park Kumjun, Park Minseong, Park Woohyuk, Park Yeounjoo, Seo Jinsoo, Seok Jaewon, Shin Dongyun + Park Sunha, Shur Kiheun, Suh Kyungwon, Sulki and Min, Sung Jaehyouk, Sung Jiyeon, Sunwoo Hyunseung, Won Youhong, Yoo Jungsook

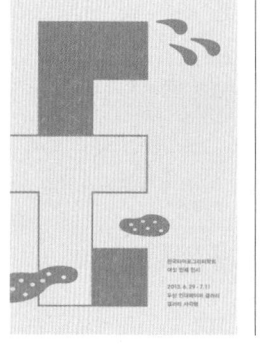

Exhibition

After launching Lee Sang's centennial exhibit 《Si:Si》 in 2010, the Korean Society of Typography began to plan one or two exhibitions annually. The theme is chosen by the Society and artists are recruited according to the Events & Exhibition Director's lead. Though the theme is always different, the experimental approach to typography remains the same. 45 artists participated in the 1st exhibition, and 83 artists took part in the 12th, presenting the biggest amount of artworks up to date. 10 foreign artists were involved in the 12th exhibition, and 6 foreign artists in the 13th, thereby introducing international diversity to the Korean Society of Typography.

2010 Korean Society of Typogrpahy 1st Exhibition The 100th Anniversary of the Birth of Lee Sang. 《Si:Si》

1–10 February 2010
Korea Design Foundation Gallery D+
Poster Design: Kymn Kyungsun

In 2010, the Korean Society of Typography held a Visible Poetry Exhibition for the 100th anniversary of the birth of Lee Sang. In honor of the poet's ideal of actively using "typeness" in the expression of poetry, the members displayed works that visualized poems created or selected by each member in the typographic language.

Ahn Byunghak, Ahn Sang-soo, Cho Hyun, Choi Sulki, Choi Sung Min, Han Jaejoon, Jang Sunghwan, Jeong Jaewan, Kang Eunsun, Kang Yousun, Kim Dongshin, Kim Doosup, Kim Eunyoung, Kim Hyunkyung, Kim Hyunmee, Kim Jangwoo, Kim Jeehyun, Kim Jiwon, Kim Joosung, Kim Myosoo, Kim Sangdo, Kim Zhongkun, Ko Seon, Ku Jaeun, Kwon Eunsun, Kymn Kyungsun, Lee Byungjoo, Lee Chae, Lee Jinkoo, Lee Kijoon, Lee Yongje, Lee Youngmi, Lim Jinwook, Noh Eunyou, Oh Jinkyung, Park Chanshin, Park Kumjun, Ryu Myungsik, Sim Wujin, Song Seongjae, Suh Seungyoun, Yeo Taemyung, Yoo Jungsook, Yu Jeongmi, Yu Jiwon

2010 Korean Society of Typogrpahy 2nd Exhibition The 6th Seoul Wow Book Festival's 100th Anniversary Invitational Exhibition 《Strange Book》

7–12 September 2010
Seoul Art Space Seogyo
Poster Design: Shin Myungsup

Under the theme of poet Lee Sang, it is an exhibition that presents the sympathy, various reactions, and interpretations of his poems in the form of books.

Ahn Sang-soo, An Mano, Byun Sabum+Park Sihyung, Choi Ahyoung, Choi Sung Min+Choi Sulki, Han Jaejoon, Jeong Jaewan, Joe Hyounyoul, Kim Hyunkyung, Kim Jangwoo, Kim Jeehyun, Kim Joosung, Ku Jaeun, Lee Byungjoo, Lee Chae, Lee Choongho, Lee Jaemin+Geel Woogyung, Lee Kijoon, Lee Seonyoung, Lee Yongje, Min Byunggeol, No Seungkwan, Noh Eunyou, Park Kumjun, Ryu Myungsik, Shin Myungsup, Song Hosung, Song Myungmin, Song Seongjae, Suh Seungyoun, Sung Jaehyouk, Sunwoo Hyunseung, Won Youhong, Yim Sungshin

Korean Society of Typogrpahy Academic Conference 18

16 June 2018
13:00–17:30
B146, ECC, Ewa Woman's University

1. Gwenzhir: Tumblbug Project of the Feminist and Queer
2. Woo Yunige: Tools of Feminism in Europe
3. Lee Dozin: Visual Language for All Genders
4. Park Cheolhee: Sunny Books and Green Poster
5. Lee Kyungmin: LGBTAIQ+ Solidarity with Visibility
6. Monthly 『Design』: Feminism Policy of Monthly 『Design』
7. 『LetterSeed』 Publishing/ Academic Team: Grammar of Gender Campaign and Contemporary Graphic Design— Archives of 『LetterSeed』 17
8. Round Table

Korean Society of Typogrpahy Academic Conference 19

18 July 2020
14:00–18:00
Auditorium 2F, Arts Education & Research Building (74), Seoul National University
Poster Design:
Yoon Choong-geun

1. Min Bon: Fonts at Apple
2. Lee Kunha: Visualization Experiment of Kim Kirim Poetry: Using Concrete Poetry and Book Design Technique
3. Kang Yeonmin: The Status and Task of Typeface Research at the National Hangeul Museum
4. Park Ee-rang: Hyundai Department Store Branding
5. Chae Heejoon: 1-Person Hangeul Design Process
6. Shin Haeok: Monthly 『Design』 Redesign
7. Han Jaejoon: Signboard of Gwanghwamun and Shape of Hunminjeongeum

Korean Society of Typogrpahy Academic Conference 14

25 June 2016
13:00–16:50
B146, ECC, Ewa Woman's University
Poster Design: Lee Jaeyoung

1. Lim Jinwook: Government Symbolic Typeface Development Process
2. Choi Jaeyoung: Metafont Next Generation CJK Font Technology Using the Metafont
3. Kim Byungjo: Technical Problems in Multilingual Typography
4. Bae Minkee: Spread Through Multiple Methods—Oblique Publishing
5. Kim Lynn: Amendment Plans for Regulations for Writing 『LetterSeed』 Articles as an International Journal
6. Lee Jiwon: Typography Curriculum Development Based on Computer Programming

Korean Society of Typogrpahy Academic Conference 15

17 December 2016
13:00–17:00
501, Areum Hall, Daehangno Campus, Seoul Women's University
Poster Design: Lee Jaeyoung

1. Lee Yongje: Suggestions for Groupings of Dat-ja (Consonant) in Square Frame Hangeul Combination Rule
2. Kim Hyunmee: Restoration of Old Characters in Overseas Type Foundries
3. Jung Harin: AG Super Black Gothic Production Process (Based on the Analysis of Super Black Gothic Original Drawings)
4. Na Kim: Common Center Branding
5. James Chae: Contradiction as Strategy
6. Ahn Byunghak: Typojanchi Pre-biennale
7. Kim Jeehyun: Survey on the Current Status and Activities of Overseas Typography-related Organizations
8. Min Byunggeol: The Beautiful Typography Books of the Year

Korean Society of Typogrpahy Academic Conference 16

17 June 2017
13:00–18:00
501, Areum Hall, Daehangno Campus, Seoul Women's University
Poster Design: Lee Jaeyoung

1. Kang Hyeonjoo: 3rd Generation of Korean Graphics Designers—Ahn Sang-soo
2. Kay Jun: Ahn Sang-soo's Magazine Art Directing: 『Ggumim』, 『Madang』, and 『Mut』
3. Min Guhong: Killing Time
4. Park Hayan: Flying Baegot, PaTI
5. Kim Hyungjae: Typography's Role of Recontextualizing the Functional Spaces as a Platform of Planning and Execution: Visual Policies of Audio Visual Pavilion
6. Bae Minkee: The Results and the Possibility of Expansion of the Graphic Design Curriculum Based on the Relationship between Screen Media and Print Media
7. Park Yeounjoo: Touch Type
8. Cho Hyunyeol: Body Dictionary
9. Kim Namoo: Body and Typography: Writing in Red

Korean Society of Typogrpahy Academic Conference 17

16 December 2017
13:00–17:30
Auditorium (1F), Daehak-ro Campus, Korea National University of Arts
Poster Design: Lee Jaeyoung

1. Yu Jiwon: Font Design Education
2. Choi Moonkyung: The Typography Curriculum Related to the Character Design Class of Paju Typography Institute
3. YangJang Type: Penbatang
4. Kang Younghwa: Kim Donghwi. Spoqa Han Sans—Customizing a Type Face from the User's Point of View
5. Noh Minji: The Development Process of Chinese Character Type Through Arita Heiti

Korean Society of Typogrpahy Summer Academic Conference 2014

13 June 2014
14:00–19:00
Dongwon Jang Bogo Hall,
Daeyoen Campus ,Pukyong
National University
Poster Design: Kim Byungjo

1. Nam Songwoo: The Aspects of Hangeul Font in Korean Poets' Self-written Poems
2. Jeong Jaewan: The Basic Structure of Hangul Lettering Design
3. Ahn Sang-soo: Typography School Design
4. Hong Dongsik: See Font, Read Busan

Korean Society of Typogrpahy Academic Conference 11

12 December 2014
14:00–18:00
Future Hall B1, Hansung University
Poster Design: Kim Byungjo

1. Seok Geumho, Jang Sooyoung: The Direction of Korean Font—Focusing on the Noto Sans
2. Fritz K.Park: The 1946 Dispute Between Max Bill and Jan Tschichold
3. Lee Yej: Jan Tschichold and Leipzig Deutsche Nationalbibliothek
4. Noh Eunyou: Hangeul Designer Choi Jeong-ho
5. Lee Jaemin, Park Haechun: Typojanchi 2015 Pre-biennale
6. Kim Byungjo: 『LetterSeed 10: Jan Tschichold』

Korean Society of Typogrpahy Academic Conference 2015

27 June 2015
14:00–17:30
415, Soojung Hall, Donam Soojung Campus ,Sungshin Women's University
Poster Design: Shim Yeri

1. Kim Minsoo: The Pending Issues of Korean Typography
2. Kim Chorong: The Reality of Multilingual Font Development Based on Thai Font Development
3. Park Jaehong: A Study of Creating a Structural Font through '므-height' in Hangeul
4. Lim Kyungyong, Shin Haeok, Shin Donghyeok: Typojanchi Pre-biennale Review

Korean Society of Typogrpahy Academic Conference 13

11 December 2015
13:30–18:00
501, Areum Hall, Daehangno Campus, Seoul Women's University
Poster Design: Lee Jaeyoung

1. Choi Bum: Landscape of Hangeul
2. Kay Jun: Linguistic Landscape in Korea in the 1970s Seen Through the Column
3. Noh Minji: Proposal for Additional Korean Characters in Complete Code System of Hangeul
4. Kwon Junho: Typography as Speech

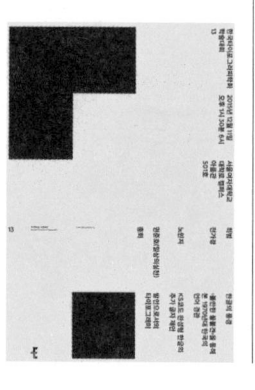

Korean Society of Typogrpahy Summer Academic Conference + Provisional General Meeting

16 June 2012. 6. 16.
14:00–18:00
Auditorium 2F, Student Union Building ,Konkuk University
Poster Design: Seo Jinsoo

1. Kim Seonggyu: Hangeul and Leonardo da Vinci
2. Park Jina: History of Modern Typography 1890–1950 with Functionalism Discourse
3. Gu Seulgi: Shape of Hangeul Letter and Semantic Elements
4. Kim Youngho: Change of the Communication by Correlation of Text and Picture
5. Noh Eunyou: A Study on the Morphological Charac-teristics and Lineage of Choi Jeong-ho's Hangeul Typeface

Korean Society of Typogrpahy Winter Academic Conference + Regular General Meeting

15 December 2012
14:00–18:00
Gallery MJ B1, Art & Design House, Myongji Collage

1. Kim Seonggyu: The Life and Death of Hangeul That Killed Hunminjeongeum
2. Yu Jiwon: 2012 ATypl Report

Korean Society of Typogrpahy Summer Academic Conference

15 June 2013
14:00–16:30
Future Hall B1, Hansung University

1. Yu Jiwon: Western Modernity, East Asia, Islamic Space and Composition
2. Lee Yongje: A Study on Standardization of Punc-tuation Mark and Symbol of Hangeul Unicode

Korean Society of Typogrpahy Winter Academic Conference 2013

14 December 2013
14:00–17:00
Auditorium, Administration Hall, Kookmin University
Poster Design: Kim Byungjo

1. Park Hyunsoo: Condition and Typographic Imagination of Modern Korean Poetry
2. Jung Younghun; Hangeul Font Design for Emphasis and Quotation
3. Lee Byounghak: The Flower of the Printer: Fleuron and Arabesque
4. Kim Jeehyun, Kim Byungjo: New 『LetterSeed』

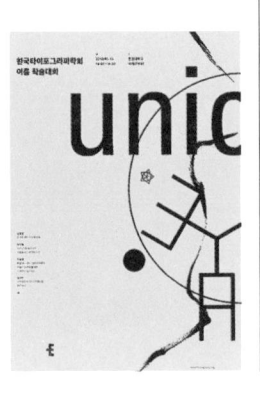

Korean Society of Typogrpahy Academic Conference + General Meeting

18 June 2010
14:00–18:00
Conference Room 5F,
Sangsangmadang
Poster Design: Kim Byungjo

Korean Society of Typogrpahy Academic Conference + General Meeting

17 December 2010
14:00–18:00
E103, Hongik University
Poster Design: Sim Wujin

1. Yim Sungshin: Lee Sang Flies Away
2. Kwon Eunsun: Seoul Typeface
3. Lee Yongje: A Proposal about the Use of 'Letter, Type, Handwriting' in Typography
4. Choi Junghwa: The Formative Characteristics and the Preference Analysis of Gulim
5. Kang Koni: Study on the Improvement of Pavement Word Marking Seen from Typographic Viewpoints
6. Sunwoo Hyunseung / A Strange Book—Structural Interpretation

Korean Society of Typogrpahy Academic Conference + Provisional General Meeting

18 June 2011
14:00–18:00
Gallery MJ B1, Art & Design House, Myongji Collage
Poster Design: Lee Heeyoung

1. Min Bon: The Letter as Equilibrium of Black and White: an Intercultural Synthesis
2. Lee Yongje: Suggestion of Sharing and Solidarity of Hangeul Typography Education
3. Kim Byungjo: Definition of Typography
4. Koo Bonyoung: Associations Between the Structures of Hangeul Fonts for Text and the Factors of Recognition
5. Yu Jiwon: Ein Jahrhundert Schrift und Schriftunterricht in Leipzig
6. Lee Youngmi: Research on Awareness and Preference of Corporate Typeface

Korean Society of Typogrpahy Academic Conference + Regular General Meeting

17 December 2011
14:00–18:00
Future Hall B1,
Hansung University

1. Hong Yoonpyo: The Principle of Hunminjeongeum Pro-duction and Its Scientificity
2. Koo Bonyoung: Associations Between the Structures of Hangeul Fonts for Text and the Factors of Recognition
3. Kim Byungjo: Typography Education
4. Lee Yongje: A Relationship Between Direction of Writing and Hangeul Letter-form
5. Sim Wujin: Punctuations as an Environment of Hangeul Typography

Academic Conference

The Korean Society of Typography holds two academic conferences annually which is once in the summer and once in the winter. As the most essential activity, research results and cases are presented to the members, students, and applicants. The academic conference covers a wide range of disciplines and industries and facilitates active exchanges between various fields. It is composed of invitational lectures, paper and research presentations, and project introductions. Part of the presentation becomes a manuscript for 『LetterSeed』. Though presentations are normally conducted live, there was a supplementary livestream in 2020 due to COVID-19.

Korean Society of Typogrpahy Inaugural Meet

12 September 2008
16:00
Conference Room 5F, Sangsangmadang
Poster Design: Min Byunggeol

Korean Society of Typogrpahy Academic Conference + General Meeting

12 September 2009
14:00–18:00
Conference Room 5F, Sangsangmadang
Poster Design: Lee Yongje

1. Yu Jiwon: A comparative Study on Italic of the Latin Alphabet and Cursive of Hangeul
2. Kim Nayoun: A Study on the Type Extraction Based on the Combination of Morphological Descrimination Element of Type
3. Ku Jaeun: Green Typography for Printed Materials
4. Lee Yongje: Ink-Saving Typeface
5. Han Jaejoon: The Sustainable Value of Hangeul
6. Ahn Sang-soo: Huiyi, Montage, Lifepeace.Symbol

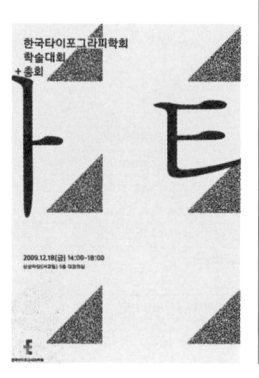

4th Executive (2015–2016)

Role	Name	Affiliation
Chairperson	Han Jaejoon	Seoul Women's University
Vice Chairperson/Editorial Board	Lee Byungjoo	Hansei University
Policy & Planning Director	Kim Doosup	nooNdesign
	Min Byunggeol	Seoul Women's University
Corporate Relations Director	Ahn Byunghak	Hongik University
	Lee Jaemin	Studio fnt
Academic Publishing Director	Chris Ro	Hongik University
	Park Soojin	Ewha Womans University
Events & Exhibition Director	Lee Jiwon	Kookmin University
	Kim Namoo	Hankyong National University
International Relations Director	Kim Kyoungkyun	Korea National University of Arts
	Kim Hyunmee	SADI
Hangeul Committee (Chair)	Lee Yongje	Kaywon University of Art & Design
Dictionary Committee (Chair)	Won Youhong	Sangmyung University
Typojanchi Committee (Chair) Ethical Conduct Commissioner	Choi Sung Min	University of Seoul
Director of Typojanchi	Kymn Kyungsun	Seoul National University
Auditor	Song Seongjae	Hoseo University
	Hong Sungtaek	hongdesign
Secretary General	Sunwoo Hyunseung	A&A company
Executive Coordinator	Kim Hansol	Seoul Women's University
Public Relations Coordinator	Han Ahram	Hongik University
Publishing Coordinator	Lee Jaeyoung	6699press
Editor-in-Chief	Kim Jeehyun	Hansung University
Editorial Board	Hong Dongsik	Pukyong National University
	Yu Jeongmi	Daejeon University
	Lee Jieun	Hokkaido University of Education
Ethical Conduct Commission (Chair)	Kim Joosung	Myongji College

5th Executive (2017–2018)

Role	Name	Affiliation
Chairperson	Yu Jeongmi	Daejeon University
Vice Chairperson/Editorial Board	Cho Hyun	S/O Project
Policy & Planning Director	Lee Choongho	University of Ulsan
Educational & Research Director	Jeong Jaewan	Yeungnam University
	Na Kim	Table Union
Events & Exhibition Director	Shim Daeki	DAEKI & JUN Studio
	Jeon Jaeun	Hongik University
International Relations Director	Choi Sulki	Kaywon University of Art & Design
	Lee Chae	Seoul Women's University
Hangeul Committe (Chair)	Park Jaehong	Kyung Hee University
Dictionary Committee (Chair)	Won Youhong	Sangmyung University
Typojanchi Committee (Chair)/ Ethical Conduct Commissioner	Kymn Kyungsun	Seoul National University
Director of Typojanchi	Ahn Byunghak	Hongik University
Auditor	Song Seongjae	Hoseo University
	Hong Sungtaek	hongdesign
Secretary General	Lee Wonjae	Dankook University
Executive Coordinator	Kang Younghyun	
	Jung Younghun	
Public Relations Coordinator	Kang Sung Youn	GIGIC TMC
Editor-in-Chief	Kim Dong Bin	Dongduk Women's University
Ethical Conduct Commission (Chair)	Kim Joosung	Myongji College

6th Executive (2020–2021)

Role	Name	Affiliation
Chairperson	Kymn Kyungsun	Seoul National University
Vice Chairperson	Kim Hyunmee	SADI
	Seok Jaewon	Hongik University
Policy & Planning Director	Moon Janghyun	General Graphics
	Choi Moonkyung	Paju Typography Institute
International Relations Director	Fritz K. Park	Freelance
	Chae Byungrok	CBR Graphic
Corporate Relations Director	Park Youngha	Starbucks Korea
	Park Ee-rang	Hyundai Department Store
Events & Exhibition Director	Shin Haeok	Shin Shin
	Hong Eunjoo	hong x kim
Academic Publishing Director	Min Bon	Hongik University
	Sim Wujin	Sandoll Co., Ltd.
Editor-in-Chief/Ethical Conduct Commission (Chair)	Lee Byounghak	Hankyong National University
Editorial Board	Jung heesook	Seoul National University
	Joo Hyun Ha	Hankyong National University
Hangeul Committee (Chair)	Ku Jaeun	Freelance
Dictionary Committee (Chair)	Suh Seungyeon	Sangmyung University
Typojanchi Committee (Chair)	Park Woohyeok	Seoul National University of Science And Technology
Diversity Commission (Chair)	Lee Kiseob	THANKSBOOKS
Auditor	Min Byunggeol	Seoul Women's University
	Lim Jinwook	Type4 Design Group
Secretary General	Moon Haewon	Seoul National University
Executive Coordinator	Kim Sooeun	Seoul National University
	Chung Youngshin	Seoul National University
Public Relations Coordinator	Nam Youngwook	Seoul National University
	Yoon Choong-geun	Freelance
Publishing Coordinator	You Hyunsun	Workroom

Executives

The executives of the Korean Society of Typography consists of a president, vice president, secretary general, director, and auditor. The president is selected by the general assembly election, who then appoints the vice president, secretary general, and director. The term of office for executives is two years and the president cannot be reappointed. In addition to participating in regular board and general meetings, the executives perform other necessary tasks for the operation of the Society in accordance to their roles. The following are the executives of 2020 along with their primary roles descriptions.

Chairperson: As the representative of the Society he executes the direction of the major activities and takes charge of external communication to establish its status
Vice Chairperson: Helps the president set the direction of major activities, organizes the system and cooperates in each department's operation.
Policy & Planning Director: Plans and operates the conference projects.
Corporate Relations Director:Links the society and the working field.
Academic Publishing Director: Responsible for educational, research, and publishing activities of the society.
Events & Exhibition Director: Responsible for the exhibition activities of the society.
International Relations Director: Responsible for the international exchange activities of the Society.
Editor-in-Chief: Manages the journal's dissertation regulations and prepares for the promotion of candidates
Editorial Board: Operates the submitted manuscripts in accordance to the editorial regulations.
Ethical Conduct Commission (Chair): Responsible for the regulations of ethical behaviors and problems in research activities of the society and its members.
Ethical Conduct Commissioner: Monitors illegal activities of the society and its members and responds to related issues.
Hangeul Committee (Chair): Responsible for compilation and revision of the typography glossary.
Typojanchi Committee (Chair): Advises the planning and operation of the Typography Festival.
Director of Typojanchi: Responsible for the overall planning and organization of the Typography Festival.
Diversity Commission (Chair): Maintains diversity in the society's activities by responding to the related issues.
Auditor: Audits the evaluation of the conference's activities and the accounting of operations.
Secretary General: Manages the overall Society's schedule and supervises the budget and expenditure.
Executive Coordinator: Manages membership activities (joining, withdrawal) as well as communication between the board of directors and the secretaries.
Public Relations Coordinator: Promotes external communication of the society by operating the promotional channels.
Publishing Coordinator: In charge of editing and designing 『LetterSeed』.

1st Executive (2008–2010)

Chairperson	Ahn Sang-soo	Hongik University
Vice Chairperson	Won Youhong	Sangmyung University
Corporate Relations Director	Han Jaejoon	Seoul Women's University
Policy & Planning Director	Song Seongjae	Hoseo University
Academic Publishing Director	Kim Jeehyun	Hansung University
Events & Exhibition Director	Kymn Kyungsun	Seoul National University
International Relations Director	Choi Sung Min	University of Seoul
Auditor	Ryu Myungsik	Hongik University
	Shur Kiheun	Kyungwon University
Secretary General	Min Byunggeol	Seoul Women's University
Executive Coordinator	Kim Nayoun	
Secretary General	Lee Yongje	Kaywon University of Art & Design

2nd Executive (2011–2012)

Chairperson	Won Youhong	Sangmyung University
Vice Chairperson	Song Seongjae	Hoseo University
Corporate Relations Director	Han Jaejoon	Seoul Women's University
Policy & Planning Director	Kim Joosung	Myongji College
Academic Publishing Director	Kim Jeehyun	Hansung University
Events & Exhibition Director	Lee Byungjoo	Hansei University
International Relations Director	Han Changho	Konkuk University
Auditor	Ryu Myungsik	Hongik University
	Jung Gyemun	Dankook University
Secretary General	Suh Seungyoun	Yuhan University
Publishing Coordinator	Kim Byungjo	
Executive Coordinator	Kim Jiwon	

3rd Executive (2013–2014)

Chairperson	Kim Jeehyun	Hansung University
Policy & Planning Director	Yu Jeongmi	Daejeon University
	Lim Jinwook	Type4 Design Group
Corporate Relations Director	Cho Hyun	S/O Project
	Lee Jaemin	Studio fnt
Academic Publishing Director	Chris Ro	Hongik University
Events & Exhibition Director	Ahn Byunghak	University of Ulsan
	Park Yeounjoo	Hezuk Press
International Relations Director	Kim Hyunmee	SADI
	Sung Jaehyouk	Kookmin University
Overseas Commissioner (USA)	Kim Jinsuk	Jacksonville State University
Overseas Commissioner (Japan)	Lee Jieun	Hokkaido University of Education
Overseas Commissioner (UK)	Min Bon	University of Reading
Hangeul Committee (Chair)	Han Jaejoon	Seoul Women's University
Dictionary Committee (Chair)	Won Youhong	Sangmyung University
Typojanchi Committee (Chair)	Lee Byungjoo	Hansei University
Director of Typojanchi	Choi Sung Min	University of Seoul
Auditor	Chung Byoungkyoo	Chung Byoungkyoo School
	Ryu Myungsik	Hongik University
Executive Coordinator	Ham Sunga	Hansung University
Publishing Coordinator	Kim Byungjo	

Introduction

For the growth of visual culture the Korean Society of Typography was introduced on 17 September 2008 and not long after it was founded in 2009. The objective is to engage in various projects based on typography and letter. With the cooperation of active members in their respective fields, academic conferences are held, works exhibited annually, and the academic thesis 『LetterSeed』 is published. In 2019 the Korean Society of Typography went on hiatus for reorganization but in 2020 they greet their 10 years anniversary.

Founding Declaration

Visual.culture.was.triggered.by.letters.
·············..Visual.culture.boomed.through.typeface...
Small.thing.are.beautiful..

Small.simple.unembellished.is.how.we.begin..

Letter/typography.are.the.roots.of.communication.design..
Its.charm.is.the.background.of.learning..

Visual.culture.grows.in.the.shelter.of.letter/typography..

Among.our.letter.design(typography).is.hangeul..
Hangeul.is.being.ourselves.our.backbone..

Small..quietly..deeply.
Properly.standing.
Creatively.indwell.gathering.is.our.wish..

Sincerely.ㅇㅅㅅ.
Four.thousand.three.hundred.forty.two.year.
17.9.2008

Membership

The Korean Society of Typography is composed of professors, students, office workers, freelancers, and other people of various backgrounds. As of 30 July 2020, 36% were office workers, and 23% were professors. Memberships can be applied through the website or by email.
To become a member, prerequisites involve 2 recommendations from the regular members as well as an approval from the board of directors.

Professor	Instructor	Student	Office Worker	Freelance	etc
67	14	16	105	21	71
23%	5%	5%	36%	7%	24%

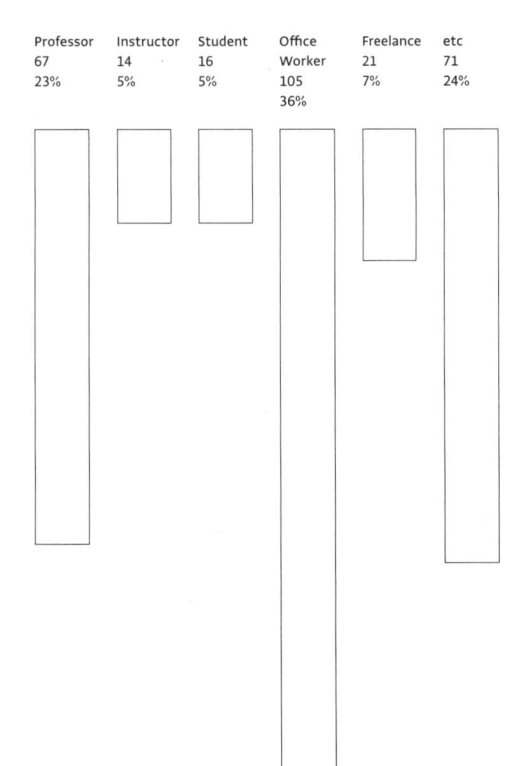

10 Years Record of the
Korean Society of Typography

Korean Society of Typography
Editorial Department

Translation: Kim Johan, Jae Mikie

"Archive" is an academic record of a presentation, article or event. While there is no set format of a presentation, article or event, forthright and true to the mission of the journal and organization. With the 10th anniversary of the KST, we looked back on the activities and accomplishments of the society.

archive
ar chive

in the gallery space. Also, the ⟨Self Portrait⟩ series which made its first appearance in the exhibition is a collaborative project with a photographer, where space juxtaposed with objects is photographed on a flat plane—which is then reinstalled in space. The systematic connecting factors between the planes and space were fascinating. ⟨Transitory Workplace, 53⟩ is also meaningful to me. It was my first exhibition with flexible conditions and also the first where actions and events taking place in the space were important to the work. That's why I came to think that space is not mere physical structure. Last but not least, designing the ÅLAND store was an opportunity for me to think about space that actually functions. Those who request me to do the space design expect me to do whatever and however I want, rather than a design that focuses on its function or commercial space. So I get to work freely. However, as it was an actual clothing store, it was important in space design to consider factors like clothing storage, product displays, and the flow of the customers' movement. It was not easy, but those constraints actually helped. The three were all very different but memorable experiences.

Installation View
of ⟨Drawing SET⟩.

acrylic sheets as I designed it. 〈GADGET nr.1: Muffler〉 was for ÅLAND Grafiker Project. The Grafiker Project was one where graphic designers collaborate with ÅLAND's partnered brands to create products. Since I was not a fashion designer, I looked for fun ideas related to the body rather than make something with sewing patterns. Then I thought of a muffler that adjusts its length based on the height of the person wearing it. I imagined a short person wearing it short, a tall person wearing it long, or the other way around. Therefore, I made 60×25cm muffler units and attached zippers on both sides. The units could connect to be 120cm or 180cm long. As I tested them out I found it intriguing that you could come up with your own ways to wear them. That's when I found zippers interesting. Thus, for this exhibition, I attached a 25cm-long zipper on the back of the coveralls I made, in collaboration with Post December. The coveralls do not have any special features, but I find appeal in its possibility to generate new features.

You Hyunsun You also seem to have a great interest in working with space. Is there one you remember most?

Na Kim I first took a serious approach on space when doing the exhibition 《Found Abstracts》 at Gallery Factory. It was my first attempt at examining the structure of the provided space. I placed my works based on the grids I set; they were made with measurements of the size of columns and girders

[p.88]
An Abstract Photograph of Exhibition View for the Catalog.

[p.89]
Exhibition View.

Bottomless Bag

the exhibition, that is for children. I am planning to take photos of scenes from the exhibition to look like abstract illustrations and create stories out of them. Therefore, I asked the poet Oh Eun to write a children's poem. Photos were taken by Unreal Studio. We took the most photos of the space that reinterpreted the book cover, and we took photos that construe the wall painting in a different light using characteristics of the space—like reflective floors and high ceilings. And Kim Sungwon, an art critic, will be writing a review on my work.

You Hyunsun I heard the furniture and costume for the exhibition were also collaborations with other teams.

Na Kim They were done with my long-time collaborators. I'm very thankful to them, and I consider myself lucky. Gom Design, who has been producing large-scale installations with me ever since 2012—the year I got back from the Netherlands— took charge of production of all the installations. And the furniture for the exhibition and space design for 〈Drawing SET〉 were done by Jeonsan System. I collaborated with Jeonsan System for space design of an ÅLAND store and the offices of DooRooDooRoo Artist Company. Costume was done by Post December, who I collaborated with on designing a muffler for ÅLAND Grafiker Project. We were next-door neighbors when my workplace was in Buam-dong—their studio was in the same building on the first floor. Unreal Studio, who I mentioned earlier, and I have collaborated for an exhibition I curated at COS Project Space. I enjoyed working with each and every one of them, and therefore I continue to do so.

You Hyunsun I want to ask about works not included in 《Bottomless Bag》. 〈Celine〉 and 〈GADGET nr.1: Muffler〉 are artworks that also have practicality. I would like to hear how they were different in the process from that of works created for exhibitions.

Na Kim To categorize them into artworks and products—I am interested in maximizing the ambiguity between the realms. 〈Celine〉 is not an actual chocolate packaging for sale. I once stayed in Sharjah, UAE for a while, and one day I went to a local market where there were boxes of chocolates stacked on top of each other. The chocolates were each wrapped in different colors of foil and attached with a logo-printed sticker, and the size of the chocolates and stickers were all different from each other. I bought them for no real reason—they were just pretty. And as I examined the chocolates I bought, I wondered why they were designed in such way from the same brand since it would not have been easy to manufacture. So, I re-designed the packaging as my own work. I pictured putting the chocolates of different sizes and heights into a single box and came up with the packaging consisted of layers with different-sized plates. I envisioned layers of different-colored

various things when I check with my own eyes and make adjustments one by one. For the installation of the ⟨SET⟩ series, the wall paintings were always painted by hand. It might not look much different in the photos from adhesive vinyl attached to the wall, but I think there is a big difference when you actually experience the space. ⟨SET v.9: patterns⟩ installed at Sungshin Women's University Station was the only version made with adhesive vinyl because it was not physically possible to paint them. The rest were done with paint.

You Hyunsun Was the bag in the exhibition poster actually made, and was it used?

Na Kim The graphic design for the exhibition was done by designer Yu Myungsang. I first met Yu at a PaTI (Paju Typography Institute), and the way he visualizes his ideas through hand-processed work was fascinating. So I wanted to work with him for this exhibition. Yu actually made the bag to be photographed for the poster.

You Hyunsun What are your plans for the exhibition catalog?

Na Kim In a broad sense, the exhibition is a recreation of the book as a space—so I didn't think there would be meaning in making a catalog with mere photos of the installation views. Instead, I wanted to make a children's book that would suit

⟨Found Composition⟩.

write about your own memories and stick to the facts, but when you are not sure, you write to your advantage or fabricate details. You keep creating fiction in the process. In this respect, I think it's similar to the process of designing.

You Hyunsun You created ⟨Found Composition⟩ by repurposing found objects. It seems they were handmade—do you prefer to work by hand?

Na Kim There are advantages of working both manually and digitally, and they cannot replace each other. But I lean towards working by hand. For instance, when making a catalog it may be the most convenient to check and choose the preview images on your computer screen. But I can't work that way. I print out all the images, cut them, place them on the table. In that way I can see which looks good next to which, in which order, or if it looks better flipped upside down or not. I can't process this on the computer. So I don't know if it's necessarily using the senses of my hands, but it's difficult for me to picture the layout by looking and touching unless it's the analog way. In a sense, I started ⟨Found Composition⟩ for the hands-on process. I find comfort in printing out and cutting the paper rather than sitting in front of the computer. I'm someone who can only make judgements when I see the printed material in its actual size to check things like the spacing in between letters. I stick to this process because I can discover and learn

Installation View of ⟨Found Composition⟩.

planned ahead; instead it throws a loose set of restrictions
and expands its context by making unexpected discoveries.

You Hyunsun Can you talk more about the act of "collecting",
which is an important part of your work process?

Na Kim I believe everyone collects. Those who say they don't
can be said otherwise depending on what one's standard of
a collection is. Unconsciously taking pictures in the same form
and composition, putting certain objects in your pocket—
these are all acts of collecting by my standards. I don't think
that only a serious collection of stamps is a collection. Everyone
has their own collection, to a greater or lesser extent.
My matter of interest is the meaning that the act of collecting
has to individuals. I think of collecting as an act of gathering
the context of time and space associated with the object.
The collected objects are not mere objects. I talk about
collections during student workshops so that the students
can revisit their memories and naturally have discussions on
them. And rather than going on and on about their memories,
the objects can present various contexts. You can talk about
your own recollections on the object, but others can see
the object from a different perspective. That is why I find the
act of collecting intriguing. I think about the process of writing
autobiography when connecting objects with memories.
Autobiographies are, in reality, very fictional. You try best to

⟨SET v.20:
page wall⟩.

Bottomless Bag

Moreover, I paid special attention to the material and texture of the objects and the space so that children could safely touch things and roll around the exhibition space. In doing so, I used less of the materials I normally use—like steel or wood—and instead chose more friendly and softer materials. Places like playrooms, kids cafes, and homes where children spend time are mostly built with shock-absorbing materials. The quality of the material can also be considered as part of the installation, so I took it importantly.

You Hyunsun　You mentioned how this exhibition gave you the opportunity to think about the future of ⟨SET⟩. Do you have any plans for your next step?

Na Kim　I will have to start thinking about that. But what I learned through doing several exhibitions is that it's not over once the installation is finished. The feedback you receive during the exhibition also plays a big role. And especially this time around, I unexpectedly got to spent a lot of time at the exhibition space since the museum temporarily closed down. And I came to wonder what exhibitions and artworks during this time of the epidemic mean and how their meanings can be presented. In one of my past exhibitions, I included my presence in the exhibition space as part of the work. Therefore, I often witnessed how the works create meaning in themselves and grow further even after they have been installed and the show has opened. In the case of ⟨Piece⟩, which was a new experiment, I thought of its idea ever since I presented the first exhibition of ⟨SET⟩ in New York. After I installed the wall paintings in the gallery, I went to my studio and drew a part of the painting on a canvas as a study. Five years later I finally got to making ⟨Piece⟩, and it gave me more clues than I had expected. I want to take some time after the exhibition to go over these thoughts.

[p82 Top Left]
《Bottomless》
Exhibition
Entrance
Installation View.

[p82 Top Right]
『SET』Covers.

[p82 Bottom]
Jisan Valley Rock
Music & Arts
Festival
⟨SET v.5⟩.

You Hyunsun　Have any of your projects been participatory?

Na Kim　I wouldn't say it's completely participatory, but for ⟨Transitory Workplace, 53⟩, I used space in the Culture Station Seoul 284 as my workplace during the exhibition. I uncovered many things in the setting of using an art museum—a public space—as my workplace with the viewers entering at times. For example, my schedule was adjusted to fit the schedule of the museum and I couldn't eat however I wanted inside— I saw my daily life being imbued with these restrictions given to a public space. Under these circumstances, I couldn't plan every part of it ahead. The unexpected conversations I had with the viewers and their reactions turned my work into a sort of participatory art. I used to wonder how I could embrace situations that are beyond my control. And my conclusion as of now is that participatory art is not something that prints out or renders the exact outcome of what you

Bottomless Bag

You Hyunsun I heard 《Bottomless Bag》 is the 20th version
of ⟨SET⟩. The series ⟨SET⟩ has been ongoing for a while,
and I am curious as to how it varies this time.

Na Kim I wouldn't say that this exhibition is the 20th version
to be precise—but the series lies at the core of the exhibition.
As this is a solo exhibition that showcases my past projects,
the ⟨SET⟩ series took a great portion of it. It was titled
'Bottomless Bag' to include works like ⟨Format Variable⟩ or
⟨2' 13", 4.6 Meters⟩. In preparing this exhibition, I asked myself
as designer or artist: Which purpose and direction will I be
taking to continue ⟨SET⟩? ⟨SET⟩ is a platform and manual for
my projects, and at times it gets tiring when it gets too
repetitive or if I haven't found an appealing point. Therefore,
I wanted to expand the boundaries this time by engaging more
in the space and looking for connections to other works.
I want to take this as an opportunity to contemplate if this work
can evolve further, or if I should consider it a starting point for
something else.

You Hyunsun The cover of the book ⟨SET⟩ was physically installed
in the entrance of the exhibition space. This practice of turning
your graphic design into installation was also done at the 《Jisan
Valley Rock Music & Arts Festival》—with balloons and steel
frames. What was the prime focus this time in choosing
the subject and its form?

Na Kim I have always been interested in the point where 2D
becomes 3D, or space. When something becomes a space,
it develops into an experience. Two-dimensional works are
experienced on a visual level; three-dimensional works involve
time and movement as well, which takes the experience to
a new level. Thus, I constantly question myself: How can two-
dimensional visuals engage in space, or vice versa? More than
anything, I think an exhibition is the best method to maximize
the experience. Also, this was a children's exhibition.
However, I tried to incorporate various features that not only
children but people of all ages can enjoy.

You Hyunsun Another thing to point out of 《Bottomless Bag》 is
that it's a children's exhibition. Were there certain elements
you had to reconfigure or focus more on?

Na Kim The goal was to make a museum with the least
restrictions possible. I couldn't allow all artworks to be
touched, but my focus was in making an exhibition where
the restrictions are minimized and the viewers can actually
build anything they want and are able to touch and fully
experience the art. So, when making the object bags of
the "Backpack Explorer", I looked for ways to broaden the
experience of the exhibition—like measuring the wall paintings
with actual rulers or being able to touch the objects in the bag.

Bottomless Bag

Na Kim
Table Union, Korea

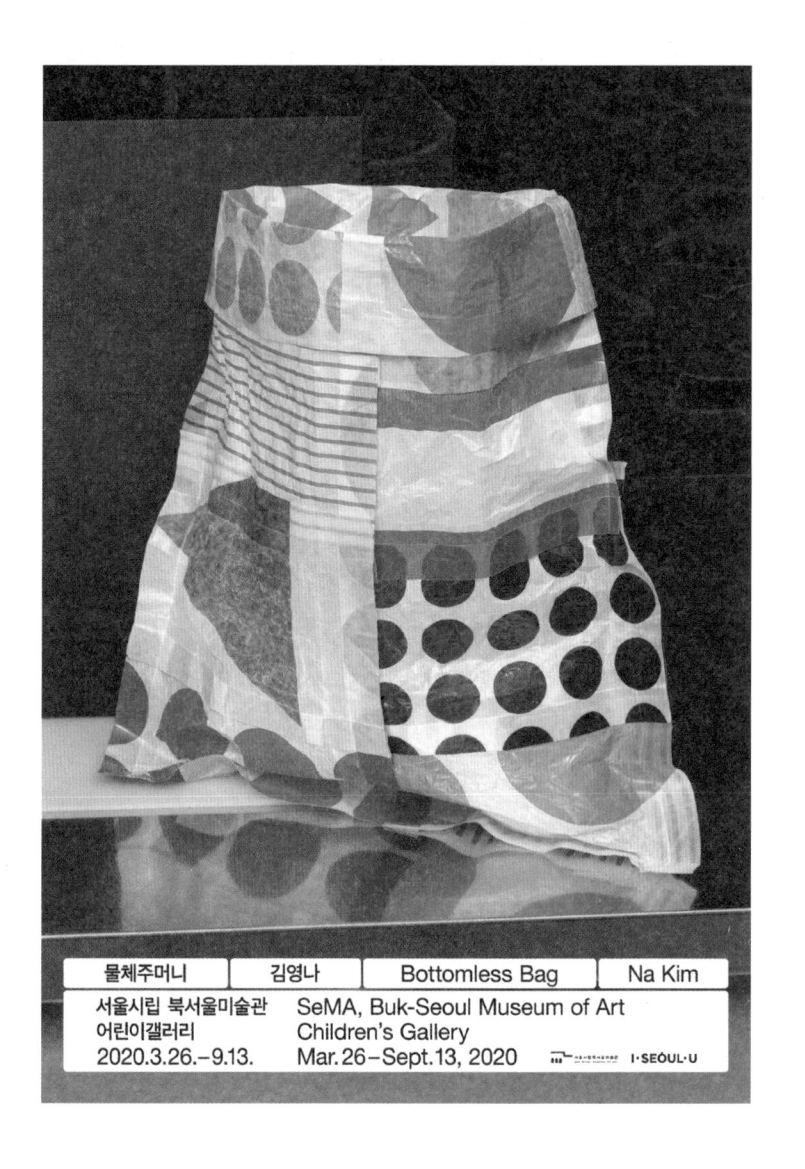

물체주머니	김영나	Bottomless Bag	Na Kim

서울시립 북서울미술관
어린이갤러리
2020.3.26.–9.13.

SeMA, Buk-Seoul Museum of Art
Children's Gallery
Mar. 26–Sept.13, 2020

I·SEOUL·U

Translation: Kim Noheul

"Conversation" is a record of a dialogue. The theme is usually the topic under discussion and endeavors to strive for a more realistic and practical direction. We discuss Na Kim's solo exhibition.《Bottomless Bag》

conversation

EN	KR	CN	Literal Translation (KR)	Literal Translation (EN)
objects	사물	事物	일과 물건	thing and objects
socks	양말	洋襪	서양 버선	western Beoseon
ring finger	약지	藥指	약 손가락	medicine finger
wash face	세수	洗手	손 씻다	wash hands
type	활자	活字	움직이는 글자	movable letter
bag	가방	—	—	—
yokan	양갱	羊羹	양고기 국	sheep meet soup
for a moment	잠깐	暫間	짧은 시간	short time
glasses	안경	眼鏡	눈 거울	eyes mirror
ring	반지	半指	반쪽 가락지	half of a set of twin rings
wallet	지갑	紙匣	종이 작은 상자	small paper box
lunch	점심	點心	마음에 점을 찍다	dot on mind
novel	소설	小說	작은 얘기	small story
not really	별로	別로	다르 게	differently
soju	소주	燒酒	불태운 술	burn down liquor
kimchi	김치	沈菜	채소를 담그다	pickling vegetables
sungnyung	숭늉	熟冷	찬물을 익히다	heat cold water
match	성냥	石硫黃	돌 유황	stone sulfur
sled	썰매	雪馬	눈 말	snow horse
candy	사탕	沙糖	모래 엿	sand taffy
neck and neck	박빙	薄氷	얇은 얼음	thin ice
blanket	이불	離佛	불심이 떠나가다	leave buddhism
small octopus	낙지	絡蹄	발이 얽히다	entagle foot
hunting	사냥	山行	산에 가다	go to a mountain
chill pepper	고추	苦椒	쓴 풀	bitter herb
beast	짐승	衆生	무리지어 살다	live in groups
brushing teeth	양치	楊枝	버들 가지	willow branch
conflict	갈등	葛藤	칡나무 등나무	arrowroot tree wisteria tree
apple	사과	沙果	모래 과일	sand fruit

Epilogue

In addition to composition and contents of 『This and That』, it has more to say in terms of the form and operation in that it utilized Instagram story platform. Maybe the limitations of Instagram story interface could be somewhat inconvenient or dozens of posts uploaded every day would be exhausting.
In spite of that, I still hope the contents and composition of 『This and That』 to be well delivered to viewers and always welcome feedbacks from 『This and That』 subscribers who have ever been anywhere around.

uploaded on the table of contents so that people could access that post based on the timeline. Due to the time and interface constraints of Instagram Stories, such as disappearing after 24 hours and not free to move around posts, it was difficult to actively utilize the system of time. I wonder how the work would have progressed if we had built an independent platform without using Instagram.

4. A function to permanently keep and re-access Instagram stories deleted after 24 hours. Accessible on Instagram account's profile page.

Pieces 2

"Something to Ask", a part of 『This and That』, is a work attempting to break down a system that has been fixed over time and then to reassemble it with the keyword "Name" under the theme of "Typography and Objects". As implied in the expression of "attaching a name", it started with imagination of "detaching" a name on an object and then "attaching" another name to it. Something to Ask introduces everyday objects and origin of their names one a day.

For example, a Chinese character noun 沙果 (an apple) literally means "sand fruit" because an apple fruit consists of small particles like sand. Focusing on apple's color or shape instead of its texture, this fruit would be called something else. Another example of 羊羹 means "lamb soup". Chinese would eat a sort of rice cake called lamb liver cake (羊肝), made of adzuki beans and sugar steamed and then shaped like a lamb's liver. While this lamb liver cake was brought to Japan, the letter "liver (肝)" was misrepresented as the letter "soup (羹)" with the same pronunciation, which led to the current name.

As shown in the examples above, Something to Ask is to reveal arbitrariness of a social system in the name of how objects are given names, to question its validity and to make us imagine the possibility of disassembly and combination about a system. The following is a list of objects introduced by Something to Ask. We collected everyday objects, looked into their origin and selected names out of common sense or social conventions.

Bits 2

Publication of the daily 『This and That』 started at 9 AM every morning and finished at 10 PM. We arranged this operational time system because 『This and That』 was a daily paper published by Ingstagram account manager's uploading each post, unlike a regular one published offline. Information about the exhibition including Something to Read, Something to Know of and Something to Happen was placed at 9 AM before exhibition hall opened. And photos or videos taken by viewers, were flexibly reposted within the publishing hours. About 20 posts were published for a day. Back issues that went inaccessible after 24 hours were made as Story Highlights[4] and they were collected under categories for permanent access.

Pieces 1

What was interesting in publishing 『This and That』 was the interface between typography and time. Art directors Jin Dallae and Park Woohyuk stated as follows on the preface of this Typojanchi.

> We are trying to look at the relationship between letters and objects as a clue to decomposition and assembly, the core of typography. Originally, typography was a way to use letters. However, when focusing on its action, typography can be rediscovered as objects. This is because today's typography is no longer judged by the use of letters. Whereas letters used to be considered the only ingredient, typography now includes pictures, photographs, symbols, movements, sounds, and almost anything else.

The ingredient of typography is not limited with letters any more but where the action takes place also expands to two-dimensional surface, three-dimensional space and four-dimensional spacetime. 『This and That』 places posts on a grid system called 24 hour using text, photographs and images as materials. It did not mark page numbers on posts but indicated a time point when a post was

This
A book's front cover. Marked with the issue number.

2. Programs named after forms of things that consisted of 《Typojanchi saisai 2018 - 2019》. Referring to research, lecture, workshop and publication respectively.

3. To share someone else's post on one's own feed.

Something to Read
A book's table of contents. Giving information on the order and time of posts to be uploaded that day.

Something to Know of
Notice for the event. Providing contents necessary to watch the exhibition including 『This and That』 introduction and how to use mobile docent, etc.

Something to Listen
Presenting schedules and lecturers for talk programs made three times during the exhibition.

Something to Happen
Guide for events at the exhibition. We held events like giving goods to viewers who visited the exhibition more than twice and gifts to visitors on Hangeul Day who wore T-shirts with Hangeul written on.

Something Made
Introducing works submitted to 《Typojanchi 2019》 with photos. 5 – 6 pieces each day on average, total of 200 pieces presented during the exhibition.

Something to Ask
Introducing everyday objects and origin of their names one a day and questioning about relationship between an object and name.

Something to Say
Online, real-time interview with 《Typojanchi 2019》 curators and artists. Online viewers write questions for curators and artists selected as interviewees through the questions sticker for Instagram story and the interviewees check and answer the questions in a written or image form in real time.

That
A book's back cover. Marked with credits including the date of issue, where the volume was published, design, technical support, help, etc.

Photos and videos that viewers uploaded also made up a great portion of 『This and That』. It is a commonplace on Instagram to take photos or shoot videos after visiting the exhibition; add GIF stickers or tags and; upload them, which is a kind of play culture. Viewers express their taste through that play and are willing to be a medium of promotion. In response to this, 『This and That』 attaches GIF sticker on viewers' posts and reposts[3] them to communicate with the viewers.

Bits 1

The name "This and That" was conceived with "The Round, The Square, The Triangular, and The Shapeless (둥근 것, 네모난 것, 세모난 것, 모양이 없는 것)"[2]— the subthemes of 《Typojanchi saisai 2018–2019》. These terms all have a Korean syllable "것" which was I supposed to be a pure Korean word for objects (事物), the very theme of this Typojanchi. Incor-porating the meaning of object and also embracing various contents of the event information and viewer responses, "This and That" was a semantically appropriate name.

　　『This and That』 aimed to be user-friendly in a form of a general book composed of front cover, table of contents, body text and back cover. We arranged occasional contents for vitality and unexpectedness as well as regular ones to secure operational stability. Contents were classified into seven sorts based on their features and named as "Something to Read" "Something to Know of" "Something to Listen" "Something to Happen" "Something Made" "Something to Ask" and "Something to Say" as an extension of "This and That". The following describes the composition and contents of 『This and That』.

This and That

『This and That』 is both an online daily to share news at
《Typojanchi 2019》 and a media project made by utilizing
Instagram platform. Jin Dallae and Park Woohyuk, art directors
of 《Typojanchi 2019》, planned and directed the project; Yoon
Choong-geun covered contents planning, editing and design and;
Kim Doheon handled technical matters.

『This and That』 has been issued as many as 30 volumes,
starting from the pre-first issue on 4 October 2019 followed by regular issue on
5 October up to 3 November each day through Typojanchi Instagram Story[1]
(@typojanchi). 『This and That』 mainly covers infor-mation guide on the event,
introduction of exhibited works and viewer responses, which facilitates
experiencing the event online without visiting the venue in person.

The online-issued 『This and That』 was played in real time at the main hall,
1st floor on Culture Station Seoul 284 where 《Typojanchi 2019》 was held.
A 55-inch TV monitor was vertically installed upon '『This and That』 Archive' at
the entrance of the exhibition hall, showing 『This and That』 issued for recent
3–4 days, which worked as a sort of storage.Viewers could browse both news
published in real time and back issues by moving their head and legs through
interaction with a sensor attached to the TV stand.

『This and That』 involved art directors, curators, artists and viewers
actively in 《Typojanchi 2019》, expanding the exhibition space online and
presenting a new method to experience the exhibition.

1. A kind of Instagram
posts, 9:16 ratio, vertical
one uploaded at the top
of feed, unlike a 1:1 post
saved on profile grid.
Automatically erased 24
hours after upload and
consequently less burden to
upload a bunch of images.

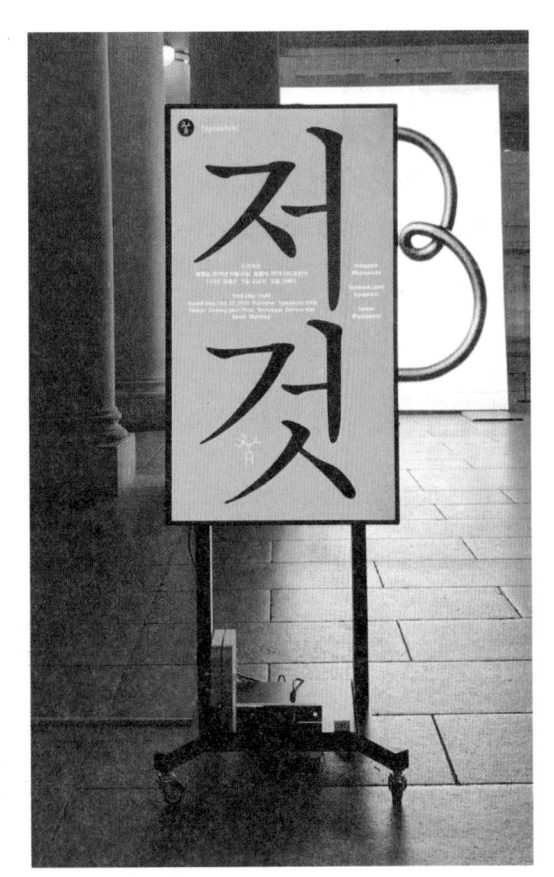

『This and That』, Bits and Pieces: Focusing on Composition and Contents of Online Daily 『This and That』 at 《Typojanchi 2019》

Yoon Choong-geun
Graphic Designer, Seoul

Translation: Kim Noheul

Website

Arthur Reinders Folmer. 〈Typearture〉. Accessed 9 June 2020.
 https://www.typearture.com
David Jonathen Ross. Accessed 9 June 2020. http://djr.com
Dinamo. 〈Darkroom〉. Accessed 9 June 2020. https://dinamodarkroom.com
〈Variable Type Show〉. Accessed 9 June 2020. https://youtu.be/17HmyM1slBw,
 https://youtu.be/i9d1owrmhrM
Laurence Penny. 〈Axis Praxis〉. Accessed 9 June 2020.
 https://www.axis-praxis.org
Laurence Penny. 〈Samsa〉. Accessed 9 June 2020.
 https://www.axis-praxis.org/samsa
Nick Sherman. 〈Variable Font Archive〉. Accessed 9 June 2020.
 https://v-fonts.com
《Typojanchi 2019》. Accessed 9 June 2020. http://typojanchi.org/2019

thousands of glyphs. For example, a 9 weight font would amount to 11,172 × 9 weights leading up to over ten thousands individual glyphs. Designing each letter would be a task onto itself but the size of the file would be a burden for users and for the web where download time is essential. The compressive traits of variable fonts could provide a viable solution to this potential problem. Variable fonts can accelerate the development of multi-weight Hangeul typefaces. The axis of each variable font contains an endless amount of possibilities and applications. Hangeul font families now do not deviate beyond weight differences, but as the designers and artists at 《Typojanchi 2019》 well showed, such experimental variables such as "movement of light" "optical" "slant" "space" "passage of time" "serif" "weight & width" "shape" etc. open the possibilities for a further exploration of font families in Hangeul.

[18] Lee Noheul×Loris Olivier. 「Root」.

visual combining the two into a single unifying typeface. The variable font axis is double-fold, one is weight and the other is Optical. Here, the Optical axis refers to "body text – display" thereby changing the stroke contrast, shape of serifs, and counters. As such for smaller size body text, the horizontal strokes and serifs are thicker. The video saw 「Optique Display」 '나무 (tree)' combine and change into 「Optique Text」 '숲 (forest)'.

Lee Noheul × Loris Olivier, 「Root」[18]
Variable Axis: Weight, Line, Seed
Lee Noheul and Loris Oliver's 「Root」 uses three variable axises to show the roots of a plant. 「Root」 are thick and prominent but branch out into smaller and thinner strands, all the while becoming stringy and squiggly as they do so. Also, the attempt was to show the first strands breaking through a seed. With "seed" as the base form and an additional axis for decoration, each variable creates a diverse range of letterforms within the given design space, showing the possibilities of varying axes in this font format.

Prospects of Variable Fonts & Hangeul
Due to its flexibility and expansive characteristics, variable fonts are especially applicable to language sets like Hangeul which have a considerable amount of glyphs. For one Hangeul font in a single weight 11,172 individual glyphs are required. To develop a family with multiple weights it would require tens of

[16] Choi Jeongho. 「AG Superblack Gothic」.

[17] Noh Eunyou. 「Optique」.

Ryu Yanghee, 「Willow」[15]
Variable Axis: Weight & Width
「Willow」by Ryu Yanghee takes inspiration from woodcut letters, the fluid shapes
of handwritten letters translated into rough cuts from a blade. The variable
font starts with the structure or 'ganun-sun' and changes according to weight
and width. With two variable axises the designer must draw four masters.
According to this configuration, "thin – wide" "thin – narrow" "thick – wide"
"thick – narrow" form a multiple axis for a flexible and diverse set of letterforms.

Choi Jeongho (AG Typography Institute), 「AG Superblack Gothic」[16]
Variable Axis: Weight & Width
Choi Jeongho's 「Superblack Gothic」developed by AG Typography Labs is
a robust sans serif typeface with bold thickness, ink traps, and highly detailed
spacing. The variable font takes the first serif designed by Choi Jeongho and
「Superblack Gothic」as the design space. The video displayed this versatile
typeface using the word '씨앗 (seed)' indicative of Choi Jeongho's role in modern
Korean typography.

Noh Eunyou, 「Optique」[17]
Variable Axis: Weight, Visual
「Optique」is a multilingual typeface design project basing each language set into
its own unique writing tool, Hangeul with a brush, Latin with a broad nib and

[14] Yoon Mingoo. 「Crotalaria」.

[15] Ryu Yanghee. 「Willow」.

Ha Hyungwon, 「Ghost Lily」[13]
Variable Axis: Form

「Ghost Lily」 variable font builds the design space axis on two drawings. In this case, the growth of the 「Ghost Lily」 is the variable axis. The interesting thing about this work are the organic changes in the strokes. Going away from the normal conventions of weight, width or slants the artist's imagination has given form to a new type family, adding vibrancy to an otherwise monotonous type design approach.

Yoon Mingoo, 「Crotalaria」[14]
Variable Axis: Space

「Crotalaria」 uses space as the variable axis. Numerals and other shapes resembling Latin script combine to make Hangeul syllables. Like plants that grow into a space, the width of each stroke changes according to the width of each letter. The axis can be diversely defines according to the designer's approach or principles. At first glance, it may seem the axis for this variable font is based on width, but further observation will reveal that the letters themselves change, or multiple in strokes, or stems change position according to the width rather than expanding or compressing the existing shape making for a much more active and dynamic change.

[12] Chae Heejoon. 「Chungjo」.

[13] Ha Hyungwon. 「Ghost Lily」.

Kim Dongwan, 「Mushroom」[11]
Variable Axis: Slant

「Mushroom」 is a series of new drawings for 《Typojanchi 2019》, made to resemble mushrooms with soft curved strokes. The variable font uses a slant axis. One thing to note is, usual slants in typefaces are toward the right but the letters here slant both left and right making it a much more versatile typeface. When viewing the video piece it is apparent that slight movement was added to each variable making each drawing seemingly dance on screen.

Chae Heejoon, 「Chungjo」[12]
Variable Axis: Sanserif – Serif (Winter – Spring)

Chae Heejoon's 「Chungjo」 is a serif typeface based on woodcuts, with the tenacity and vibrancy of brushstrokes. For this variable font, the letters were re-drawn without serifs. The premise for this variable font was if temperature played a part, then serifs would be hotter than sanserifs, as such the axis was defined as "Winter", or 「Chungjo Minburi (Sans Serif)」 and in "Spring", 「Chungjo Buri (Serif)」. The barren strokes of Minburi with the rise in temperature would blossom into thick Buri style letterforms. In the video, the change resembles flowers blossoming in the Spring. For this font, a serif and sanserif axis was established as the design space. If such a function was put into use, designers could choose the size and shape of each serif that is appropriate for the text they were setting.

[10] Ham Minjoo. 「Blazeface Hangeul」.

[11] Kim Dongwan. 「Mushroom」.

2. Hangeul Variable Font Works

At 《Typojanchi 2019》, curators Noh Euyou and Ham Minjoo "Plants: The Object of Circulation, the Typography of Circulation" which included 22 participating teams and artists who presented work based on multilingual typography and variable fonts. Among the works shown, nine artists presented work based on Hangeul variable fonts. To better help the understanding of the artists a short workshop was conducted and the artists took their existing fonts or created new work based on variable fonts. Artists were asked to choose a word from 'plants' and express it in a variable font setting. German type designer Mark Frömberg produced a video with HTML and CSS as a backdrop for the works.

Principles of Variable Fonts

[9] is a breakdown of how variable fonts work. For example, a thinnes version and thickest version of the syllable '빛' is drawn. Both should follow the same structure and position and should be identical in basic structure. Both masters are aligned on a variable axis forming the design space. Lastly, when you export the font as a variable font you have a font that can be adjusted according to the weight of the font. The variable axis in this case can be many other things than just weight, it can be width, slant, visual size etc. really whatever the designer can think of.

Ham Minjoo, 「Blazeface Hangeul」[10]
Variable Axis: Weight

「Blazeface Hangeul」 is a Hangeul display font meant to compliment James Edmondson's 「Ohno Blazeface」 typeface. The unique shapes and contours of the Latin typeface have been applied to Hangeul. The 「Blazeface Hangeul」 variable font works on a 'weight' axis with the thinnest stroke when exposed to light most and thickest when exposure is the least. According to time and exposure of light the letters become thin or thick.

[9]　Principles of variable fonts.

How Do You Use Variable Fonts?

Variable fonts can be used on Sketch 59, CorelDRAW 2020, Adobe Creative Cloud InDesign CC 2020, Photoshop CC 2018, Illustrator CC2018.

Let's look at the Adobe InDesign Character panel. If the selected font supports variable font functions this will appear next to the name of the font. When you click on the button below it an axis control slider will appear.

Excluding Internet Explorer, all web browsers support variable fonts. To preview variable fonts on the web visit Darkroom[6] by Dinamo or AxisPraxis[7] and Samsa[8] by Laurence Penny. In the browser, click and drag the variable font file and adjust the axis controls. Especially in Samsa a dot follows the progression of the changes you are making on the axis making it easier to understand how these fonts work.

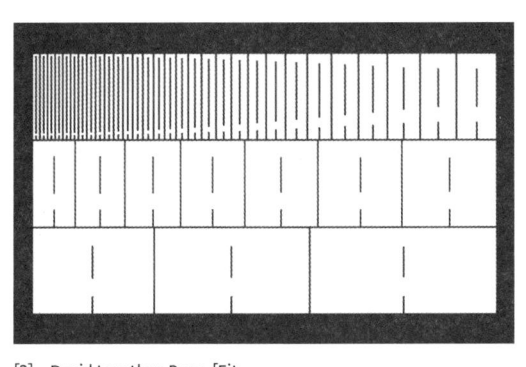

[3] David Jonathan Ross. 「Fit」.

[4] Nick Sherman. 〈Variable Font Archive〉. https://v-fonts.com

[5] Arthur Reinders Folmer. 〈Typearture〉.
https://www.typearture.com

[6] Dinamo. 〈Darkroom〉. https://dinamodarkroom.com

[7] Laurence Penny. 〈AxisPraxis〉. https://www.axis-praxis.org

[8] David Berlow's 「Amstelvar」 as seen from Laurence Penny's 〈Samsa〉. https://www.axis-praxis.org/samsa/

1. What is a Variable Font?

Variable is defined as "able to be changed or adapted", variable fonts is a single font format that contains a variety of styles.
In general, font format contained a single style in a single file, with variable fonts a number of styles is stored based on a given axis in a single file.

In ⟨Gerrit Noordzij's Cube⟩[1], the lowercase 'e' is expanded upon on a 5×5×5 axis. This zone formed by the axis is called 'design space'. Type designers can utilize this design space in one variable font file, users of this file can choose the style they want based on the variable settings.[2] Most variable settings work off of a slider controller while video cams and kinetic data can also be used.

1. Organized by ATypI (Association Typo-graphique Internationale).

[1] Gerrit Noordzij's Cube.

[2] Structure of a Variable Font.

Where was Variable Fonts Developed?
Variable fonts were developed in conjunction with Adobe, Apple, Google, and Microsoft and announced at "ATypI Warsaw 2016".[1] In that same year, CJ Dunn released 「Dunbar」, a variable font with a weight, x-height and Optical size axis. Since then, David Berlow's moving dingbats variable font 「Zycon」, David Jonathan Ross' 「Fit」[3], an extreme variable of weight and width font as well as other interesting typefaces have been released. Typographer Nick Sherman is archiving variable fonts online with a continuous updated list of fonts, operating systems, browsers and applications.[4]

Advantages of Variable Fonts
The first advantage of variable fonts is the economic file size. According to studies conducted by Monotype USA, when combining a 48 style font family into one variable font 88% file space is reduced. This considerable reduction of size is especially advantageous on the web or other platforms where speed and file size is important. Also, in responsive web design, using variable fonts to compensate for the differences in screen size and ratio is an added advantage.

Second, variable fonts contain a variety of styles for more diverse and dynamic typography. For example, by moving the axis a series of transitions can create an animation for the web, which in many cases is much smaller in file size than Flash. Arthur Reinders Folmer on his website Typearture utilizes this function for a colorful variable font based animation.[5]

Variable Fonts & Hangeul

Noh Eunyou
NohType, Seoul

Ham Minjoo
Type Designer, Seoul·Berlin

Translation: Fritz K. Park

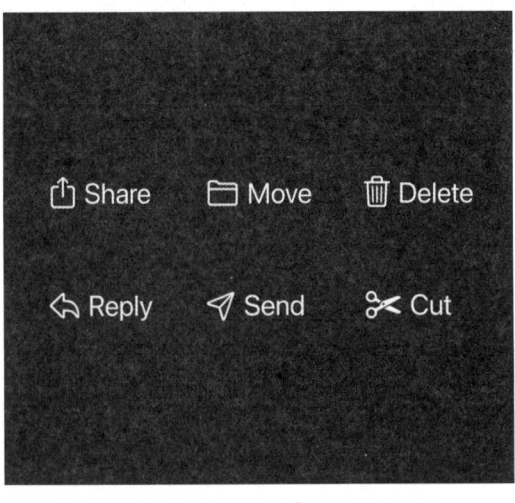

[9] Sending money through iMessage app in iOS.
https://www.apple.com/apple-pay/

[10] The harmonization between the 「SF」 Latin alphabets
and the 「SF Symbols」. https://developer.apple.com/videos/
play/wwdc2020/10207/

Conclusion.

Let me wrap up this brief retrospection on my type design experience at
the multinational corporation of Apple.

Succeeding the character culture established over a long time, today's
type design feels like an interesting formative game that presents a new form to
reflect the times we live in and to obtain consent from users of the characters or
cope with arguments at the same time. Thus, anyone equipped with common
sense about a society's tradition and the present and pursuing artistry based
on appropriate logic and philosophy can enjoy playing (designing) a typeface
regardless of what kind of character it is or where it is used.

As most Koreans have relatively less opportunity to learn character culture
other than Hangeul, there seems to be a prejudice that Koreans would not be very
competent for dealing with letters except Hangeul. Working in this field in Europe
for the first time, I was also confused that I couldn't figure out some formative
senses about the Latin alphabet that was genetically embedded in European
colleagues. Learning their letters from scratch as a child would do, however, I soon
realized Europeans of different nationalities and backgrounds sought various
qualities as well so there were diverse ideal types of the Latin alphabet.

The Latin alphabet do not belong to any race or nation but it is the out-
come built with a number of civilizations intertwined from the alphabet's
creation to the present and consequently, if you succeed in satisfying
the game's requirements—obtaining social consent, the Latin alphabet can ever
be infinitely changing with impact from a new culture. I believe 「SF」 design is
one of examples which demonstrates that aspect. To share opinions on fonts
at a cultural dessert of the American West with people from many different
countries and cultural spheres naturally yields an idea with which more world
citizens would agree and fonts produced on the basis of global consent can
spread out to the whole world with multinational corporation's international
marketing strategy. That happens sometimes.

Hopefully more players will be in the game.

[7] Watch Faces included in WatchOS. https://www.apple.com/watch/

SF Mono

As 「SF Compact」 already incorporated optimal design for small text type based on the grid system, we rearranged it as a fixed-width typeface and could extract a mono-spaced font.[8]

Custom Font for Apple Pay

A numeral font designed to indicate the amount to be paid on Apple Pay. As it was to show amount of money, a visual effect was needed to make the numbers more significant and weightier than other plain figures. We got the idea from 「Chiseled」, one of Watch Faces fonts.[9]

SF Symbols

Alphabets in 「SF」 font and symbols of the existing system visually collided at the MacOS' top menu and it actually bothered us. That's why this project was initiated to newly design the symbols for 「SF」. The complaint about this visual collision led to discontent about overall mismatch of fonts, symbols and figures in UI of iOS and MacOS. We examined the entire symbols of OS and UI on all sorts of apps and worked on redesigning them in a font form to be harmonized with 「SF」 for years.[10]

```
                                    ⌃ bonmin — bash — 70x9
Last login: Wed Jul 29 02:31:04 on console

The default interactive shell is now zsh.
To update your account to use zsh, please run `chsh -s /bin/zsh`.
For more details, please visit https://support.apple.com/kb/HT208050.
Bons-Silver-MacBook-Pro:~ bonmin$ ▊
```

[8] Terminal app in MacOS.

[6] From top to bottom, left to right. Alternate numerals "4" "6" and "9", alternate uppercase "I", lowercase "l" and numeral "0", double storey "a" and single storey "a", numerals proportional and tabular.

alternate characters that are effectively utilized in such cases. Modifying only a few special characters to different shapes facilitates a variation of the entire typographic voice as shown in the examples [6].

Point 3. Extension cases

Application of 「SF」 was a highly successful case in the company and consequently, its application rapidly spread out to device's both internal and external components, marketing, promotional materials and website. As a single font was supposed to cover all those purposes, its fatigue remarkably piled up so quickly. We were in a hurry to extend family fonts and created fonts with identical design genes but in different styles. The following are examples of extended application of 「SF」 into different UI and promotion.

SF Pro

As the new typefaces for Apple Watch was specially produced for typography on a small screen, we refined it into a more generalized shape, extending the font family as a system font for iOS and MacOS. The grid system that used to lock up a letter was released and compactly narrowed spacing returned to a natural proportion. Thus, the font for existing Apple Watch was realigned as 「SF Compact」 while the more generalized font as 「SF Pro」.

Custom Fonts for Watch Faces

These display fonts were exclusively drawn in order to develop Watch Faces on Apple Watch. We selected a certain width of 「SF font」 to keep linkage with the system font, maintained its framework and; came up with intriguing graphical styles. Only the numbers were developed at first to indicate time but uppercase letters were subsequently included. These are being used at Apple Music, merchandise display at Apple stores, etc.[7]

[4] A comparison of the proportions of the Uppercase letters. Left is 「Neue Haas Grotesque」 and the right is 「SF」.

[5] A comparison of the widths of the Uppercase letter "P"s. Above is 「SF」 and the below is 「Neue Haas Grotesque」.

Letter Proportion

The term grid-based Grotesk seems to recall uppercase letters with fixed width. It is because Grotesk fonts for display purposes conventionally enlarge or reduce uppercase letters frequently in order to make them fit into a block with certain width and in that case, what is applied is the grid that compels stricter uniformity than block. These fonts, however, were originally made for a small screen so we strived to apply the traditional uppercase letter proportion with variable width as much as possible. It is because the traditional uppercase letter proportion helps to recognize characters one by one in a text written only with uppercase letters and it also has an advantage for balanced spacing with lowercase letters. And for the stroke width proportion, we slightly put proportion based on nib principles into Grotesk manner that utilizes reversal of figure. It is not very much recognizable because the width does not dramatically vary but taking a closer look, you can find more natural flow of strokes than other Grotesk fonts.[4, 5]

Division of Text and Display

As the change of letter size is non-continuous on traditional print media, types for display and text usually have considerable distinction on their shapes. However, letter size on digital devices is mostly enlarged and reduced organically. Thus, we made only a minimum of changes while maintaining continuity by holding the form for display and text cuts as the same as we could—for example, spacing, ink trap size, how much the font hole is closed, maximum thickness and thinness for family font composition, etc. And we set them to be automatically converted in accordance with the size chart preset within the system.

Alternate Characters

As to a font to be omnidirectionally utilized on OS, it is hard to detailedly designate and design a specific reading method for a certain reader. It is

[2] One of the early sketches 1.

because it feels like going back to the past. In this case, however, the product shape itself consists of elaborate curves that would be only theoretically possible so only a little bit of adjustment on the corner curvature would quite afford proper factors for letters.[2]

Grid System and Grotesk

We thought the directivity of type design that could harmonize with that of product design which sought some restrained aesthetics and extremely simplified new UI should be found by actively adopting universal graphical factors such as mathematics, geometry, grid, etc. When the grid, among others, particularly had a heavier impact on letter forms, the shapes on curves were mathematically defined, which made an advantage that chances for touch point with product and icon edge's curvature were increasingly produced.

For the type framework, a sans-serif font of Grotesk series was regarded as appropriate. American Gothic and Humanist Sans were once considered as a candidate but the finally selected idea was of applying on grid the Grotesk which turned out to be more persuasive for its modifiability of letters' width and height and applicability to other languages.[3]

01.NOV.

pearon aerdiso ?? CONTRAST 네오

pearon aerdiso GRID Big 네오

pe aron aerdiso SQUARED COUNTER tiny aerdiso 네오

pearon aerdiso GROTESQUE small!? 네오

[3] One of the early sketches 2.

[1] From the left, a lowercase "a" printed on a paper (12pt size), an "a" printed on a fabric banner (about 40×40cm), an "a" found from Apple.com website. All three "a"s are from 「SF」.

products. And we sensed the intention to supplement a substantial part of information delivery missed by this Graphic User Interface (GUI) through typography. We actively discussed and thought about what functions typeface design should incorporate and what kind of letter shapes would be advantageous to solve that issue.

Third, it was necessary to think of letter shapes on screen with sharper definition than that of printed media. Typeface designers have perceived rough surface of paper or ink stain in the printing process and pixel shapes visible to the naked eye on early low-resolution screen as factors that made letters illegible and efforts to find solutions have been continuously made for long. The so-called visual correction techniques are typical examples of such solutions; the correction techniques for letters on printed media and screen are properly mixed, which makes an axis of today's type design education. In contrast, it seemed typography on screens whose resolution was superior (Retina Display) to most of print quality had to be redefined as to the purposes and methods of the correction. In other words, what we pursued was to distinguish the visual correction made to overcome media's technical limitations from morphological distinctions required depending on optical size purely for utilization of letters, trying to deliberately focus more on the latter.[1]

Point 2. The design was actually realized roughly as follows
Corner Curvature

The distinctive corner curvature of the then Apple products was called 'continuous curvature' or 'squarcle' and forming a sort of design identity. Every device seemingly had the same pattern of corner curvature but taking a closer look, its application scope varied even on a single unit of device; the ratio was also variable; the corner curvature was applied in three dimensions—sometimes swelling or flattening. There were too many variations to recognize at a glance.

On the other hand, the cubic effect of app icons and graphical factors disappeared on the screen, which led to clear distinction from the product appearance and; the corner curvature applied to the product edge was identically adopted to that of newly designed app icon—serving as a tool to maintain a minimum of linkage between product design and UI design. Thus, we sought to reinterpret corner curvature and introduce it yet again to the type design field as well in its own way. Though letters originated from the same category of figures, its functionality has been more delicately developed as a sort of linguistic symbols. Consequently, it often looks awkward that any trace of drawing a specific object is directly shown within a letter

Introduction.

「San Francisco (Abbr. SF)」 was a digital font first created for Apple OS and User Interface (UI) when Apple Inc. was working on developing the new device of Apple Watch.

Since its release in 2014 with Apple Watch coming into the market, the font has gone through a series of change including family font extension, expansion of supported languages, reinforcement of typographic elements, refinement of details and the like and then sequentially applied to OS and UI of iPhone and Macintosh lineup. It was also selected as a marketing font thereafter, widely used for product logo, packaging, advertisement, website, merchandise display at Apple stores, etc. It has served as the design norm for subsequently produced serif font titled 「New York」 and 「SF Symbols」 literally composed of symbols and icons, the Apple's representative font which has been consistently evolving and improving up to now. Recently, corporate fonts are often viewed to try integrating their corporate identity and letter form as a part of marketing activities. In comparison, however, 「SF」 was first put into User Experience (UX) field, which confirmed its usability and; then unconsciously built enough familiarity in users' mind, which led to expanding its application into Apple's marketing and branding sectors. In other words, its singularity lies in this directivity. Thus, it was not to focus on "form" to express abstract notions like "identity" but rather on "functionality" of typography within UI in the process of type design and it accelerated decision making; we did not stick to viewpoints presented by a few number of type designers or conventions in different typographic fields but rather sufficiently reflect practical opinions from designers and engineers in many different domains.

As the present font is a corporate possession, its information cannot be fully disclosed. In addition, its family fonts and detailed forms have been continuously extended and updated, it would be a quite challenging task to examine the entire history in the limited space. Therefore, I'd summarily introduce what letters a few type designers conceived in its early development phase and how those letters were given forms in practice.

Point 1. What was pursued in the early phase of typeface design was as follows

First, the degree of neutrality and readability exceeding those of typography for printed media. Considering that information written in this typeface is translated into numerous languages and characters within this most widely consumed product lineup on a global scale, any design that takes account solely of typographic traditions in a few European countries couldn't have satisfactorily secured the neutrality. In addition, letters in different sizes of screens were not to be gracefully placed in a printed form as a medium merely for clear communication; they became ones to be tapped, touched, enlarged and reduced with fingers and tools, moving and swaying with media. Thus, it was necessary to come up with a measure to secure more stable readability.

Second, we had to think about how to make formative languages compatible that subtly vary in different design sectors (mainly in terms of design). The powerful branding of 'Apple' was already achieved around product design and new directivity was being explored through developing new products. UI design was bringing about a revolution from 'skeuomorphic' to 'flat'. In other words, UI was composed solely of plane figures with minimal shapes and colors without graphic effects to make things realistic and our work was under way on how to identify differentiations and interfaces from physical

San Francisco Development Log

Min Bon
Hongik University, Seoul

Translation: Kim Noheul

however, I was often tormented by so many headaches and it took a much longer time to produce Arvana than expected as it is my very first publicly released typeface. And I also wanted to instill my personality to the typeface more than I thought and I actually did so a little too much. For example, users would be somewhat unfamiliar with OpenType features, to which I didn't give much weight. But I don't find it very much regrettable because that issue would be gradually relieved over time.

In addition, I didn't want to miss any detail on 「Arvana」 Latin alphabets either so I worked with a Latin native typeface designer. Collaboration sometimes goes so smoothly like two people are of a mind but other times, it doesn't work out as intended. As the project director, I should have clarified the overall design direction to the collaborator but it was very challenging, which would give him a hard time.

「Arvana」 will be, either slowly or quickly but absolutely, updated. As a typeface designer myself, the happiest part in future updates would be expectations for new applications to come. These experiences would definitely be spiritual nourishment for planning out my next work.

[15] FDSC. 『Design FM』. 2019. / Photo: Lee Noheul / Used on the body of 『Design FM』 published in 2019. The first monumental commercial use right after 「Arvana」 release. Brilliant work of detailed typesetting in the body text.

[16] Seoul Youth Hub, kakao Impact. 『Young Researcher Defines Problems of City 'Seoul'』. 2020. / Photo: O-O-H / Used on title, body and tables of a research report 『Young Researcher Defines Problems of City 'Seoul'』. Applied with various sizes extensively from the book title to the tables inserted, clearly demonstrating that the graphic designer fully understands the typeface designer's intention.

[17] Exhibition hall. Designed through collaboration with graphic designer Lee Hyunsong. / Photo: Lee Noheul

The version 0.1 was released at futurefonts.xyz, an overseas typeface sales platform, on 9 October 2019 and then updated as version 0.2 in January 2020 that includes additional Hangeul characters and diverse signs and symbols. (The current version 0.2 incorporates total of 2,780 Hangeul characters, 245 Latin characters, 44 numerals and 135 punctuation marks, signs and symbols.)[14] The next update on Regular and release of 『Arvana』 Black' are planned in July 2020. 『Arvana』 is to be extended as a font family including hairline, medium and bold weights. It is hard to say yet when 『Arvana』 is to be finalized but I am gratified as of now with current progress in that I can consistently update and improve on it.

『Arvana』 in Use

I've been archiving the actual typeface use since 『Arvana』 was first introduced in early October last year. Some are perfect fit with my intention while others show unexpectedly original applications. The main examples are 『Design FM』 published by FDSC (Feminist Designer Social Club, Design: Shin Inah, Jang Yunjeong)[15]; a research report titled 『Young Researcher Defines Problems of City 'Seoul'』 (Design: O-O-H); 『Surprise with Threads: Embroidery-Teaching Cartoon』 published by YOUR-MIND; a photography magazine 『Vostok』 volume #18; an exhibition design of 《Engraving, Engraving, Engraving》 (Design: Chris Ro) at National Museum of Modern and Contemporary Art, Gwacheon and the like.

『Arvana』 Exhibition

Sponsored by Bang Il Young Cultural Foundation Fund for Hangeul Typeface, 『Arvana』 was commemoratively exhibited at exhibition space whatreally matters (wrm) in Mapo-gu, Seoul for a week, from 26 November to 2 December 2019. The exhibition was organized through collaboration with a graphic designer Lee Hyunsong. Letters of different sizes were attached on cube walls in order to display them in different scales and videos and installations were properly arranged within space to make colorful mood. There were some unexpected visitors who were not typeface or graphic designers. I wasn't that much favorable for this typeface work exhibition held in a white room at first but letters in bigger scales and their display in space and with other objects brought about another kind of experience, where I found significance and value of typeface exhibition.

What is to be Desired and the Next?

『Arvana』 is an outcome after exploring possi-bility somewhere between text and display typefaces. That may be why I'm so moved to see various applications with body texts and titles as if the user thoroughly understood both my mind and work. On the other hand,

[14] Some images from typeface sampler. See futurefonts.xyz/noheul-lee/arvana and download it as a pdf file.

[11] Phoneme Shapes ㅍ.

올리브 오일
맑은 하늘
열림과 닫힘
언짢은 왈츠

올리브 오일
맑은 하늘
열림과 닫힘
언짢은 왈츠

[12] Final Consonants ㄴ, ㄷ, ㄹ, ㅌ.

[13] Use of OpenType features: Application on a paragraph.

applied for ㅁ on 「Arvana」 while four strokes are used on existing Hangeul writing. The final line at the bottom of 「Arvana」 ㅁ and ㅂ are not even slightly diagonal on vertical strokes while the diagonal is emphasized on cross strokes for finish.

Phoneme Shapes ㅇ, ㅎ [10]
I applied the cut that broad nib leaves between strokes to the top left corner of ㅇ (ieung), the consonant's start point, as a design element. It is to consider the start point where a pen reaches paper so that large area is taken and the connecting point that the stroke returns to the large area yet again as a single feature element. I removed the stalk of ㅎ (hieut) to make ㅇ but applied pen's cursive feeling for the connection with the horizontal line of ㅎ, which applies the same for ㅍ (pieup) to be followed.

Phoneme Shape ㅍ [11]
I applied the pen's cursive feeling between the vertical strokes of ㅍ as a design element. Through feedback on ㅍ as the final consonant, I erased the cursive touch and simplified it.

Final Consonants of ㄴ, ㄷ, ㄹ, ㅌ [12]
The slight curve on the final consonants of ㄴ (nieun), ㄷ (digeut), ㄹ (rieul) and ㅌ (tieut) is expressed as dynamic and vivid by applying the cursive style from both the Eastern and Western calligraphy, which is one of the best features of 「Arvana」. The form of these letters is also reflection of my hope to write letters fast with tools. The flexible flow and unique rhythm at the bottom lines affects letter structure and details, which displays a distinctive impression as if they were written in a cursive style. I also wanted to introduce straight line-typed final consonants other than the default curved version. Thus, I used OpenType features as a source to extend user convenience and added 'Parallel line'. When a user selects this option on the program, the curved final consonants of ㄴ, ㄷ, ㄹ and ㅌ are shown in a straight line form.[13]

「Arvana」 was initiated from seeking a feeling somewhere between text and display typefaces but I'd keep its character and readability even on letters smaller than bodytype (e.g. captions or newspaper use). The first version of 「Arvana」 Regular consist of 2,400 characters that include Hangeul KS code and additional characters; 278 characters with extended Latin alphabets for European language support and numerals and; essential punctuation marks.

Production Process

Developing the design, I softened the sharp form while not violating delicacy of strokes and reflected my own handwriting style to some of phonemes. For example, I applied calligraphic cursive touch to slight curves on final consonants of 'ㄴ (nieun)' and 'ㄹ (rieul)' and at the same time, stressed consonants incorporated in my name in order to individuate text and blend, not excessively, my identity. I started working on the Latin alphabet after achieving some progress on Hangeul. As to the Latin alphabet, I solely left the concept of the motive typeface and made it into a tender humanist typeface to match Hangeul when making its actual form.[5, 6]

Thickness for Text Type
The thickness for text type is set as slightly thicker than regular ones of existing serif typefaces. 「Arvana」 is different from other serif typefaces that its difference between horizontal and vertical strokes is reduced in order to accentuate the shape drawn with broad nib.

Variable Width
「Arvana」 is of a variable width form. Width varies with different vowels.

Serif Form[7]
A bent point which starts from a cross stroke or; a serif on a vertical stroke depending on writing direction is designed to stress impressions made by using broad nib.

Finishing Part[8]
I stressed the impression of a pen by finalizing each letter with straight and sharp touch. However, I adjusted stroke angles less stiff so that it would not be very much visible when read on a text. The finishing angles are applied a little differently depending on vowels and final consonants.

Phoneme Shapes ㅁ, ㅂ [9]
I put differences on stroke sequences and finishing touch on ㅁ (mieum) and ㅂ (bieup). Three strokes are

[7] 부리 형태.

[8] 맺음 형태.

[9] 자소 형태 ㅁ, ㅂ.

[10] 자소 형태 ㅇ, ㅎ.

types. Altering a stroke's angle and direction can make either thick or thin lines. The line form that varies with different angles is one of charms in using broad nib.

In addition to interests in writing tools, I was also curious about whether there would be a Hangeul typeface which makes a good match with Latin alphabet. Given Hangeul design environment where interweaving is a commonplace, what would such typeface look like? Such curiosity about creating a typeface that can be applied to the multilingual setting also heavily affected production of 「Arvana」. The Latin alphabet typeface which served as a motif on early phase was 「GT Sectra」[3]—I had kept my eyes on it for a while—which was released by Grilli Type in 2014. I was also greatly inspired by the book 『The Stroke: Theory of Writing』 and the typeface 「Burgundica」[4], all of which are works of Gerrit Noordzij, a prominent Dutch typeface designer. 「GT Sectra」 is a serif typeface that simultaneously embraces a sense that seems to be cut off by calligraphic broad nib and scalpel knife. However, it doesn't reflect a letter form made by using classic writing tools as it is; it is a digital typeface in a new form that combines two different writing tools, which attracted my attention. I wanted to apply that feature to the design process of Hangeul typeface to incorporate both the contrast made with straight lines and curves using a calligraphic nib and the sharpness of scalpel knife. In short, 「Arvana」 is an outcome from imagining what Hangeul Myungjo font design would look like if it is written with tools other than a brush and; a humanist style, bi-scriptual typeface, giving both sharp and soft impressions at the same time.

[3] Grilli Type. 「GT Sectra」. 2014.

[4] Gerrit Noordzij. 「Burgundica」. 1983.

[5] Idea Sketch 1.

[6] Idea Sketch 2.

「Arvana」is a humanist style, bi-scriptual typeface selected at the 6th Bang Il Young Cultural Foundation Fund Competition for Hangeul Typeface which features broad nib and scalpel knife qualities, giving both sharp and soft impressions at the same time. 「Arvana」started with imagining what a serif Hangeul typeface would look like if it is written using the Western writing tools, not the Asian traditional brushes. I wanted to express a sharp form in a gentle way while not violating delicacy of strokes and reflected my own handwriting style to some of phonemes, a main characteristic of Arvana. Lee Noheul myself and Loris Olivier worked respectively on Hangeul and Latin alphabet.

Background

As publications using both Hangeul and Latin alphabet have increased, typeface designers have developed diverse know-hows about interweaving the two of Hangeul and Latin alphabet. However, Latin alphabet has a variety of bodytypes available but Hangeul, until recently, is most of fonts with a little variations from the basic form of Myungjo style (Haeseo, standard script). There are some typefaces created on the basis of Choseo form (cursive script) but they hardly diverge from the conventional calligraphic framework.

My work on 「Arvana」started largely from the two perspectives as a typeface designer and a contemporary Korean citizen who speaks, reads and writes Hangeul. I hoped to make a typeface in Myungjo style which can be used as a bodytype as there aren't enough Hangeul typefaces as I mentioned earlier.Yet, I wanted this typeface to be a brand-new Myungjo typeface based on tools other than the traditional brush. Exploring methods to achieve that goal, I noticed formative characteristics of broad nib pen, one of Western calligraphic tools, and decided if the broad nib's unique aesthetic sense—straight and cursive—is well applied to the structure of calligraphy-based Myungjo style, it would definitely make a tonish typeface.

I had to figure out characteristics of pens lying in calligraphy of Latin alphabet because 「Arvana」started with interests in a tool used in another cultural sphere.

[1] Parallel Line.

1. Parallel Line[1]

A main characteristic of broad nib is that the nib's edge is broader and flatter than that of other pens. This line form can express a style similar with Western calligraphy than brush writing demonstrated with Gungseo style (court-style script) or Myungjo style.

2. Varying Strokes as an Angle[2]

The broad nib is usually adopted while keeping its horizontality at a certain angle and the nib's angle should be differently applied depending on script

[2] Varying Strokes as an Angle.

Arvana

Lee Noheul
Type Designer/
lo-ol type foundry, Geneva

Translation: Kim Noheul

"project" is recent typographic projects and works selected by the editorial committee.

We collect projects and works based on the theme set out for the issue.

From this 18th issue we will feature one typeface and set the article with it.

This is in line with the intent of Lee Noheul's 'Arvana', Min Bon's 'San Francisco and will act as a type specimen.

For this issue, we introduce the journal and set the article with it. Noh Eunyou, Ham Minjoo's 'Variable Fonts: focusing on Composition

Development Log), Min Minjoo's 'This and That', Bits and pieces: focusing on Composition

Yoon Choong-geun's 'This and That' at 『Typojanchi 2019』

and Contents of Online Daily 《《Typojanchi 2019》》

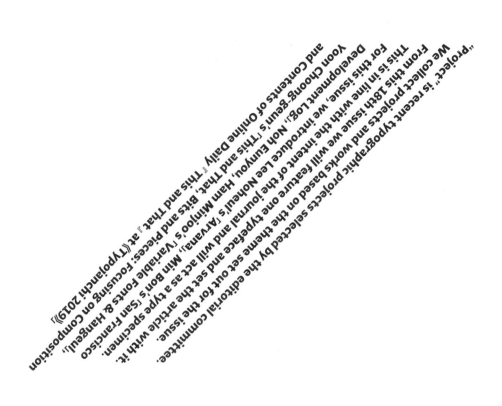

project

Lee Changbae. 「A Tale of Poetry」. Seoul: Taehagsa, 2005.
Lee Jaeun. 「A Study on the Poetics of Kim Ki Rim」.
 Seoul: Sungkyunkwan University, 2013.
Lee Kwangju. 「A Story of a Beautiful Book」. Seoul: Hangilsa, 2007.
Lee Yujin. 「An Analysis on the Visual Metaphor of Contemporary Poems Expressed
 in Visual Language」. Seoul: Seoul National University of Science
 and Technology, 2009.
Na Minae. 「An Era of 'Chosun Imagism' in the 1930s」. Seoul: Prunsasan, 2016.
Na Minae. 「A Study on the Consciousness and Metaphor of Imagism of Poems
 in 1930s in Korea」. Seoul: Seoul National University, 2013.
Seo Junseop. 「A Study on Modern Korean Literature」. Seoul: Iljisa, 1988.
The Korean Association of Film Critics. 「Dictionary of Literary Criticism Terms」
 (I & II). Seoul: Kookhak, 2006.
Yoon Taesung. 「A study on the modernity of Kim, Ki-Rim's poetry in 1930s」.
 Seoul: Myong Ji University, 1997.
Yoon Yeotak. 「Critique of Kim Kirim Literature」. Seoul: Prunsasang, 2002.

Website
Artnstudy. 〈The Relationship Between Lee Sang and Kim Krim, Members of
 The Circle of Nine—Jan Seokju (Poet, Literature Critic)〉. Accessed 16
 June 2020. https://www.youtube.com/watch?v=MM9htH-_lrU
Encyclopedia of Korean Culture. Accessed 16 June 2020.
 http://encykorea.aks.ac.kr/
Kwonlab. 〈Kwon Kyuho's Literature You Didn't Know, The Sea and the Butterfly
 by Kim Kirim〉. Accessed 16 June 2020. https://www.youtube.com/
 watch?v=JtL0Ie80KtI
Lee Sangeum. 「Creating Meaning by Making Images From Letters,
 German Concrete Poetry」. 「Pusan National University Newspaper」
 (18 May 2015). Accessed 16 June 2020. http://weekly.pusan.ac.kr/
 news/articleView.html?idxno=4490
Modern Korean Literature WiKiDOK. 「Kim Kirim」. Accessed 16 June 2020.
 http://ko.kliterature.wikidok.net/wp-d/588080335fb7f1a936080de0/View
Yonsei University Institute of Humanities. 「Make letters as a Subject of Poetry—
 German Concrete Poetry」. Accessed 16 June 2020. http://munja.yonsei.
 ac.kr/archives/archives_02_1_concrete_poem.php

this poetic transition of intellectual literature through reason and emotion.) Moreover, by adding an intellectual approach, the lacking graphic elements were substituted with book design techniques, visualizing the imagery of concrete poetry. This is in no way limited to poetry; when literature is studied from the approach of a designer, studies like this one can find new potential in ways of appreciating literature. To point out an error of this paper, it may have stressed the Suprematist approach too much, being carried away in combining the techniques in the visualization experiment of concrete poetry.

Through this experiment, it was convicted that modern literature can be reborn through concrete poetry and the attributes of a book. The poets at the time likely did not know the exact styles and techniques of concrete poetry. As long as the original text is not harmed, searching and developing connections to today's society will have academic value in the field of literature, and as a designer.

Bibliography

Ahn Sang-soo. 『A Typographic Study on Lee Sang's Poetry』. PhD Thesis, Seoul: Hanyang University, 1995.

Andrew Haslam. 『Book Design』. Translated by Song Sungjae. Paju: Ahn Graphics, 2008.

Cho Hyejin. 『A Study on the Other on 1930's Modernism Poetry』. Seoul: Sungshin Women's University, 2007.

Chung Heemo. 『A Discourse on Modern Korean Criticism』. Seoul: Saemi, 2001.

Chung Soonjin. 『Saemi Study of Writers 10 Kim Kirim』. Seoul: Saemi, 1999.

Eom Sungwon. 『A Study on the Modernity and Tropology in the Korean Modernism Poetry: Centered on the poem of Kim Ki-rim · Lee Sang · Kim Su-young · Cho Hyang』. PhD Thesis, Seoul: Sogang University, 2001.

Han Juyeon, 『A Study on the Role of Typography in Modern Korean Visible Poetry』. MA Thesis, Seoul: Hongik University, 1997.

Han Kiho. 『A Jolly Encounter of the Digital and Paper』. Seoul: Changhae, 2000.

Hong Dongwo. 『Eleven Stories of Bookmaking』. Seoul: Typomedia, 2014.

Hwang Yunseok. 『Eine studie über die konkrete poesie von helmut heißenbüttel: In bezug auf 『Textbücher 1–6』』. Seoul: Sogang University, 1989.

Jung Byungpil. 『A Study of Image in Kim Ki-Rim's Poetry』. Gwangju: Chonnam National University, 2013.

Jung Kyunghae. 『Special Quality and Image Research of Girim Kim' s Poem』. Seoul: Chung-Ang University, 2003.

Kim Hakdong. 『A Critical Biography of Kim Kirim』. Seoul: Saemoon Books, 2001.

Kim Jiyeon. 『A Study on the Spirituality and Plasticity of Concrete Poetry Viewed from Artistic Aspect of Typography』. Seoul: Hongik University, 2006.

Kim Yaeri. 『The Politics of Image and Mondernism: Kim Kirim's Theory of Arts』. Seoul: Somyoung Books, 2013.

Kim Yoonjeong. 『Kim Kirim and his World』. Seoul: Prunsasang, 2005.

Kim Yujoong. 『Kim Kirim Essay Anthology』. Seoul: Zmanz Books, 2015.

Kim Yujoong. 『Modern Korean Literature and its Surroundings』. Seoul: Prunsasang, 2006.

Koh Won. 『I am Two』. Seoul: Ieung and Rieul, 2004.

Koh Won. 『Konkrete Poesie im deutschsprachigen Raum und in Korea』. 『Koreanische Gesellschaft für Germanisti』 Vol. 15 No. 0 (January 2006).

Koh Won. 『Ieung Inside Mieum』. Seoul: Taehagsa, 2002.

Kwon Youngmin. 『Encyclopedia of Lee Sang Literature』. Seoul: Literature&Though, 2017.

[12] Visualization experiment representing the blooming of a "peony"—the medium of visualizing poetic imagery.

8. Conclusion

Concrete poetry may not be positively received by all readers. The graphic elements using the arrangement of characters and geometrical abstraction seem to be more focused on 'seeing' rather than 'reading'. This is based on not the sentimental poetic expressions but a rational and logical structure of poetry. However, the emotional elements were not completely eliminated from this experiment. Instead, adhering to an intellectual approach through concrete poetry and book design techniques to visualize imagery can be considered to have pioneered a new style of poetry. This is in the conviction that in the form of concrete poetry where the poem is first "read" and then next "seen", that readers each have their own ways of interpreting the text. Such grounds to this assertion is applied to the extent of this study.

The biggest concern before this argument was made was: what would come of the combination of concrete poetry and book design? The method chosen simplified the style of concrete poetry and stimulated "sentiment"—an emotional element—for the readers. (「The Sea and the Butterfly」 attempted

O glowing republic, be at ease
As you sit on the shoulders of a young man—

O young republic
O— the budding flower on our heart
Don't hesitate like the daring dawn
And come to the streets awaiting you all night

「O Young Republic」

「O Young Republic」praises the establishment of a new country: a 'young republic'. It wishes the 'young republic' to blossom like a peony, overcoming the era of suffering and hardship. According to this interpretation, a peony is used as a medium to express the time of wait and the final delight with the blossoming of the flower. It illustrates how when the black seeds have endured the suffering and hardship to finally sprout and bloom, they can finally welcome a new era and plant a budding flower in their hearts. The text of the poem begins from both ends and ends in the center of the book. The spread-out pages of the book represent the shape of a blossoming flower.

Composition
Imagery: Blossom, The Wait
Book size: 150×100mm
Pages: 100p
Printing: Digital, Risograph
Bookbinding: Perfect Binding
Processing: Cover Gloss Coated
Font: Source Han Sans
Paper: Gloss Paper (Art) 250g/㎡, 120g/㎡

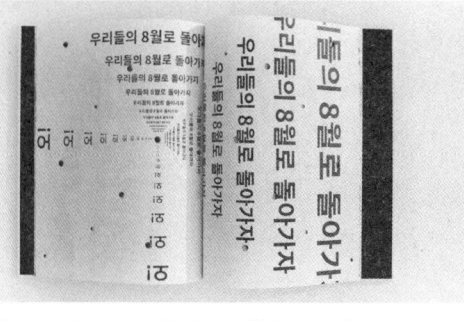

[11] The concrete poem in the shape of light spreading.

the poem was visualized through the spreading of light, and the positions of the holes were pressed in gold foil for the book cover. The cover graphics has the effect of light spreading out, and the shape of the light is visualized with the concrete poem to deliver the imagery.

Composition
Imagery: Radiance, Spreading Light
Book size: 198×257mm
Pages: 164p
Printing: Digital
Bookbinding: Perfect Binding, Hardcover
Processing: Drilling, Gold Foil
Font: Source Han Sans
Paper: Matte Paper (Snow) 150g/㎡, Simili Paper 120g/㎡

7.3. Third Poem: O Young Republic
A small bush of fire quietly fluttering
On the grounds of a cold volcano
Spring water vibrating like mercury
Under the grounds of clattering hooves
You may now blossom like a peony, o young republic

The property hidden in the shade
Our long-awaited dream, o young republic
A miracle stolen from the cortege of the bleak "modern"
The beloved son of history, o young republic

O— no need for honor, status, nor wealth
Just let me come along your way, under the yoke of joyful labor

Bookbinding: Perfect Binding, Hardcover
Processing: Die-cut (by hand)
Font: Sandoll Gothic Neo
Paper: Studio Collection New Black 216g/㎡

14. Kim Hakdong. 「A Critical Biography of Kim Kirim」. Seoul: Saemoon Books, 2001. p157.

7.2. Second Poem: Let's Go Back to Our August

The plain, the streets, the sea, the businesses
All will sacrifice to build a new nation
Going back naked, supporting this nation
Wanting just to be a cobblestone
O— Let's go back to our August.

Strip away from fame, status, luxury
Under the flag of our nation fleeting like a cloud
But vowing to be a bare and devoted servant
O— Let's go back to our August.

How can the rooster cry on three times
Five, seven times, the day aches when you said you don't know him
Angry tears down your face on the ground
Our August when we fought

Even the aggressive ones who bled
And shifted through the faraway nation, prison, and knives
Pleading to be a modest messenger
O— Let's go back to our August.
From the endless anger and rage
Came a piece of our dream bitten out with our own teeth
We will make a beautiful land without a leader
The August we cried for
With no one to give orders
But blossoms of wisdom, fidelity, and kindness
A nation where the angels return with envy
My dream of August is a shiny basket of gems.

O— Let's go back to August.
To the sweet-smelling season surrounding my genesis
In the rotten flames and brick dust
An August that disorderly blossomed like a lotus
O— Let's go back to our August.

「Let's go back to our August」

This is a poem that wishes to go back to the time when it was filled with hope for a new era—when Korea first gained independence. It yells to go back to 'our August', in misery of the situation where it is filled with hostility and jealousy with conflict after time has passed since the liberation.[14] What the era wishing for a new nation wants is to go back to the time of zeitgeist of springing hope. The imagery of focus here is the 'radiance' that this poem desperately wishes for. Drilling and pressing methods were used for the post-process printing. The texts are drilled irregularly, and centered around the holes is the shape of a concrete poem where the letters spread out. The message conveyed in

[10] Visualization experiment of 「The Sea and the Butterfly」.

She returns, weary like a princess.

As the sea in March hasn't bloomed
A blue crescent moon feels sour by the sad butterfly's waist.

「The Sea and the Butterfly」

This poem is representative of the namesake book. It is about intellectuals in the 1930s, who had admiration for a new modern civilization but had misleading ideas about the reality, coming back scarred after having experienced frustration and despair. The wound of the butterfly that jumped into the sea thinking that it was a blue radish farm is compared to a weak princess. The modern civilization they experienced was not actually the world they imagined and admired but a deep ocean of danger. This book visualizes the imagery of falling into a dark abyss. To create the effect of falling into a dangerous ocean, the pages were die-cut (Thomson) in rectangular shapes and made a concrete poem where the texts are aligned to be even on both sides. The typeface gets bolder the further inside it gets—which is to emphasize the effect of a deep abyss. The bookbinding and the cover are not meant to be flipped but 'opened' so that the imagery can be dramatized. To physically recreate the wide and large form of the sea, the book was made with 1,280 pages of 216g/㎡ paper. The rectangular die-cutting and bookbinding of the 1,280 pages were all done by hand, and after spot color printing it was perfect bound and topped with a hardcover.

Composition
Imagery: Deep Darkness, Enormity, Sinking
Book size: 215×285mm
Pages: 1,280p
Printing: White Spot Color Printing

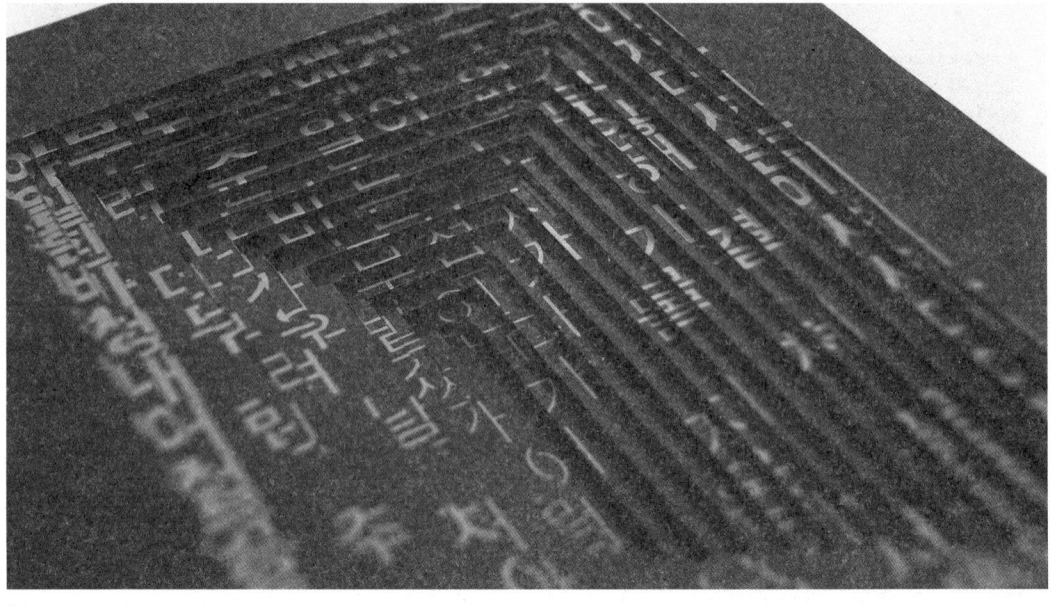

[9] Sample of 「The Sea and the Butterfly」. 1/5 of actual size.

a form of poetry that uses the graphic elements of words to express and deliver the imagery in the poems. It conveys and configures the images associated with the poem. This is in accordance with the intention of this visual experiment. The fact that Kim Kirim's poetry selected for visualization focuses on imagism and intellectualism also coincides. This is one of the reasons why a Suprematist approach was taken in interpreting Kim's poems. In other words, the focus was on elements such as the tone, rhythm, development, and imagery of the poems. However, as alterations of concrete poetry have been defined in the literature, ones that are outside the spectrum had limitations. Then, it was questioned if attempting physical alteration was possible if there are limitations to altering the poem itself. As this experiment presupposed the final result to be a printed book, techniques of book design were applied. It was figured that the physical form of the book can be appropriately used as an element of concrete poetry, stimulating the visual and auditory senses. The binding process, variations in the material and color of the paper, and post-process printing were experiments of emphasizing the imagery.

As it was mentioned earlier, a piece of poem becomes a volume of book, and it focuses on maximizing the expression of imagery in a single piece of poem. This section will elucidate the process of creating works with the three concrete poems selected from Kim Kirim's famous book, 『The Sea and the Butterfly』, and the thought process behind the experiments. The interpretation of the poems is based on Kim's poetic approach and the zeitgeist, and the research in 『A Critical Biography of Kim Kirim』.

7.1. First Poem: The Sea and the Butterfly
Because no one told her how deep the water is,
The white butterfly is not afraid of the sea.

She flies low, thinking it is a blue radish farm,
But with her callow wings soaked by the waves

[8] Kwon Youngmin. 「Crow's Eye View」No.1. 『Encyclopedia of Lee Sang Literature』. Seoul: Literature&Thought, 2017. p50.

material, or color of the paper can actively stimulate the readers' senses. In addition, through post-processing techniques used in printing, the emotions and imagery in the book can be more actively conveyed to the readers. We can now read books through a variety of means, but this study supposes that printed books have the closest distance between the readers and the books.

First, the structure of printed books was examined. The "structure" signified here is limited to the physical components, not including the paratexts like the book cover, texts, table of contents, copyright, headings, titles, subtitles, footnotes, and reviews. This was to remove the elements unnecessary in the experiment of making a poem into a book. The definition of a "book" in this experiment is slightly different from the meaning in the dictionary. It is not necessarily a book that has binding; it can be defined as a physical form of printed or process paper that can be read or seen by the reader. In other words, even if it does not have the perfect appearance of a conventional book, it can become a "book" in any form as long as it can deliver its contents. However, bookbinding and printing were not completely eliminated from this experiment. Using the physical characteristics that a book has according to its binding method, the appropriate method was applied for expressing the poetic imagery.

Print-based post-processing, which is a technique widely used in modern book design, implies or emphasizes the content of the book. It is also for the convenience of the readers. The post-processing in the experiment of this study was used to emphasize the imagery of concrete poetry. Apart from drilling, pressing, coating, and die-cutting, the books were processed by hand rather than post-processing them in the usual method. An appropriate use of post-processing supports the maker's work to her intentions and therefore enhances the quality of the book.

7. Emphasizing Poetic Imagery: Visualization Experiment through Concrete Poetry + Book Design

To summarize what has been offered so far, concrete poetry can be explained as

teristics of hangeul into the poems. Korean concrete poetry shows the plasticity inherent to hangeul. Unlike general poetry, concrete poetry develops, shifts, and advances the meaning between the consonants and vowels or between phrases and words, rather than conveying the meaning of the sentence or paragraph as a whole.[11]

Koh Won's concrete poems seem simple, but the image of the letters can be found connecting with the title. Design critic and professor Kim Minsu (Seoul Natl. University) critiques 「Ieung Inside Mieum」 as stated below. "His poems are too simple. Yet they are never simple. Visual, auditory, and fluid. The fragmented stream of consciousness seems to come together somewhat unusually." Moreover, Gomringer's 「Schweigen」 is considered to be the basic form of Koh's early hangeul poems and is important in that Koh escapes from concrete poetry later on. In other words, Gomringer's concrete poetry was what drove Koh to write his first book of concrete poetry, 「Hangeul World」.[12] Influences of Gomringer's concrete poetry can also be found in the book 「Ieung Inside Mieum」.

In Korea, designer Ahn Sang-soo has presented the Korean style of concrete poetry with hangeul. He did not necessarily write a concrete poem, but he applied its style to graphic design. Centered around the geometric and graphic elements of hangeul, he creates images out of characters. In the magazine 「Bogoseo\Bogoseo」, which Ahn published with sculptor Geum Nuri, experimental works of characters transformed into geometrical abstraction were made apparent. Concrete poetry can also be found before it was used for modern design, from poets in the 1930s. The first and foremost figure to be mentioned for concrete poetry in literature is the poet Lee Sang. Lee Sang's 「Crow's Eye View」[8], which was published in Chosun Chungang Ilbo in 1934, was cut off due to criticisms from readers that the poems were too difficult to understand as they were experimental with form. However, it is considered to have advanced Korea's poetry by presenting a new form of comprehending poetry. 「Crow's Eye View」 attains the form of series poetry where the subjects overlap and are juxtaposed. Every time a new poem was added, the new spirit and technique controlled the entire circumstances of the series. The numbers on the titles of the works in 「Crow's Eye View」 do not, however, signify the sequence of the series. This numbering substitutes the title and illustrates the juxtaposition, repetition, and overlapping of the poetic subjects. Therefore, the serial form of 「Crow's Eye View」 can be seen as pursuing the sequence of 'juxtaposition' and its aesthetic, to express the ambivalent psychological impulses.[13]

This style of concrete poetry was found to be appropriate for experimenting on emphasizing poetic imagery. It can express and deliver various senses depending on the intent of the writer, and an unconventional method of comprehending poetry can be discovered when book design and post-processing print are applied. Moreover, from the perspective of a designer, it can be developed into a new method of emphasizing the style and effects of concrete poetry.

6. Paper and Books & Book Design Techniques

Nowadays, books can be read from different media unlike the past when they were printed solely on paper, and they do not only serve to deliver information but instead have various uses in various fields. However, it is believed that the prototype of the first book printed with ink on paper can suggest a way of reading different from that of books used as different media. The binding, or the thickness,

11. Koh Won. 「Konkrete Poesie im deutsch-sprachigen Raum und in Korea」. 「Deutschland-forschung」 Vol. 15 No. 0 (January 2006): p116.

12. Koh Won. 「Ieung Inside Mieum」. Seoul: Taehagsa, 2002. pp162–168.

13. Kwon Youngmin. 「Encyclopedia of Lee Sang Literature」. Seoul: Literature&Thought, 2017. p41.

[4] 「I am Two」. 「I am two or not and this is inside」.

[5] 「I am Two」. 「I am Two」.

[6] 「Ieung Inside Mieum」. 「Vertical」.

[7] 「Ieung Inside Mieum」. 「Cityscape」.

Visualization Experiment of Kim Kirim Poetry

In traditional poetry, words are used as images, symbols, or metaphors and they convey the meaning of the poem. On the contrary, concrete poetry repeats and arranges words or rearrange the characters according to a certain set of principles to give the words a new set of meanings. Moreover, it breaks the traditional form of poetry by arranging the words and letters to create graphic patterns associated with the poem, or by transforming their geometric and graphic elements.[8] [1] is a concrete poem by Eugen Gomringer, which demonstrates silence within silence through the geometric form of the words. The poem deconstructs the grammar of the conventional form of poetry and emphasizes the visualization of the words. Though it may not convey its linguistic meaning, it visually demonstrates the form of the image—not only visually but also auditorily. Meanwhile, Gomringer published a number of manifestos on concrete poetry. In a 1956 manifesto, he presents three values concrete poetry should obtain.

First, in the visual aspect, concrete language structures should not follow the traditional verse and line order.

Secondly, on information and communication, concrete language should not communicate through its meaning; it should be presented as signs.

Thirdly, it should be international and supranational.

Out of the subjects Gomringer presented, the visual aspect serves as the most distinct feature of concrete poetry.[9] Poems of Stephane Mallarmé, the most prominent figure of French symbolist writers, offer experimental graphic elements.[2] This work explicitly demonstrates the style of concrete poems—with various typefaces and in an unusual layout, having an animated effect. French poet and novelist Guillaume Apollinaire also used sentences for geometrical abstraction to paint the imagery of the poems. The poem 『Il Pleut』 [3] by Apollinaire is written with letters that create a visual likeness of raindrops falling down. The poem that can be read and 'seen' displays the rhythm of the visual form of falling rain.

As concrete poetry imprints the impression of the poem with an image, the expressions are free from constraints and the poems can be written with the aesthetics and intents of the poet. There may be countless different styles of concrete poetry, but the common characteristic is that they all input and print in unique ways with bold transformations through cut-down language. Also, a piece of poem draws the attention of its readers as an object that can be sensed as a visual unity. In this regard, many concrete poems cannot be read in the conventional method. That is due to the fact that the poems are composed of words and phrases in different orders and sequences, broken words or fragments of meaningless syllables, letters, numbers, punctuations. Adding to such composition are various typefaces in different sizes and colors— sometimes even adding a picture to the text.[10]

Concrete poetry was first introduced in Korea by the poet Koh Won with his books 『Love Inside Mieum』, 『I am Two』[4, 5], 『Ieung Inside Mieum』[6, 7], and 『Hangeul World』. The concrete poems in these books seem to feed the charac-

4. Han Juyeon. 『A Study on the Role of Typography in Modern Korean Visible Poetry』. MA Thesis, Seoul: Hongik University, 1996. p4.

5. Ahn Sang-soo. 『A Typographic Study on Lee Sang's Poetry』. PhD Thesis, Seoul: Hanyang University, 1995. p74.

6. Korean Society of Typography. 『Dictionary of Typography』. Seoul: Ahn Graphics, 2012. p297.

7. Kim Jiyeon. 『A Study on the Spirituality and Plasticity of Concrete Poetry Viewed from Artistic Aspect of Typography』. MA Thesis, Seoul: Hongik University, 2006. p69.

8. Yonsei University Institute of Humanities. ("A Sociocultural Study on Typeface" Typeface as Subject of Poetry—German Concrete Poetry). http://munja.yonsei.ac.kr/ archives/archives_02_1_ concrete_poem.php

9. Kim Jiyeon. 『A Study on the Spirituality and Plasticity of Concrete Poetry Viewed from Artistic Aspect of Typography』. MA Thesis, Seoul: Hongik University, 2006. pp81-82.

10. The Korean Association of Film Critic. 『Dictionary of Literary Criticism Terms』 (I). Seoul: Kookhak, 2006. p268.

schweigen schweigen schweigen
schweigen schweigen schweigen
schweigen schweigen
schweigen schweigen schweigen
schweigen schweigen schweigen

[1] Eugen Gomringer. 「Schweigen」.

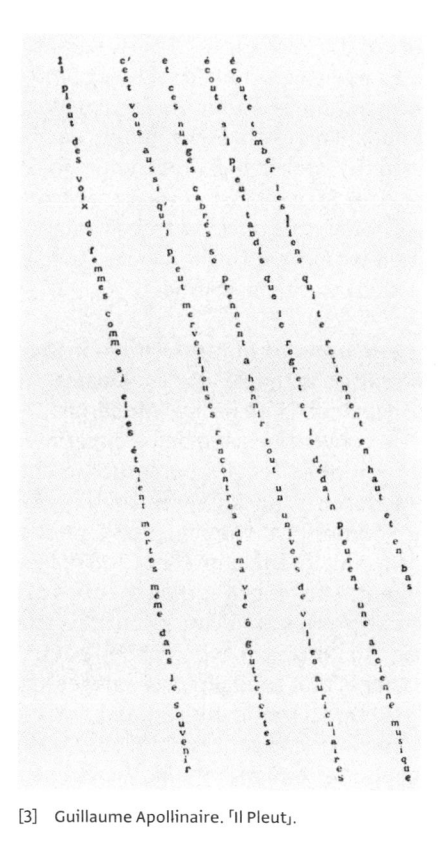

[2] Stephane Mallarmé. 「Un Coup de Dés」. [3] Guillaume Apollinaire. 「Il Pleut」.

In other words, typography plays a significant role in the creation of process.[4] This study escapes from the conventional process of 'reading' with the visual arrangement of the characters and instead 'sees' the poem with images. This is a form of concrete poetry that developed from visible poetry in countries around Germany, France, and Central and South America after 1945. Concrete poetry developed into new typography with complex aspects like symmetry, contrast, functionality, pictoriality.[5]

Visible poetry is a form that visualized the text of the poems, while concrete poetry is based in literature—the difference between the two being that the latter is an interpretation of typography while the former is not. The notion of the "visible" in visible poetry signifies the physical materiality of letters and punctuations, and the size, arrangement, and order of the characters are deconstructed irregularly.[6] Drawing on these facts, concrete poetry can be seen as a subordinate of visible poetry. However, the genre of concrete poetry is normally nominalized to include all experimental poetry like visible poetry or sound poetry. As there is a myriad of forms divided into periods and each artist, it may not be reasonable to label each type into certain categories.[7] Concrete poetry applies concrete art to poetry literature, and Eugen Gomringer of Germany is known to be one of the flagship writers of concrete poetry. The notion of concrete poetry was first established in 1955. In that year, Eugen Gomringer incorporated the art movement known as "concrete art" (Mondrian, Kandinsky) and defined concrete poetry as "a unit of an order composed through the sequence of words and letters, and through new structural methods". This definition summed up where concrete poetry should head and the potentials it carries.

the imagery of the poem. In summary, ways to visualize and materialize a book were looked for using book design techniques and the form of concrete poetry so that a piece of poem can become a book. This enables the imagery of the poem to be illustrated in the book in full effect, and it maximizes the experiment technique for expression. As it is an experiment based on book design where the physical transformation of the book is prominent, it was intentionally avoided to have more than one poem included in a single volume.

3. Development of Modernism in Modern Literature

Modern literature in the 1930s developed around The Circle of Nine, which included Kim Kirim. "Modernism" in literature means breaking the conventions and being experimental. It applies to various schools of writers that emerged in the early 20th century. In Korea, modernism quickly spread in the 1930s after KAPF broke up. Modern literature at the time was founded on intellectualism and imagism, and it valued intellect and reason over emotions and sentiment. The first to spread theories of modernism in Korean literature was Choi Jaeseo, but this study instead turns its attention to Kim Kirim, who imbued poetry with Modernist theories. Poems that used pictorial images and sensory language shocked the literary world. Kim argued that modern poetry was critical of romantic and sentimental poetry and instead used vivid imagery of poems that put intellect before sentiment.

4. Kim Kirim's Modernist Movement: Founded on Imagism and Intellectualism

Kim Kirim provided the basis of the Modernist movement with sharp insight on politics and literature of the time. He admitted the fact that new literature cannot be developed without the effect of Western civilization, and he made the following argument:

> "After the mid-19th century, Western civilization has greatly affected Eastern empires. New literature in empires such as Japan, China, and India first started by imitating Western literature. It is inevitable with the invasion of the civilization—the matrix of literature."[3]

As it is written, Kim strongly criticized romanticism based on emotions and sentiment and led a radical development in modern literature by actively embracing new literature. Before Kim came to prominence, theories of Western literature in the 1920s were blindly accepted. However, with the effort of Choi Jaeseo and Kim Kirim in the 1930s, British and American literature began to be brought in and studied in earnest.

5. Drawing Poetry with Characters: Using Concrete Poetry

Visible poetry is not a mere means to convey the meaning of the words. Instead, it stemmed from avant-garde ideas that study graphic forms in the early-21st century and were examined in pursuing the possibility of the confluence of poetry and painting. This type of poetry visualizes the form of characters by permeating the notion of images and paintings to poetic words. The arrangement of the characters in print or the type of typography used to play important parts.

1. Kim Yujoong. 『Kim Kirim Essay Anthology』. Seoul: Zmanz Books, 2015. p268.

2. The Circle of Nine. A literary group formed in Chosun under the Japanese regime in October of 1933, the Circle of Nine was organized by Lee Jong-myoung and Kim Yuyoung and formed with nine members including Lee Hyoseok, Lee Muyoung, Yu Chijin, Cho Yongman, Lee Taejun, Kim Kirim, and Chung Jiyong. The group was complete when Lee Sang and Park Palyang joined after Lee Jongmyong, Kim Yuyoung, and Lee Hyoseok left, and Kim Yujeong and Kim Hwantae joining after Yu Chijin and Cho Yongman leaving. The group led the development of literature in the 1930s and after.

3. Chung Soonjin. 『Saemi Study of Writers』 10: Kim Kirim. Seoul: Saemi, 1999. p43.

1. A Brief Background for Visualization

Modern Korean poetry started with the poetics of the poet Kim Kirim in the 1930s. According to Kim Yujoong, Kim Kirim first came to prominence when writers of the Korea Artists Proletariat Federation (KAPF)—categorized as classicists—started to decline in their careers. Kim sensed the limitations of their ideological biases and propagandistic activism and therefore employed modern poetics to pursue Modern literature.[1] The focus of this study is on the issues surrounding the poetic language of the Modernist movement that Kim argued. Founded on imagism and intellectualism, emotional expressions were eliminated and instead the pictorialization, or the imagery of poetry, was valued. This was clearly in opposition to the romantic poetry of the 1920s that relied on sentiment. Through the Modernist movement, Kim opposed the tradition and authority of literature at the time and tried to find Modernism in poetry with Western intellectualism and imagism. This imagism in poetry came to prominence in the field of contemporary design. In Korea, Ahn Sang-soo, who received his Ph.D with 『A Typographic Study on Lee Sang's Poetry』 made the start. Ahn was interested in the poet Lee Sang, who worked with Kim in the 1930s, and he took Lee's "visible poetry"—which used poetry as a graphic element—as a typographic study. In 2010, in celebration of the 100th anniversary of the birth of Lee Sang, the Korean Society of Typography hosted a visible poetry exhibition titled 《Si:Si》, and several graphic designers participated to interpret the works of Lee with visual elements. However, Kim Kirim who focused on poetic imagery based on imagism was almost never discussed in the field of design. Poet and literary critic Jang Sukjoo saw Kim as Lee Sang's mentor and argues that Kim, out of all the members of the Circle of Nine[2], understood Lee's works the most. With the poetry of Kim Kirim who put Modernist ideas into his works, an experiment was conducted on visualizing his poetry by incorporating it with visual and tactile senses. The visualization in this study aims to strengthen poetic imagery through imagism-based poetics and poetry interpretations and discover a new way of appreciating poetry.

2. The Approach and Perspective

An intellectual approach was taken to interpret the works of Kim Kirim and visualize his poetics. This approach values logic and intellect over emotion, eliminating the emotional and sentimental aspects in appreciating and interpreting poetry. This perspective becomes the core of Kim's modern literature that criticized the emotional and romantic poetry of the 1920s, concretizing the approach and perspective that should be taken in the process of visualization. In the position of the readers of Kim's poetry, poetic imagery was created by thinking of the images in the poems through a Suprematist perspective.

First of all, to make the end results into the physical form of letters printed on paper, or the form of a book, book design techniques were required. In addition to bookbinding, print-based post-processing, which is being used today, is employed as a method to implicitly express or emphasize the contents of the book. It is also for the convenience of the readers. In the experiment, the methods of bookbinding and post-processing were used as means to reinforce poetic imagery. Apart from drilling, pressing, coating, and die-cutting, the books were processed by hand rather than post-processing them in the usual method. An appropriate use of post-processing supports the maker's work to her intents and therefore enhances the quality of the book.

Lastly, to express the imagery from Kim's famous poem 「The Sea and the Butterfly」, techniques of concrete poetry were applied to emphasize

Abstract

The purpose of this paper lies in discovering ways of appreciating poetry through visualization of poetic imagery and combining different senses using concrete poetry and book design. Concrete poetry is a type of poetry that emphasizes the visual elements of the poem by arranging the words and letters to create certain shapes or form while ignoring the context, meaning, and logic of the text. This form of poetry, which focuses on delivering one specific element out of the various ones that compose poetry, uses letters as a means to create shapes, and it concentrates more on delivering the imagery of the poem rather than conveying the linguistic meaning.

This study starts with an interrogation towards the potential of pioneering a new way of expressing images of poetry and delivering poetic imagery when unconventional techniques and methods are grafted onto concrete poetry. Based on various interpretations of the poems, this study explored ways to represent the feelings, gravity, colors, texture, and metaphors found in the poems in different shapes and forms. As the prerequisite of the study was to make books with the printed results of the study, it was crucial to apply techniques of book design. By materializing the results using these two means, the structure of concrete poetry is emphasized and a combination of visual and tactile elements for poetic imagery is attempted.

For this experiment, the collection of poems titled 「The Sea and the Butterfly」 by Kim Kirim—a poet who approached Korean literature from a new and fresh perspective—was selected. Kim was a poet who was also a member of the Circle of Nine (Guinhoe) in the 1930s. Kim, a critic and a poet who was one of the first to employ modern theories in Korean literature, was selected in this experiment for the following reasons. First, Kim propagated Modernism which valued pictorialization, unlike lyric poetry. Second, Kim Kirim's famous work 「The Sea and the Butterfly」 was received as a piece that provided visual expressions and imagery much more vividly than those of the 1930s. Third, Kim was influenced by the British poet and critic T.S. Eliot and was devoted to sensory expressions that combined images. This corresponds to the visualization experiment that focuses on emphasizing the form of concrete poetry and delivering poetic imagery. There may not be many studies or experiments on concrete poetry in Korea, but there seems to be various attempts starting to be made. However, finding work with clear standards for visualizing the poetry is not easy. This study has meaning in suggesting the visualization of literature and its way of appreciation in diverse forms.

Visualization Experiment of Kim Kirim Poetry: Using Concrete Poetry and Book Design Technique

Lee Kunha
GRAPHICHA, Paju

Keywords: Poetry, Concrete poetry, Book design

Received: 25 May 2020
Reviewed: 1 June – 21 June 2020
Accepted: 25 June 20200

Translation: Hong Khia

a little to be desired on my current decision.

The most significant one above all things is lack of entertainment and technical expansion in terms of visualization. As the study was excessively biased towards considerations and datafication, its results ended up falling far short of those from interactive typographic works that have already been numerously attempted as well as depth and abundance in analog writing such as calligraphy. It is certainly greatly attributed to my narrow understanding of programming and lack of technical comprehension and experience in fonts.

Other than these issues, there still are a host of problems to be solved such as support and input of various languages in addition to English and Hangeul and reflecting additional physical values that are identifiable through the current technology including italics and roughness, interpretation of voice and photo recognition, etc.

Though this study has a lot of weaknesses, it is significant to find out that "handwriting" means more complete reflection of various unique values generated upon a human's writing process regardless of environmental factor— analog or digital. The most positive aspect of the study consequently is to establish the algorithm, the end product of the research, in a form of an open website. It is because this environment will serve in a way researchers in this field can not only utilize existing studies themselves but also easily grasp limitations and improvements. This humble study hopefully helps to enrich and elaborate digital environment as one of tools given to humans.

Bibliography

Alessio Leonardi et al. 『A Line of Type』. Translated by Yoon Seonil.
 Paju: Ahn Graphics, 2010.
Cho Youngho. 『AS-YOU-ARE.org: Typographic Algorithm Design to Realize Identi-
 fiable Digital Handwriting』. MA Thesis, Seoul: Hongik University, 2018.
Claude. E. Shannon. 『A Mathematical Theory of Communication』.
 『The Bell System Technical Journal』 Vol. 27 (1948).
Emil Ruder. 『Typography』. Translated by Ahn Sang-soo. Paju: Ahn Graphics, 2001.
James Gleick. 『Information』. Translated by Park Raeseon et al. Seoul:
 Dongasia Books, 2017.
Jiwon Lee. 『User Aspect Type Design』. California: California Institute of Arts, 2006.
Korean Society of Typography. 『A Dictionary of Typography』.
 Paju: Ahn Graphics, 2012.
Park Younju et al. 『Touch Type』. Seoul: Korea Craft & Design Foundation, 2016.
Robert Bringhurst. 『The Elements of Typographic Style』.
 Translated by Park Jaehong et al. Seoul: Mijinsa, 2016.

Website

AS-YOU-ARE website. Accessed 30 June 2020. http://as-you-are.org/
Doopedia. Accessed 30 June 2020. http://www.doopedia.co.kr
John Maeda. 〈Reactive Books〉, 《MAEDASTUDIO》. Accessed 30 June 2020.
 https://maedastudio.com/
Kim Suzung. 〈Sound Reactive Font〉. Accessed 30 June 2020.
 http://www.suzung.com/
Michael Flückiger. 『LAIKA』. Accessed 30 June 2020. https://www.laikafont.ch/
Naver Korean dictionary. Accessed 30 June 2020. https://ko.dict.naver.com/
Nicolas Nohornyj. 〈Lazy Pen〉. Accessed 30 June 2020. https://www.nahornyj.com/
Yuzo Azu. 〈INSTAMP〉, 《Lexus Design Award》. Accessed 30 June 2020.
 https://discoverlexus.com/experiences/lexus-design-award-2020

"Re-play" button, "Reset" button and "View Log" button to comprehensively review key logs generated between input and visualization outcome. Pressing the "View Log" button floats "TYPING LOG" window as shown in the following.[15]

The left pane of "TYPING LOG" window is composed of visualization utilizing logs, information on input environment and functions necessary for saving. When a user wants to review his/her own logs and then save them, he/she should fill in the entire required entries, click on "Save Your Log" button then the logs are registered on the website's "ARCHIVE" page. The right pane is information zone and consists of three parts—"Summary" to show the number of typing done, errors, time consumed and the like; "Timestamps" to output key-down and key-up Timestamp in a table form and; "Graph" to graphically visualize the flow of key-hold duration and key input interval.

The [16] and the [17] are, respectively, the draft of list and detail view of "ARCHIVE" where each user can browse their logs saved. It is designed to connect to a detailed view screen when clicking on the list. The detail view screen is composed almost identically with the aforementioned "TYPING LOG" but it differs with buttons to go to the previous or the next post instead of saving-related functions and with 'Delete' button to delete a log by entering password.

"AS-YOU-ARE.org" is of alpha-open status that some of its functions have not been realized; only the demonstration of an algorithm is currently available.

4. Conclusion and Limitations

This study for digital handwriting realization is to reflect human features to the shape of digital text that has been of no uniqueness and ultimately visualizes it as a unique object, serving as a part of an attempt to generalize this awareness.

The first limitation of this research is lack of objectivity; while examining the digital handwriting process using the keyboard automaton I developed before designing the algorithm, I was the only subject adopted for the experiment due to technical and circumstantial problems. It should be further reviewed whether keyboard input made by a number of subjects is clearly distinguished with different patterns.

The second is a sort of latency in some visualization algorithms incurred depending on the performance of different computers. It is a problem associated with algorithm optimization rather than low performance of a computer— the program requires future improvement for replay method and realization in order to prevent overload.

The third is a problem of consistency caused when applying the same algorithm to different languages, which is also covered by the study— the imbalance problem. For example, when applying key-hold duration to thickness, Hangeul generally becomes thicker with multiple syllables combined and values accumulated. However, each syllable makes up a letter in case of English and consequently the input value is relatively small, which unavoidably outputs thin results. To resolve this problem, it is being reviewed to develop another visual algorithm type to which a new reference value is applied— key-hold duration average of each syllable within a letter.

The fourth is handling of the backspace. The current algorithm has something to be desired in that it leaves logs but deletes the text visually when pressing the backspace. As to this aspect, however, the act of pressing the backspace is realized to be identifiable through replay, taking full advantage of digital environment. Depending on points of view, deleting errors or non-errors can be definitely seen as reflecting human features in the text input process as handwritten texts leave eraser or paint over marks, which leaves

The website's basic form was designed by assuming a case when a browser is in full screen on a 1920×1080px ratio screen. "Apple SD Gothic Neo" was used for prototyping but "Noto Sans CJK" font family was applied on the actual website so that the prototype could be output with the identical font on a variety of OS and browser environment. On the project's initial stage, it was considered to provide users with more diverse font options upon outcome realization but with the progress of the research, I thought that the core of digital handwriting would not be the font and it could be excessively subjective to select a particular font, which was consequently excluded. The website largely consists of 'MAIN' page where digital handwriting is output and the user can check detailed log; "ABOUT" page to make ones who have visited the website understand the project and to express gratitude to those who have helped make the website and; "ARCHIVE" page that shows saved logs.

[14] "MAIN" Page.

The main function of "MAIN" page is to produce digital handwriting, the core of this study, through text input. Thus, I designated the biggest, the most readily perceivable central zone as the visualization zone. The text field where input can be made with a keyboard is located at the bottom left and on the opposite side are the type select buttons with which visualization algorithm can be chosen. When text is input in the text field, keyboard automaton combines it and at the same time, values necessary are automatically calculated based on Timestamp and then visualization is performed in real time appropriate for the algorithm type selected in the visualization zone. Though it varies depending on visualization algorithms, the visualization of the last letter completes only after the combination is finished on the keyboard automaton.

[15] Floated "TYPING LOG" Window.

Thus, the current version is configured to complete the last letter's combination by pressing the enter key for convenience. The visualization type is of four sorts— the alpha version made for the test at the developmental stage and the other three finally selected among outcomes from the secondary visualization prototype; even when making input and then selecting another type, the visualization type that falls under the selected algorithm is realized to replay based on the input value. From left at the bottom of the text field are arranged

[16] AS-YOU-ARE.org "ARCHIVE"'s List Screen.

[17] AS-YOU-ARE.org "ARCHIVE"'s Detail View Screen.

| **Paper** |

a syllable is input, which gives a little visual delight. An underlying problem here is, however, expression fairness in case of writing Hangeul and English side by side as English is generally output with a thin font as it is expressed solely with a single syllable without any combination.

The next prototype #7[12] is an outcome of making additional graphic elements, not directly applying visual effects to a letter itself. The face filled with color and the blank space at the bottom demonstrate the time take to create each letter and flow of input interval between letters. The face and space are generated while the peak (or vertex) is visually elevated in accordance with the duration of letter creation from the center at the bottom or with the input interval between letters. This prototype does not realize digital handwriting solely with letters but it can be sufficiently regarded as an approach to digital handwriting because it is visualization with which how the typing process is done can be interpreted. This visualization mode has an advantage that it is capable of pencraft expression almost without disrupting readability of the current digital text.

The last prototype #8[13] visualizes almost all values at once that can be generated in the text input environment through the current universal keyboard such as key-hold duration for syllable, input interval between syllables, input duration per letter, etc. The input interval between letters is only excluded. In case of Hangeul, the process that letters are combined is particularly shown in a form of accumulated layers, which displays the letter input process by syllable unit. When pressing a key, a syllable corresponding to the key grows in the direction of diagonal right to the bottom and the input interval between syllables is parted as much as the time gap in the diagonal direction toward the bottom. This is the most visually interesting prototype for me among others but unfortunately this prototype certainly is of poorer readability than other visualization modes when it is written in lines. This problem was compensated a little by supplementing its color system upon actual program realization.

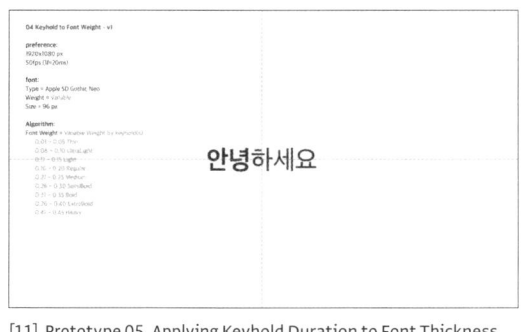

[11] Prototype 05. Applying Keyhold Duration to Font Thickness. Animation URL: vimeo.com/248626859

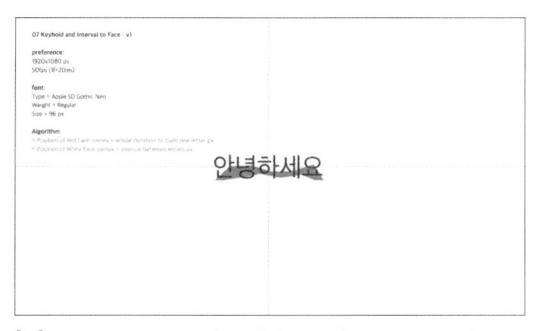

[12] Prototype 07. Expressing Whole Duration per Letter and Input. Interval with Face. Animation URL: vimeo.com/248626897

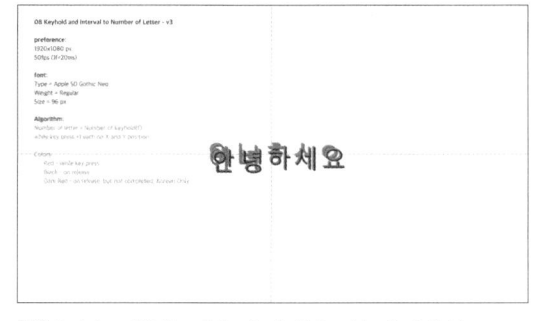

[13] Prototype 08. Visualizing Keyhold Duration for Syllable and Input Interval with Volume. Animation URL: vimeo.com/248626909

3.5. Realization of Digital Handwriting Algorithm

The final goal of this study is to realize the digital handwriting algorithm on the web where anyone has access so that the digital handwriting does not just remain as one-time output but can serve as a foundation both for my and other researchers' future studies. Thus, I used a nonprofit domain name (org) for the website, which was entitled "AS-YOU-ARE".

http://AS-YOU-ARE.org

drawn from the values above. Each list incorporates links to check the animation.

"0. Normal text typing sample" on the above list is animation samples made which are to serve as standard for visualizing operation based on the number of frames organized to be utilized as guide, which is almost identical with replay of the process shown when text is input on the notepad, etc. My thesis, a source of this study, covered every prototype in detail but the three of #5, #7 and #8 which were actually realized on the web are to be more specifically described herein.

The prototype #5[11] is to divide the key-hold duration section by section within a font family, allocate and apply them to each thickness. As the applied "Apple SD Gothic Neo" has nine levels of thickness, this one is designed to divide the key-hold duration at 0.05s unit; allocate sections to each font thickness and; output Heavy, the maximum thickness, when it is greater than 0.41s. This prototype gradually increases the font thickness whenever

Eng	Han-geul	Down Timestamp (sec)	Up Timestamp (sec)	Down Timestamp (frame)	Up Timestamp (frame)	Number of Frames per English letter		Number of Frames per Hangeul letter		
						Keyhold Duration	Keypress Interval	Total Keyhold Duration	Interval btw. Letters	Whole Duration per One Letter
d	ㅇ	0.00	0.15	0s00	0s08	8	0	17	0	26
k	ㅏ	0.21	0.29	0s11	0s15	4	4			
s	ㄴ	0.41	0.51	0s21	0s26	5	6			
s	ㄴ	0.61	0.71	0s31	0s36	5	5	15	5	26
u	ㅓ	0.78	0.88	0s39	0s44	5	3			
d	ㅇ	1.03	1.14	1s02	1s07	5	8			
g	ㅎ	1.38	1.49	1s19	1s25	6	12	11	12	16
k	ㅏ	1.60	1.69	1s30	1s35	5	5			
t	ㅅ	1.78	1.89	1s39	1s45	6	4	11	4	17
p	ㅔ	2.02	2.11	2s01	2s06	5	6			
d	ㅇ	2.31	2.43	2s16	2s22	6	10	11	10	29
y	ㅠ	2.59	2.69	2s30	2s35	5	8			

[9] Calculating the Number of Frames for Secondary Visualization Prototyping 1.

Sequence	Visualization Method	Animation URL
0	Normal text typing sample	vimeo.com/248626477
1	Applying keyhold duration to Y position	vimeo.com/248626660
2	Applying keyhold duration to scale (1)	vimeo.com/248626682
3	Applying keyhold duration to scale (2)	vimeo.com/248626695
4	Applying keyhold duration to opacity	vimeo.com/248626837
5	Applying keyhold duration to font thickness	vimeo.com/248626859
6	Visualizing keyhold duration for syllable with dotted line	vimeo.com/248626884
7	Expressing whole duration per letter and input interval with face	vimeo.com/248626897
8	Visualizing keyhold duration for syllable and input interval with volume	vimeo.com/248626909

[10] List of Secondary Visualization Prototyping Outcome.

combinations different from that of English so it was required to set three additional values as follows.

1. Total Key-hold Duration
A reference value made considering that key input interval is relatively less consistent than key-hold duration, applied to some approach to visualization. Using this value, even when key input interval is not consistent, in other words, the input is not consecutively made, it generates similar-looking digital handwriting at all times only with consistency of key-hold duration ensured.

2. Interval between Letters
The interval between a Hangeul letter's last syllable and the first syllable of the next letter. This value is not necessary to consider in case of English that each input makes a letter but it varies when it comes to Hangeul. It is because reflecting the interval value between syllables in Hangeul directly means development of a new, responsive font system. It is beyond the conventional development of fonts, which I supposed not to be covered in this study. Thus, this study set the interval per letter only as a reference value which can be immediately applied both to English and Hangeul within the given current technical circumstance.

3. Whole Duration per Letter
A reference value made in order to apply the second reference value above to English and Hangeul with the same standard. As a Hangeul letter is combined by syllable unit as aforementioned, this study created a notion of whole duration per letter which can be consistently applied to English and Hangeul. This value was used together only when the second reference value was applicable.

In other words, English text can be visualized with two values with the difference in input/output mode while Hangeul visualization should consider five values in total. When actually developing the keyboard automaton for Hangeul digital handwriting at the final stage this study, it required more careful consideration and time to design it to recalculate the physical value in accordance with key input appropriately for a combined letter. On the one hand, it means once a digital handwriting algorithm is well established for Hangeul with high level of complexity, that of English would be somewhat automatically resolved. Thus, this visualization prototyping did not particularly deal with the case of English text. The following [10] is a list of animated visualization prototype outcomes

[8] Comparison of Graph of 'gktpdy (하세요)'. Input Value.
Result on 23 August 2017 (2 rows on the left) / Result on 24 September 2017 (2 rows on the left).

Typographic Algorithm to Realize Unique Digital Handwriting

constant handwriting data. One more point I found interesting is that I became accustomed to the trial custom keyboard with repeated input during the test and consequently achieved a more stable 'gktpdy (하세요)' input pattern, i.e. handwriting, on the test conducted in September.

3.4. Secondary Visualization Prototyping

Based on the result values and insight obtained from the aforementioned test using the custom keyboard, the secondary visualization prototyping focused on formulating various directions for visualization.

I assumed one of the most outstanding points of visualization in a digital environment, compared to analog one, was reproducibility through datafication. Digital environment is able to dataficate text input process and further, replay the input process in a time sequence based on that datafication. Thus, this study utilized Adobe After Effects on the visualization-applying stage; replayed in an animated form the process that digital handwriting was created and; ultimately intended distinctive difference of digital handwriting from analog handwriting on which the input process should be inferred through stationary outcome by realizing the replay as a function available on the web as well.

For this operation, I selected one of sample values obtained through custom keyboard input; rounded off the sample's Down and Up Timestamp in a form starting with 0 followed by two decimal places; replaced the values with frame values for 50fps video as shown in the [9] below and; applied it to key-hold duration per English and Hangeul letter and the number of frames for key input interval.

In order to make 50fps video, 0.02 second was converted into 1 frame. For example, the value of Up Timestamp (sec.) in row 1 is 0.15, which is converted as 7.5 frames. As the number of video frames cannot have a decimal place, it is rounded off to an integer, which makes 8 frames as a result. This case is marked as 0s08 on the table. Besides, Hangeul is completely made through

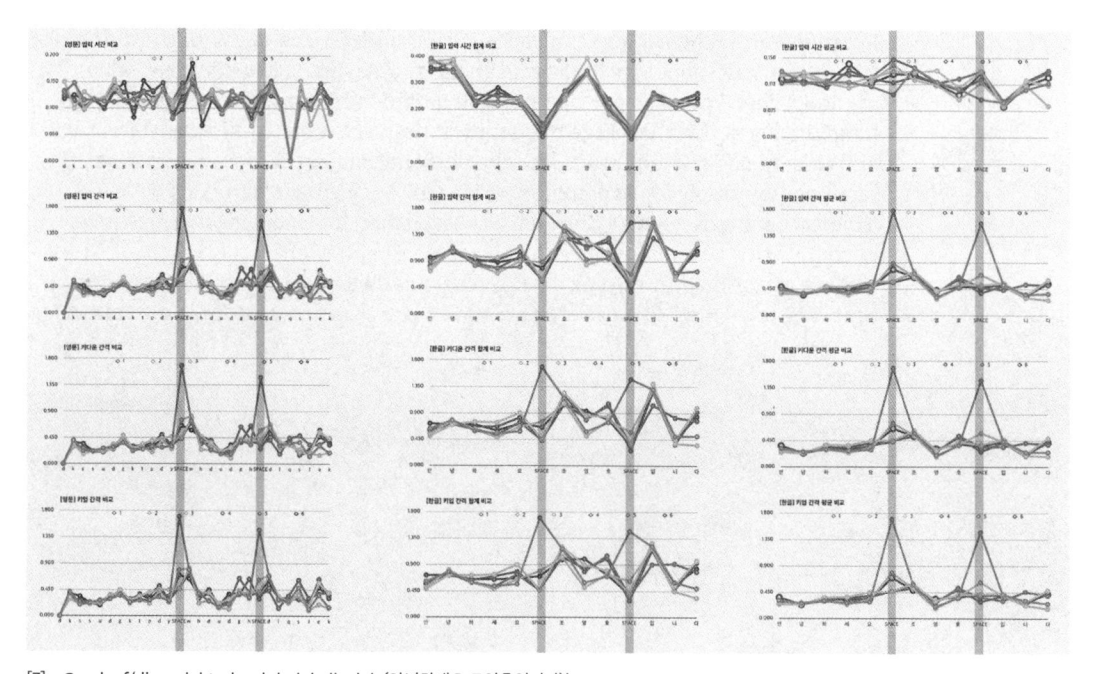

[7] Graph of 'dkssudgktpdy whdudgh dlqslek (안녕하세요 조영호입니다)'.
 English input, sum of input by Hangeul letter unit and average input by Hangeul letter unit from left.

●●●○○ KT 📶 오후 4:59 ⚹ ☀ 100% 🔋

dkssudgktpdy

dkssudgktpy

dkssudgktpdy

dkssudgktpdy

dkssudgktpdy

Log >>> Key / Down / Up / 누른시간 / 기간격 / 다운간격 / 업간격
d / 1503475124.384 / 1503475124.586 / 0.181999 / 0.0 / 0.0 / 0.0
k / 1503475124.661 / 1503475124.777 / 0.115999 / 0.392999 / 0.276999 /
0.210999
s / 1503475124.851 / 1503475124.96 / 0.108999 / 0.209 / 0.19 / 0.183
s / 1503475125.062 / 1503475125.161 / 0.098999 / 0.309999 / 0.210999 /
0.200699
u / 1503475125.228 / 1503475125.327 / 0.098999 / 0.284999 / 0.165999 /
0.165999
g / 1503475125.451 / 1503475125.56 / 0.106999 / 0.332 / 0.223 / 0.233
g / 1503475125.738 / 1503475125.842 / 0.105999 / 0.301 / 0.285 / 0.282
k / 1503475125.911 / 1503475126.028 / 0.117 / 0.292 / 0.174999 / 0.186
t / 1503475126.076 / 1503475126.176 / 0.1 / 0.265 / 0.164999 / 0.148
p / 1503475126.212 / 1503475126.324 / 0.111999 / 0.247999 / 0.135999 /
0.147999
d / 1503475126.408 / 1503475126.54 / 0.131999 / 0.328 / 0.196 / 0.216
y / 1503475126.641 / 1503475126.757 / 0.115999 / 0.348999 / 0.233 / 0.217

q w e r t y u i o p
a s d f g h j k l
⇧ z x c v b n m ⌫
123 🌐 🎤 SPACE RETURN

[5] Trial Custom Keyboard (English).
Development environment:
MacOS 10.12. Apple Swift 3
Test environment: iPhone7, iOS 10.13

in order to check whether there was another singularity. This test went further to make an adding-up formula applied to values generated upon English input by Hangeul phoneme unit for each section and organize the dataset, which is visualized as the graph on the [7]. The sentence used for the test is as follows.

dkssudgktpdy whdudgh dlqslek (안녕하세요 조영호입니다)

The longer input also demonstrates a consistent pattern in general. However, unexpected singularities are also found; the first is input value of space bar (which is marked with the column on the graph). This value is mostly consistent but a few are remarkably different because of momentary hesitancy or pause upon input of space bar. This aspect may turn up no matter who makes such input so it was required to additionally review how it should be handled. Another singularity is that the interval values are more inconsistent than those of key-hold duration and; the key-hold duration average (the top graph on the right) is more inconsistent than sum of key-hold duration (the top graph in the middle). It means that using key-hold values over interval and; sum of key-hold values over the average would be more appropriate to create Hangeul text handwriting. The study lastly reviewed once again a case that the same text is used on different sentences and whether new input is associated with existing one. To do this, I isolated the text 'gktpdy (하세요)' from 'dkssudgktpdy (안녕하세요)' input on 23 August 2017 and 'rmaksgktpdy (그만하세요)' input a month later and compared the result. This last review confirms yet again that if the same individual inputs the same text, it is very likely to make a relatively consistent pattern, in other words,

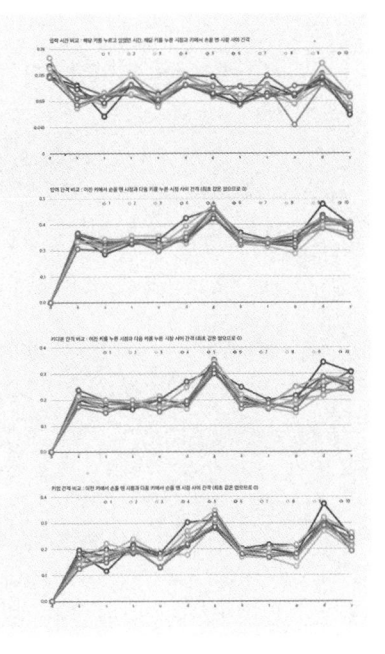

[6] Graph of 'dkssudgktpdy (안녕하세요)'. Result of test conducted on 23 August 2017.

3.3. Utilization of Trial Custom Keyboard

Following the primary visualization prototyping, this study developed a trial custom keyboard that automatically identifies the time value generated upon repetitive input and continued the experiment in order to review whether the digital handwriting could have a consistent pattern—uniqueness. The trial custom keyboard was made at a level that only facilitates input and output of English keyboard on Apple iOS, not every OS due to time restrictions. Apple Swift 3 was utilized for program development.

The [5] is an actual screen on which the developed trial custom keyboard is being used. For the test, the text 'dkssudgktpdy' is input 10 times the same as I usually type a Hangeul keyboard and then the key of each log is identified. For identifying the test time value, Unix Timestamp is applied which does not reset hour, minute and second as 0 and for convenience, the '123' key at the bottom left of the keyboard is functionalized with copying all the logs identified to clipboard en bloc. Regarding production of test samples, it was hard to find those who could naturally make Hangeul input only with English keyboard on a smartphone and consequently, I was the only subject for this experiment, which I should admit is an approach that lacks data objectivity. However, this experiment primarily aimed to see whether the text input multiple times by one individual could demonstrate a consistent, or unique pattern and whether singularity would be found among different sets of input so it was viewed as the appropriate test to conduct despite lack of accuracy and objectivity.

The following [6] is to arrange 10 sets of sample data identified on a spreadsheet and to accordingly demonstrate the result of graphic visualization. A few misprints were made upon input, which were excluded in order to raise analytical accuracy. The graph confirms that multiple input values generally have a consistent pattern, which suggests the possibility that a relatively simple input method like typing can sufficiently create an individual's handwriting.

The study subsequently conducted another test with a longer sentence

[4] Outcome of Primary Visualization Prototyping.

digital handwriting can be distinctively visualized so that its output is remarkably different from the existing digital text output to the extent that it is identifiable, which is one of the main prerequisites for uniqueness. To briefly introduce this process, I entered the text '안녕하세요 (typed as dkssudgktpdy with English keyboard)' with Apple MacOS standard keyboard I usually use; recorded the screen with text output as a 30fps video; manually identified the number of frames consumed when a letter was made using a video player and; applied that value to visualization. The number of frames identified per letter is as follows.

안29 (19) 녕22 (12) 하7 (9) 세10 (8) 요13
dks29 (19) sud22 (12) gk7 (9) tp10 (8) dy13

The figures next to each letter are the number of frames consumed to make that letter and those in parentheses are the number of frames consumed during the gap between letters. It is followed by calculating the average of these figures to set a reference value for visualization.

Average number of frames consumed to complete a letter ≒ 16
Average number of frames between letters ≒ 12

The following [4] is the draft on which the number of frames identified is applied to each letter with different positions and opacity levels. Though this experiment was simply conducted, it is found that application of only the two physical values that can be generated upon the input process can extend an individual's input into diverse text shapes. In addition, shapes of extended letters are distinctively different from the default digital text output provided by the system, which I assume suggests a unique visual pattern based on input, in other words, handwriting, is quite feasible.

	Analog Handwriting	Digital Text	Auxiliary Expression Tools for Digital Text	Digital Handwriting
Definitions	Letters written on actual substances or on canvas such as handwritten text and calligraphy	Text outcome realized only with pure text values on digital environment	Tools that supplement incomplete communication such as font, emoticon, sticker, etc.	Outcome of digital text to which handwriting-creating algorithm is applied
Does the original have uniqueness?	Yes	No	No	Yes
Are the writer's physical features reflected?	Yes	No	No	Yes
Easy to imitate?	Difficult	Easy	Easy	Somewhat difficult
Can be copied/ mass-produced?	No	Yes	Yes	Yes
Is the writer identifiable?	Yes	No	Partly yes	Yes
Possible to reproduce the writing process as it is?	No	Partly yes	Partly yes	Yes

[3] Definition of Digital Handwriting Features Through Comparison.

as its basic unit is simpler than that of characters but music is of complexity in terms of combination. As a result, music was capable of datafication on another level from the initial stage of digitization compared to the character system.

5. Naver Korean dictionary, the search word 'Notation'.

3. Digital Handwriting Algorithm
3.1. Detailed Realization Goal and Method Setting

Taking a closer look at the aforementioned delivery systems, it is found that the point where digital text's delivery system fundamentally differs from the rest three delivery systems is when thoughts input by the writer is output in the writer's digital environment. That means the entire data except the text is lost as soon as the writer makes the input. Based on the current, universal digital text input environment, therefore, it is the physical value generated when the writer types that is the missing core necessary for making a text to which the writer's uniqueness is reflected, in other words, the handwriting.

Digital handwriting that this study aims is to realize a new form of handwriting appropriate for the new tool of digital, which is a departure from imitation of analog handwriting. Based on it, the direction of digital handwriting realization and research approach of this study is largely summarized as the following four issues.

First, producing letters with uniqueness in digital environment, that is, letters in which human is physically involved
To this end, this study analyzed the time value of key-down event and key-up event that is produced between key input; substitutes it with keyhold and interval value and; applied the value to letter visualization.

Second, actively accepting the advantages of digital environment
It means this study will fully utilize many advantages of digitality. This study designed an algorithm in which a writing process is replayed based on physical values generated upon input.

Third, realization of universal digital environment
It means the final visualization will be realized solely with algorithm design and programming, not developing any new input device. Thinking handwriting could be realized regardless of the level of tools used, I decided the text input/output environment, or an algorithm, should be priorly realized to which human motions are reflected rather than developing a new tool.

Fourth, establishing environment where digital handwriting can be analyzed and trained
Digital handwriting requires the polish through training as penmanship and calligraphy does. Thus, this study provides archiving on a website beyond outputting the outcome on a web page so that a user can trace his/her input and analyze the log of values generated between input in order for comparison when necessary and utilize the data for the purpose of developing his/her own digital handwriting.

3.2. Primary Visualization Prototyping

This study largely went through two stages of prototyping. The primary prototyping is conducted in a relatively light manner in order to review whether

necessary to briefly see what happened when analog music was transplanted into a digital one.

Since computer music at the initial stage was so narrow that the pitch and the length of a note and the volume could barely be reproduced, it was impossible to deliver features of an instrument's own sound that people could feel through natural performance, variations likely to be made depending on methods of musical performance or waveforms of a detailed sound. However, the process that music is transplanted into a digital form through advanced digital technology would definitely be different from text visualization and the music transplant was possible as music has a distinctive recording mode, that is, the score.

Making contents and meanings with simple information of notes that are composed solely of the pitch requires the mutual linkage between notes, composition and combination of various lengths, variations of sound intensity, etc. Features of this combination look similar to those of phonograms such as alphabets or Hangeul whose smallest unit hardly has any meanings. However, unlike a phonogram which is completely assembled only with consonants and vowels with fixed reading sounds in a relatively simple manner, music should go through combination with complex technic such as octave, length, chord composition, prolonged sound, intensity variation and diverse playing styles in order to finally realize what is to be delivered. In addition, music has complexity in that it develops totally different meanings and feelings even with combination of identical notes depending on how many notes are put in a bar, how fast it is played or how the sound of each note is made while letters are generally developed into words or sentences with the same meanings when those letters are combined the same.

Due to this complexity, music has developed notation long before, a system to record and pass down a score using complex and detailed signs. The system of notation, a way to document a piece of music using signals in accordance with agreement and rules made for the purpose of music performance, release, preservation and study[5], enables a recipient to more elaborately interpret and reproduce the pitch and music as well. This is a sort of transcoding process, which can be regarded as a process in which a human's intention is encoded and then decoded again and it can be applied basically the same to the communication process of character language and music. However, music has highly encoded various information even on the analog stage and has long established the rules

Music Delivery System

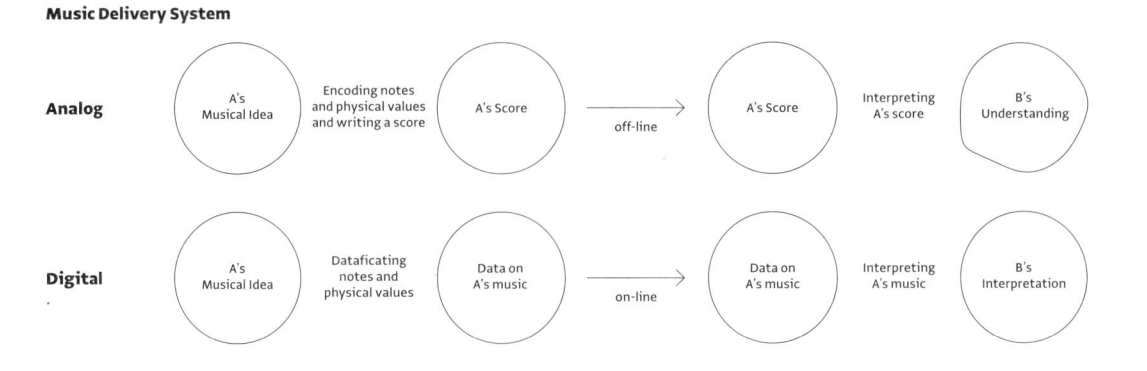

[2] Comparison of Analog Music and Digital Music Delivery System.

Typographic Algorithm to Realize Unique Digital Handwriting

process. I supposed that the establishment of Shannon's diagram of communication system would be the main cause for the current text output's losing its uniqueness because I considered the notion of code handled on this diagram for the process of transmitting and receiving a message tends to notionally refer only to the text in sentences composed of letters. However, this is by no means a flaw in Shannon's diagram and I rather thought his diagram is still valid even in today's digital information delivery system, transcending time. Thus, I erased the notion of noise and restructured the basic tendency of text delivery system both in digital and analog environments based on his diagram for this research's purpose and additionally marked a lump to show and compare how well Writer A delivers its uniqueness to Recipient B in order to examine at which point information is missing upon the digital text delivery system and how it can be improved.

In the analog text delivery system, only some of the information to be delivered is encoded as in the digital text and it doesn't have a process to decode it yet again. Thus, Writer A's letters are delivered to Recipient B unabridged. Writer A will have an opportunity to express A's own intention other than the content and B will also have an opportunity to interpret what A intends to deliver in terms of letter-form or circumstantial aspects other than the content even if B cannot exactly grasp it.

On the other hand, only the text is converted to data in the digital text and then transmitted to B. Here also is a form put into characters but that is a computer type, that is, a font preset on OS or a program. Thus, the notion of 'A's handwriting' disappears simultaneously with input on this delivery system. Writer A who created the text can hardly get involved with the shape of text that will be transmitted to B and B has nothing to rely on but the text received from A to interpret A's message. It may cause a serious misunderstanding depending on the message's content, which is more likely to happen when B does not have sufficient prior information about A. In addition, B would even have a difficulty in deciding whether A certainly made that text or someone else is pretending to be A.

One reason that incurs this situation may be because type technologies and methods that were used to effectively mass-produce documents have been applied to the current digital conversation environment almost the same without particular improvement since mankind would have mainly dealt with letters in terms of content delivery alone for a long time. Another hypothetical reason is the information processing technology of the past that was relatively a lot slower than the current one. As an increased amount of unit data transmission back then literally meant enormously increased expense, it was important to make any sort of data smaller and in that process, the rest of the information left behind which was regarded as relatively less important was ignored.

2.2. Digital Music vs. Digital Text

Taking a look at the music field that is reproducing the conventional analog expression into a digital form at a high level. The following [2] is to organize the delivery system of analog music and digital music based on the [1] above. Playing instruments or recording and delivering songs were not considered as they do not fundamentally serve the purpose of this study.

As demonstrated with a figure, this study supposed that digital music would not only reflect A's intention to some extent but rather reflect A more accurately as analog music is transmitted. In order to understand this, it is

3. Doopedia, the search word 'technic'.

4. Shannon, Claude. E. 「A Mathmatical Theory of Communication」. 「The Bell System Techincal Journal」 Vol. 27 (July, 1948): pp379-423.

the writer's personality or education level and state of mind as well as a circumstance when the article was written or tools used and consequently, handwritten text is of a technic that inevitably requires the polish. The technic means a physical and mental activity in artistic creation and reproduction that deals with material in order to achieve its goal effectively, solves problems and forms a piece of work[3] and it can be polished up by any human being in order to make better and his/her own unique expressions, which is as valid in digital creation, in other words, design field utilizing computers, as digital one. Whenever we approach any sort of expression besides the handwritten text, we definitely go through a process to be skilled at it and the process unavoidably entails individual variation for environmental and empirical reasons.

In the digital environment, however, if the final text is identical no matter how an individual presses the keyboard, it yields the same shape; thus, there is no concept of great input considering the letter itself and consequently, the process for skillfulness is of little significance. For example, neither how many mistakes a writer made before pressing the enter key nor how long it took for the key input is visible to a viewer so the writer is not motivated to make the text greater. Typing faster would be the only technic that humans should polish up in digital conversation environment. In addition to that, new technology for note-taking or voice recognition increasingly reduces the necessity to practice writing letters as people did in the past.

Some would think that this circumstance is favorable as a more convenient one or an environment that enables them to focus more on the content. On the other hand, however, wouldn't it force human beings to give up the opportunities and chances in digital conversation environment to express our uniqueness by delivering additional information other than the content of the text? Even if the current digital text input and output environment is a prerequisite for convenience, shouldn't there be any method given to avoid uniformity not intended by a user, at least selectively?

The following [1] is structuralization for the delivery system of analog and digital texts. This delivery system model was made with a reference to the Schematic Diagram of a General Communication System (Claude E. Shannon, 1948).[4] The original diagram referenced is fine technical structuralization of (i) a process that information source is encoded as a form of signal through a transmitter and a receiver receives and then decodes it into information yet again and (ii) the noise incurred during the transmitting and receiving

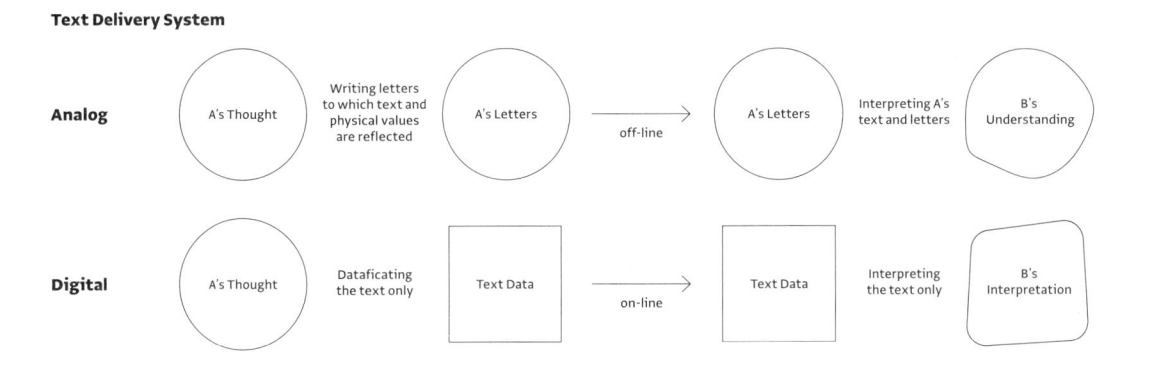

Text Delivery System

Analog: A's Thought → Writing letters to which text and physical values are reflected → A's Letters → off-line → A's Letters → Interpreting A's text and letters → B's Understanding

Digital: A's Thought → Dataficating the text only → Text Data → on-line → Text Data → Interpreting the text only → B's Interpretation

[1] Comparison of Analog Text and Digital Text Delivery System.

real writing tools such as a brush, a pen, etc. As a letter written with an analog machine like a typewriter conceptually reflects physical values generated by a human to the outcome, it can also be regarded as a type of analog handwriting.

1. Naver Korean dictionary, the search word 'Handwriting'.

2. Naver Korean dictionary, the search word 'Algorithm'.

Digital Handwriting
The outcome that this study aims. Refers to the shape of digital text output on which input made by utilizing digital tools such as keyboards, microphones and cameras reflect the writer's uniqueness.

Algorithm
Means a set of rules that induces desired output on the basis of input data.[2] This study defines the rules used to visualize digital text-based on physical values extracted between keyboard input as "Digital Typographic Algorithm".

Keyboard Automaton
A program automatically assembling Hangeul syllables typed with keyboard. Though the default keyboard automata built in most OS do assemble letters, the event that delivers the letter assembly process— a required value in this study—is omitted from them. Thus, this study developed and used a new type of keyboard automation, combinant letter assembler of two sets Hangeul that is able to visualize the assembly process and replay logs.

Keypress Event
All the events that happen through the action of pressing a keyboard are collectively called the keypress event. Divided into a key-down event that a key is pressed down by hand and key-up event that hand releases a pressed key.

Key-hold Duration
Refers to the duration that a key is pressed by hand, in other words, the interval between a key-down event and a key-up event.

Keypress Interval
Means the interval between a key-up event from the present key input and a key-down event of the next key input.

2. Consideration in Digital Handwriting
2.1. Analog Handwriting vs. Digital Text
A handwritten text facilitates comprehensive evaluation of whether the writer elaborated it, the situation was urgent or who the writer is. It is because various information other than its content such as paper type, homogeneity of letters and informativeness is delivered all together. In addition, the handwritten text has a unique pattern with which the writer can be identified and, on the other hand, when the same writer writes the same content with the identical tool in a similar circumstance yet again, the outcome somewhat varies each time.

It is because a letter shape can serve as a standard for a viewer to decide

1. Introduction
1.1. Research Background and Purpose

Unlike communication through handwritten texts, conversation with digital texts does not clearly show the writer's uniqueness. However, the current circumstance that emoticons, stickers and new words are being constantly produced and consumed suggests that people definitely have information that they want to additionally express or deliver about themselves in conversations other than literal contents.

Writing and texts primarily intended for content delivery such as reports, diagrams and informative articles are required to be equipped with a high level of homogeneity and regularity for objectivity and quick delivery and this requirement is better realized by today's digital text output than ever before. When it comes to personal texts like chatting or text messages, however, the text's visual aspects may be as important as the accurate and quick delivery of content. It is because forms and shapes of a message also make up a great portion in the identification of the message recipient or interpretation of its meaning.

The technology of letter combination that dates back to the type era obviously has provided us with much more convenient and elaborate usability and outcome through the digital environment. However, wouldn't that convenience and elaboration deprive us of our humanity and diversity little by little? Would it be OK if the convenience that used to be necessary for functional word processing is applied to all the digital text input and output environments used by mankind as it is? The world has changed and so have tools. Digital devices now enable note-taking that was required to use a pen or a pencil in the past. Then, wouldn't it be fine to see not only texts made with conventional analog tools but ones made through digital input as handwriting?

This study examines the process of changing handwritten texts into the current digital conversation environment; defines the cause for the absence of uniqueness in the current digital text, in other words, missing "handwriting elements" and; consequently proposes a typographic algorithm to realize text made in digital environment as an individual's unique digital handwriting.

Last but not least, the professional programmer Kwon Jaeyoung (TFX) greatly helped the development of keyboard automation used for prototyping and the realization of the designed algorithm on a website.

1.2. Terms and Definitions

Terms used in this study that are likely to have a difference in interpretation or difficulty in understanding are defined as follows.

Text
Refers to the content only, not the form of an article. Regardless of writing environment, texts are visualized by an agreed sign of letters to be delivered to humans, in other words, put into characters.

Handwriting
Lexically means the shape of written letters[1] but on this study, more extensively utilized to refer to the text's shape on which the writer's uniqueness is reflected. Handwriting is largely divided into two categories—analog handwriting and digital handwriting.

Analog Handwriting
Refers to the shape of analog text written on an actual substance using

Abstract

The digital text usually does not show each character of writers as the analog text does, which is written by hands. On the other hand, in digital conversations, various fonts, emoticons, and new words used to personalize the expression are overflowing. This is a conflict between the anonymity of digital text and the desire of the author to reveal more personal intentions and the individual itself. This can be considered as the challenge of the current digital text input and output.

 Therefore, this study considers the missing elements and their causes in the process of changing handwriting into a digital text dialogue environment and attempts to realize handwriting within the current digital text environment through prototyping and software development. It is a small attempt to recover the diversity of the digital conversation which was not expressed enough and was pushed back by the priority, the content. Although the researcher's empirical and technical limitations have not been able to provide in-depth and sufficient realization, I hope this research will provide a small clue to future related research.

Typographic Algorithm
to Realize Unique Digital Handwriting

Cho Youngho
05studio, Seoul

Keywords: Digital Handwriting, Interactive Typography, Algorithm, Data Visualization, Interactive Design

Received: 30 May 2020
Reviewed: 1 June – 10 June 2020
Accepted: 12 June 2020

Translation: Kim Noheul

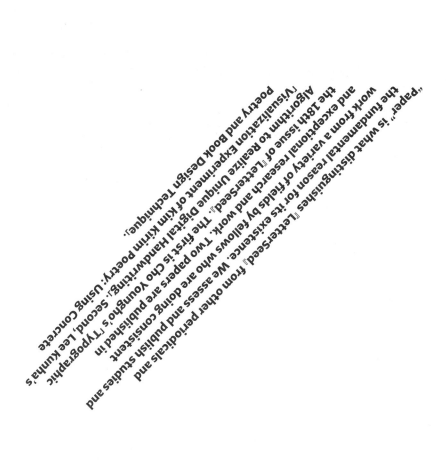

"paper" is what distinguishes 『Letterseed』 from other periodicals and the fundamental reason for its existence. We assess and publish studies and work from a variety of fields by fellows who are doing consistent and exceptional research and work. Two papers are published in the 18th issue of 『Letterseed』. The first is Cho Youngho's 『Typographic Algorithm to Realize Unique Digital Handwriting』. Second, Lee kunha's 『Visualization Experiment of Kim Kirim poetry』 using Concrete poetry and Book Design technique.

Notes

The names of foreign individuals, titles of foreign organizations,
and imported technical terms were written following
the orthographic rules for loanwords by the National Institute of
Korean Language and 『Dictionary of Typography』.

『LetterSeed』 follows the following Korean notation.
Double hook brackets(『 』) were used for the title of
books, periodicals, and dissertations(for degree).
Hoot brackets(「 」) were used for the title of texts,
dissertations(for academic journal), articles, and typeface.
Double angle brackets(《 》) were used for the title of
exhibitions and albums.
Angle brackets(〈 〉) were used for the title of works,
broadcasts, songs, and movies.

I recall when we thought of the name for the journal. The first chairperson and a few other board members were at a Korean restaurant in Insa-dong thinking of possible ideas, "visual culture, letter, seeds, seeds of letters, letters or type, what's the correct pronunciation?..." to what eventually became "LetterSeed" is now in it's 18th iteration thanks to the work and sacrifice of so many people. From small beginnings 『LetterSeed』 has grown to encompass a much larger global perspective, growing out of its adolescent stage into a more mature journal representative of a new and changed organization championing Korean typography. This issue of 『LetterSeed』 is proof of a new direction and greener pastures ahead.

Cho Youngho and Lee Kunha's Papers and the Projects of Lee Noheul, Min Bon, Noh Eunyou, Ham Minjoo are indicative of the current typographic landscape in Korea as well as what to expect in the future. Yoon Choong-geun's digital daily project for 《Typojanchi 2019》 presents a plethora of possibilities for typography to unfold. Our Interview with Na Kim and her exhibition 《Bottomless Bag》 was an experiment in non-contact exhibition design and was informative as well as unique, 「10 Years Record of the Korean Society of Typography」 is a look back on the activities and accomplishments of our organization and how to progress forward. 「Meaningful Handwriting」 is meant to be a fun break in between articles followed by Kim Hyunmee's Review of Stanley Morison's first principles set out a century ago echoing to the present as well as the future of typography. The first People article focuses on the 5th vice chair, Cho Hyun and the rich legacy of design he left behind.

What started with only 50 members has now increased to over 300. What started from discussions based around the printed word has quickly evolved to the screen and the digital environment, as we continue to expand and increase the possibilities of typography in our world. We have many projects and events in the works as well as a new website and many partners who have pledged their support for our organization. We hope all these efforts will show through from these pages you are about to read and you too will support us and 『LetterSeed』 in the coming days ahead. Finally, I am grateful to our publishing coordinator You Hyunsun and the countless others who worked so hard to make this issue a reality.

Kymn Kyungsun

Korean Society of Typography
LetterSeed 18

Ahn Graphics, 2020

LetterSeed 18

ISBN 978-89-7059-557-3(04600)

Printed in 12 October 2020
Published in 19 October 2020

Concept: Korean Society of Typography
 Editorial Department
Author: Cho Youngho, Choi Sung Min,
 Ham Minjoo, Kim Hyunmee,
 Kymn Kyungsun, Lee Jihye, Lee Kunha,
 Lee Noheul, Min Bon, Min Byunggeol,
 Na Kim, Noh Eunyou, Yoon Choong-geun
Translation: Choi Sung Min, Fritz K.Park,
 Hong Khia, Kim Johan, Kim Noheul,
 Mikie Jae
Editing: Korean Society of Typography
 Editorial Department,
 Ahn Graphics Editorial Department
Design: You Hyunsun

Publisher: Ahn Graphics
 125-15 Hoedong-gil, Paju-si,
 Gyeonggi-do 10881, South Korea
 tel. +82-31-955-7766
 fax. +82-31-955-7744
President: Ahn Myrrh
Chief Editor: Moon Jiook
Managing: An Mano
Marketing: Lee Chong-suk
Communication: Kim Na-young

Printing & Binding: N2D Printek
Paper: Doosung Invercote Creato 260g/㎡,
 Doosung Munken Print White 15 80g/㎡
Typeface: Sandoll Greta Sans Beta, Arvana,
 Yoonseul Batang, Charter, IBM Plex Sans

This research paper, as well as
others, is published on the Korean
Typography of Society website.
koreantypography.org

A CIP catalogue record for this book is
available from the National Library of Korea,
Seoul, Republic of Korea.

CIP Code. CIP2020042386